Painting the Town: Cityscapes of New York

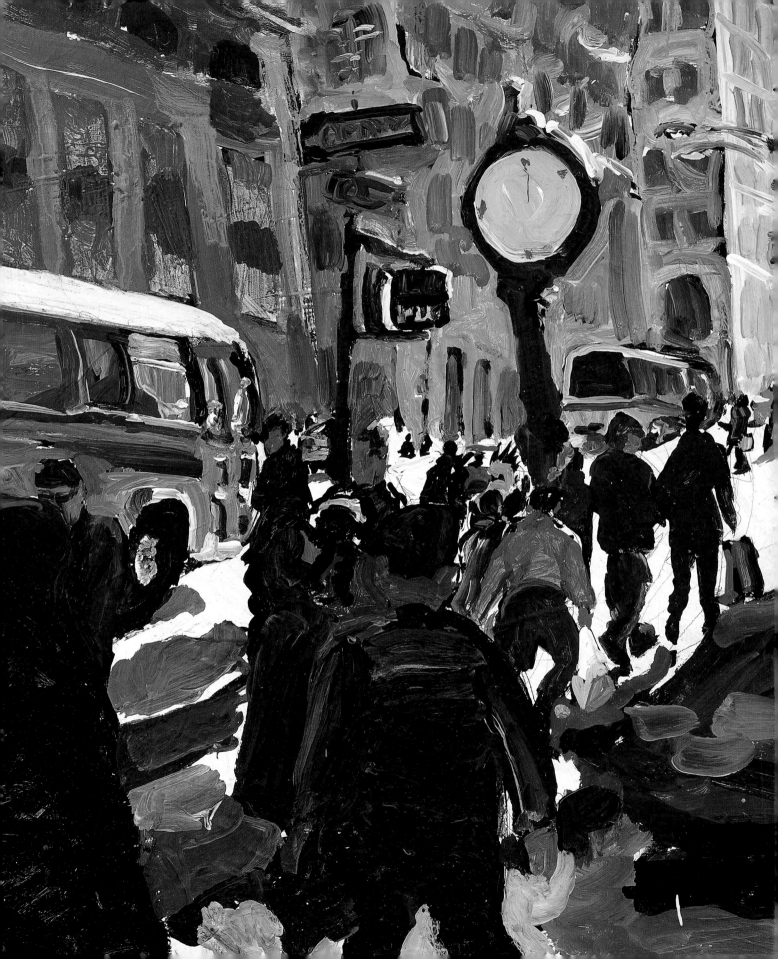

Painting the Town

CITYSCAPES OF NEW YORK

Paintings from the Museum of the City of New York

Museum of the City
of New York
in association with
Yale University Press
New Haven and London

Edited by

Jan Seidler Ramirez

Essays by

Michele H. Bogart
Jan Seidler Ramirez
William R. Taylor

Entries by

Barbara Ball Buff
Jan Seidler Ramirez

Designed by Leslie Fitch.
Set in Adobe Minion, Gill Sans, and Berthold City type by Leslie Fitch.
Printed in Singapore by Tien Wah Press.

LIBRARY OF CONGRESS CATALOGING-IN-PUBLICATION DATA
Museum of the City of New York.
 Painting the town: cityscapes of New York: paintings from the Museum of the City of New York/edited by Jan Seidler Ramirez; essays by Michele H. Bogart, Jan Seidler Ramirez, and William R. Taylor; entries by Barbara Ball Buff and Jan Seidler Ramirez.
 p. cm.
Includes bibliographical references and index.
ISBN 0-300-08199-5 (alk. paper)
1. Painting, American—Catalogs. 2. New York (N.Y.)—In art—Catalogs. 3. Painting—New York (State)—New York—Catalogs. 4. Museum of the City of New York—Catalogs. I. Ramirez, Jan Seidler. II. Bogart, Michele Helene, 1952– III. Taylor, William R. IV. Title
ND205 .M87 2000
758'. 77471'0747471—dc21 99-054934

A catalogue record for this book is available from the British Library.
The paper in this book meets the guidelines for permanence and durability of the Committee on Production Guidelines for Book Longevity of the Council on Library Resources.

10 9 8 7 6 5 4 3 2 1

Frontispiece: Tom Christopher, *Last Clock on Fifth Avenue,* 1996 (plate 128).

Contents

Foreword

REMEMBRANCE is the authentic capital of museums. This is particularly true of history museums, whose collections are the fountainhead of individual and communal memory. Portrait collections present the visual memoir of individuals and families. Holdings of landscapes and cityscapes evoke recollections of shared spaces, reinforcing an affinity with particular places and an awareness of their transformations through time.

In 1923 the Museum of the City of New York was established as America's first museum with the mission of preserving a city's remembrances, an objective as simple as it is profound. The Museum's founders believed that the material culture their new institution gathered would encourage natives and newcomers alike to learn about and value their distinctive and shared histories and, in so doing, would strengthen their sense of themselves as New Yorkers.

The collections assembled by the Museum of the City of New York over the past seventy-five years form the memory bank of one of history's most imposing communities. Jan Seidler Ramirez has probed a significant segment of this treasury: the Museum's sizable holding of city scenes. In her essay "Painting the Town: Collecting Cityscapes and Urban Character at the Museum of the City of New York," she links the Museum's collection of city views with the persistent attempt by visual artists to explore and preserve the complexities of the urban stage in a city undergoing perpetual transition. By placing the Museum's collection of urban scenes in the context of New York's evolution, she has confirmed the significance of the Museum's holdings as a resource central to the study of New York City.

This project would not have been possible without the generous support of the National Endowment for the Arts; the National Endowment for the Humanities; *Furthermore*, the publication program of The J. M. Kaplan Fund; the Moore Charitable Foundation; and W. Cody Wilson. The Museum of the City of New York is grateful for the contributions of collaborating scholars Michele H. Bogart and William R. Taylor. Their informed insights stimulate consideration of this genre from new and differing perspectives. Barbara Ball Buff applied her knowledge of urban-scene painting in preparing entries that add historical dimension to the art. Peter Simmons, the Museum's Deputy Director for Exhibitions, Publications, and Electronic Media, guided this book to completion with intelligence and perseverance. His associate, Kassy Wilson, meticulously prepared the manuscript for publication. Finally, the Museum thanks those curators and donors who over the years have contributed their talents and generosity to assembling a collection that serves as an irreplaceable visual memory for present and future generations of New Yorkers.

ROBERT R. MACDONALD
Director
Museum of the City of New York

Max Arthur Cohn,
Cityscape (detail), 1975
(plate 108)

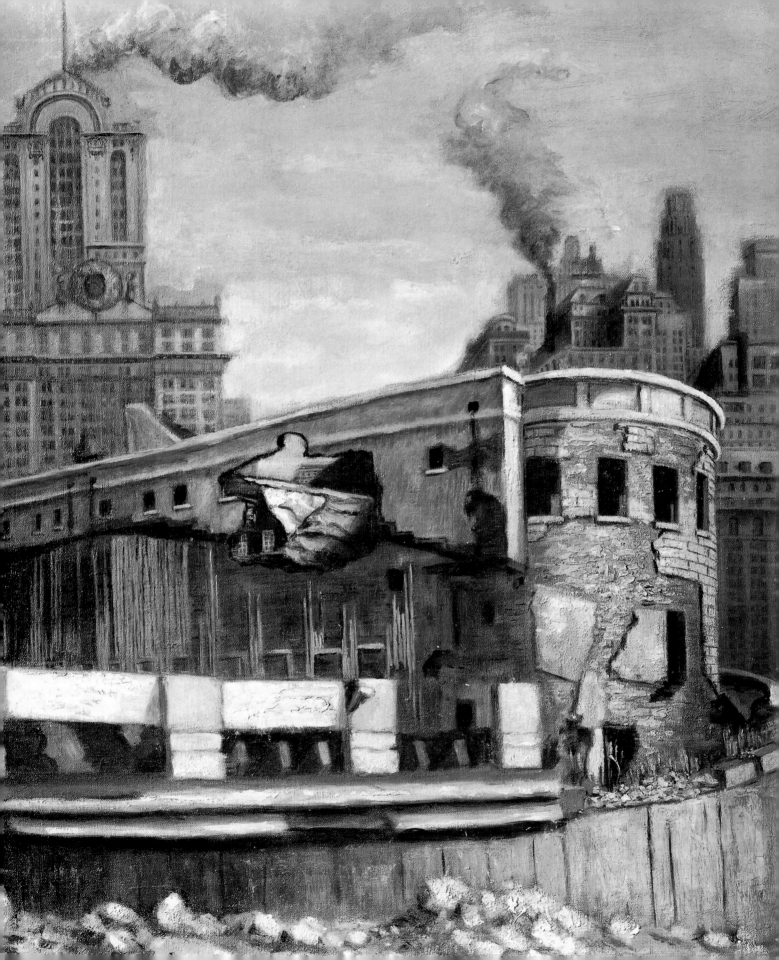

Painting the Town

Collecting Cityscapes and Urban Character at the
Museum of the City of New York

Jan Seidler Ramirez

IN 1946 a painter named Mary Mintz Koffler climbed some
rubble skirting Castle Clinton, a protean site on the Battery
that had served New York City as a military stronghold, opera
house, immigration center, and aquarium over its 130-year
existence. The structure, already partially demolished, had
been doomed five years earlier when harbor pollution and
lack of room to expand prompted aquarium administrators
to look elsewhere for an improved facility (the aquarium was
temporarily housed at the Bronx Zoo until the new facility
was built on Coney Island). Their exit enabled the audacious
Robert Moses to accelerate his plans for razing the old fort
and the area adjoining it to accommodate the new Brooklyn-
Battery Tunnel. Koffler, bracing her sketchpad from the con-
struction blasts that had resumed after the interruptions of
World War II and a prolonged unsuccessful legal campaign to
have the landmark preserved, began to record the building's
carcass from the nearby pile of debris. In *The Aquarium in
Destruction* of 1947 (fig. 1), she memorialized the structure as
an antique ruin against the backdrop of lower Manhattan's
modern skyline.[1]

 Although straightforward in style, the picture carries
a subtext relating to the crossfire that surrounded the aquar-
ium's threatened destruction. In their efforts to rescind the
authorization to rid Battery Park of what remained of Fort
Clinton, opponents of the Moses project, including members
of the Citizens Union, the Fine Arts Federation of New York,
and the American Scenic and Historic Preservation Society,
had approached the city's Board of Estimate with a proposal
to finance the fort's restoration with private funds in recogni-
tion of its historical value. When these efforts proved unsuc-
cessful, they next appealed to the courts, a protracted process
that bought some time (but not immunity from the start-up

1 Mary Mintz Koffler, *The Aquarium
in Destruction* (also exhibited as
Aquarium Asunder), 1947, oil on
canvas, gift of the artist, 82.117

of site clearance) to press for legislation that would deed the property to the federal government as a national park.

A stay of execution materialized when an injunction was issued forbidding further demolition without approval by the New York City Art Commission. A few months later, however, New York's Appellate Court overturned that ruling, opining, "We hold that what now remains of the Aquarium structure or the walls of the old fort which preceded it does not constitute a 'monument' or a 'work of art' within the meaning of the City Charter."[2] Jurisdiction was returned to the Board of Estimate, which considered the structure to have outlived its practical usefulness. Demolition proceeded. Belatedly, Congress rewarded the preservationists with a compromised victory by declaring Castle Clinton a federal monument, but not before the wrecker's ball had dismantled all but the walls of the original fortress.

Threaded through the saga were all the recurrent debates pitting nostalgia against pragmatism, enshrining the past versus expediting the future, at the bedrock of New York City's history. Attuned to these tensions, Koffler used her brush to effect what bureaucratic taxonomy would not concede: she transformed into art a piece of real estate denied legal recognition as art, thereby "landmarking" the monument on canvas for posterity.

Koffler's elegy to the condemned aquarium is the sort of painting tailored to the Museum of the City of New York, with its interest in the city as a living organism. She eventually donated the work to the Museum, and it is now among the 1,750 "urban scenes" entrusted to the Paintings and Sculpture Collection, a curatorial department formally established by the Museum in 1987 to promote access to this important but little known and thus undervalued historical resource.

Paintings comparable to Koffler's, illustrating sites laden with narrative or sentimental association, were among the core materials gathered by the nascent Museum, which was incorporated in 1923, to help chronicle the aims and vagaries of New York's development via exhibitions lodged at its purpose-built headquarters on upper Fifth Avenue. In April 1929 Mayor Jimmy Walker laid the building's cornerstone; its interior time- and theme-driven displays made their public debut on January 11, 1932. Although the Museum had been housed successfully in several temporary locations during the robust years of the 1920s,[3] upon taking occupancy of this new facility it was immediately hobbled by the financial fallout from Wall Street's crash. A chronic shortage of discretionary funds would test the institution's health and ingenuity thereafter, and gifts from artists—such as Koffler's *Aquarium*—became vital to the enlargement of its visual holdings.

Adhering to organizational models from abroad that had seeded this maiden American effort at a municipal history museum, the founding administration made no medium-based distinctions when assembling the instruments of urban iconography. Content mattered; the more direct in its delivery, the better. Just how such information was visually crafted, embroidered, concealed, jettisoned, or retrofitted, and what compelled artists to probe New York City's physicality, were issues considered less germane to the cause of educating citizens about their city's history. "Scene paintings" consequently spent almost sixty-five years tethered to the vast Print Collection, interspersed with maps, drawings, photographs, postcards, and a treasury of printed views.

Nonetheless, new acquisitions of oils, watercolors, and other brush-made landscapes arrived steadily, if randomly, through bequests and occasional pursuits of donations useful

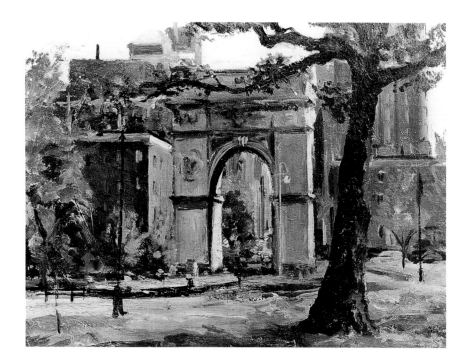

2 Franz Kline, *Washington Square Arch*, 1940, oil on board, Museum purchase, 84.94.5

to specific exhibitions. Supplementary loans were secured as needed, and contemporary city-scene painters were honored with sporadic monographic surveys, solidifying the Museum's reputation as a venue receptive to this genre of picture.[4] Along the way, however, the collection's custodial situation took an inevitable toll. Canvases housed as "prints" lost their materiality as artifacts. The origins of these unique artworks were largely forgotten. Only rarely did painterly techniques or makers' intentions surface in the discussion accompanying paintings on display.

Hindsight also exposes many missed opportunities to develop the collection proactively. A case in point: during the Museum's formative years, no courtship was paid to the "Ash Can School" painters, who were still in force locally, or to their patrons. Their bold forays into urban realism, though borrowed for occasional presentations, evidently were never recruited for the permanent collection, whether as gifts or purchases via specially solicited funds. Given the exalted prices commanded today for work by the "Eight," the likelihood of filling such a lacuna, at least in the form of a painting, seems improbable.[5]

The Museum's separation of paintings into a new division independent from prints, in 1987, was the lead step in bringing accountability to this sprawling collection and in rationalizing its future growth. By 1989 a comprehensive inventory and conservation assessment of these holdings had been completed, with dedicated research files compiled for the majority of works and artists represented. Contacts with artists or their estates also generated pertinent recollections for this evolving archive. Grant-supported cleaning proceeded on paintings prioritized for treatment, yielding many fresh revelations. Blendon Reed Campbell's *Queensboro Bridge* (plate 85), for example, was transformed from a leaden view of Manhattan, mood-toned to the Depression, into a pristine city of promise with the removal of a filmy grime that had obscured Campbell's high-keyed palette.

In the course of re-cataloguing, a profile emerged of a collection molded by idiosyncrasies innate to the museum's mission, operational circumstances, and service as a municipal memory bank, yet also characteristic of the immense proportions, variety, and constancy that have marked the enterprise of cityscape painting over the past two centuries. Consider, for instance, Franz Kline's 1940 *Washington Square Arch* (fig. 2), a rather pedestrian scene predating his celebrated breakthrough into nonobjective painting. What may seem marginal according to aesthetic canon can be lifeblood

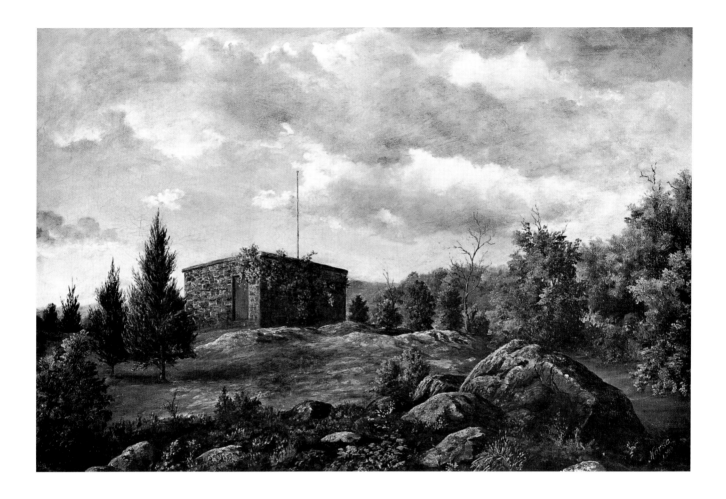

to an institution trafficking in imagery specific to place; hence the Museum's accommodation of this aberrant Kline as prime evidence of the pictorial gold the artist had spun from the hay of souvenir views when odd-jobbing around Greenwich Village in the late 1930s.[6]

Another goal of the documentation process was to recover contemporaneous meanings distanced from paintings during their long residency in the Print Collection—contexts further obscured by the blanket of critical neglect that generally dropped on visual realism after the rise of Abstract Expressionism. Stansbury Norse's *Old Blockhouse in Central Park*, 1888 (fig. 3), received as a gift in 1952, epitomized the challenge, underscoring, too, that a scene's simplicity could prove deceptive.

Date, author, donor, and nominal subject were the extent of facts volunteered on its spare registry record. A cat-

aloguer had remarked that the painting depicted an artillery magazine built in 1814 as part of a defense erected against the possibility of British invasion of Manhattan from the north. The scene's creator proved to be a little-known painter who exited New York City in the 1890s to take the post of drawing instructor at the State Normal School in Potsdam, New York.[7] A work of modest power, its virtue seemed limited to the topographical evidence Norse had supplied of Central Park's rocky northwestern summit, which had been enfolded into the Greensward Plan, blockhouse included, only after the park's northern boundary was extended from 106th Street to 110th Street.

The view's meditative mood, however, encouraged deeper investigation. The boarded-up blockhouse, research disclosed, was one of just two structures surviving from the park's pre-development era.[8] By the late nineteenth century,

its eroding condition had provoked calls for removal and outcry over the rubbish accumulating in its interior. Discussions followed about whether, and then how, to reclaim old "blockhouse no. 1." In 1905 the Women's Auxiliary to the American Scenic and Historic Preservation Society placed a commemorative tablet on the freshly rehabilitated site. Uncertainty lingered, however, over whether to press for additional restoration or to risk leaving the structure to rusticate.

The military relic, while undistinguished architecturally, acquired symbolic appeal during these years as material proof of New York's continuum—as a monument to historical memory all too rare in an urban landscape where amnesia, justified as progress, was the rule. "Overturn, overturn, overturn," nineteenth-century diarist Philip Hone had observed of the city's relentless forward momentum. Norse's painting, which details the picturesque overgrowth on the blockhouse's masonry as well as its glacier-shaped site sloping toward a foreground of primordial boulders, assumes richer interest in the context of the larger ideas of preservation at stake in this remote corner of Central Park.

In a strong practical sense, the Museum of the City of New York itself was indebted to a series of local failures in New York's outdoor preservation movement, which paralleled the 1898 launch of Greater New York as a new, five-borough enterprise and then its aggressive re-sculpting into the world's touchstone mega-city.[9] The prospects for the consolidated city were cause for excitement, but the breakneck pace of its modernization also prompted concern. How could a metropolis so large and provisional foster civic pride? How could urban memory be conveyed to newcomers spilling into this magnet for commerce when its place markers were

so vulnerable? As construction accelerated after World War I, particularly in Manhattan, predictable landmarks used to reference city traditions were disappearing. The patriarchal homesteads of New York's old guard were being dismantled as their occupants regrouped in luxury apartments or decamped for the suburbs. Salvaging elements of the city's history in the safety of a professionally managed museum was a timely concept by 1923, the inception date of the Museum of the City of New York.

The Museum opened as a depository for the material evidence and residue of New York's three centuries of settled history, with the purpose of awakening "in the schoolboy and immigrant an understanding and pride in his citizenship," as noted in an early annual report. City-history crusader Henry Collins Brown, a preservationist, publisher, and prolific annalist of Old New York, helped to pilot the venture and briefly served as the museum's first director.[10] Consultation was sought, too, from I. N. Phelps Stokes, an architect, philanthropist, and connoisseur of historical maps and prints who was then deep into his multi-volume illustrated study *The Iconography of Manhattan Island* (1915–28), which drew largely on his own authoritative collection.[11]

Creating an antiquarian shrine, however, was not the objective. Here, retrospection would be a device, not an end. With scholarship as a foundation, this city-history museum resolved to make learning a dynamic process, facilitated through collections, public programs, and didactic exhibitions. At the institution's Fifth Avenue home, the exhibitions included the progressive use of period alcoves installed as windows into the domestic culture of yesteryear, and a comprehensive scheme of miniaturized dioramas dramatizing, in twenty-five-year increments, episodes from local history. The

4 Thomas Hicks, *Portrait of George Trimble*, 1854, oil on canvas, gift of the Board of Education of the City of New York, 82.155

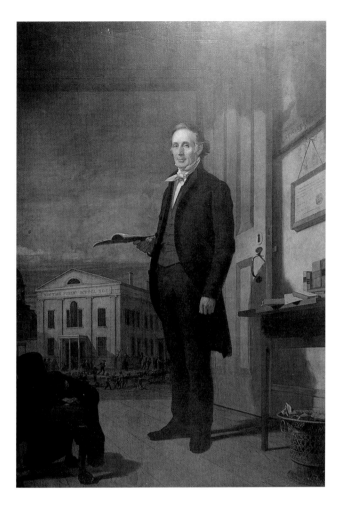

first pair of dioramas readied, representing the reputed 1626 purchase of Manhattan Island and the Empire State Building then under construction, suggests the Museum's sweeping chronological interests. These are borne out in the topics of early special exhibitions, which ranged from views of old houses to watercolor studies of skyscrapers borrowed from contemporary artists. By straddling the past and present, the Museum's planners theorized, visitors would be afforded more informed perspectives about urbanization over time—an appreciation of the gains ultimately achieved through sacrifices along the way. By looking back, one could also look forward with keener sight.

As instructional aids, paintings were instrumental in pointing New Yorkers toward models of civic character worthy of emulation. Not surprisingly, portraits of early community pillars, leading families, and other contributors to the city's commonwealth found immediate opportunities for exhibition. Although biography was the focus, a number of portraits acquired by the Museum offered incidental glimpses of New York City as background settings, to some extent forecasting the emergence of the cityscape as a "character" meriting independent documentation on canvas.

Several eighteenth-century portraits of local merchants in the collection contain what amount to generic New York Harbor views and other oblique allusions to public settings associated with the sitter. By the midpoint of the next century, however, convincing site details had entered the formula, sometimes competing for attention with the painting's announced subject. Thomas Hicks's "grand manner" portrait of banker and business leader George T. Trimble (1823–1890) (fig. 4), dated 1854, illustrates this tendency. To acknowledge the subject's dedication to educational philanthropy (Trimble championed the Public School Society in New York for thirty-five years and became a founding member of the Board of Education when it merged with the society in 1853), Hicks positioned Trimble in a school room with its door flung open. The view beyond reproduces, with considerable accuracy, the classical architecture and locale of Free School Number 2, on the corner of Tyron Row and Chatham Street, whose frolicking pupils have spilled into the street, providing scale to the scene.[12]

Although the expediency of portraits was a given, urban landscape paintings per se do not seem to have been an acquisition priority for the young museum. Finances pre-

cluded outright purchases, and storage inadequacies may have been another concern (within months of the Museum's opening, it was evident that space requirements for its proliferating collections had been greatly underestimated). A sense emerges, too, that paintings were judged of lesser utility to the agenda of preserving sites through iconography. A city in chronic transience required an appropriately reactive medium to capture its flux and ever-shifting targets of development. As objects crafted by hand, paintings resisted immediacy by requiring a period of gestation for their manufacture. Moreover, artists were often intrusive record keepers, bringing irrelevant mannerisms into the process of picture making. An early institutional emphasis consequently fell on photography as the workhorse for documenting New York, with hard-to-find funds occasionally diverted to its service.[13]

If not an actively cultivated area, painted cityscapes nonetheless appeared among the flood of donations being pressed on the Museum and immediately earned their keep. Their foremost contributions were to the mission of instilling an appreciation of New York City's heritage in those newly arrived or unfamiliar with history as a living resource. Like portraits, the cityscapes held lessons beneficial to citizenship. New York City's parks, streets, waterfront, bay, and commercial areas were shared by New Yorkers, harboring stories meaningful to the public culture. Views of the pre-modern city also documented generational alterations of appearance and topography, allowing change to be evaluated visually as a constant, progressive impulse moving New York from a fringe trading post to its destiny as a world-class metropolis. (Scholars today refer to this cyclical trend of physical overhaul as "creative destruction.") By helping to trace the urbanization process, cityscape paintings, like vintage maps and

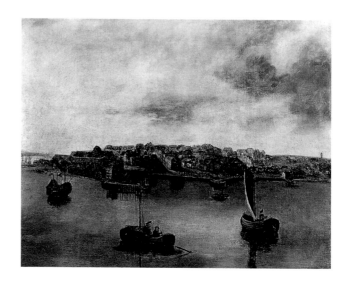

printed views, offered contemporary New Yorkers comparative yardsticks and, the argument held, a heightened sense of ownership in the city they, too, would be shaping for, and bequeathing to, the future.

Paintings of New York City became more numerous the later their date of production. These mathematics reflected the slow, peripheral start of this pictorial genre on American shores in contrast to the lively specialty of urban view-making that major foreign capitals had supported from the seventeenth century onward. An extraordinary prize, therefore, was the Museum's receipt in 1929 of an oil-on-canvas prospect of New York seen from the East River, which experts of the day pronounced "of seventeenth or very early eighteenth century origins" (fig. 5). The painting, dubbed *View of New York* (circa 1674), had been acquired as part of a staggering lead gift of fifteen thousand New York views, maps, and other locational documents made to the institution by Bronx realtor

and iconophile J. Clarence Davies, a generous early patron.

Transfer of this "municipal treasure" into the Museum's publicly accessible holdings made front-page news in several local papers. The *Herald Tribune,* in the opening of its article announcing the donation of Davies' $500,000 trove of "city relics" to the Museum, celebrated the scene as "the first oil painting ever made of Manhattan, showing small sailing vessels off the Battery and the little low-lying Dutch town with an occasional two-story-and-attic skyscraper jutting into the skyline."[14] The artist, conjectured print historians, probably knew the engraved inset of Manhattan from the map published by Carolus Allard of Amsterdam around 1674, known as the Restitutio View, commemorating the fleeting triumph of the Dutch recapture of New Amsterdam on August 7, 1673. Maps featuring this view had appeared in several editions as late as 1760.

The primal cityscape, apparently modified from Allard's composition, fascinated Museum visitors. Depicted was a sputtering trading town of minimal scenic attractions, which nevertheless boasted long-vanished curiosities: Fort Amsterdam at the Battery, fortifications along the shoreline, a ship's signal tower, the indentation for the canal that once cut inland from the harbor, and gabled row houses reminiscent of Amsterdam. Borrowed from the Restitutio View is the line of soldiers marching along the quay. Absent here, however, are the cannon firing from the fort and the armed Dutch ships offshore seen in the earlier print. Other variances were accounted for by the speculation that the view had been purposely updated by the artist, or perhaps by another, some years after its original creation.

Great faith was placed in the picture's antiquity ("antedated by drawings only," affirmed the *Herald Tribune's*

reporter) and in the facts about New York's topography that it supplied. These assumptions suggest the credence given, at least by the Museum's first curators, to such historical paintings as neutral documents that aspired to present an objective record of the cityscape, with outcomes dependent only on the artist's individual skill.

Years later, suspicions about the painting's authenticity emerged based on its provenance, condition, and peculiar rarity. Reportedly, the work had been discovered in the second decade of the twentieth century in the attic of an old house in New Dorp, Staten Island, which had been leased for the summer by an artist. Badly damaged by rain leaking through the roof, the abandoned canvas was brought by its finder to Paris for restoration, where the work was "badly done," as I. N. Phelps Stokes conceded in his notation about the view.[15] With the passage of time, no other works by the same hand or school emerged to better situate the painting as the product of an artist active, however briefly, in colonial New York or perhaps Amsterdam. Moreover, corrective overpainting by the Paris "conservator" obscured any subtleties original to the picture that might have assisted attribution.

Today, the status of the work remains unsettled. Some experts accept the painting's oldness but assign its origins to the Netherlands, where it may have been developed from rough site sketches or other period sources; others speculate that it represents a falsified "find" planted sometime in the early twentieth century to capitalize on Colonial-Revival ardor for quaint Americana. Most, however, now date the painting from the nineteenth century, identifying it as probably the handiwork of an artist conversant with antiquarian iconography who was pleased to oblige curiosity about the old-fashioned Manhattan no longer discernible to present-day eyes.

6 Lester B. Bridaham, *Manhattan Island,*
 1931, 1931, watercolor, gift of Lester B.
 Bridaham in memory of Kimon
 Nicolaides, 89.39

That the painting may not be contemporaneous with the view it presents obviously calls its neutrality into question. Instead of diminishing its value as a document, however, the scene's retroactive creation shifts the picture into a category of reminiscent cityscapes now considered an important demonstration of "forgotten" New York's allure to generations that preceded Davies, Stokes, and the original sponsors of the Museum of the City of New York. By the middle of the nineteenth century, it is worth remembering, modernizing forces were furiously at work in the city. Manhattan's natural topography had undergone wholesale remodeling: it was "squashed, degreened, flattened, dried, and gridded with right-angle streets," as one writer summarized its transformation.[16] Traces of New York's pre-1800 settlement had been largely eradicated by fires and develop-

ers; haphazard colonial charm had been supplanted by a cityscape systematized for speed, commerce, and land profits. While few lamented these changes as negative to society, they spurred the same sentimental glances back at a simpler city that reemerged at the beginning of the twentieth century, and recurrently during later periods of intense physical transition in New York.

View of New York remains a good example of the Museum's historical preference for literalism when it came to paintings of place, for depictions of tangible truths about the city's built environment. Seventy-five years later, these parameters have loosened. Today the collection reflects a far broader spectrum of motives that have driven painters of New York, encompassing conventional "portraits" of the urban envelope along with apocryphal views, memory studies, tourist souvenirs, autobiographical vignettes, and capriccios for which New York's streets have functioned as points of departure. In terms of large categorical sorts, a balance now exists between paintings concentrating on "scape" and those focusing on "scene," the latter visualizing the uses of, and interactions with, the city by urban humanity.

Lester Bridaham's *Manhattan Island, 1931* (fig. 6), added to the Museum's holdings in 1989, is a measurement of the distance traveled from fact-based content as a requisite for acquisitions. Whereas the setting may be recognizable as the junction of 42nd Street and Sixth Avenue (the spire of the nearly completed Empire State Building thrusts skyward at the picture's left), its presentation is fantastical. Here, midtown Manhattan has been enlisted as a carnivalesque stage set, compressing into this famous intersection a swirling spectacle of Jazz Age commercialism and irreverence. The artist, who had trained at the Art Students League in the late

1920s before touring Europe in 1930 to study "the grotesque" in French Gothic sculpture, works the scene at both playful and profound levels. For instance, echoes may be found in Bridaham's complex composition and unsettling palette to Belgian painter James Ensor's *Christ's Entry into Brussels in 1889* (1888), a sardonic tableau of monstrous-looking citizens jostling through an urban plaza aflutter with political banners and a lone placard imploring "Vive Jesus."[17]

This book offers a general profile of the urban paintings accumulated by the Museum of the City of New York since its inception. Using cityscapes from the collection as arguing points, essayists William R. Taylor and Michele H. Bogart introduce this survey by considering the larger cultural implications of "picturing" New York City as historical craft and art product. Their contributions shed light on the dynamics of symbiosis that have characterized the long-lived relationship of artists to New York City as a source for ideas, income, training, shelter, and professional community. The evolving formats and types of information associated with urban-scene art are distilled in the 128 works selected as catalogue entries.

The collection's terrain will be navigated more meaningfully if its general contours are understood. It seems obvious, yet bears repeating, that the Museum's holdings are, at essence, a compilation of visual insights. Although intentions, techniques, and individual skills vary, the painters represented in these holdings have shared the challenges of attempting to define the properties of a matchless place; of stilling New York's cinematic existence into revealing "frames" that invite scrutiny while offering optical delectation. Indeed, one group of paintings in the collection can be said to fall into the category of perceptual experiences. In

them, content is submerged by the intense sensation of seeing and sifting meaning from the city's collage of lights, colors, shapes, movement, textures, and material stuffs.

Themes braided through these holdings more typically connect to high and low watermarks in the city's evolution. There are clusters of images, for instance, celebrating engineering achievements in New York's infrastructure. Others mark exceptional public events, dramatize catastrophes like fires, and expose the miseries of crime and blight. Historically, urban view makers have also commemorated activities and architecture so banal that they disconcert us, forcing reconnections to what is commonplace about the extraordinary universe of New York City. The quotidian, too, receives its due in the collection.

Still other cityscapes can be sorted into a category of geography-as-biography. These views, in their comparative density, graph the local movements of artists. Evidence of their explorations outward, for instance, are documented in landscape content drawn from such destinations as Coney Island (by the late nineteenth century) and Van Cortlandt Park in the Bronx (several decades later), made accessible via elevated trains, subways, and extending commuter rail networks. Paintings similarly witness their literally upward mobility: the continual search by artists for unobstructed and unprecedented views of the developing city. "El" platforms, bridge spans, high-rise windows, and skyscraper rooftops served as generating stations for a series of painted panoramas in the collection.

Subjects convey residential mobility, too. In their concentrated number, for example, scenes of early twentieth-century Greenwich Village speak to the painters then congregated in this picturesque enclave of cheap boarding

houses and bohemian cafes. Slightly later, an increase is seen in the number of midtown panoramas and streetscapes, reflecting the realignment of artists around the professional resources of galleries, schools, and newer studio buildings centered around 57th Street.[18] Frederick Detwiller's *Temples of God and Gold* (1923) (fig. 7), an aerial prospect of mid-Manhattan looking west from the eleventh floor of Carnegie Hall, is not only a striking view but also one enabled by Detwiller's workaday mooring in the building, which contained 150 artists' studios and a street-level gallery to display their work. Since 1990, the Museum's cityscape databank has registered an upswing in studies of neighborhoods formerly assigned to the geographic fringe, such as Red Hook and Williamsburg, Brooklyn, and the area known as Dumbo (Down Under the Manhattan Bridge Overpass). Prohibitive rents in the city's trendier art pockets have propelled painters to improvise studios in these industrial and working-class locales, from which a fresh crop of place-specific pictures is emanating.[19]

Exhibition initiatives tied to paintings also account for certain artificially seeded strengths within the collection. Exhibitions devoted to single artists have sometimes occasioned plural gifts of work. Theme-based projects have also generated activity. In 1973 the Museum's pathbreaking *East Harlem,* which looked at the history and art of its neighboring community, resulted in a windfall of contemporary work by resident painters. Entering the Museum were numerous date-specific views reflecting the harsh realities of a district gripped by drugs and poverty, yet taking note of El Barrio's transcendent sociability. In 1983 *Painting New York,* a vehicle to showcase recent paintings by twenty-five emerging artists, resulted in a flush of acquisitions representing urban-scapes of the early 1980s. The presentation in 1989 of *Window on Wonder City* as a companion piece to a major exhibition commemorating the fiftieth anniversary of the 1939 New York World's Fair also generated donations from former participants in locally based New Deal art programs between 1935 and 1941. This aging pool of painters, many of whom specialized in city-scene imagery during some portion of their careers, often recalled the Museum as a lifeline during the "hard times" of abstraction and other nonrepresentational "isms," and expressed satisfaction at now being able to give something back to an institution that had been dauntless in advocating the importance of art-of-the-city. The recent installations *New York Now* (1996) and *New New York Views* (1999) have also coaxed gifts from painters of disparate styles who are contributing to the current, reinvigorated stream of cityscape art coursing through the five boroughs of New York and beyond.

The Museum's collection is also a collection of sub-collections, assembled by individuals of far-ranging back-

grounds and attitudes toward cityscape painting. J. Clarence Davies' bounty of New York iconography (which came with the services of his cataloguer, J. H. Jordan) was parceled out to the Museum in two gifts, the majority arriving in 1929, with the balance registered in 1934, following Davies' death. Enjoying status as the Museum's seminal "views" collection, its organizing purpose would set a tone for later acquisitions growing from and around it. When interviewed about his passion for collecting, Davies traced its inception to a print he chanced upon in a back issue of *Valentine's Manual* when he was an aspiring, fourth-generation realtor in the family firm, a leading promoter of Bronx properties.[20] Reportedly, the view showed an improbably pastoral intersection at Fifth Avenue and 42nd Street in Manhattan around 1840, before its metamorphosis into Manhattan land gold. Struck by the concrete demonstration that old pictures provided of the potential for, and inevitability of, urban growth, Davies bought it to "show to clients, in order to stir their imagination as to what was going to happen in the Bronx." Pragmatism, not nostalgia, attended the birth of Davies' collection. Views of the stripling city, he observed, wasting no words, "illustrate real estate arguments."[21]

The Museum has benefited from the generosity of others whose individual visions are now preserved in groups of paintings represented in the collection. Three short case histories illustrate the point. Natalie Knowlton Blair (1883–1951), a resident of Park Avenue and Tuxedo Park, New York, was a discriminating collector of Americana. Cushioned by financial resources and aided by prominent social ties as well as the advice of knowledgeable dealers, she assembled an extraordinary trove of antiques and period views in her lifetime. Much of this material was installed in museum-like room settings at her Tuxedo Park mansion. The significance

of these holdings, however, far exceeded tasteful decoration. After Blair died in 1951, her collection was distributed among four New York City museums in memory of her in-laws, Mr. and Mrs. J. Insley Blair. Her bequest to the Museum of the City of New York included two oil paintings and sixteen watercolors, dating from 1731 to 1880, which still rank as some of the collection's most important, scrupulously observed New York cityscapes (see, for instance, plates 2, 3, 4, 9, 11, and 21).[22]

Robert R. Preato (1941–1991), whose legacy survives in thirty-nine New York City scenes bequeathed to the Museum in 1991 (see plates 54, 59, 66, 71, 86, 88, 92, and 100), pursued collecting steered by two main reference points. An art professional who was a valued adviser to numerous private dealers, collectors, auction houses, and art publications, he had a seat on center court when it came to spotting investment opportunities, and as director of American Masters at the venerable Grand Central Galleries, he enjoyed access to some stunning work undervalued in the market. Preato was also a native New Yorker who relished the city's intensity and constant visual surprises. For his private nourishment and with relatively modest means, he began to buy oils, watercolors, and drawings that captured New York's theatrics of change—older buildings sacrificed to the future and vistas forever erased by new construction, concentrating on the period of the city's physical journey into modernity between 1890 and 1940. This was the New York that Preato remembered from his youth, reflected a colleague about the personal sentiments these paintings embodied: "He was transported back to these days by living with his collection of New York cityscapes."[23]

Martin Wong (1946–1999), a painter of Chinese-Mexican heritage, settled in the East Village in the early 1980s as a transplant from San Francisco, where he had been active in

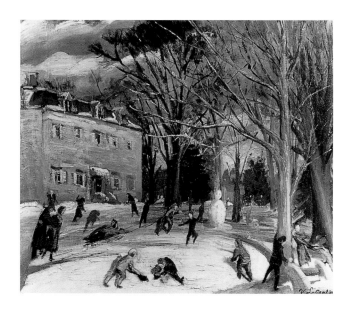

several Bay Area performance-art groups. A self-taught painter who favored cowboy attire, Wong imported to New York a mystical creativity but no solid assets beyond conviction to support his ambitions to make art and, in a matter of months, to collect it as well.[24]

He succeeded at both. Wong's own career as an urban landscape painter took flight just as the phenomenon of urban graffiti was growing more brazen and adroit on the storefronts, tenement walls, and handball courts near his walk-up flat. Sensing something fascinating, if ephemeral, at work in the city landscape, he sought out the young writers behind the movement (most, like Wong, were outsiders to America's majority culture) and schooled himself in their renegade aesthetics. Briefly, he and an associate operated an American Graffiti Museum on Bond Street, which folded in the late 1980s. Through purchases, gifts, and barters, Wong amassed a singular collection of aerosol art by New York writers on the front line in shifting their expressive energies from underground to legitimate surfaces, thereby registering their "tags" and pictorial work in formats translatable to the art market. These holdings, consisting of hundreds of piece-books, spray-painted canvases, and decorated objects, eventually taxed Wong's storehousing abilities. His decision to return to California in 1993 prompted him to consider donating the collection to a museum where its cultural contexts would be well guarded. With its historical interests in the cityscape,

the Museum of the City of New York seemed the logical repository. *Howard the Duck* (1989), by the Bronx "king" Lee George Quiñones, serves as standard-bearer for the Wong Collection in this catalogue (see plate 116).

Finally, the Museum's collection is a collection of artists: of works by individuals steered by the imperative to paint New York City. Many cityscapes gathered in public trust over the years were outright gifts from painters or their descendants. Although chefs d'oeuvre may have been reserved for higher-paying clients, views chosen for presentation to the Museum are nonetheless "signature," as they often represent subjects with personal resonance for their creators, relate to a larger body of work, or contain insights about an artist's style in formation.

As part of the Museum's recent efforts to explore previously uncharted dimensions of the collection, a number of new stories specific to paintings emerged for the record. To cite only one of multiple examples, *Van Cortlandt Park* (1944), by the Italian-born artist Vincent La Gambina (fig. 8), acquired a charm beyond its colorful rendering of a snow-glazed landscape outside the mid-eighteenth-century Van Cortlandt Mansion situated within this multi-acre Bronx preserve. An interview with the artist, then in his eighties, elicited an autobiographical overlay for the picture. Snow, the painter recalled, was an experience absent from his upbringing in Sicily. In 1944 he happened upon this scene of wintertime recreation by overriding his subway stop en route to visiting an army acquaintance. Wholly unaware of the history attached to the storied Georgian-era manse, he was captivated instead by his contact with an authentic American snowfall in his adopted city. The encounter with this wondrous attraction, there at Broadway and 242nd Street, is what La Gambina wished to memorialize.[25] This and other col-

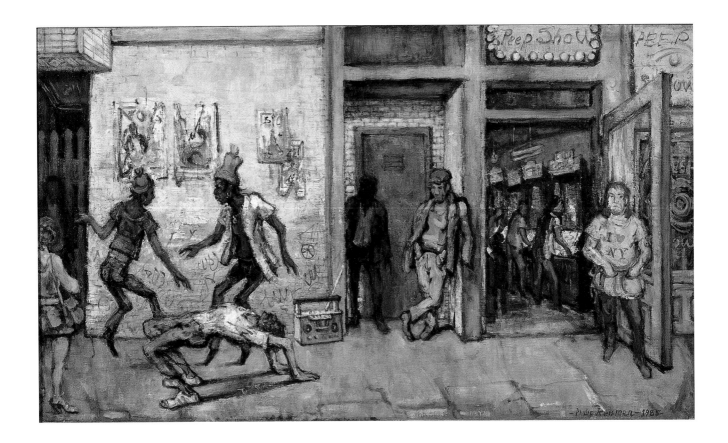

lected stories enrich appreciation of the real lives behind the cityscapes that constitute the Museum's collection.

In the history of American art, urban-scene painters have been a heterogeneous lot. Accordingly, the artists represented in the Museum's collection span a wide compass of backgrounds, from eminent professionals to devout dabblers. Their incentives for picturing the city have been as varied as their subjects and shadings of realist presentation. Certain painters preferred to work in the buffer of a studio. Some painted New York remotely, relying on printed imagery and written description. Still others took their curiosity to the streets, braving sunburn, wind chill, traffic, and sidewalk critics to catch impressions of their subject *al fresco*. Although Ash Can School art may be missing from the Museum's collection of twentieth-century cityscapes, the

chronology contains other painter-reporters who, with portable easels, tracked their prey into the urban storm center. The confrontational oeuvre of the Street Painters (epitomized in Philip Sherrod's 1982 *Pussycat Theatre* [plate 110]) makes the point. A consortium of contemporary artists fluctuating in number but committed to live-action painting in the spirit of the Eight, they began their rounds painting in Manhattan's tenderloin and other high-pulsed sections of the city in the 1970s and are still at it today.

For artists choosing to make a specialty of cityscapes, the odds often have seemed stacked against success, with critical indifference frequently being the outcome of their commitment. Yet many continued the course. The social-realist painter Philip Reisman (1904–1992), honored with a one-man exhibition at the Museum in 1979, devoted much of his

career to painting and sketching New York, as documented in a combination of accessioned prints, drawings, and canvases ranging from the late 1920s to 1985, the date of his lively oil *Games* (fig. 9). He persevered with the subject over six decades, despite claims from the art world that his brand of direct, acutely felt urban picture-making had disappeared in the 1940s, swallowed up by the modernist movement. A 1987 retrospective of the Ash Can Circle, which featured several Reisman streetscapes, prompted one young art critic to liken Reisman "to one of those Japanese soldiers hiding out on some remote island, who is still fighting World War II." How to explain Reisman's accomplishment, he wondered? Like the Japanese soldier, he may never have heard that his "side" lost the war. Or more likely, Reisman "ignored trends and fashion," never looking for a new style, "simply getting better at the one he started with."[26] The Museum's collection acknowledges the integrity and tenacity of hundreds of such artists who have painted New York.

It has been said that New York's cityscape is a palimpsest onto which consecutive generations have marked their historical comings and goings. This book was conceived to function in a similar way. By making accessible a portion of its large collection of urban-scene paintings, the Museum hopes that curiosity will encourage deeper inquiries into this richly layered resource. In turn, each look from scholars and other city-history enthusiasts will generate new interpretive possibilities to superimpose on the images awaiting, and inviting, study.

The Painter and the City

The Evolution of the New York Subject

William R. Taylor

To a CULTURAL historian with little formal training in art history, the paintings listed in this catalogue present themselves primarily as historical documents, sources of insight into the history of the city. Yet the process of interpreting these sources is not as simple a matter as this might suggest. What exactly does it mean to consider a painting historically, to see it as a "document"? Certainly, it must be regarded first as a painting. Most obviously, the historicity of a painting lies in its subject matter, the scenes and events from the past as they are portrayed at a particular time. One tries to look at these paintings as searchingly as the painter's contemporaries did, yet it is not possible for us to see the paintings as viewers did at the time they were painted. Our perceptions have been shaped by profound cultural changes, by photography and film, for example, as well as by the dramatically different urban world in which we now live. The meaning of these paintings is locked within the conventions the artists employed, and it is left to us to puzzle it out. In short, despite our preoccupation with the New York context, our responses are profoundly shaped by the character and quality of the representations themselves, the manner, the idiom, the genre employed in each case by the artist. Their meaning, or at least their historical meaning, lies—with painting as with every other kind of document—in some combination of subject and manner, of the what and the how, which when they are combined make up the New York subject in all its mutations.

New York as a subject of painting and lithography (and later photography and other graphic arts) has a complex history that differs in interesting ways from its place in other art forms. New York figures prominently, for example, in the American novel and in poetry. Beginning with Washington Irving's satirical *Dietrich Knickerbocker's History of New York*

Ernest Fiene, *Night View,
St. Patrick's Cathedral* (detail), 1956
(plate 100)

in 1807, a flood of fiction about the city or set in the city began to appear and continued through the nineteenth century and into the twentieth. It seems that the New York subject was adopted by almost every major talent—Herman Melville, James Fenimore Cooper, William Dean Howells, O. Henry, Theodore Dreiser, Hart Crane, Henry James, F. Scott Fitzgerald, Damon Runyon, John Dos Passos, and many others. Poets, too, have made the city their subject, no one more so than Walt Whitman. Whereas the crest of New York literary portrayals may have passed, novels about the city by E. L. Doctorow and other contemporary writers continue to appear. New York as a setting for mystery writers is rivaled only by Los Angeles. The fascination that New York has exercised over writers of fiction as a vast emporium of urban imagery and diverse human experience clearly continues.

Literary works—novels and long poems like Whitman's *Leaves of Grass* and Hart Crane's *The Bridge*—provide an interesting contrast to graphic art in their development of New York as a subject. In verbal narrative and discursive writing the city takes shape over time, necessarily, because the city gradually unfolds for the reader as the plot progresses. Narrative voice also incrementally qualifies the character of the city in literary works. Verbal images of the city, that is, build consecutively for a reader, whereas viewers confront visual images all at once. Another striking difference between verbal and graphic portrayals of New York lies in the unique kind of subjective perspective provided by poems and novels, as portrayals of the city unfold from the narrator's fictive consciousness. This kind of singularity of consciousness is most apparent in poetry, as in Whitman's "Crossing Brooklyn Ferry," where the sweep of the harbor as seen from the ferry deck is projected, as he puts it, from "the impalpable sustenance of me from all things at all hours of the day."[1]

No matter who the author—Herman Melville, Henry James, Theodore Dreiser, or Scott Fitzgerald—a descriptive passage may reveal something of interest about the city, but it is far more likely that it will reveal something of significance about the narrator and the narrative in progress, that it will predict some aspect of the narrative to follow. In the opening chapter of Melville's *Moby-Dick,* for example, his narrator, Ishmael, having spent the night in the city, wanders down to the Battery and reflects on the universal magnetism of the sea: "Circumambulate the city of a dreamy Sabbath afternoon. Go from Corlear's Hook to Coenties Slip, and from thence, by Whitehall, northward. What do you see?—Posted like silent sentinels all around the town, stand thousands upon thousands of mortal men fixed in ocean reveries. Some leaning against the piles; some seated upon the pierheads; some looking over the bulwarks of ships from China; some high aloft in the rigging, as if striving to get a still better seaward peep."[2] Although there is descriptive detail in this passage, some of it similar to that of many paintings of the New York waterfront, this detail is subordinated to the singular consciousness of the narrator. It is, you might say, rhetorical and functional rather than pictorial. How, for example, would one paint or draw "thousands upon thousands of mortal men fixed in ocean reveries?" The New York here, as in so many novels, is the city as threshold. Whether the narrator is passing through, as in this case, or entering, the city is made to stand for some kind of imminent possibility locked within the narrative's future.

In Dreiser's *Sister Carrie,* Carrie Meeber's first sight of Broadway at theater time is another example of the New York scene as prognosticator: "Carrie stepped along easily enough after they got out of the car at Thirty-fourth Street but soon fixed her eyes on the lovely company which swarmed by

them as they proceeded. With a start she awoke to find that she was in fashion's crowd, on parade in a show place! Jeweler's windows gleamed along the path with remarkable frequency. Florist shops, furriers, haberdashers, confectioners—all followed in rapid succession. The street was full of coaches."[3] The Broadway scene described here is not the Broadway of any graphic artist but a highly personal one deeply encoded with Carrie's future as an actress and fashionable celebrity.

Narrative prognosticator and *singularity of consciousness* are scarcely graceful terms, but they help to define what seems to be unique about verbal descriptions of New York in poetry and fiction. In fiction the flow of narrative consciousness largely determines what aspects of the city a novelist chooses to describe. For this reason conventions of the kind that characterize paintings do not exist in fictional New York, which becomes a kind of grab bag of narrative needs. Drawing and painting may, of course, be highly personal, but the city as described is not enveloped in consciousness as it is in fiction, and, except perhaps in illustrations, a picture does not point but, so to speak, *is*. What it is, however, is shaped by conventions that developed in painting for portraying cities and city life. Within these conventions there is space for narrative, but the kind of narrative embedded in painting is very different from fictional narrative—less focused, with multiple strands, in most cases implicit rather than developed.

Nineteenth-century New York as it was portrayed in painting was a kind of cracked mirror or jumbled jigsaw. Its fragmented character, in contrast to the New York of fiction, resulted from the standardization of the facets of New York life that drew the attention of artists. A relatively short list of subjects suggests the comparatively narrow range of this work: perspectives on the city and the harbor as seen from a distance; recreational scenes of parks and public places; pictures of parades and other public events; pictures of important buildings and central sites within the city; such dramatic events as fires; and, perhaps the most urban subject, genre scenes depicting typical urban types and urban activities. These subject headings pretty much exhaust the repertory of New York's early nineteenth-century painters. Judged by our standards of realistic portrayal, all this work strikes us as highly stylized.

The New York Harbor and waterfront were at the center of consciousness for anyone living in New York during most of the nineteenth century, far more so than they are today. One popular subject was the marine life of New York harbor. The frequency with which maritime scenes and portraits of sailing ships appear in this book results in part, no doubt, from the Museum's inheritance of the former Marine Museum collection, but there is little question that the visual world of the harbor held fascination and romance for artists throughout the century. In all these paintings, what I have called the city as city takes a back seat.

Two gouache paintings by Nicolino Calyo executed in 1837 are characteristic examples of this maritime genre. Calyo was a Neapolitan by birth and typified the kind of itinerant artist who toured American cities in this period in his use of a particular genre of painting and engraving that he appears to have drawn upon for these pictures. These cityscapes developed during the seventeenth century as a way of portraying European cities.[4] They pictured the city as it appeared against the skyline, with harbor or river in the foreground, as in Jan Vermeer's *View of Delft* or Pieter Bruegel's *Bay of Naples*. Appearing at about the same time, a more popular genre of engraving catered to the city's commercial interests and

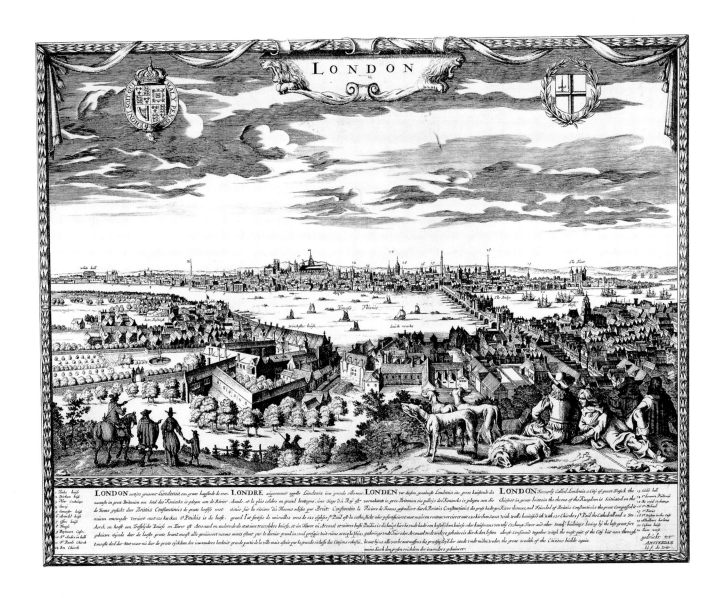

apparently sold widely.[5] One such engraving by Frederik de Wit (*London, a City of Great Traffic*, c. 1690), depicting London after the Great Fire, had a particularly wide circulation (fig. 10). These works were a variant of the developing genre of the romantic landscape. The foreground was often devoted to figures in a pastoral setting. The horizon was low, and almost half the engraving was generally devoted to sky and clouds.

Itinerants and journeyman artists from Europe, who were clearly familiar with such conventions, produced a surprisingly large proportion of the work in this genre. Calyo practiced his art first in Malta. He arrived in Baltimore in 1830, moved to New York in 1835 just in time to paint the great fires that swept the city in December of that year, and then remained in the city another fifteen years. The firm he later founded with one of his sons, N. Calyo and Son, offered instruction in painting and contracted for painting commissions. Calyo exhibited widely during these years. A panorama of the Connecticut River and his paintings of the Mexican War, for example, were shown in New York, Boston, and New Orleans in 1849. In Washington, D.C., he had earlier shown some Italian landscapes and a series of paintings depicting Vesuvius in eruption. He is believed to have worked for a few years in Spain, although he apparently returned to New York before his death in 1884.[6] In addition to the two pictures I shall discuss, he also contributed other characteristic New York work.

As an experienced and well-traveled professional, Calyo was no doubt keenly aware of what was marketable. He drew upon the conventions for this kind of cityscape in his New York paintings. In the first of these pictures, entitled *View of New York from New Jersey,* the city makes its distant appearance as a narrow black ribbon just below the horizon with only a few tiny church spires and the rough outlines of the Battery to define it (fig. 11). The painting is dominated by two large sailing ships in heavy weather apparently making for the Jersey shore against an ominously cloudy sky, their crews hard at work. The other picture, called *The Brooklyn Navy Yard and New York from Wallabout Bay* (fig. 12), is an almost perfect pictorial analogue to the Sabbath Battery scene Melville described in *Moby-Dick.* The emphasis in Calyo's painting, however, is different. The picture shows Manhattan in the distance from a perspective in Brooklyn. A grouping of trees in the foreground along the waterfront, a moored dory, and a few figures walking along a road and fishing from a pier set a classic pastoral tone. Half a dozen ships are either anchored or moving about the estuary. Once again, Manhattan is scarcely more than a ribbon of building elevations, a pincushion sprouting minute church spires—clearly an example of the city absorbed into the landscape and neutralized by an overhanging sky that takes up two-thirds of the canvas. No attempt has been made to highlight individual buildings or to delineate the overall shape of the city, as analogous seventeenth- and eighteenth-century European urban views had tried to do.[7]

The first half of the nineteenth century produced countless examples of this kind of harbor perspective. Other paintings in the catalogue represent only slight variations on the same essential rendering of the city. One of the most detailed harbor perspectives on Manhattan is a painting by Anthony Imbert, *The Erie Canal Celebration, New York, 1825* (plate 6). Imbert was a former French naval officer who had acquired proficiency in painting and drawing while a prisoner of the English. Once in the United States, he settled on

Fulton Street just in time to receive a commission to prepare lithographic plates for a volume commemorating the completion of the Erie Canal in November 1825. This particular painting shows the American ships filing by and saluting the British warship, *Swallow*, off the lower end of Manhattan at the end of the day's festivities. Imbert's view differs from the other harbor paintings in the detail and accuracy with which buildings are drawn. Castle Garden in Battery Park, for example, is clearly visible, as are the spires of Trinity Church and St. Paul's Chapel. In addition to being a harbor perspective, this painting provides an early example of a second genre of New York painting, which records public and historical occasions. It could also be considered a very early (if inattentive) skyline view of Manhattan. Another record of a historic moment, remarkable in many of the same ways, is

Joseph B. Smith's watercolor *Steamer "Hartford" Capt. LeFevre, Bound for California, Sailed from New York February 1849* (plate 21). Like pictures of the lunar missions slightly more than a century later, this picture depicts the launching of an epic and dangerous undertaking, this one employing new and relatively untried steam technology on an itinerary around the Cape, a voyage notorious for its dangers. This picture is also notable for the detail with which the Brooklyn waterfront in the background is rendered, but it is especially noteworthy for the inclusion of the crowds seeing the ship off and the passengers on deck. This depiction of the crowd on the pier waving and passengers waving back underscores the air of civility implicit in all these paintings, a particular narrative moment captured by an artist's rendering of a public event in progress. This is a well-behaved and decorous crowd perfectly

in keeping with the socially uncontested image of urban civility prevalent in paintings of this period.[8]

In December 1835 Nicolino Calyo, working from a perspective near the Bank of America on the corner of Wall and William Streets, executed a gouache of the great fire that destroyed the Merchant's Exchange and most of the buildings surrounding it (plate 11). In selecting this subject, Calyo was anticipating the appetite for the theatrical and catastrophic to which the illustrated press would later cater. Here he sketched in the scene with its teams of firefighters battling the blaze in the night. He also included an important detail that explains a good deal about the kind of representation to be found in much of this early work. Off to the left in the background he included lines of orderly spectators, their faces illuminated by the flame, intent on what is occurring before them—a narrative detail that seems to locate the audience for the picture within the picture itself. The audience is encouraged by such a strategy to see themselves as occupying a place within the historic event portrayed in the painting, almost as though the event were actually taking place in their presence. The civic order and decorousness that characterize representations of New York in this period would therefore appear to compose a frame that viewers were expected to bring to their perception of the city, even, or perhaps especially, during such a destructive and threatening event as this conflagration.

It is not difficult to see, if there is validity in such a hypothesis, why the picturesque occupies such a central place in the aesthetic thinking of mid-century New York. The association of New York with urban violence grew during the 1840s and 1850s, as riots of one kind or another, culminating in the Draft Riots of 1863, wracked the city.[9] The picturesque,

which after all depicts the world not as it is but as it ought to be, comes into conflict with the realities of a developing commercial city, perhaps never more interesting aesthetically than in the Greensward Plan submitted by Frederick Law Olmsted and Calvert Vaux in 1858 in a competition for the design of Central Park. They argued for the importance of creating a "natural" park in the city to alleviate the negative visual features of the modern commercial city. They described their conception of a park as a three-dimensional picturesque painting that would allow thousands of visitors to wander unimpeded through a constantly changing natural landscape. The noxious and disruptive commerce of the city was to be routed through submerged transverse roads that would convey it unperceived through the park. The reality of the city, in other words, was acknowledged but kept from view, as in the urban paintings of the period.[10]

It is not surprising that Central Park emerged as a popular subject for painters in the last half of the century. An

early example is George Loring Brown's 1862 painting of the still largely treeless park, viewed looking south from a point near the Ramble (plate 39). The picture is a classic landscape, with only one slight variation—the distant urban skyline. Most of the canvas is devoted to a picturesque scene in progress. Canopied boats filled with passengers drift about the lagoon, and other visitors to the park walk along distant roadways and across a bridge over the lagoon. The Terrace north of the Mall in the background to the left provides Brown's landscape with the obligatory formal structure. A foreground group of trees frames the view. The city is here distanced visually from the park but is at the same time coalesced into it, as Olmsted and Vaux might have wished. That is to say, Brown has painted it on the skyline so as to make it appear barely distinguishable from the underbrush and the trees along the horizon.

An 1878 painting of ice skating at night in the park underscores the romantic distance of the nocturnal from the workaday city and contains no visual evidence of the city proper at all (plate 41). Ice skating, already popular in Hol-

land and Scotland, became fashionable in the United States after the Civil War. John O'Brien Inman, son of artist Henry Inman, captured a moment in which a decorous crowd was enjoying this newly popular sport on the lake by the Terrace. The skaters compose a virtual manual of civilized group behavior and social order. The painting is also notable for the complexity of its narrative content. A handful of spectators standing along the shore take in the scene, once again as stand-ins for the viewer. Good manners reign, as gentlemen bow to ladies and ladies curtsy to men; couples drift across the ice. Two women skating together approach in the center foreground, and to the left another skater is being helped to his feet after a fall.[11] One younger skater in the background appears to be clowning, but there is no suggestion of disorder or rowdiness in the scene. In 1866 the annual report of the park's commissioner seemed to take account of this phenomenon when it commented that ice was "preserved day after day in good order and order preserved day after day on good ice." Inman was a native-born itinerant who traveled in the South and in the West executing portraits of the kind

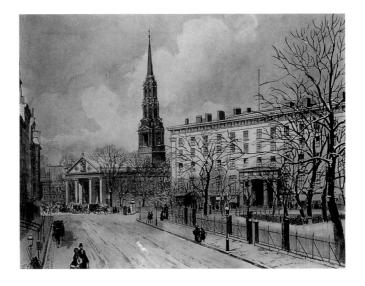

of genteel people who were engaged in this new and popular recreation.[12] It is scarcely surprising that in New York he would have chosen to depict the scene in this way.

Artists who sketched the densest parts of the city tended to populate them with the kinds of people Inman had portrayed in his skating scene. One favorite site for artists in this period was the intersection on Broadway just below City Hall Park where Park Row angles off to the northeast, for many years the central axis of the city. City Hall, the Astor House (the city's grandest hotel), and Barnum's Museum faced each other across the triangle of streets. For a while Matthew Brady's daguerreotype studio was also nearby. St. Paul's Chapel was adjacent to the Astor House, and the city's newspapers were clustered along Park Row to the east. Broadway, then the major artery between the Battery and Westchester, was jammed from morning until night with horse-drawn carriages, omnibuses, and other vehicles. So busy were the streets in this part of town in the late nineteenth century that pedestrians feared for their lives when crossing the roads.[13] Paintings of the area, however, rarely hint at the diverse crowds in the streets, the bustle of business, or the traffic jams that seem to have been present from dawn to dark. Instead, they portray decorous assemblies similar in tone to Inman's ice skaters in the park. A watercolor of Broadway executed by Augustus Kollner in 1850 is characteristic of this kind of street scene (fig. 13). Kollner was the kind of omni-competent, market-sensitive professional artist characteristic of New York in this period. Born in Dusseldorf and trained in Frankfurt, he was a lithographer, mapmaker, and illustrator of books for children and books on horses and sporting life. He also appears to have traveled widely and worked as an itinerant artist.[14] Kollner painted the scene from a perspec-

tive near the foot of City Hall Park, facing down Broadway. The Astor House is off to the right, Trinity Church is visible to the south, and Barnum's Museum is on the left where Park Row joins Broadway. Traffic in the streets is confined to three omnibuses, several smaller carriages, and, on the sidewalks, a few gentlemen, all wearing top hats. One horseman crossing in front of the Astor House appears to be cantering, while a number of pedestrians are strolling or conversing on the sidewalks on either side of the intersection. Even the garishness of Barnum's Museum appears muted.

Ten years later August Meyer, another German-trained artist, painted the same area from a slightly different perspective.[15] Meyer's watercolor pictures the scene from a site up Park Row (fig. 14). Almost the entire facade of the Astor House is in view across the bottom corner of City Hall Park, with St. Paul's at its side. The ground is covered with snow. A few carriages move along the streets, and a few genteel strollers populate the sidewalks. There appears to be a crowd in front of St. Paul's, so it may be Sunday. There is no sign of the busy city. Meyer and Kollner, in fact, both portray the commercial center of the city almost as though it were a genteel recreational park.

Depictions of mercantile activities in the city differed little in social character. B. J. Harrison's watercolor drawing *Annual Fair of the American Institute at Niblo's Garden* (circa 1845) shows such an event in progress (plate 19). Niblo's Gar-

den was a pleasure palace and exhibition hall on lower Broadway. These fairs sold everything from top hats to works of art of various kinds. Harrison's portrayal of this gala of materialism is interesting because it suggests in detail the immense range of domestic manufactured goods on display. An upper mezzanine contains artworks. The walls of the ground floor display quilts, and glass cases are arranged to provide access to items of clothing and household goods. At the right, a cashier completes a sale for a customer. Nothing in this scene hints at the frantic pace of commercial activity in the surrounding city. Indeed, the goods in all their variety are displayed in an order that rivals that of the clientele browsing through the display cases and the balcony above. Once again the city is portrayed as an uncontested urban space occupied exclusively by polite ladies and gentlemen at leisure.

Many of these paintings portray commercial activities as a kind of popular theater. An 1843 oil painting possibly by French-born artist Eugene Didier depicts an auction in progress at a designated location for such activity in Chatham Square, a part of the downtown retail district known for the cheap goods available in the nearby shops (plate 14). Furniture and other household goods are being sold to the highest bidder. From the look of those items on display, the sale consists of worn and ramshackle goods. Didier has chosen to represent the scene in a genre painting with comic overtones. The auctioneer, in a stovepipe hat, is given an almost simian face and crouch. Two men, gentlemen by their clothes, appear to be doing the most active bidding. Another gentleman, on the right, stands by. All the other figures, some with their faces barely sketched in, a few others individualized, seem from their dress to belong to the city's poorer classes. One of the women in the foreground, her face showing dis-

tress, is trying to halt the auctioneer or to get his attention. A small boy, seated on the table, is keeping a record of the bids. One couple in modest dress seems undecided about bidding. Other working-class figures hover indistinctly in the background, seemingly uninvolved.

Among the most informative portrayals of economic activity in antebellum New York was a series of thirty-six watercolor drawings completed by Nicolino Calyo between 1840 and 1844 under the title *New York Street Cries, Chanters and Views* (fig. 15). Such portrayals of commercial street life and peddlers were an established tradition in Europe.[16] Calyo, the Neapolitan-born itinerant artist, here brings this tradition to the portrayal of New York street occupations. Calyo chose for his gallery of New York's menial service class such figures as boot cleaners, newsboys, chimney sweeps, milkmen, the oyster man, the match boy, and someone described as "the auctioneer in public streets." The series forms a collective portrait of the street economy, that of domestic service and provisioning: butcher, baker, oil man, and watchman are actors in Calyo's pageant of petty urban vendors. These watercolor studies were collected into a volume published in the 1840s, with sentimental poems and other commentary following the drawing of each of the trades. The commentary makes clear that these figures were menials in the service of a householder class. The note below the chimney sweep says: "It is indispensable that the chimneys should be swept often and thoroughly, as a provision against fire. The poor sweep, therefore, as he follows a useful and indispensable occupation, should not only be treated kindly but be also well paid for his labor. In this city the business of sweeping chimneys is confined to colored men and boys, although in London white men and boys are thus employed."[17] Calyo's pictures

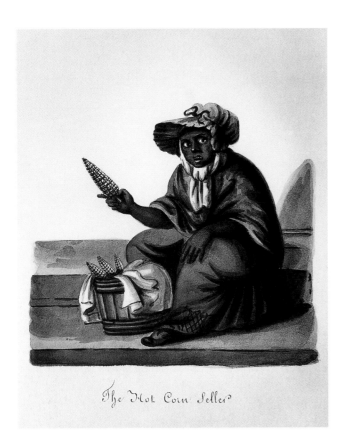

The Hot Corn Seller?

have been devoted to the changes that were sweeping over Manhattan, to social unrest or labor conflict, or to the colorful ethnic neighborhoods that were beginning to develop on the Lower East Side and along the western rim of the island—the social milieu that O. Henry and Stephen Crane exploited in their stories. The new high-rise buildings are also little evident in the catalogue selections.

Cityscape painting dating from the late nineteenth century, to judge from this sample, appears far more conservative in its selection of subjects than photography, which in this period had begun to expand its subject range enormously. Successful New York artists such as Childe Hassam continued to reproduce the picturesque, decorous New York of parks and streets that contained little evidence of these changes. Hassam had trained and exhibited in Paris before settling in New York at the end of the 1880s, and he had clearly been influenced by such urban Impressionists as Camille Pissaro and Claude Monet. Hassam and other artists who painted New York in this period, such as Paul Cornoyer and Joseph Oppenheimer, brought back much more than Impressionist technique from their sojourns in Paris. They also returned with the vision of contemporary urbanity that Paris embodied. Through an aesthetic rendering of streets and parks, public monuments and Beaux Arts buildings, painters learned to promote New York as a work of art and a subject of romance.

American Impressionists, like their French progenitors, also seem to have been interested in new industrial structures, lighting materials, and the ways natural light played over them, but the effect of their technique, as in Hassam's 1907 painting of the Wall Street area (fig. 18), was to soften

range from the black "hot corn" woman crouching on the street in a colorful hat with a shawl around her shoulders, her bucket of corn before her (fig. 16), to the portrait of Irishman Patrick Bryant dispensing wares at his oyster stand, dressed in stovepipe hat and frock coat (fig. 17). All are less an affirmation of the city's diverse population than a pictorial assessment of New York's service class from the perspective of the gentleman's kitchen door.

In the catalogue's paintings dating from the final decades of the century, there is little change in aesthetic attitude. This is especially surprising considering the magnitude of the changes occurring in the city itself during these years. The comfortable middle-class world portrayed in paintings earlier in the century was being replaced by a city gripped by mercurial changes: industrial expansion, booming ocean commerce, a flood of immigrants, and unprecedented social problems. Yet in the work of artists, little attention seems to

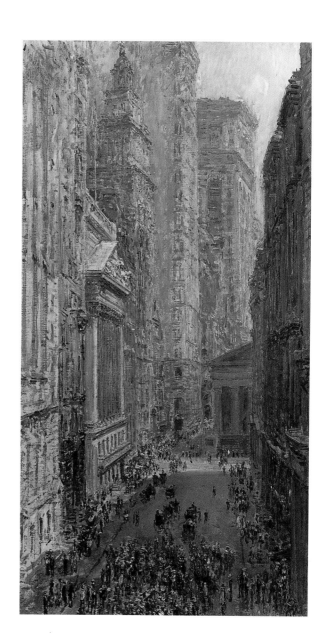

the city's harsh realities behind veils of light. The Impression-
ist palette in France had retouched and romanticized not only
its parks, churches, and cathedrals but also its railway sta-
tions, canal barges, bridges, industrial sites, and the sloping
curving streets of Montmartre. Poverty, dirt, and low life
were rendered as compositions of color and light. And Has-
sam's New York work, like that of many of his contempo-
raries, differed from that of earlier artists in palette and
exhibited such Impressionist touches as light reflected from
wet pavement and the blurred contours of street life in a
snow storm. His Union Square was not the Union Square of
labor protests that began to take place there as early as 1882,
nor that of Tammany Hall around the corner. The only rec-
ognizable figures in his 1890 painting *Rainy Late Afternoon,
Union Square* are the genteel bodies in the foreground. The
crowd in the park is depicted as a wall of umbrellas in a dis-

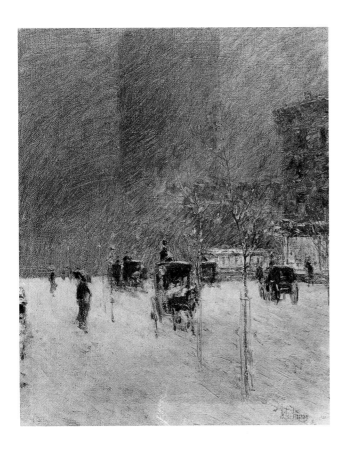

19 Frederick Childe Hassam,
Winter Afternoon in New York,
1900, oil on canvas, bequest of
Mrs. Giles Whiting, 71.120.107

tant background, its social composition only to be inferred from the foreground figures (plate 50). His painting *Winter Afternoon in New York,* produced ten years later, shows an almost deserted street rutted with snow as three hansom cabs pass and a half dozen pedestrians move through the driving storm (fig. 19). The only hint of the modern city is the obscure outline of a high-rise building in the background.

Much of the other work in the catalogue from this period is similar in character. In 1900 Paul Cornoyer's *Washington Square* and Joseph Oppenheimer's *Madison Square* inaugurated the twentieth century with Impressionist tonalities on a distinctly Parisian note. Cornoyer chose a perspective from somewhere in the middle of the park facing north toward the Memorial Arch (plate 56). A few figures stroll in the middle ground shrouded by overhanging trees. Oppenheimer chose an elevated perspective looking north on a winter day from Fifth Avenue across the confluence of Broadway

and Fifth Avenue opposite the park (plate 53). Hansom cabs are crowding down Fifth Avenue in the foreground, and another row of waiting cabs lines the southern boundary of the park. A few indistinct figures are scattered about the streets and the park, which itself appears as a cluster of trees rooted in the snowy surface below. Samuel Landsman's 1899 watercolor *Dewey Celebration at Madison Square,* drawn from a similar perspective, differs from other contemporary painting in the highly stylized rendering of the ranks of troops moving through the memorial arch. It is the orderly geometry of the parade and the pageantry surrounding it, not the park or Madison Square Garden towering in the distance, that dominates the scene (fig. 20).

The Museum's collection includes some paintings that illustrate the magnitude of the changes in subject that were taking place in the early part of the twentieth century. In the first decade the gritty urban realism of the Ash Can School had turned the attention of painters to a much wider vector of social and recreational life. Painters were somewhat late in their embrace of these "other half" topics, which photographers, draftsmen, and illustrators had been interpreting since the turn of the century. Suddenly in the work of such painters as John Sloan the entire city, its sights, its troubles, and its colorful mix of people at work and at play became part of the New York subject. By the 1920s the Precisionists such as Charles Sheeler were finding geometry and abstract beauty in the urban industrial scene. After seeing Paul Strand's photographs of the city's tall buildings, around 1915, and his arresting views from their summits, painters were quick to follow suit. John Marin's watercolors of New York turned the city into a kinetic fantasy of color and design. By the 1930s

20 Samuel Landsman, *Dewey
 Celebration at Madison Square*
 (also exhibited as *Parade in Honor
 of Admiral George Dewey)*, 1899,
 watercolor, gift of the artist in
 memory of Stephen Jenkins,
 41.232.3

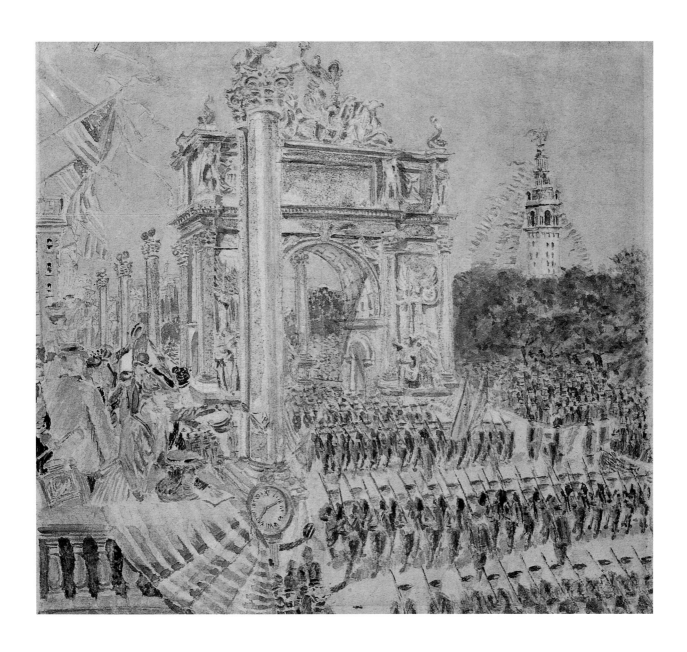

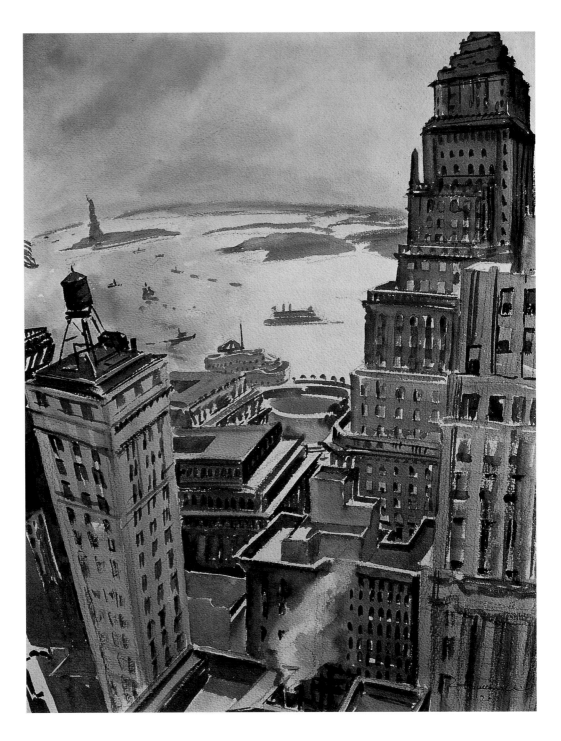

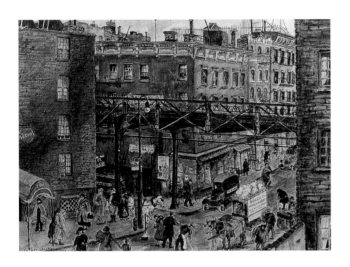

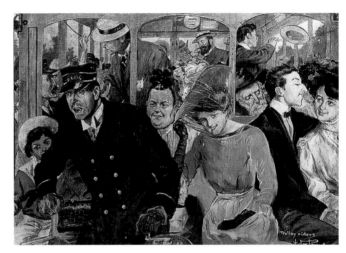

Stuart Davis and Joseph Stella began to move the city into the realm of abstraction.

 Robert Hallowell's 1929 view of Wall Street, the harbor, and the Statue of Liberty in the distance, painted from a pinnacle near the Standard Oil Building, shows that the skyscraper had come of age as a subject (fig. 21). By the 1930s the transformation in the New York subject was complete. Maurice Kish used a dark palette for his 1932 *East River Waterfront,* showing a setting of factories, smokestacks, and industrial machinery that would have been unthinkable as a painter's subject thirty or forty years earlier (plate 70). The growing painterly interest in the city's ethnic life and working-class recreation, first introduced by painters such as John Sloan and later by Reginald Marsh, is demonstrated by several of the catalogue entries. Esther Goetz's 1936 *Sullivan Street* (fig. 22) attempts to capture the multifaceted street life

and visual clutter of a predominately Italian Greenwich Village neighborhood. Victor Perard, like Hassam, had been trained at the Ecole des Beaux-Arts in Paris, but his reading of the New York social scene in *Trolley Riders* (1907–1910) was far different from Hassam's focus on the decorous world of turn-of-the-century New York (fig. 23). His trolley passengers returning from Coney Island appear to be a cross section of urban social types shown in a relaxed and high-spirited mood.

 Several paintings by James W. Kerr reinforce the shift that had taken place. His 1931 *In Chinatown, New York City* pales in comparison to contemporary Chinatown but suggests the exotic attraction that Chinese culture had begun to exercise over the city's artists (fig. 24). Here Kerr singled out a segment of street that includes a laundry, a barber shop, and a tailor's shop with a Chinese Alliance on the upper floor. His

24 James W. Kerr, *In Chinatown,*
New York City, 1931, oil on canvas,
gift of the artist, 77.16

25 James W. Kerr, *Shootin' Gallery,*
1946, oil on canvas, gift of the
artist, 71.78

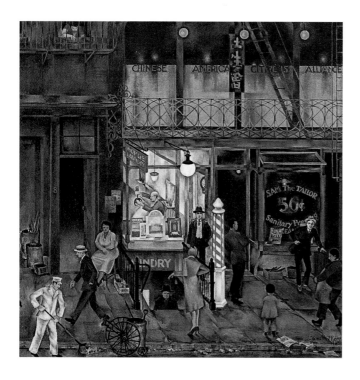

foreground, creating an eerie vision of the Great White Way in wartime.

One of the cityscapes included in the catalogue underscores the dramatic change that has recently transformed the New York subject. Max Ferguson's *Self-Portrait in Subway I* captures a particular moment in the city's history (plate 114). The artist has painted himself sitting on a bench in a subway station. On the sign above his head, only the last letter and a bit of the letter before are visible. He is drinking coffee and looking into a graffiti-laden subway car facing him, with a single door, probably broken, open before him. The year is 1982, when the subway system was at its lowest ebb and graffiti were everywhere. Nothing in the painting suggests a moral stance by the artist or any kind of critical posture. He is simply sitting on the platform and looking intently, apparently at a viewer on the train. In small neat lettering among the graffiti to the right of the door, Ferguson has signed his name and given the year. In a way, this painting has reversed the perspective of the early nineteenth-century paintings discussed earlier. In the earlier work, it was the viewer, the spectator of the scene being depicted, who was included vicariously in the picture as a way of referring to the values of the social order. Here it is the artist who stands in for himself within the picture, as if to underscore that he is agent of everything you see here. The absence of anyone else in what seems to be a deserted station is itself ominous. If anything is being judged in this painting, it would seem to be the viewer whom he is scrutinizing. Perhaps the viewer is a potential threat? The figure of the artist, in any event, seems both a part and not a part of the situation around him, threatening and being threatened simultaneously. The artist could be almost any figure: an undercover cop, a rapist or some other kind

1946 *Shootin' Gallery* seems to highlight the wartime expansion of cheap amusements on 42nd Street (fig. 25). The clients at the gallery, most of them servicemen with their women friends, are portrayed from the rear. The figure in the foreground, cigarette in hand, may be Kerr himself. His 1944 *Times Square Dim-Out* catches the Broadway wartime scene during the blackout in 1942 (plate 93). The diverse crowd moves through the darkened street against a background of unilluminated signs. A solitary woman, possibly a prostitute, stands against a building on the left, a single woman examines a window display, and the haunting face of another young woman seems to float across the canvas in the right

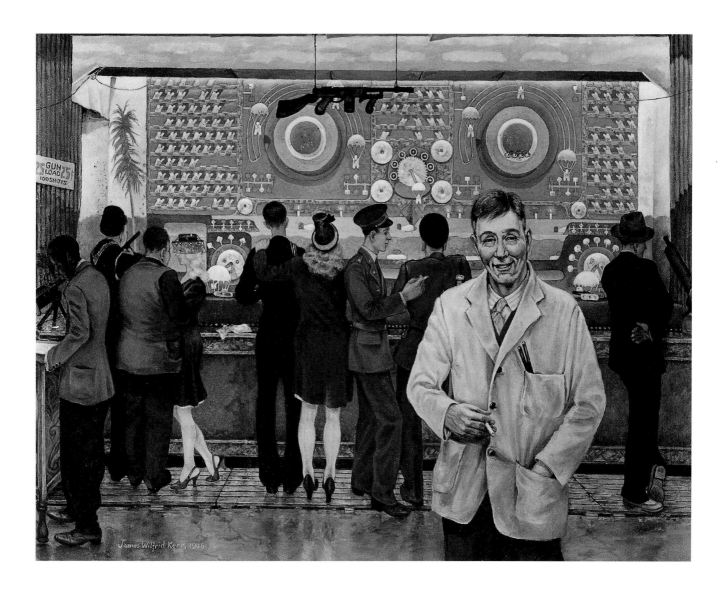

James Wilfrid Kerr, 1946

of criminal, or simply a student waiting for a different train. What could better suggest the anonymity and the vulnerability of New York in the 1980s?

A shift in perspective that placed the artist prominently within his urban subject, as in the Kerr and Ferguson examples, underscores the magnitude of the change in paintings of New York during the past century and a half. In the early nineteenth-century paintings it was the spectator and the spectator's ideas of urban order that stood between urban reality and the canvas world of the paintings. More and more as the nineteenth century gave way to the twentieth, it was

to be the artist who interceded in urban reality and gave it a unique imprimatur. A preoccupation with civil order and aesthetic convention in earlier paintings of New York appears to have given way to formal, often abstract renderings of the urban experience just as distant from the particularities of everyday experience.

Art Scenes and the Urban Scene in New York City

Michele H. Bogart

Bascove
Pershing Square Bridge (detail), 1993
(plate 121)

THE PUBLICATION of this catalogue offers a suitable occasion to reflect upon the historical centrality of New York urban-scene painting and, at the same time, on its peculiar marginality to American "art." Broadly speaking, the collection of urban-scene paintings in the Museum of the City of New York owes its genesis to New York City's ascendance as a cultural and commercial center in the second decade of the nineteenth century. Two of the nation's earliest and most influential art academies, the American Academy of the Fine Arts and the National Academy of Design, were founded in New York City. By the late nineteenth century, with the formation of the Cooper Union for the Advancement of Science and Art (1859), the Art Students League (1875), the Pratt Institute (1887), and a myriad of other small schools and academies, New York had become the nation's foremost center for art education.[1]

Over the course of the nineteenth century, New York also emerged as the nation's center for the production, display, and sale of artworks. The city's elites formed the most important group of American collectors in the first half of the nineteenth century, commissioning portraits and (less enthusiastically) marine scenes, genre subjects, and landscapes. Through the rest of the nineteenth century and into the twentieth, however, most painters, working outside the framework of patronage, had to struggle to exhibit and sell their works in an open marketplace amid stiff competition. Starting in the mid-nineteenth century, large trade fairs (such as the Crystal Palace Exposition and the Sanitary Fairs), art unions, commercial galleries, auction houses, gentlemen's social clubs, and art dealers provided new venues for display and sales. Artists themselves also worked actively to achieve greater visibility—through renting exhibition space,

distributing publicity flyers, and charging admission fees; buying into cooperative artists' studios (such as the Tenth Street Studio or the Hotel des Artistes on West 67th Street) and advertising their work by throwing open houses; or sending their work to juried shows or art fairs. Late nineteenth-century artists also turned to such dealers as William MacBeth or marketed their work out of their own studios.[2] The market for American painting expanded tremendously during the twentieth century.

At any given moment, only a small minority of painters achieved professional recognition or financial success. Nonetheless, New York City's abundance of commercial and cultural offerings continually attracted both eminent and aspiring artists. Despite their diverse social backgrounds and styles, all the artists in this catalogue shared this fascination with New York City. The existence of this particular group of works is a testament to the importance of New York City as the locus of numerous art worlds.

To point to the city's centrality as a cultural crossroads may be to dwell on the obvious. Yet for all its vitality as a metropolis and an art center, New York rarely took center stage on painters' canvases. The preeminent national institutions and organizational frameworks that emerged in the city never particularly encouraged painters to focus on local subjects. Art schools, exhibitions, and even art lotteries (held by the American Art-Union in the mid-nineteenth century) all placed primary emphasis on the "bigger picture." Artists were implored to transcend the local and forge a "national," "universal," or "ideal" art. Industrialization, urbanization, and the Civil War left a lingering nostalgia for pastoral imagery in the third quarter of the nineteenth century.[3] Training,

display, and collecting practices generally discouraged the representation of place when that place was New York, with all its attendant excitement, hardship, and social tensions. Artists certainly did portray the city, as the Museum's collections attest. Yet depictions of life in New York City did not find much individual or institutional support until the early twentieth century, when the "painting of modern life"—influenced by artistic developments in France and by the expansive physical transformations of the metropolitan landscape—became more widespread as a national aesthetic priority.[4]

At that cultural moment, increasing numbers of painters working in a loosely painted, sketchy Impressionist and "realist" vein depicted the city's parks, buildings, monuments, and street life in a picturesque fashion. As many later scholars have observed, most such images avoided confrontations with the city's darker side. A growing coterie of dealers (notably, again, William MacBeth) and collectors exhibited and purchased such work, and art critics at New York newspapers and magazines increasingly devoted attention to illustrations and paintings of the city.[5] The roots of acceptance of urban-scene painting can also be found in local responses to the painters of the Ash Can School. They exhibited around the city, and their professional and social ties to the New York press helped them to secure critical attention in newspapers. Interest in contemporary urban-scene paintings may well also have been piqued, through association, by the activities of men like I. N. Phelps Stokes and J. Clarence Davies, who, in an effort to cultivate and protect urban memory, began to acquire old views of the city's fast-disappearing physical past.[6]

Yet despite the augmented production and acceptance of urban-scene paintings, they were generally not regarded as a central aspect of the nation's artistic heritage. Relatively few such pictures found their way into museums and private collections until some years later. Only during the Depression—when many artists on federal relief depicted the city as an expression of their commitment to modernity, locale, and Social Realism—did contemporary urban subjects become more widely visible as a distinct genre in exhibitions, on the art market, and in private and public collections.

Because urban-scene painting was a marginal endeavor from an institutional standpoint, the enterprise never entered the historical record. The major surveys of American art chronicled and recapitulated the values articulated in the art theory promoted by influential art organizations and institutions and imbibed by would-be collectors. Most of the early historians of American art were New Yorkers during some portion of their careers, and all acknowledged New York's contributions to the advancement of the nation's artistic life. Yet their books—for example, William Dunlap's *History of the Rise and Progress of the Arts of Design in America* (1834), Henry Theodore Tuckerman's *Book of the Artists* (1867), Sadakichi Hartmann's *History of American Art* (1901), Samuel Isham's *History of American Painting* (1905), and Suzanne LaFollette's *Art in America* (1929)—slighted images of the city.[7]

Although the methods and outlooks of these surveys differed in significant ways, most sought to invoke, through art, a distinctively national experience; hence they privileged the national over the local. They highlighted artists, genres, and styles that typified American "experience" in a given era:

portraiture in the Colonial period; history painting in the Federal period; landscape and genre painting in the mid-nineteenth century; and, circa 1900, ideal and vanguard art (which emphasized formal elements as an integral aspect of content).[8] Authors of surveys written after World War I (Isham, LaFollette, Oliver Larkin, and Milton Brown), more attentive to "realisms," did mention some urban-scene painters. Only Larkin and Brown, however, who conveyed left-liberal sympathies born out of Depression-era cultural politics, attended to painterly responses to New York actualities and hardships. The prevalent tendency was to ignore visual or textual representations of circumstances that confronted New York historians and painters on a regular basis.

New York urban-scene paintings did not fit neatly into the predominant typological categories, and thus historical surveys rarely mentioned them or their creators. Very few artists achieved "canonical" status in any case (signified by inclusion in the historical surveys); moreover, once an artist was added to the ranks of canonical masters, he or she tended to remain there. Given these circumstances, it is not surprising that only a minority of the artists represented in the Museum's painting collection are household names.

In other words, using the conventional evaluative criteria, it is difficult to assess the significance of the collection of urban-scene paintings at the Museum of the City of New York. Art history has traditionally been concerned with constructing coherent narratives of aesthetic achievement and development; the principal art institutions have reinforced these priorities. Engaged with specific works of art and canonical artists, art history has limited scholars' perspectives of painting practice, implicitly relegating works like those in

this catalogue to marginal provincial status. Such an outlook seems hard to reconcile with the fact that most of these paintings were inspired by and produced in the nation's leading metropolis. Clearly, then, if we are to make sense of the paintings in the Museum's collection, we must look at them in another way; we must start from different premises.

The picture changes if we shift our focus from great artists or canonical objects, expressive of national tendencies, to artistic activity and subject matter. Examined from this perspective, the collection of the Museum of the City of New York, representing diverse modes of material culture,

offers new ways of conceptualizing the history of art. This alternate strategy acknowledges the centrality of New York City in the production and meaning of images, regards the artists in this catalogue as pivotal and typical actors in the cultural scene, and recognizes urban-scene subjects as crucial to the history of American art and society.

New York urban-scene painting, then, can be considered as one aspect of the history of artistic activity. Details about the Museum's collection—biographical data on individual artists and information on the provenance of the Museum's paintings—are limited. However, sufficient infor-

mation exists to demonstrate a variety of modes of artists' engagement with the city. Examination of the paintings in this catalogue enables us to outline a range of practices and art-world circuits with which painters were involved.[9]

Painters have had different motivations and purposes. Some artists painted urban scenes for purely personal reasons. Baroness Hyde de Neuville's view of the Bridewell (fig. 26) and Baron Axel Klinköwstrom's 1818 view of Broadway and City Hall Park (plate 3), to name but two, were souvenirs rendered by amateur painters—cultivated European aristocrats who were touring the city. Other images were com-

mercial ventures painted on commission. Several of these portrayed the products or ventures that either exemplified or contributed to the patron's business success. Thus, as historian Kenneth Myers has demonstrated, Thomas Birch's *New York Harbor from the Battery* (fig. 27), commissioned by the shipbuilder James A. Stevens, celebrated the vibrancy of an active harbor and the commercial and industrial achievements of water transport made possible by Stevens' construction of the steamboat *Albany*.[10] The charming anonymous painting of the Bauern Haus and Carousel at Rockaway Beach, c. 1880 (plate 43), Leo McKay's 1898–1906 panorama

of Steeplechase Park (plate 55), and E. P. Chrystie's delicate watercolor rendering of the 1939 World's Fair (fig. 28) were, when painted, bright paeans to their patrons' accomplishments. They have since taken on significance as commemorations of particular aspects of the city's built environment— aspects that were dedicated to commercialized leisure and amusement and have since disappeared.

Only a minority of painters worked on commission. Most painted on speculation, and the Museum's collection illuminates some of the varied ways New York artists sought audiences and markets. One method was to create works that were explicitly commemorative in purpose. Rendered in the era just before the ascendance of photography, Nicolino Calyo's *Burning of the Merchants' Exchange, New York, December 16 & 17th, 1835* (plate 11) and Albertis Del Orient Browere's view of the 1842 Tombs fire (plate 13) functioned as dramatic visual documents of conflagrations as urban

calamities. Such sensational views of the cityscape served varied functions but were especially geared toward tourists and connoisseurs.

Many such images reached broader audiences indirectly, not as paintings but as print reproductions. Calyo's *Burning of the Merchants' Exchange*, for example, served as a prototype for printed images destined for distribution among the middle class. Conversely, certain paintings were modeled on popular prints. The Museum's anonymous rendering of a clearly idealized City Hall Park, circa 1835 (fig. 29), was either a model for a contemporary print or was itself a modified copy of that print. The print versions of several of these pictures, such as the anonymous view of City Hall Park (fig. 30), were subsequently appropriated by preservationist campaigns in the early decades of the twentieth century. The City Hall Park painting, in its manifestation as an engraving, was reproduced in a host of books and articles;

30 Artist unknown, *The Park and City Hall, New York*, c. 1840, engraving by J. Archer, gift of Hobart Ford, 54.138.40

THE PARK AND CITY HALL, NEW YORK.

exception. By the late nineteenth century, such artists as Childe Hassam (whose *Rainy Late Afternoon, Union Square* is in the collection [plate 50]) marketed their art through dealers and auction houses.[11] Some artists sold their work directly out of their own lavishly appointed studios; Sanford Gifford, for example, represented in the Museum's collections by the painting *Coney Island* (plate 37), undoubtedly forged deals in his rooms in the famous Tenth Street Studio building. By the 1930s many painters, including Franz Kline (whose painting *Washington Square* is owned by the Museum [see fig. 2]), sold their work through juried exhibitions and open-air art shows like the famed Washington Square Outdoor Art Exhibition, which had been recently inaugurated to provide help to local artists feeling the pinch of the Great Depression (fig. 31). During the Depression, painters like Anthony Velonis (represented in the Museum by *Fulton Fish Market Dock,* 1934 [fig. 32]) pursued their craft with financial support from the Works Progress Administration's Federal Art Project. Others, like Reginald Marsh and Ben Shahn, received commissions for murals for public buildings through the Treasury's Public Works of Art Project (the Museum's holdings include Marsh's designs for the United States Customs House and Shahn's *WCTU Parade* [plate 76] for his Central Park Casino commission [plates 76–81]).[12]

The urban-scene painting collection at the Museum of the City of New York provides additional insights into the

from 1910 until about 1950 it functioned as a favored "memory image" of the park's supposed appearance in the previous century.

Only a small number of artists succeeded in having work reproduced and thus widely disseminated. Most reached a public in other ways, often with the help of commercial brokers. Mid-nineteenth-century painters aspired to have their work displayed in such new art unions as the American Art-Union and the Cosmopolitan Art Association, in galleries, in dry goods stores, at such fairs as the 1853 Crystal Palace Exposition, and sometimes in bars and restaurants. The artists represented in the Museum's collection were no

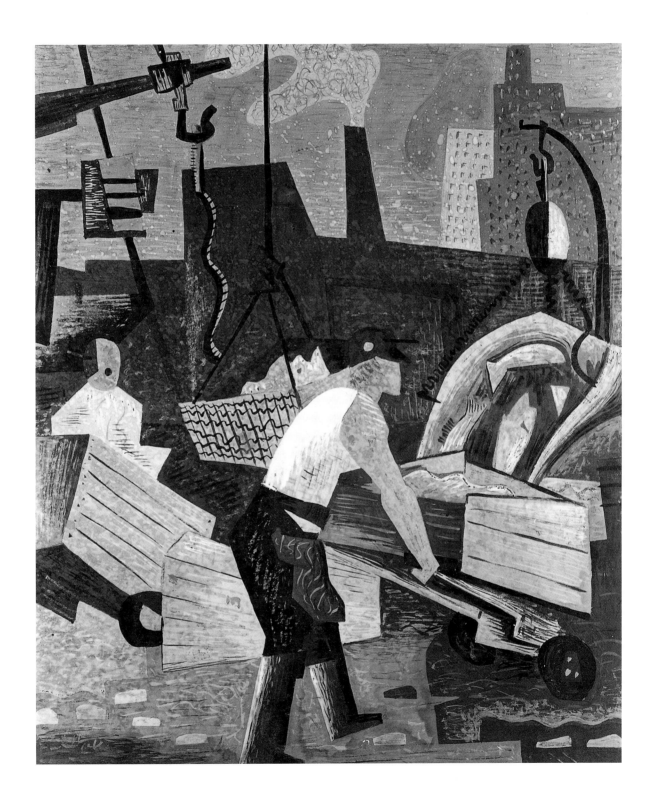

nature of painters' lives and their occupations.[13] The evidence suggests that only a small percentage of artists actually earned a living from sales of their paintings alone. Most of the artists whose work is included in the catalogue were locally trained, were involved with New York City or suburban art organizations, and exhibited in juried, group, and solo shows locally or nationally. Yet most did not achieve great fame or commercial success. Many of the Museum's painters (among them Philip Reisman and Bascove) earned a living as teachers. Many worked in other art-related professions. Johannes Oertel engraved banknotes; John Beverley Robinson and Miklos Suba were architects; Sebastian Cruset and Allen Stone both did artwork for magazines; Cruset also designed textiles, and Stone worked at Grumbacher (research laboratories making oil paints and other artists' supplies); da Loria Norman illustrated books; James Kerr founded Fairbairn Publishers, specializing in art reference materials for schools and higher educational institutions. Others engaged in non-art-related professions: Johannes Oertel was an Episcopal priest as well as an engraver, Victor Gatto was a plumber and steamfitter, and Fanny Holzmann was a judge.

Many of these artists were actively involved in some sector of New York City's diverse art scene, exhibiting work, for example, in group exhibitions or art fairs. Others simply painted for pure pleasure, with no intent to exhibit or sell. Given these facts, and given the sheer numbers of painters at work in the city, it is unsurprising that a number of the Museum's urban-scene paintings entered the collection as donations from the artists or their families (see, for example, figs. 33, 37, and 39) and that some artists' names are unfamiliar. Some of these paintings may never have circulated in the market at all.

Although most of the artists represented in this catalogue have been excluded from the history books, they are hardly insignificant. In fact, they were an integral part of the art worlds of New York and of the nation as a whole. In many instances, these artists were bound up in the same institutional and commercial circuitry as painters who concentrated on other subjects. The contingencies of this broader, complex nexus of cultural production well merit their own detailed study. Such an analysis, however, would extend far beyond the scope of this essay.

Moreover, there is yet another outlook to consider in our effort to reassess the historical importance of New York urban-scene painting: one that considers urban-scene paintings as sites of memory.[14] This second perspective would link urban-scene painting to other modes of visual culture that seek to image "place"—in this specific instance, "New York City." By the beginning of the twentieth century, New York City was an especially popular locale for such representations; indeed, the city was the center of a veritable picture industry. The rise of an organized tourist trade was one important catalyst. Images on postcards and maps, in advertisements, newspapers, and guidebooks, served as crucial instruments of information, documentation, nostalgia, and promotion; it is thus not surprising that there was a complementary upsurge of painted renderings intended to appeal as both attractions and souvenirs.

We need a comparative history of all such New York images, one that would encompass both singular representations (such as paintings) and multiple or commercial modes of picturing: prints, photographs, print and outdoor advertisements, cartoons, and cinema. Again, such an expansive inquiry falls outside the scope of this essay.[15] I will point

John Beverley Robinson
J.B. Robinson
1881

to the possibilities, however, by sketching some of the ways select catalogue paintings—specifically, those focusing on public works and monuments—created and salvaged a history and experience of New York as place. These paintings shared with other pictorial modes a similar ambition to document, to commemorate, and to "fix" an image of New York City. But as paintings, they also used particular stylistic, representational codes, specific to the medium, to convey the artists' "personal" response to their subjects. The paintings may be absent from the art-history surveys, yet the formal and iconographic components of the works themselves convey historical significance.

Before we embark on this discussion, it should be noted that the very impulse to document, commemorate, preserve, and collect images of New York, so prevalent at the turn of the century, was part of a larger cultural phenomenon characterized by historian Max Page as the dynamic of "creative destruction." The phrase refers to the tensions arising from the city's status as the capital of capitalism, its well-known proclivity to build and rebuild; it alludes in particular

to the paradoxical tendency to both destroy and revere the city's physical past. The process was bound up with real estate development and preservation and was manifested as well in the collecting activities of city-builders I. N. Phelps Stokes and J. Clarence Davies (a real estate developer whose collection of old New York City views formed the core of the Museum's early holdings). As Page has demonstrated, the Museum and the Davies bequest, which aimed to educate immigrants and advance civic community, operated collectively (if not fully consciously) to interpret the cyclical destruction and transformation of the city as a "natural" and "benevolent" process.[16] This framework helps to explain the presence of certain prevalent themes—such as the expansion and destruction of the cityscape—in many images in the collection. The ensuing discussion thus inevitably recapitulates the categories and themes effectively built into the Museum's mission, collections, and narratives from the very outset. Acknowledging this fact, we may proceed to consider specific paintings as historical statements about urban development and memory.

New York's penchant to build and rebuild was not just a fin-de-siècle obsession. Many of the Museum's oldest paintings highlight the rise and expansion of civic New York. In the views of City Hall Park by Baron Axel Klinköwstrom, Arthur J. Stansbury, and an anonymous painter (plates 3 and 4 and fig. 29, respectively) the artists trained their eyes on an area that had undergone significant transformation in the years around 1800. Formerly a common that housed a British barracks, a gaol, and an almshouse and which abutted the "Negro Burial Ground," the area south of Chambers and north of Fulton was, by 1825, being transformed into an elegant landscaped park and civic and cultural center.[17] The three paintings highlighted New Yorkers' aspirations toward gentility through emphasis on the built environment: the park, promenades, and the primary commercial thoroughfare (Broadway), its beautiful new City Hall (completed in 1814), and (in plate 4 and fig. 29) its new cultural institutions (the American Museum and the Rotunda in plate 4; the Park Theater in fig. 29). Hippolyte Victor Valentin Sebron's 1855 view (plate 31) depicted the City Hall Park area as a vibrant commercial and tourist district, with the elegant Hotel Astor serving as focal point. Together, then, these paintings accented structures and spaces that marked New York's ascendance as a bustling yet refined civic and mercantile center.

Continued growth depended upon availability of fresh water. Another painting in the Museum's collection (fig. 34) depicts the fifty-foot frontage of the Manhattan Company Reservoir (chartered 1799), which formed part of the northern boundary of the new civic area with its recently enclosed park. Located between Broadway and Centre Street at 31–33 Chambers Street, the reservoir supplied water to parts of southern Manhattan until 1842, when it was made obsolete

by the opening of the Croton Aqueduct.[18] The structure, anchoring the composition, is shown literally as central to the progress, health, and welfare of the city. Focusing on the reservoir's solid Egyptian-style walls and its classical Greco-Roman iconography, the painting highlights the enduring nature of the reservoir's (and the water company's) mission.

The importance of such a reservoir is made apparent by the numbers of paintings in the catalogue that record destruction of city landmarks due to the capriciousness of fire. The paintings serve as reminders of the fragility and transiency of structures and place; buildings could function as enduring civic monuments only when they did not go up in smoke. John Rubens Smith's watercolor of St. George's Episcopal Church (Varick Street) after the fire of January 6, 1814 (fig. 35), focused on the aftermath of the destruction of a beloved symbol of stalwart Episcopalianism and religious community. The painter depicted the parishioners surveying the ruins and trying to shore up the building. Smith conveyed

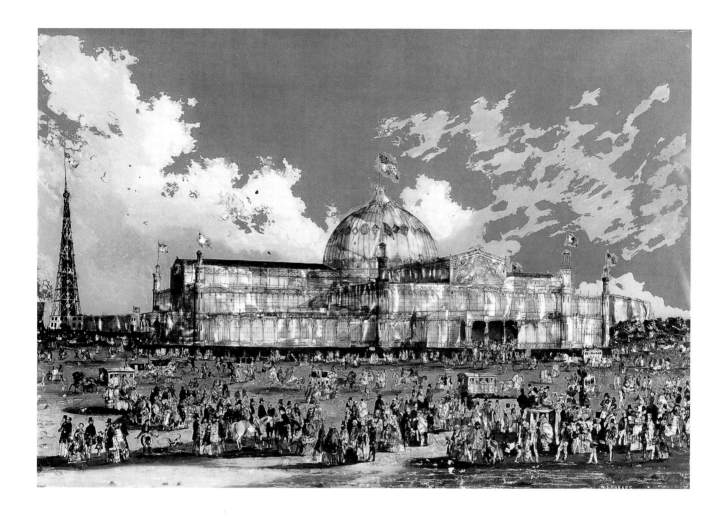

the loss at hand through a formal contrast (heightened by the sharply angled perspectival recession) between present circumstances—the monumental ruin in the foreground—and the past—the diminutive yet undamaged steeple in the background, a reminder of what St. George's Church once was.

In the pre-photographic era, paintings recorded fires and other urban catastrophes and memorialized the ensuing losses of life and property. Smith represented the aftermath of such a disaster. In *Burning of the Merchants' Exchange* (plate 11), the Neapolitan-born Nicolino Calyo sought to convey a greater sense of drama and immediacy by painting the cataclysmic destruction of a magnificent symbol of New York's civic and commercial vitality. (Calyo, who had studied at the Naples Academy of Art, was obviously familiar with that city's tradition of "Vesuvius erupting" paintings.) Asserting the authenticity of the visual account, Calyo inscribed his

presence as witness ("Painted on the spot") above his signature. Using dramatic contrasts of scale, light and shadow, and hue, the painting evoked the sublimity of the inferno; the tiny figures are powerless to combat the flames that engulfed the Merchants' Exchange and surrounding buildings. Calyo's sensational image thus enabled the viewer to experience vicariously the spectacle of destruction. It also commemorated a devastating civic and economic loss.

Like the Merchants' Exchange, the Crystal Palace building (constructed in 1853 to house the nation's first world's fair) was regarded as an expression of civic pride, technological ingenuity, and commercial progress. W. S. Parkes's rendering of the cast-iron and glass exhibits building (fig. 36) was likely painted as a fair souvenir. The crowds, spritely clouds, and sparkling iron structure depicted in the painting presented the Crystal Palace as the embodiment of spectacle: a monu-

36 W. S. Parkes, *Crystal Palace,*
 c. 1850, oil on glass backed with
 mother-of-pearl, gift of Mrs.
 Samuel S. Schwartz, 64.94

37 Victor Wilbour, *The Tombs,*
 c. 1900, oil on canvas board,
 gift of the artist, 30.43.6

ment to display and an ethos of consumption that were then finding expression in enormous new dry goods stores like the one built by A. T. Stewart just a few doors down from the former site of the Manhattan Company Reservoir. The supposedly fireproof Crystal Palace building burned down in 1858. Thus, like Smith's and Calyo's pictures, this painting also commemorated an ephemeral structure—the antitype to the conception of building as monument. The painting's transient subject allies this work with others in the museum's collection.

Late nineteenth- and early twentieth-century painters continued to render buildings and monuments in order to highlight municipal expansion and its transformation of the past and the cityscape. John Beverley Robinson's 1881 *Jefferson Market Courthouse* (see fig. 33) depicted one outgrowth of New York City's exploding population and of the

city government's determination to maintain law and order.[19] The Jefferson Market Courthouse, one of several new courthouses built during the last third of the century, reflected the enlargement of the city's court system and the efforts to solve the problem of overtaxed courts and overcrowded prisons. Robinson's watercolor disregards the more depressing connotations, however, favoring instead a positive vision of the four-year-old building. The image shows a picturesque contrast of turrets and finials towering playfully over low-rise buildings and telegraph poles.[20]

Robinson's painting revealed the beauty of the new modern-style courthouse. Victor Wilbour's desolate view of the Tombs, circa 1900 (fig. 37), eulogized an outmoded relic of a building and penal system. The 1898 consolidation of the five boroughs served as a stimulus for enlargement of the apparatus of governmental oversight and control through the

38 Allen Stone, *Municipal Building*,
 c. 1930, oil on canvas, gift of Jane
 Peterson Philipp, 59.185

an older urban order of individual contacts and small businesses signified by horses and carts, small commercial structures and dingy tenements, and narrow streets.[22] The future of this past was indeed uncertain. During this period, plans were underway to demolish the areas west and north of the Municipal Building to make way for a civic center.

By contrast, Allen Stone's *Municipal Building* (fig. 38) honed in on the building's western entrance, with its triumphal arch portal. The entrance was rendered as passageway to the city's true civic center, the bustling Chambers Street. In contrast to Wilbour's and Warner's views of the areas on the periphery, Stone's scene is teeming with people and traffic. Crowds and congestion evoke the mundane noise and movement that so many paintings of civic New York evaded.

In the eyes of painters, municipal public works could also stand as enduring monuments to progress, place, and modernity. James Monroe Hewlett's *New York Connecting Railroad Bridge at Hell Gate* (plate 64) celebrated a crucial engineering achievement: when completed, the structure was the nation's longest steel arch bridge. Providing a vital rail link between the Bronx and Queens, the bridge was an integral part of the new systems of circulation and the new rapid transportation that were transforming modern urban life and traditional concepts of place.

Da Loria Norman's 1929 *Holing Through* (plate 68) focused on new transportation systems as well. The painter orders and monumentalizes the process of subway construction, appearing to visually equate the tunnel's huge steel armature with a classical temple. Norman locates the viewer dead center to invoke the immediacy, dangers, and thrill of construction and the promise of rapid transit. In contrast,

construction of new correctional facilities. Set on the stage of an eerily unpopulated Centre Street against a backdrop of office buildings, the 1833 Egyptian-style prison stands as a monument to New York City's crime-ridden past, soon to give way to a new, more serviceable, and philosophically enlightened structure.[21]

Modern municipal development engendered not only new courthouses but also numerous other civic projects that transformed the cityscape. The Municipal Building, constructed to house new city offices, was finished in 1915. The Museum's collection includes two works that show the structure in very different ways. Everett Warner's *Municipal Building* (plate 60), painted right around the time of the building's completion, sets up a contrast between a present of an expanded, centralized, impersonal, and powerful city government (epitomized by the massive new office building) and

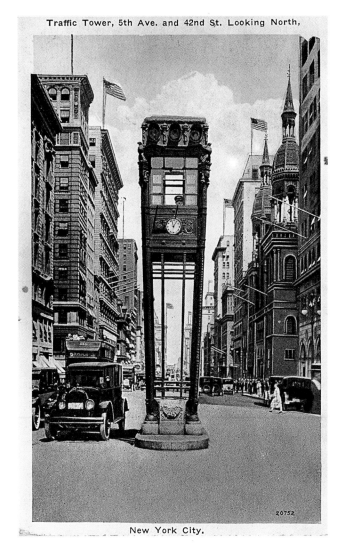

Traffic Tower, 5th Ave. and 42nd St. Looking North,

New York City.

Maurice Kish's *The End of an Epoch* (plate 89), depicting the dismantling of the Sixth Avenue El, positions the viewer as an outsider, removed from the discrete "epoch" that the El's presence signified. The viewer witnesses the making of a ruin, a casualty of urban progress.

Emily Noyes Vanderpoel's 1927 *Fifth Avenue* (fig. 39) commemorates a different aspect of the built environment of municipal public works. Like her counterparts in postcard photography (fig. 40), Vanderpoel depicted the five-year-old traffic control towers that facilitated the free flow of traffic and goods above ground. Placed at strategic intersections along the avenue beginning in 1922, they helped to alleviate traffic congestion and the dangers of crossing the street.[23] In contrast to the postcard, Vanderpoel's nuanced rendering consciously transformed the signals into art. The picturesque plays of light enhance the sense of the ephemeral. Yet those same patterns, in conjunction with the vertical towers that anchor the vista down the street, also create an aura of timelessness in tension with the rapid movement that is

42 Dan Gheno, *Lost Highway*, 1988,
oil on canvas, gift of the artist,
90.79

manent" structures, in an attempt both to generate memory and to deter or lament its annihilation. Edward Lamson Henry's *Old St. John's Church on Varick Street,* 1905 (plate 15), typified growing efforts at the turn of the century to represent memory on behalf of preservation politics. Depicting the church and surroundings as they purportedly appeared in 1840, Henry implicitly contrasted past glory with present-day physical and spiritual deterioration in order to rouse public opposition to the impending desecration of a part of New York's early heritage (regarded as especially scandalous because Trinity Church owned the property). As pictorial persuasion, the painting serves as a counterpoint to paintings like *New York Connecting Railroad Bridge at Hell Gate* (plate 64) or *Holing Through* (plate 68), which celebrated civic development.

Mary Mintz Koffler's *The Aquarium in Destruction,* 1947 (fig. 1), depicts, with understated irony, a fait accompli: the

demolition of a beloved family attraction, motivated, insisted critics, by the sheer hubris of New York City Parks Commissioner Robert Moses.[27] As with Everett Warner's earlier *Municipal Building* (plate 60), the statement hinges on a visual contrast, in this case between the cavalcade of modern, smoke-spewing (and hence occupied) skyscrapers and the abandoned wrecks of the old aquarium and Castle Clinton—itself a time-honored symbol of civic vigilance, strength, and community. In Calyo's *Burning of the Merchants' Exchange* (plate 11), crowds toil unsuccessfully to prevent the destruction. By contrast, Koffler's desolate landscape invokes the tragedy of political arrogance and indifference. Dan Gheno's *Lost Highway,* 1988 (fig. 42), offers an updated, "postmodern" memorial to a once-celebrated manifestation of the city's modern system of circulation, one of the causes of New York's centrality. The West Side Highway (Miller Elevated Highway), an engineering feat completed in 1948, is depicted as a ruin. The painting underscores the fragile and abbreviated life span of New York's built environment. A casualty of neglect and political impasses, the highway is a road to nowhere.

The elegiac sentiments conveyed in these paintings resonated with many New Yorkers in the era after World War II, a period of significant urban development. Like Edward Lamson Henry earlier in the century, preservation-minded citizens campaigned to ensure that the myths and monuments of the old (modern) civic metropolis would remain present and palpable, not merely transformed into memories and images.[28] The Museum's collections include representations of several success stories for preservationists. Frank Mason's *Old Police Headquarters,* 1979 (fig. 43), depicts a Beaux Arts–style landmark on Broome and Grand Streets.

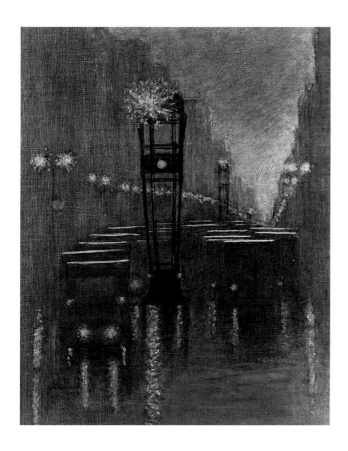

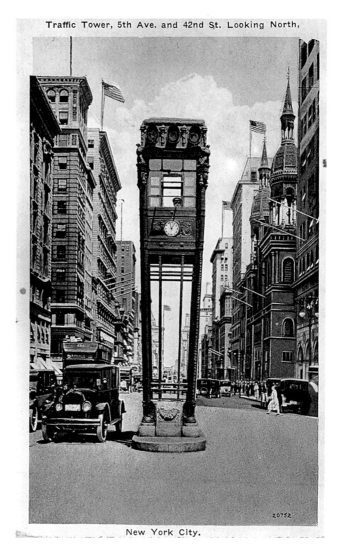

39 Emily Noyes Vanderpoel, *Fifth Avenue,* 1927, oil on canvas, gift of Mrs. John A. Vanderpoel, 35.86

40 Artist unknown, *Traffic Tower, 5th Ave. and 42nd St. Looking North, New York City,* c. 1920, postcard, Archives of the Museum of the City of New York

Traffic Tower, 5th Ave. and 42nd St. Looking North,

New York City.

20752

Maurice Kish's *The End of an Epoch* (plate 89), depicting the dismantling of the Sixth Avenue El, positions the viewer as an outsider, removed from the discrete "epoch" that the El's presence signified. The viewer witnesses the making of a ruin, a casualty of urban progress.

Emily Noyes Vanderpoel's 1927 *Fifth Avenue* (fig. 39) commemorates a different aspect of the built environment of municipal public works. Like her counterparts in postcard photography (fig. 40), Vanderpoel depicted the five-year-old traffic control towers that facilitated the free flow of traffic and goods above ground. Placed at strategic intersections along the avenue beginning in 1922, they helped to alleviate traffic congestion and the dangers of crossing the street.[23] In contrast to the postcard, Vanderpoel's nuanced rendering consciously transformed the signals into art. The picturesque plays of light enhance the sense of the ephemeral. Yet those same patterns, in conjunction with the vertical towers that anchor the vista down the street, also create an aura of timelessness in tension with the rapid movement that is

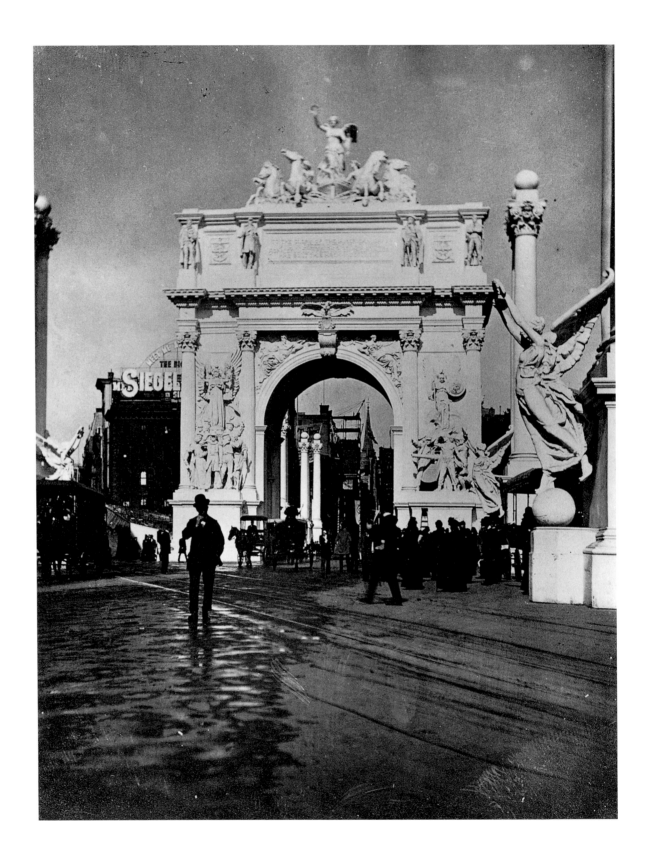

the towers' raison d'être. In hindsight, the invocation of the ephemeral was fitting. By 1930 hanging lights and underground wires would become commonplace, rendering traffic towers obsolete. The scene captured so exquisitely by Vanderpoel would soon become a memory, much like the El in *The End of an Epoch*.[24]

The triumphal arch, already noted in Stone's *Municipal Building* (see fig. 38), is a common motif in this catalogue. Triumphal arches were among the numerous public monuments built at the turn of the century. They were expressions of the same aesthetic and social impulses that produced the Municipal Building and other civic structures. With their explicit allusions to Rome's Arch of Constantine and Paris's Arc de Triomphe de l'Etoile, New York's triumphal arches asserted the city's achievement, power, and stature on a par with the great cosmopolitan capitals of Europe. Three paintings of the Washington Arch, painted by Paul Cornoyer in 1900 (plate 56); by Carton Moore-Park, circa 1913 (plate 61), and by Franz Kline in 1940 (fig. 2), commemorated the well-known landmark, if not specifically the histories it embodied. Built to honor the centennial of Washington's inauguration as first president, the arch was a particular favorite among artists, many of whom lived near it. The Museum's three paintings captured the arch from varied vantage points and at different times of day. All three treated the arch in picturesque fashion (note, for example, how trees frame the arch in each painting). By minimizing sculptural detail and emphasizing the arch's basic structural outlines, all three rendered the monument as a timeless, enduring marker of place, even though the three paintings were made at different times. Cornoyer depicted a merely five-year-old arch. Moore-Park's painted landmark marked the heart of

Greenwich Village as emergent center of social and cultural radicalism. The arch painted by Franz Kline had become an artistic cliché. The stock in trade of participants in the Washington Square Outdoor Art exhibitions, it signified Greenwich Village bohemianism commodified for the tourist trade.[25]

The Museum's other paintings of New York City arches, those showing temporary arches celebrating war victories, represent a notable contrast to the pictures of the permanent stone Washington Arch. Samuel Landsman's *Dewey Celebration at Madison Square*, 1899 (fig. 20), and Jane Peterson's *Victory Arch at Madison Square*, 1919 (plate 62), depicted commemoration in a literal fashion; they sought deliberately to record ephemeral commemorative monuments and moments. Symbols of the city's monetary clout and material egotism as well as of national triumph, these temporary arches also illustrate New York's penchant for tearing down and rebuilding. The paintings highlight the arches' monumental presence along with the rituals and traffic they engendered. In contrast, and perhaps in reaction to many contemporaneous photographs (fig. 41), the artists did not focus on the elaborate sculptural groups that were an integral part of the nationalistic programs of both monuments. The pedestrian and automotive activity is at odds with the stasis of the arches and the very medium itself; that tension is heightened further by the awareness that such movement, like the temporary structures that inspire it, is also transitory.[26]

If Landsman and Peterson sought to commemorate acts of remembering by depicting recently constructed temporary monuments, other twentieth-century painters concentrated on the imminent destruction of ostensibly "per-

42 Dan Gheno, *Lost Highway*, 1988,
oil on canvas, gift of the artist,
90.79

manent" structures, in an attempt both to generate memory and to deter or lament its annihilation. Edward Lamson Henry's *Old St. John's Church on Varick Street*, 1905 (plate 15), typified growing efforts at the turn of the century to represent memory on behalf of preservation politics. Depicting the church and surroundings as they purportedly appeared in 1840, Henry implicitly contrasted past glory with present-day physical and spiritual deterioration in order to rouse public opposition to the impending desecration of a part of New York's early heritage (regarded as especially scandalous because Trinity Church owned the property). As pictorial persuasion, the painting serves as a counterpoint to paintings like *New York Connecting Railroad Bridge at Hell Gate* (plate 64) or *Holing Through* (plate 68), which celebrated civic development.

Mary Mintz Koffler's *The Aquarium in Destruction*, 1947 (fig. 1), depicts, with understated irony, a fait accompli: the

demolition of a beloved family attraction, motivated, insisted critics, by the sheer hubris of New York City Parks Commissioner Robert Moses.[27] As with Everett Warner's earlier *Municipal Building* (plate 60), the statement hinges on a visual contrast, in this case between the cavalcade of modern, smoke-spewing (and hence occupied) skyscrapers and the abandoned wrecks of the old aquarium and Castle Clinton—itself a time-honored symbol of civic vigilance, strength, and community. In Calyo's *Burning of the Merchants' Exchange* (plate 11), crowds toil unsuccessfully to prevent the destruction. By contrast, Koffler's desolate landscape invokes the tragedy of political arrogance and indifference. Dan Gheno's *Lost Highway*, 1988 (fig. 42), offers an updated, "postmodern" memorial to a once-celebrated manifestation of the city's modern system of circulation, one of the causes of New York's centrality. The West Side Highway (Miller Elevated Highway), an engineering feat completed in 1948, is depicted as a ruin. The painting underscores the fragile and abbreviated life span of New York's built environment. A casualty of neglect and political impasses, the highway is a road to nowhere.

The elegiac sentiments conveyed in these paintings resonated with many New Yorkers in the era after World War II, a period of significant urban development. Like Edward Lamson Henry earlier in the century, preservation-minded citizens campaigned to ensure that the myths and monuments of the old (modern) civic metropolis would remain present and palpable, not merely transformed into memories and images.[28] The Museum's collections include representations of several success stories for preservationists. Frank Mason's *Old Police Headquarters*, 1979 (fig. 43), depicts a Beaux Arts–style landmark on Broome and Grand Streets.

Its drum, dome, and lantern tower triumphantly over neighboring rooftops, highlighting the building's monumentality. Silhouetted against a sunset, the Old Police Headquarters is rendered as both a timeless monument and a nostalgic memorial to the grandeur of a lost, yet mythical civic New York.

The publication of this catalogue is important for reasons that go beyond its achievement of documenting the holdings of a major cultural institution. In addition, this book will enable readers to understand both art and New York from crucial new vantage points. The information in this catalogue encourages readings of paintings as manifestations of complex artistic processes; it thus enables us to construct a more comprehensive picture of urban artistic practices. Moreover, the paintings recorded herein represent an important effort to make sense of the events, places, and experiences that have constituted "New York City." Individually and collectively, they contribute to a heightened awareness and understanding of time and place, history and memory, in ways impossible to achieve through other modes of picturing. Thanks to this publication, the artists' renditions of the city are assured a longevity that has eluded many of the landmarks and places they depict. Together, words and paintings contribute to a history of urban-scene painting that is a vital aspect of the histories of New York City and national cultural life.

Notes to Essays

James W. Kerr,
7th Avenue Subway (detail), 1931
(plate 73)

PAINTING THE TOWN

1 Koffler (b. 1906), a native of New Jersey, trained at the Art Students League and moved to Manhattan in 1939. Active in many artists' associations in the area, she exhibited this painting as *New York Aquarium Asunder* in a 1965 one-woman show at Mansfield State College in Pennsylvania. The title was amended to *The Aquarium in Destruction* in 1982, when she donated the work to the Museum of the City of New York. For a condensed biography of the artist, see "Mary Mintz Koffler," in Richard Koke, *A Catalog of the Collection, Including Historical, Narrative, and Marine Art* (Boston: New-York Historical Society in association with G. K. Hall, 1982), p. 249. The artist described her memories of visiting the aquarium site at Battery Park in 1946–1947, when the roof and upper stories of the fort were in process of removal, in a cover note of June 5, 1982, accompanying her gift to the Museum (Mrs. Arnold [Mary] Koffler to Steven Miller, registrar files, receipt number 23160).

2 As quoted in "Moses Wins Plea on Castle Clinton: Court Rules Former Aquarium Is No Monument and May Be Demolished," *New York Times*, March 30, 1949. Copies of other contemporaneous newspaper articles charting the "Save the Aquarium" campaign exist in the Archives of the Museum of the City of New York (hereafter Museum Archives). The remaining walls of Castle Clinton were officially transferred to the U.S. Department of the Interior in 1950; the landmark was restored as a national park in the 1970s and today houses ticket booths to the Ellis Island and Statue of Liberty ferries.

3 Gracie Mansion on the East River at 88th Street, now the official residence of New York City's sitting mayors, was made available by the city as a home for the new Museum of the City of New York in 1924. Yet the mansion was difficult to access by public transportation, and its cramped quarters quickly proved inadequate. A search ensued for a larger, more convenient, and fireproof site, ultimately secured at 1220 Fifth Avenue. In 1926 the

Museum mounted *Old New York,* a preview exhibition that surveyed the city's history with borrowed materials, at the Fine Arts Building on West 57th Street. During its nine-day run, the exhibition drew an astonishing attendance of 18,928 visitors.

4 New York scene paintings were borrowed for an eclectic range of special exhibitions mounted by the Museum between 1932 and the mid-1970s, including *Glimpses of Fifth Avenue* (1932), *New York at the Turn of the Century* (1936), *East River in the Making* (1940), *Painting the Town: Small Paintings by Esther Goetz* (1947), *The Nathan M. Orbach Collection of Contemporary New York Paintings* (1947), *New York Scenes/Broadway* (1950), *Three Rivers Around Manhattan* (1949), *Marine Paintings by Gordon Grant* (1954), *Contemporary Paintings of New York by Virginia Livingston and Robert Freiman* (1959), *Peter Cooper's New York* (1961), *How Green Was My City* (1972), and *Cecil C. Bell: The Vanished City* (1973).

5 Today, the temperament of the so-called Ash Can School is represented selectively in the Museum's holdings only through prints, sketches, and magazine "art." A small gouache-and-watercolor view of the Washington Square Arch, attributed to George B. Luks, entered the collection in 1991 through the Robert R. Preato Bequest (91.76.28). A policy of not accepting works by contemporary artists was sometimes cited in letters declining gift offers written by the Museum's early Print Department staff. However, no confirmation of this institutional "policy," probably referenced as a diplomatic excuse for rejecting work, has been uncovered in back records, and acquisitions of photography and graphic materials by living artists at the same period are evidence against any comprehensive Museum restrictions on collecting work-of-the-times.

6 Realist views of Sheridan Square and MacDougal Street by Kline dating from the same period also survive. A biographer of the artist later characterized these quickly painted studies as "buck-eye paintings which helped pay the rent." During the 1930s and 1940s Kline and his wife moved around Greenwich Village, occu-

pying a succession of inexpensive walk-ups and loft apartments. In 1939 he participated in the biannual Greenwich Village Outdoor Art Show, a magnet for tourists known for generating impulse sales. Kline's career as a Village artist and resident is discussed by Evie T. Joselow in "The Early Work of Franz Kline— The Bleecker Street Tavern Murals, 1940," CUNY Graduate Center, paper for the course "New York Painting," 1986. This paper is housed in the Museum Archives.

7 Records indicate that Norse had studied landscape painting at the National Academy of Design in New York between 1883 and 1885, while living on Third Avenue and then East 125th Street. In a letter that Norse wrote to New York City gallery owner William MacBeth from the Potsdam Normal School in 1904, the artist recounts having "been buried up here for the past dozen years or so," during which time he "accumulated a lot of pictures." Norse took charge of the school's drawing program in 1893 and resigned from the faculty around 1905. The results of recent research into the artist's career are collected in the Museum Archives.

8 The history, controversies, research, and restoration attempts weathered by Blockhouse Number 1 are summarized in "Historic Structure Report, Blockhouse No. 1, Central Park, New York City," prepared by the Central Park Conservancy, April 1991, in the Museum Archives.

9 The connections between the formation of the Museum of the City of New York and the larger politics of preservation and reclamation of the local history movement in New York City are discussed by Max Page in his provocative dissertation "The Creative Destruction of New York City: Landscape, Memory, and the Politics of Place, 1900–1930" (Ph.D. diss., University of Pennsylvania, 1995), chap. 5. This chapter was revised for publication as "A Vanished City Is Restored: Inventing and Displaying the Past at the Museum of the City of New York," *Winterthur Portfolio* 34, no. 1 (1999): 49–64.

10 Brown, a history enthusiast but not a trained museum professional, struggled under the task and was replaced in 1926 by

Harding Scholle, then a promising young curator at the Chicago Art Institute. The Museum's trustees gave Scholle time at the outset of his tenure to travel to Europe to study models of city-history museums abroad, including the Musée Carnavalet in Paris, the Museum of London, and the city museums of Berlin and Hamburg. He retired from active service as the Museum's top administrator in 1951.

11 Both Brown and Stokes were pioneering preservationists, Brown noted for his advocacy efforts on behalf of preserving City Hall and its park, Stokes for his work in saving the facade of the Bank of the United States on Wall Street, later installed in the American Wing of the Metropolitan Museum of Art. Beginning in 1916, Brown had spearheaded publication of the historical compendium *Valentine's Manual.* He is said to have urged the Museum to adopt the Vanderbilt Mansion on 58th Street as its home, in hopes of sparing the building from demolition. Stokes, a professionally trained architect, housing reformer, and self-disciplined historian, had deep family roots in various New York City charities. He became an informal adviser to Harding Scholle, who assumed the Museum's directorship in 1926. For twenty years Stokes also served as a respected board member of the New York Public Library and the city's Art Commission.

12 Founded in 1805, the Free School Society erected New York Free School Number 1 in 1806, on Madison Street near Pearl Street. In 1808 the former Arsenal Building was conferred on the society as Free School Number 2, "on the condition that they educate all the poor children in the Almshouse." The roughly dressed boys playing outside the columned Arsenal Building probably represent pupils drawn from this source. A minor error seems to have been committed in the painter's identification of this structure as the first New York Free School. An engraved view of Free School Number 2, nearly identical in composition, was published in *Valentine's Manual* (1866), p. 604.

13 From its inception, the Museum's founders embraced the camera as the most expedient tool for realizing their objective of building a definitive pictorial record of the city's appearance, with old prints and maps filling in where photography could not. As early as 1924, a proposal was under consideration to fund a photographer to document every New York street, running from the Bronx to the Battery. Although this plan was never realized, realtor J. Clarence Davies, a prominent patron of the Museum, donated a similar project to its Print Archive in the early 1930s: a record of every wood-frame building still standing on Manhattan Island, which he had commissioned from Charles Von Urban, a professional photographer. Occasional expenditures on contemporary photographs were authorized by the Museum for exhibitions and to expand the Print Archive.

14 Alva Johnson, "N.Y. Museum Gets City Relics in $500,000 Davies Collection: First Oil Painting and First Directory...," *New York Herald Tribune,* March 2, 1929.

15 I. N. Phelps Stokes, *The Iconography of Manhattan Island* (New York: Robert H. Dodd, 1915), vol. 1, pp. 153–154. In his analysis of the hand-colored, engraved inset scene of the Restitutio View, Stokes mentioned the related painting soon to be given to the Museum, which was then in Davies' private possession: "An oil painting, evidently of seventeenth century or very early eighteenth century origin, and closely resembling the Restitutio View, has recently been found in an old home on Staten Island, and now belongs to Mr. J. Clarence Davies. Unfortunately, the former owner had the picture restored in Paris, and the work was very badly done. The view contains some anachronisms for which it is difficult to account, even if we suppose that an attempt was made to bring it up to date some years after it was first painted. Nevertheless, it is an interesting document and merits careful study" (p. 154).

16 Tony Hiss, "Foreword: A Closer Look," in Paul E. Cohen and Robert T. Augustyn, *Manhattan in Maps, 1527–1995* (New York: Rizzoli International Publications, 1997), pp. 14–15.

17 Some art historians have interpreted this painting by James Ensor (1860–1949) as the artist's personal diatribe against rival

groups of contemporary European painters—hailed as avant-garde by some critics—whose work he loathed. Bridaham may have encountered Ensor's painting in Antwerp in 1930–1931, when he was studying "gargoyles and grotesques" in Europe and traveling to galleries throughout the continent under the auspices of the American Field Service. He had returned to Manhattan by 1932, when the G. R. D. Gallery mounted a show of his small paintings of "people and places." Critics commented on the "alien gaiety" of Bridaham's work in the context of the deepening American Depression, with a writer from *Art Digest* commending his bright, strange scenes as "the artistic equivalent of a good cocktail" ("Bridaham Cocktail Mixer," *Art Digest* [February 1932]).

18 For an overview of the turn-of-the-century origins of midtown Manhattan as a magnet for professional artists and services for them, see John Davis, "'Our United Happy Family': Artists in the Sherwood Studio Building, 1880–1900," *Archives of American Art Journal* 36 (1996): 2–19.

19 The flowering of Williamsburg's art colony in recent years is reviewed by Roberta Smith in "Brooklyn Haven for Art Heats Up," *New York Times,* November 6, 1998.

20 When Davies made his major donation to the Museum of the City of New York in 1929, interviews with the collector were in demand. For one period account of his collection's genesis, as recounted by Davies, see William C. Garner, "A Fortune in Old New York Pictures," *Little Old New York* 4, no. 7 (June 1929): 23–27.

21 Quoted by Johnson in "N.Y. Museum Gets City Relics."

22 Possibly these New York views decorated Blair's apartment on Park Avenue. Before 1951 she had donated ceramics and other decorative-arts items to the Museum of the City of New York. Between 1932 and 1949, loan records also document the short-term stays of selected cityscapes from her private collection. The Blair Bequest occasioned an article acknowledging the gift's importance by Grace M. Mayer, the Museum's curator of prints and photographs under whom care of the paintings collection then rested. See Grace M. Mayer, "Views of Manhattan Island," *Magazine Antiques* 62, no. 6 (December 1952): 498–502.

23 Ronald G. Pisano, "Foreword," in *The Robert R. Preato Collection of New York City Paintings and Drawings,* exhibition catalogue (New York: Museum of the City of New York, 1992), p. 7. For a fine contextual summary of the collection see, in the same catalogue, Cassandra Langer's essay "In the Same Space: The Robert R. Preato Collection of New York City Art," pp. 9–16.

24 Wong was the subject of a 1998 mid-career retrospective organized by the New Museum of Contemporary Art in New York, which contains five overview essays analyzing his evolution and influences, including graffiti, as an artist. See Marcia Tucker, Dan Cameron, Barry Blinderman, Yasmin Ramirez, Lydia Yee, and Carlo McCormick, *Sweet Oblivion: The Urban Landscape of Martin Wong* (New York: New Museum of Contemporary Art; New York: Rizzoli, 1998).

25 The artist's reminiscences were sought in preparation for the survey exhibition *Around the Town,* marking the 1993 gift of fourteen scene paintings to the Museum by the artist and his wife, Grace La Gambina. Some of these memories were distilled in the gallery-guide essay accompanying the exhibition: Jan Seidler Ramirez, *Around the Town: Paintings by Vincent La Gambina* (New York: Museum of the City of New York, 1993).

26 John Zeaman, "Painting the Sidewalks of New York," *Record* (Bergen County, N.J.), April 16, 1987. Reisman's paintings were included in the exhibition *The Ash Can Circle: A Texture of the Times* at the Bergen Museum of Art and Science in Passaic, New Jersey (Spring 1987).

THE PAINTER AND THE CITY

1 *The Works of Walt Whitman* (New York: Modern Library, 1948), vol. 1, p. 167.

2 Herman Melville, *Moby-Dick* (reprint, New York: Modern Library, 1926), pp. 1–2.

3 Theodore Dreiser, *Sister Carrie* (New York: Modern Library, 1927), p. 341.

4 I have been unable to find the origin of the term *cityscape*, although it was in common use by the end of the nineteenth century, probably as an extension of the genre of landscape painting to works depicting ocean perspectives. See Svetlana Alpers, *The Art of Describing: Dutch Art in the Seventeenth Century* (Chicago: University of Chicago Press, 1983), pp. 119–168.

5 Ibid.

6 Museum Archives.

7 See Alpers, *The Art of Describing,* chap. 4.

8 Peter Buckley, *To The Opera House* (Oxford: Oxford University Press, forthcoming).

9 Ibid.

10 The Greensward Plan, 1857. Reprinted in Roy Rosenzweig and Elizabeth Blackmar, *The Park and the People: A History of Central Park* (Ithaca: Cornell University Press, 1992), pp. 122–123.

11 Buckley, *To the Opera House.*

12 On Inman, see Museum Archives.

13 Horatio Alger, *Ragged Dick* (reprint, New York: Modern Library, 1969), p. 83.

14 On Kollner, see Museum Archives.

15 On Meyer, see Museum Archives.

16 Christine Stansell, *City of Women: Sex and Class in New York, 1789–1860* (New York: Knopf, 1986).

17 Francis S. Osgood, *Cries of New-York with Fifteen Illustrations* (New York: John Dogget, Jr., 1846), p. 5.

ART SCENES AND THE URBAN SCENE

1 On art education, see Paul J. Staiti, "Ideology and Politics in Samuel F. B. Morse's Agenda for a National Art," in *Samuel F. B. Morse: Educator and Champion of Art in America,* exhibition catalogue (New York: National Academy of Design, 1987), pp. 11–53; Eliot Candee Clark, *History of the National Academy of Design, 1825–1953* (New York: Columbia University Press, 1954); Mary Bartlett Cowdrey, *The American Academy of Fine Arts and the American Art-Union* (New York: New-York Historical Society, 1953); Marchal Emile Landgren, *Years of Art: The Story of the Art Students League of New York* (New York: McBride, 1940); Michele H. Bogart, *Artists, Advertising, and the Borders of Art* (New York: University of Chicago Press, 1995), pp. 26–32.

2 For discussions of New York art institutions, see Neil Harris, *The Artist in American Society: The Formative Years, 1790–1860* (New York: Clarion Books, 1966), pp. 98–99, 104–106, 108–119, 254–257; Lillian Miller, *Patrons and Patriotism: The Encouragement of the Fine Arts in the United States, 1790–1860* (Chicago: University of Chicago Press, 1966), pp. 90–102, 160–172; Maybelle Mann, "The New-York Gallery of Fine Arts: 'A Source of Refinement,'" *American Art Journal* 11 (January 1979): 76–86; Rachel N. Klein, "Art and Authority in Antebellum New York City: The Rise and Fall of the American Art-Union," *Journal of American History* 81 (March 1995): 1534–1561; Susan Burns, *Inventing the Modern Artist: Art and Culture in Gilded Age America* (New Haven: Yale University Press, 1996), pp. 46–76. For nineteenth-century examples of artists' marketing enterprises, see Annette Blaugrund, "The Tenth Street Studio Building: A Roster, 1857–1895," *American Art Journal* (Spring 1982): 64–71; Blaugrund, *The Tenth Street Studio Building: Artist-Entrepreneurs from the Hudson River School to the American Impressionists* (Southampton, N.Y.: Parrish Art Museum, 1997); Kevin J. Avery, *Church's Great Picture: The Heart*

of the Andes (New York: Metropolitan Museum of Art, 1993); Nancy K. Anderson, *Albert Bierstadt: Art and Enterprise* (New York: Brooklyn Museum of Art, 1990); Sarah Burns, "The Price of Beauty: Art, Commerce, and the Late Nineteenth Century American Studio Interior," in *American Iconology: New Approaches to Nineteenth-Century Art and Literature,* ed. David C. Miller (New Haven: Yale University Press, 1993).

3 Sarah Burns, "Barefoot Boys and Other Country Children: Sentiment and Ideology in Nineteenth Century America," *American Art Journal* 20 (1988): 25–50; Burns, *Pastoral Inventions: Rural Life in American Art and Culture* (Philadelphia: Temple University Press, 1989).

4 The rise of urban cityscape painting among French Impressionists has been explored in depth by Robert L. Herbert, *Impressionism: Art, Leisure, and Parisian Society* (New Haven: Yale University Press, 1988). On the "painting of modern life," see T. J. Clark, *The Painting of Modern Life: Paris in the Art of Manet and His Followers* (New York: Alfred A. Knopf, 1984). The connections between French developments and American artistic production with regard to urban-scene painting have been examined in several recent studies, most notably H. Barbara Weinberg, Doreen Bolger, and David Park Curry, *American Impressionism and Realism: The Painting of Modern Life* (New York: Metropolitan Museum of Art, 1994); William H. Gerdts, *Impressionist New York* (New York: Abbeville Press, 1995); Marianne Doezema, *George Bellows and Urban America* (New Haven: Yale University Press, 1992); Kathleen Pyne, *Art and the Higher Life: Painting and Evolutionary Thought in Late Nineteenth-Century America* (Austin: University of Texas Press, 1996), pp. 220–290; Rebecca Zurier, "Six New York Artists," in Rebecca Zurier, Robert W. Snyder, and Virginia M. Mecklenburg, *Metropolitan Lives: The Ashcan Artists and Their New York,* exhibition catalogue (Washington, D.C.: National Museum of American Art, 1996), pp. 62, 73.

5 For discussion of the New York dealers, galleries, and markets for painting, see Linda Henefield Skalet, "The Market for American

Painting in New York, 1870–1915" (Ph.D. diss., Johns Hopkins University, 1980); Gwendolyn Owens, "Art and Commerce: William MacBeth, the Eight, and the Popularization of American Art," in Elizabeth Milroy, *Painters of a New Century: The Eight and American Art,* exhibition catalogue (Milwaukee: Milwaukee Art Museum, 1991), p. 65; Doreen Bolger, "William MacBeth and George A. Hearn: Collecting American Art, 1905–1910," *Archives of American Art Journal* 15 (1975): 9–14; Saul Zalesch, "What the Four Million Bought: Cheap Oil Paintings of the 1880s," *American Quarterly* 48 (March 1996): 77–109. On Impressionism, realism, and other artistic developments at the turn of the century, see Saul E. Zalesch, "Competition and Conflict in the New York Art World," *Winterthur Portfolio* 2–3 (Summer–Autumn 1994): 103–120; Weinberg, Bolger, and Curry, *American Impressionism and Realism;* Gerdts, *Impressionist New York;* Marianne Doezema, *George Bellows and Urban America* (New Haven: Yale University Press, 1992); Zurier, Snyder, and Mecklenburg, *Metropolitan Lives.*

6 Elizabeth Milroy, "Modernist Ritual and the Politics of Display," in *Painters of a New Century,* pp. 21–51; Virginia M. Mecklenburg, "Manufacturing Rebellion: The Ashcan Artists and the Press," in Zurier, Snyder, and Mecklenburg, *Metropolitan Lives,* pp. 191–213. On Stokes and Davies, see Max Page, "The Creative Destruction of New York City: Landscape, Memory, and the Politics of Place, 1900–1930" (Ph.D. diss., University of Pennsylvania, 1995), pp. 246–260, 332–370, revised as *The Creative Deconstruction of Manhattan* (Chicago: University of Chicago Press, 1999).

7 Two post-Depression histories by Oliver Larkin and Milton Brown were notable exceptions. Brown lived in New York for most of his life; Larkin, however, lived in Cambridge and Northampton, Massachusetts. See Oliver Larkin, *Art and Life in America* (1949; reprint, New York: Holt, Rinehart, and Winston, 1960) and Milton Brown, *American Painting from the Armory Show to the Depression* (Princeton: Princeton University Press, 1955). For a historiographic overview of the surveys of American

art, see Elizabeth Johns, "Histories of American Art: The Changing Quest," *Art Journal* 44 (Winter 1984): 338–344; and Johns, "Scholarship in American Art: Its History and Recent Developments," *American Studies International* 22 (October 1984). The earliest historians, Dunlap and Tuckerman, took New York patrons to task for not supporting a wider range of artists and painting genres, but when it came to painters of the city, they, too, were inattentive. It is possible that ethnic prejudices came into play. Dunlap mentioned the English-born Francis Guy, whose work inspired the painter of the Museum's *Winter Scene in Brooklyn;* Tuckerman included the English-born marine painter Thomas Birch. The Neapolitan-born aristocrat and émigré Nicolino Calyo (painter of *Burning of the Merchants' Exchange*), in contrast, was not included in any of the surveys, even though he had a successful career in both New York and Baltimore.

8 Angela Miller, Alan Wallach, and Elizabeth Johns have compellingly shown that landscape and genre painting, respectively, both commissioned and hailed as a national art, were, despite their non-urban subjects, distinctively New York products in terms of their patronage, display, motivations, and significance. See Angela Miller, *The Empire of the Eye: Landscape Representation and American Cultural Politics* (Ithaca: Cornell University Press, 1993), pp. 65–105; Elizabeth Johns, *American Genre Painting: The Politics of Everyday Life* (New Haven: Yale University Press, 1991), pp. 1–23; Alan Wallach, "Landscape and the Course of American Empire," in William H. Truettner and Alan Wallach, *Thomas Cole: Landscape into History* (New Haven: Yale University Press, 1994), pp. 33–49.

9 All the biographical and provenance information in this chapter comes from the artists' files and accession files of the Museum of the City of New York, Department of Painting and Sculpture.

10 Kenneth John Myers, "The Economics of Arts Patronage in Jacksonian New York: The Example of the Stevens Collection," paper delivered at the Brooklyn Museum of Art, March 19, 1995.

11 Brown, *American Painting from the Armory Show to the Depression,* pp. 92–99; Skalet, "The Market for American Painting in New York"; Owens, "Art and Commerce." See also provenance information on Childe Hassam's paintings in the Metropolitan Museum of Art, in Doreen Bolger Burke, *American Paintings in the Metropolitan Museum of Art,* vol. 3 (New York: Metropolitan Museum of Art, 1980), pp. 353–356.

12 For discussion of Shahn's New Deal Paintings, see Diana Louise Linden, "The New Deal Murals of Jewish Identity, Social Reform, and Government Patronage" (Ph.D. diss., Graduate School and University Center of the City University of New York, 1992).

13 For the years before about 1960, the artists represented in the collection of the Museum of the City of New York are fairly representative of the range of ethnic groups engaged in professional art practice, with the notable exception of African Americans, many of whose activities paralleled those of white artists. Because of racial biases and the color line in the job market, however, many African American artists experienced greater overall hardships not only in finding exhibition venues and patronage but in finding regular work. Painters such as Beauford Delany (1902–1977), Palmer Hayden (1890–1973), and Malvin Gray Johnson (1896–1934) worked at a range of menial jobs to support themselves. All of them received awards from the New York City–based Harmon Foundation. Johnson, who painted Harlem rooftops and other street scenes, was one of the few of these artists who depicted New York subjects. Jacob Lawrence and Romare Bearden, both of whom achieved broader recognition in the art world, were also painters of life in New York. See Gary Reynolds et al., *Against the Odds: African-American Artists and the Harmon Foundation* (Newark, N.J.: Newark Museum, 1989).

14 The term *sites of memory* derives from Pierre Nora's *Lieux de mémoire.* Nora's phrase refers to self-conscious efforts to represent memory within contexts in which "true," living memory no longer exists or governs people's lives. Although Nora applied the phrase specifically to the French context, and the need for such images arose from circumstances different from those in the

United States, it is nonetheless viable to use the term with reference to representations of New York. See Pierre Nora, "Between Memory and History: *Les lieux de mémoire*," *Representations* 26 (Spring 1989): 7–25.

15 Recent comparative discussions can be found in Michele H. Bogart, *Artists, Advertising, and the Borders of Art* (Chicago: University of Chicago Press, 1995), pp. 79–110; Ellen Wiley Todd, *The "New Woman" Revised: Painting and Gender Politics on Fourteenth Street* (Berkeley: University of California Press, 1993); Zurier, Snyder, and Mecklenburg, *Metropolitan Lives;* Whitney Museum of American Art, *City of Ambition* (New York: Whitney Museum of American Art, 1996); Page, "The Creative Destruction of New York City"; Robert A. M. Stern, Gregory Gilmartin, and Thomas Mellins, *New York, 1930: Architecture and Urbanism Between the Two World Wars* (New York: Rizzoli, 1987), pp. 48–89; Robert A. M. Stern, Thomas Mellins, and David Fishman, *New York, 1960: Architecture and Urbanism Between the Second World War and the Centennial* (New York: Monacelli Press, 1995), pp. 1155–1211. For comparison with visual culture of an earlier period, see Joshua Brown, "Reconstructing Representation: Social Types, Readers, and the Pictorial Press, 1865–1877," *Radical History Review* 66 (1996): 5–38.

16 Page, "The Creative Destruction of New York City," p. 257; see also his important chapters on the Museum of the City of New York and I. N. Phelps Stokes on pp. 214–260 and 332–370. Page attributes the phrase "creative destruction" to economist Joseph A. Schumpeter's 1942 *Capitalism, Socialism, and Democracy*. On J. Clarence Davies, see also J. Clarence Davies files, Museum of the City of New York, and Jan Ramirez, "Painting the Town: Collecting Cityscapes and Urban Character at the Museum of the City of New York," in this book.

17 On City Hall Park, see Michele H. Bogart, "Public Space and Public Memory in New York's City Hall Park," *Journal of Urban History* (January 1999); Elizabeth Blackmar, *Manhattan for Rent,*

1785–1850 (Ithaca: Cornell University Press, 1989), pp. 89–94.

18 New York City Landmarks Preservation Commission, *The African Burial Ground and the Commons Historic District Designation Report* (New York: City of New York, 1993), pp. 35–36.

19 Early courts had been housed in the City Hall, the Rotunda, and several other structures in City Hall Park (see fig. 30).

20 Robinson's outlook was hardly unusual. In 1885 a national poll of architects named the Courthouse as one of the nation's most beautiful buildings; see Margot Gayle, "Jefferson Market Courthouse," in *Encyclopedia of New York City*, ed. Kenneth T. Jackson (New Haven: Yale University Press, 1995), pp. 616–617.

21 On the old Tombs, see Eric Homberger, *Scenes from the Life of a City: Corruption and Conscience in Old New York* (New Haven: Yale University Press, 1994), pp. 14–16.

22 Such juxtapositions between past and present were typical of Warner's work. See Gerdts, *Impressionist New York*, p. 170.

23 On the dangers of modern urban life, see Ben Singer, "Modernity, Hyperstimulus, and the Rise of Popular Sensationalism," in *Cinema and the Invention of Modern Life*, ed. Leo Charney and Vanessa Schwartz (Berkeley: University of California Press, 1995), pp. 72–99.

24 On the traffic towers, see Henry Collins Brown, *Fifth Avenue Old and New* (New York: Fifth Avenue Association, 1924), p. 116; "The New Bronze Traffic Towers on Fifth Avenue, New York," *Architecture* 42 (February 1923): 46; Stern, Gilmartin, and Mellins, *New York, 1930*, p. 696.

25 The first, temporary arch, built in wood one hundred feet north of Washington Square, proved so popular that elite homeowners around the square sponsored a campaign to reconstruct the arch in more enduring Tuckahoe marble. On the Washington Arch, see Michele H. Bogart, "Historical Background," in Swanke Hayden Connell, "Washington Arch Survey of Existing Conditions," report prepared for the Department of Parks and Recreation of the City of New York, January 1992, pp. 4–12; Mindy Cantor,

"Washington Arch and the Changing Neighborhood," in *Green-wich Village: Culture and Counterculture,* ed. Rick Beard and Jan Seidler Ramirez (New Brunswick: Rutgers University Press, 1993), pp. 83–92; Donald Martin Reynolds, *Monuments and Mas-terpieces: Histories and Views of Public Sculpture in New York City* (1988; reprint, New York: Thames and Hudson, 1997), pp. 356–366.

26 On the tension between mobility and stasis, the ephemerality of sensation, and the efforts to freeze those sensations as a peculiarly modern urban phenomenon, see Leo Charney, "Introduction," and "In a Moment: Film and the Philosophy of Modernity," in Charney and Schwartz, eds., *Cinema and the Invention of Modern Life,* pp. 6, 279–294. On the Dewey and Victory arches, see Michele H. Bogart, *Public Sculpture and the Civic Ideal in New York City, 1890–1930* (1989; reprint, Washington, D.C.: Smithso-nian Institution Press, 1997), pp. 97–110, 271–292.

27 On the destruction of the aquarium, see Robert A. Caro, *The Power Broker: Robert Moses and the Fall of New York* (New York: Random House, 1974), pp. 678–682; Gregory F. Gilmartin, *Shap-ing the City: New York and the Municipal Art Society* (New York: Clarkson Potter, 1995), pp. 325–330.

28 The 1965 establishment of the Landmarks Preservation Com-mission helped to fulfill this mission. On the postwar preserva-tion movement in New York, see Gilmartin, *Shaping the City,* pp. 344–424; Stern, Mellins, and Fishman, *New York, 1960,* pp. 1091–1153.

Michele H. Bogart wishes to thank Elizabeth Blackmar, Daniel Bluestone, Barbara Ball Buff, Sarah Burns, Deborah Gardner, Philip Pauly, Jan Seidler Ramirez, and Carol Willis for com-ments and suggestions that helped improve her essay.

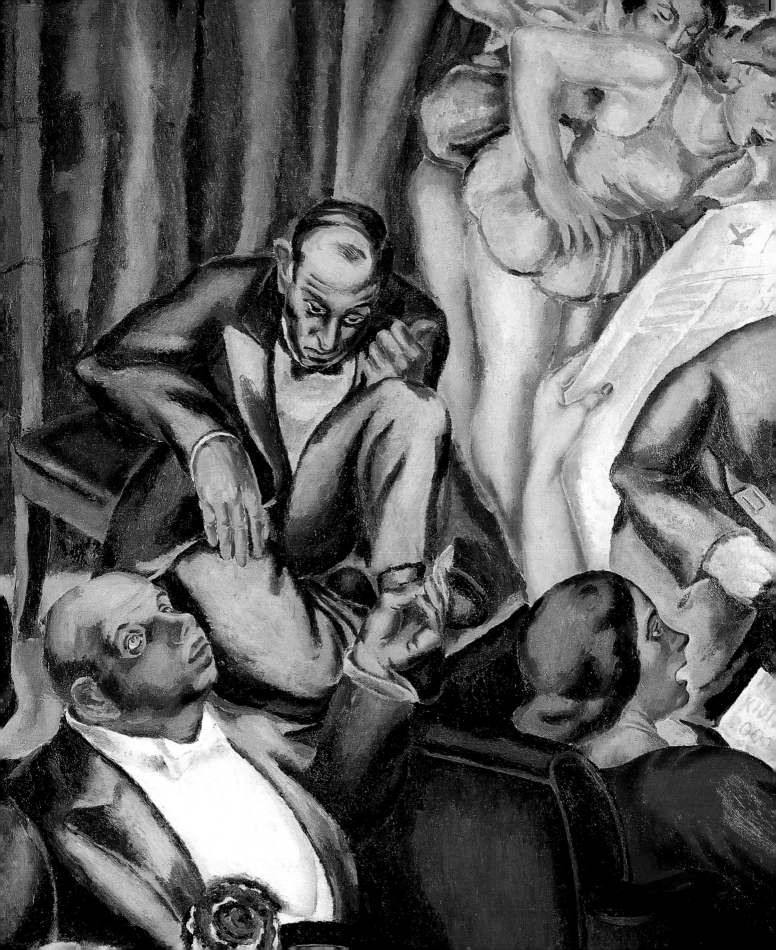

Catalogue

The following works, representative of the much larger survey of painted cityscapes in the Museum of the City of New York, reflect the chronological, stylistic, and thematic range of this rich collection. The accompanying text documents the various kinds of historical evidence about the physical and ideological properties of New York City that curators have extracted from such paintings. The selection also suggests the wide variation of urban-scene artists encompassed in these holdings, from observant amateurs to academy-trained professionals.

The date of a subject or event depicted in a painting, whether synchronous with the painting's production or remembered by the artist years after the fact, has governed the general chronological arrangement of entries and associated plates. In the course of researching individual paintings, efforts were made to confirm or correct dates (those of execution as well as of scene depicted) and titles associated with the works at the time of their acquisition by the Museum. Entries and endnotes explain any significant variations or inconsistencies encountered during these investigations. The titles and dates of some paintings were indicated by the artist. Other works have assumed revised titles based on exhibition records and archival sources consulted in the process of preparing this book. Paintings that entered the Museum without any associated titles or dates have been assigned approximate dates and subject titles, usually based on stylistic evidence, conservation

analysis, knowledge of the artist's working activity in New York, and place or section of the city documented.

Dimensions of paintings are given in inches, with height preceding width. Curatorial front matter for each painting also includes its accession number, indicating the year in which the work was processed into the permanent collection of the Museum of the City of New York. The Museum Archives typically contain a great deal of supplementary information about the individual work as "artifact" (including conservation, ownership, and exhibition histories), the subject matter shown, and the biographical context of the painting within the career of its maker.

Anatol Shulkin,
American Life (detail), 1934
(plate 75)

Dance on the Battery in the Presence of Peter Stuyvesant

1838 (depicting 1809)

Asher B. Durand (1796–1886)
Oil on canvas, 32 ¼ × 46 ⅝
Signed lower center: *A. B. Durand, 1838*
Gift of Jane Rutherford Faile through Kenneth C. Faile, 55.248

Dance on the Battery, painted in 1838, dates from an important juncture in the career of its creator. Earlier in the 1830s, Asher B. Durand, a founding member of the National Academy of Design, had changed careers from engraving, a field in which he excelled, to painting.[1] This shift in focus propelled him into a period of experimentation with different pictorial formats that lasted through the end of the decade. Durand initially embarked on a series of presidential portraits (1834–1836) commissioned by Luman Reed, a prominent New York City merchant and art patron who offered the artist instrumental support during this bridge period. An 1837 sketching trip to the Adirondacks in the company of Thomas Cole, however, inspired Durand to shift his allegiance to landscapes. After a pilgrimage to study art in Europe in 1840–1841, Durand emerged as an influential painter of American nature, inheriting a preeminent position among his Hudson River School contemporaries upon Cole's death in 1848.

On the brink of pursuing this trajectory into landscape, Durand briefly turned his brush to literary genre scenes. It was for Luman Reed that he first dipped into Washington Irving's droll *Knickerbocker's History of New York.* In *The Wrath of Peter Stuyvesant* (1835; collection of the New-York Historical Society) Durand portrayed the Dutchman's putative choler upon learning of the Swedish capture of Fort Casimir. Irving served as a resource

again for *Rip Van Winkle's Introduction to the Crew of Henryck Hudson* (present whereabouts unknown), which Durand displayed at the National Academy of Design in 1838. Included in that same exhibition was *Dance on the Battery,* his third excursion into Irving's work, which he produced for Thomas H. Faile, a local businessman and art aficionado.[2] Acquired by the Museum of the City of New York from Faile's descendants, the canvas fuses an episode from Irving's 1809 pseudo-history of New Amsterdam with a lower Manhattan landscape fabricated by Durand. As a double piece of urban fiction, the work reveals more about nineteenth-century nostalgia brought on by the erasure of New York's past than it does about the actualities of a youthful provincial city.

The tableau dramatizes the response of New Amsterdam's humorless director-general to a Saturday frolic on the Battery in the fall, "a season for the lifting of the heel as well as the heart," according to Diedrich Knickerbocker, Irving's invented annalist.[3] As told, the town's citizenry had, by habit, assembled one afternoon on this southernly tip of land under the shade of a spread of trees to smoke pipes and admire the autumnal dance festivities. The gathering was suddenly spiced by the appearance of a young belle newly returned from Holland, dressed in "not more than half a dozen petticoats, and these of alarming shortness." Adding scandal to shock, a breeze caught the

damsel's skirts as she performed a jig, causing a "display of her graces" and grievous displeasure to the onlooking Stuyvesant.

Preparatory sketches for the painting, which survive in charcoal, pencil, and chalk, demonstrate Durand's efforts to integrate the multiple figures of the composition into the background landscape and to refine the individual gestures of the cavorting dancers and riveted bystanders.[4] Transported into this canvas from his 1835 romp into *Knickerbocker's History* are the recognizable figures of the rotund trumpeter Anthony Van Corlaer (standing at left with his instrument), who officiated as Stuyvesant's high chamberlain, and (seated at center) the peg-legged potentate of the painting's title. According to later hearsay, the model for the dark, dour caricature of Stuyvesant was Luman Reed.[5] The artist's son, however, vouched for the painting's wholly "imaginary" genesis. Durand's portrayal of Stuyvesant certainly accords with the "Great Peter" described by Irving's hypothetical historian as being armed with "ominous walking-stick" and "a countenance sufficient to petrify a millstone." Durand's bright, clear palette (restored for appreciation through a conservator's careful cleaning in 1998) also seems to correspond with the afternoon filled with "golden" sunlight and "green lawn of the Battery," as recounted by narrator Knickerbocker.

Irving's fanciful retrospective of Dutch New York was motivated in part by the realization that the modern city he occupied was poised to undergo radical change and that the vestiges of its formative past, already sparse by 1809, would be eradicated by progress. New York's heritage of fires, hill levelings, landfills, and other rationalizing urban developments also left nineteenth-century artists with few physical landmarks to consult when attempting to visualize New Amsterdam. Oral and written histories, a scattering of quaint prints and maps, and imagination were their resources, the last of which informed Durand's apocryphal view of the Colonial-era Battery.

Le coin de Waren [*sic*] et de Greenwich. Dessiné en janvier 1809. Pendant la neige

[The Corner of Warren and Greenwich. Drawn in January 1809. During Snow], 1809

BARONESS ANNE MARGUERITE HENRIETTE ROUILLE DE MARIGNY HYDE DE NEUVILLE (c. 1761?–1849)[1]
Watercolor, 13 ⅛ × 7 ¼
Inscribed at bottom: *Le Coin de Waren et de greenwich. Dessiné en Janvier 1809. Pendant la Neige.*
Bequest of Mrs. J. Insley Blair in memory of Mr. and Mrs. J. Insley Blair, 52.100.6

SLEIGH RIDING was a time-honored New York City custom, having been introduced by the Dutch in the seventeenth century as an efficient means of winter transportation for both people and goods. Snow-packed streets muffled the sound of approaching sleighs, to the extent that pedestrians would sometimes be run down and even killed by these silent conveyances. As late as 1908 the city was passing ordinances requiring that each sleigh be equipped with bells to alert the unwary.

In this small watercolor by the Baroness Hyde de Neuville, drawn and painted as one of a group of New York City scenes, the routine urban activities of a middle-class neighborhood are recorded on the day of a snowfall.[2] Several figures pick their way along the un-shoveled streets, while some remain indoors, observing the passing activity from windows. A woodcutter carries his equipment through the street, shoppers arrive and depart from the corner store at the far right, and children amuse themselves with a small sled. The view chronicles an era when simple, two-story wooden houses, such as those documented by Hyde de Neuville, combined the functions of family home and business. Later in the century, Greenwich Street, which starts at the Battery and continues north to the junction of Gansevoort and Little West 12th Streets, became a fashionable area as brick mansions replaced such earlier structures. Today, a large apartment house, a school, and assorted businesses occupy the corners at the intersection of Greenwich and Warren.

Baron Hyde de Neuville and his wife had been exiled from their native France for his outspoken loyalty to the Bourbon regime. Between 1807 and 1814 the Hyde de Neuvilles traveled the eastern United States from Wilmington, Delaware, to Niagara Falls, and the Baroness seized the opportunity to record what she saw along the way, using skills traditionally taught to an aristocratic young Frenchwoman.[3] The Baroness probably observed this commonplace but nonetheless charming New York scene from the Warren Street residence into which she and her husband moved soon after their arrival in the United States. Despite inaccuracies in perspective and scale, the straightforward account provides a glimpse of early nineteenth-century New York. Following the restoration of the French monarchy, the couple returned to France and came back to the United States in 1816, when the Baron was named French minister to Washington, D.C.

Le Coin de Waren et de greenwich. Dessiné en Janvier 1809. Pendant la neige.

Broadway and City Hall

1818

BARON AXEL KLINKÖWSTROM
(1775–1847)
Watercolor, 15 ½ × 22 ⅜
Inscribed in lower margin:
*Original watercolor drawing by
Baron Klinköwstrom / Broadway-
gatan och Radhuset, New York*
Bequest of Mrs. J. Insley Blair in
memory of Mr. and Mrs. J.
Insley Blair, 52.100.8

SWEDISH BARON Axel Klinköwstrom (alter-
natively spelled Klinckowström) visited New
York City in 1818 as part of a two-year trip to
study American steamboats for use in his
country. Although he found that some aspects
of the city compared poorly with his native
Stockholm—dirty streets and rough manners,
for example—he came to admire American
political ideals.

The Baron, an accomplished amateur
watercolorist, recorded views of the places he
visited. In 1824 he compiled these in an "atlas
publication" accompanied by a book of letters
originally written to his friend Admiral Count
Claes Cronstedt in Sweden. These two vol-
umes provided his fellow Swedes with abun-
dant information about New York City and the
rapidly expanding young nation it represented.

This view looks north along Broadway
from St. Paul's Chapel, a narrow segment of
which is visible on the extreme left. Vesey
Street is just beyond. On the northwest corner
of Vesey Street stands a house occupied in 1819
by a merchant named Elijah Secor. Just be-
yond, 221 Vesey Street housed, on the first
floor, another merchant firm, Ryerson and
Thompson; in the upper stories Daniel Fraser
probably operated a boarding house.[1] John
Jacob Astor owned the third house from the
corner. On the right, beyond the park named
for it, rises City Hall, the architectural master-
piece of Joseph F. Mangin and John McComb,
Jr., completed in 1812. Curiously, despite his
generally accurate descriptions of the area, the

Baron depicted a cross on the City Hall cupola
rather than the wooden figure of Justice, de-
signed by John Dixey and installed in 1813.[2]

Klinköwstrom concentrated on the pic-
turesque qualities of the City Hall neighbor-
hood, enlivening the scene with a diversity of
vehicles and portrayals of fashionable prome-
naders. He described his enthusiasm for the
area: "Of all the streets, the one called Broad-
way is the finest and the widest.... About one-
third of the way up from the Battery is a large
enclosed triangle planted with magnificent
trees. Here is the City Hall, built in a cheer-
ful, attractive style.... You will see the current
fashion in clothes and carriages from the use-
ful buggy to the modest wheelbarrow which a
licensed porter uses to carry a traveler's bag-
gage to the harbor. Broadway is the most pop-
ular promenade where all the new styles are
first seen and admired."[3]

Pigs, whose tendency to roam freely about
New York City's streets annoyed Baron Klin-
köwstrom, appear in the drawing later engraved
for the Baron's atlas. Even cleansed of this evi-
dence of local color, however, Klinköwstrom's
watercolor provides valuable physical infor-
mation about Federal-era New York. He has
documented, for example, the lampposts in
front of St. Paul's, used only until the 1827
introduction of gaslight. Sidewalks of "flatt
Stones" and stretches of unpaved roadway
also convey the city's small-town appearance
in that early period.[4]

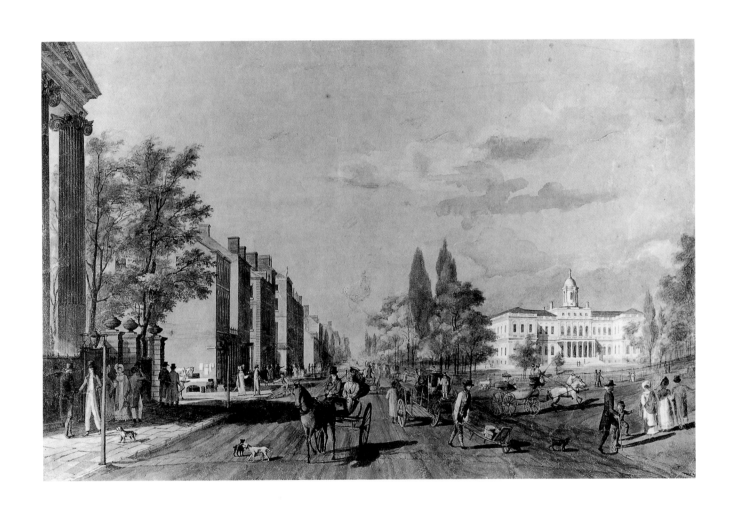

Winter Scene in Brooklyn

(also exhibited as *Brooklyn Snow Scene, Brooklyn Snow Piece,* and *Brooklyn in Winter*), 1853 (depicting 1817–1820)

Louisa Ann Coleman
(1833–1884)
Oil on canvas, 48 × 97
Signed lower left: *Louisa A. Coleman, Brooklyn / December 8, 1853*
Inscription: *To be Seen / A View / of / Brooklyn / by / guy / of / baltimore*
Anonymous gift, 53.2

Winter Scene in Brooklyn represents "the most important and compact portion of Brooklyn as it stood in 1820…. [It] will forever be invaluable as exhibiting the architectural character of the village at that period; and, in some degree for half a century previous."[1] In fact, the architectural character exhibited here reveals a place in transition from an eighteenth-century village with an eclectic, irregular arrangement of buildings—including a farm, substantial Federal-style homes, and mixed-use buildings providing both living and business space—to a more modern, more urbanized town. The wood and coal piles in the foreground denote the moment of transition from wood- to coal-burning stoves and document the need for coal for the newly established steam ferry between Manhattan and Brooklyn. Along the hillside at the far right can be seen the newer buildings of Brooklyn Heights, the emerging modern suburb that was developing because of the easier access to Manhattan provided by the ferry.

The scene depicts Front Street from Main Street (on the left) to Fulton (on the right), an area now partially covered by approaches to the Brooklyn Bridge and a section of the Brooklyn-Queens Expressway. A few blocks inland from the East River and the Fulton Ferry slip, this picturesque neighborhood occupied land that was once part of a farm belonging to a Loyalist family named Rapalje. It was next used as the British Quartermaster's Yard during the Revolution and then, after the intro-

duction of the Brooklyn-Manhattan ferry service in the second decade of the nineteenth century, became known as the ferry district of the village of Brooklyn. The poplar trees visible on the hill are in Brooklyn Heights.

Some of Brooklyn's finest dwellings stood on Front Street in the early nineteenth century. Physician, genealogist, and local historian Henry Stiles (1832–1909) developed a key for a similar version of this scene, in which he identified all the buildings as well as many of the figures, who were local citizens.[2] Stiles acquired this information from Thomas W. Birdsall, owner of the hardware store and two-story white frame house situated at the right. Visible at the center of the canvas are the barn and slaughterhouse of butcher Abiel Titus, seen feeding his chickens. Across the yard from the barn is the Titus residence. Behind the barn stands a blacksmith shop belonging to Edward Cooper. Across the street is the home and carpenter shop of Benjamin Meeker. To the right of Birdsall's store, which also served as the neighborhood post office, stands the shoe and bootmaker shop of Rydll and Seamer. Recognizable full-length portraits of Messrs. Sands, Graham, Birdsall, Hicks, Meeker, Patchen, and Judge Garrison were incorporated into the tableau by Francis Guy, artist of the original work from which this was copied. Tradition has it that while working near his window, he would call out to friends and passersby, asking them to stand still while he captured their characteristic postures.

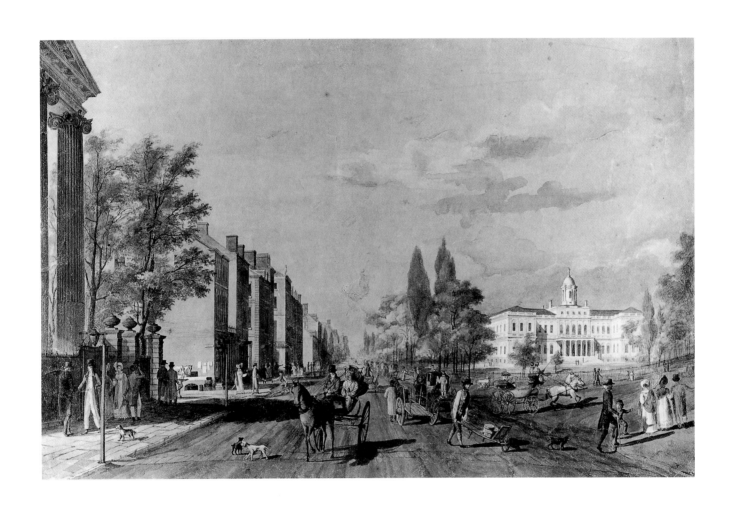

City Hall Park and Chambers Street from Broadway

(also exhibited as *City Hall Park from the Northwest Corner of Broadway and Chambers Street*), c. 1825

Arthur J. Stansbury
(1781–1845)
Watercolor, 12 ¼ × 17 ½
Signed lower left: *Arthur J. Stansbury delin*
Bequest of Mrs. J. Insley Blair in memory of Mr. and Mrs. J. Insley Blair, 52.100.16

In this watercolor of City Hall Park, Arthur Stansbury has emphasized the civic centrality of the site by giving greater prominence to City Hall than does Baron Axel Klinköwstrom's earlier work (see plate 3). On October 24, 1825, the Common Council's Committee on Lands and Places was directed to plant trees and lay out walks and spaces in the grounds at the rear of City Hall, perhaps inspiring Stansbury to paint the building from that viewpoint. The back wall of the building was built of brownstone at the behest of the Common Council in an attempt to cut costs and in the belief that New York City would never grow north of City Hall, so the brownstone would not be seen very frequently.

The American Museum, in the west wing of the Old Almshouse, was first established as the Tammany Museum in 1790 by the Tammany Society. After the Common Council took over the entire building for public offices and courts in 1830, the museum moved to its new building at Broadway and Ann Street.[1] At the other end of the Almshouse can be seen the dome of the rotunda built by John Vanderlyn (1775–1852) in 1818 to exhibit his panorama *The Palace and Gardens of Versailles.*[2] Between City Hall and the Almshouse is the New Gaol. It was built in 1755, converted to a "hall of records" in 1829, and torn down in 1903.[3]

Whereas Baron Klinköwstrom delighted in the elegant people he depicted in his painting, Stansbury populated his scene with a more democratic array of figures. In addition to a child with a hoop and a couple of strolling figures, there are a vendor, a man with a wheelbarrow, another with a pick and shovel, and several carrying loads on their heads and shoulders.

Although Arthur Stansbury's career has not been thoroughly documented, there are nine ink-and-wash silhouette portraits by him at the Maryland Historical Society, and he is known to have been skilled "at cutting silhouettes with scissors, out of black paper."[4] His finely detailed watercolors illustrated the first American botanical book, *The Grammar of Botany,* published in New York in 1822 by J. F. Seaman.[5] An author and illustrator of children's books, Stansbury also executed a print titled *Plan of the Floor of the House of Representatives Showing the Seat of Each Member* and drew a series of New York views printed in 1828 by Rawdon, Clark and Company.

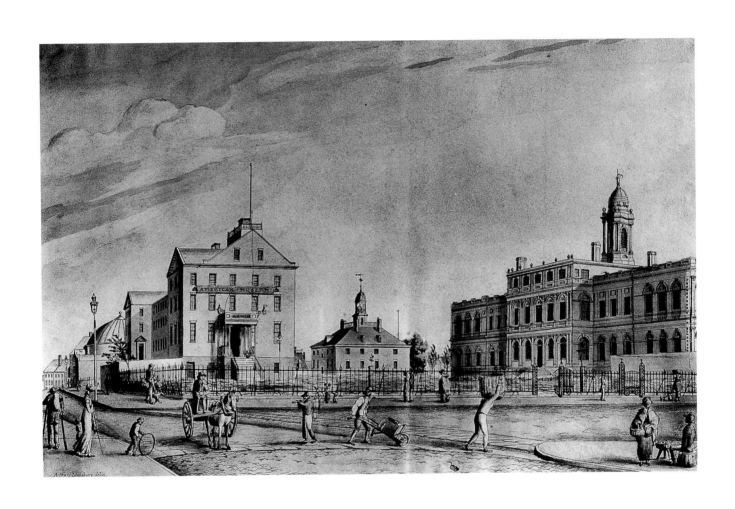

Arthur J Stansbury delin.

79

Winter Scene in Brooklyn

(also exhibited as *Brooklyn Snow Scene*, *Brooklyn Snow Piece*, and *Brooklyn in Winter*), 1853 (depicting 1817–1820)

LOUISA ANN COLEMAN (1833–1884)
Oil on canvas, 48 × 97
Signed lower left: *Louisa A. Coleman, Brooklyn / December 8, 1853*
Inscription: *To be Seen / A View / of / Brooklyn / by / guy / of / Baltimore*
Anonymous gift, 53.2

WINTER Scene in Brooklyn represents "the most important and compact portion of Brooklyn as it stood in 1820 [It] will forever be invaluable as exhibiting the architectural character of the village at that period; and, in some degree for half a century previous."[1] In fact, the architectural character exhibited here reveals a place in transition from an eighteenth-century village with an eclectic, irregular arrangement of buildings—including a farm, substantial Federal-style homes, and mixed-use buildings providing both living and business space—to a more modern, more urbanized town. The wood and coal piles in the foreground denote the moment of transition from wood- to coal-burning stoves and document the need for coal for the newly established steam ferry between Manhattan and Brooklyn. Along the hillside at the far right can be seen the newer buildings of Brooklyn Heights, the emerging modern suburb that was developing because of the easier access to Manhattan provided by the ferry.

The scene depicts Front Street from Main Street (on the left) to Fulton (on the right), an area now partially covered by approaches to the Brooklyn Bridge and a section of the Brooklyn-Queens Expressway. A few blocks inland from the East River and the Fulton Ferry slip, this picturesque neighborhood occupied land that was once part of a farm belonging to a Loyalist family named Rapalje. It was next used as the British Quartermaster's Yard during the Revolution and then, after the intro-

duction of the Brooklyn-Manhattan ferry service in the second decade of the nineteenth century, became known as the ferry district of the village of Brooklyn. The poplar trees visible on the hill are in Brooklyn Heights.

Some of Brooklyn's finest dwellings stood on Front Street in the early nineteenth century. Physician, genealogist, and local historian Henry Stiles (1832–1909) developed a key for a similar version of this scene, in which he identified all the buildings as well as many of the figures, who were local citizens.[2] Stiles acquired this information from Thomas W. Birdsall, owner of the hardware store and two-story white frame house situated at the right. Visible at the center of the canvas are the barn and slaughterhouse of butcher Abiel Titus, seen feeding his chickens. Across the yard from the barn is the Titus residence. Behind the barn stands a blacksmith shop belonging to Edward Cooper. Across the street is the home and carpenter shop of Benjamin Meeker. To the right of Birdsall's store, which also served as the neighborhood post office, stands the shoe and bootmaker shop of Rydll and Seamer. Recognizable full-length portraits of Messrs. Sands, Graham, Birdsall, Hicks, Meeker, Patchen, and Judge Garrison were incorporated into the tableau by Francis Guy, artist of the original work from which this was copied. Tradition has it that while working near his window, he would call out to friends and passersby, asking them to stand still while he captured their characteristic postures.

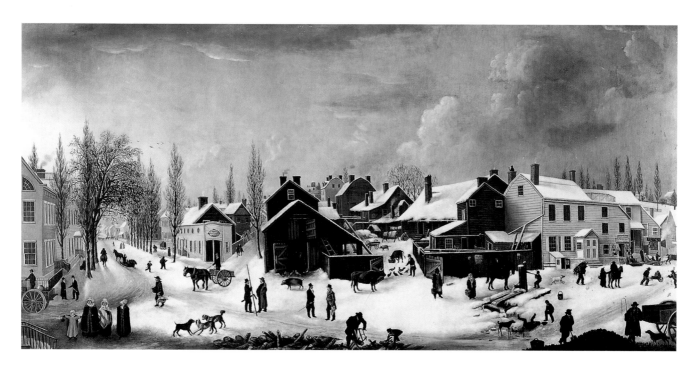

In the 1820s the population of Kings County, of which Brooklyn was a part, numbered more than 11,000, including approximately 1,700 black residents. At that date there were probably few, if any, slaves in Brooklyn, as Unitarianism, the dominant religion in the community, proscribed slavery.

The many occupations depicted in the painting emphasize that this Brooklyn neighborhood is a thriving community. Its diverse inhabitants pursue a variety of everyday activities: gathering wood, drawing water from the town pump, making deliveries, and pausing to gossip. Pedestrians share the streets with drays, sleighs, wheelbarrows, horses, dogs, and farm animals. The man crossing the street on the left appears to be carrying freshly butchered meat, while the man to the right of the pack of dogs holds surveyor's tools, perhaps a reference to the laying out of streets and roads in the newly expanding community. In 1861 the poet Walt Whitman commented

that the scene was "altogether a picture quite curious to stand on the same spot and think of now."[3]

Francis Guy made several versions of this scene, some featuring the same location in summer and at least one without any people. This painting is a copy, probably of the Guy rendering at the Brooklyn Museum, by Louisa Ann Coleman, granddaughter of Augustus Graham, a founder of the Apprentices' Library, which was a forerunner of the Brooklyn Museum.[4] In this painting Graham stands with his back toward his residence at left, in conversation with Joshua Sands. Coleman married Joseph Byron Hayes in 1861 and moved to Canandaigua, New York.[5] Several of her very competent paintings, possibly also copies of others' work, are in the possession of her descendants.

The Erie Canal Celebration, New York, 1825

1825–1826

Anthony Imbert (1794–1834)

Oil on canvas, 24 × 45

Anonymous gift, 49.415.1

An event that had a profound influence on the economic development of nineteenth-century New York City was the opening of the Erie Canal in 1825. This four-hundred-mile waterway, nicknamed "Clinton's ditch" because it was authorized and completed during the tenure of Dewitt Clinton (1769–1828) as governor of the state, connected the Atlantic Ocean to the Great Lakes via New York Bay.[1] Hailed as a marvel of modern engineering, it facilitated the transportation of goods to new consumer markets in the Midwest and the retrieval of valuable raw materials from areas that had hitherto been difficult to access.

A triumphant celebration was held in New York City to commemorate the canal's official completion on November 4, 1825. An influx of nearly twenty thousand visitors gathered on the city's shoreline to watch an impressive aquatic display that featured a flotilla of watercraft parading through New York Harbor to greet the *Seneca Chief,* the first canal boat to travel the full span of the newly opened canal.

The Erie Canal Celebration, New York, 1825, is the earliest of three known oils by Imbert, a French émigré best known as one of America's pioneering lithographers. As a historical document, it is valuable in providing a visual record of an event that heralded New York City's ascendance as a center of national trade and finance. The artist chose to illustrate the conclusion of the day's festivities, when a fleet of American ships sailed in salute around the British ships of war *Swallow* (shown in the foreground) and *Kingfisher* (the sister vessel visible in the middle distance).[2] The location of the salute is documented by Imbert's inclusion of Fort Clinton and Governors Island on the horizon to the left. The artist took pains to indicate the densely built landmass of lower Manhattan, with the spire of Trinity Church the tallest in the skyline. The tonal values, spatial arrangement, and looming sky of the picture suggest the influence of Dutch marine painting. The gay colors of the ships' flags, together with the stylized quality and formality of the vessels and tiny figures arrayed throughout the canvas, lend the scene an almost Chinese character, recalling the paintings of Western clipper ships at Whampoa.

Imbert's study of drawing and painting had commenced as a pastime while he was a political prisoner in a British jail. Just how the newly transplanted former French naval officer secured a commission to supply thirty-seven graphic images of the canal festivities for the illustrated appendix to *Colden's Memoir,* the major historical publication commemorating them, is a matter of speculation.[3] Possibly this painting was done to provide the committee with tangible proof of his professional qualifications as a marine artist.

Of the thirty-seven illustrations that Imbert contributed to *Colden's Memoir,* the chef d'oeuvre of the series is considered to be his two-sheet panoramic print entitled *Grand Canal Celebration: View of the Fleet Preparing*

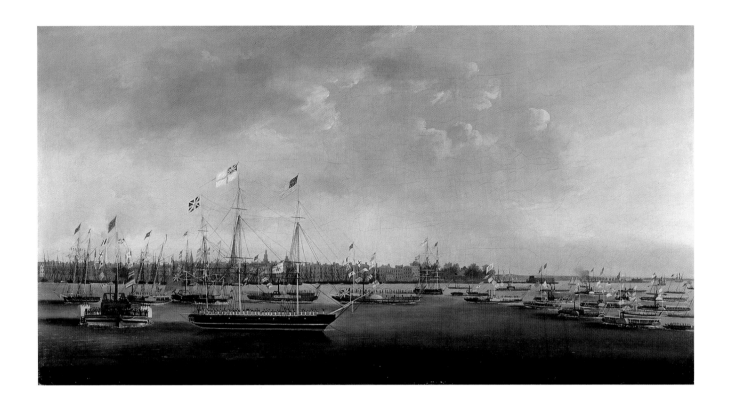

to Form in Line. This print, a version of which exists in the Print Collection of the Museum of the City of New York, has been viewed by scholars as a technical milestone in the pioneering art of American lithography.

After his acclaimed debut as the portrayer of the canal celebration for *Colden's Memoir,* Imbert embarked on an active career as a lithographic artist and publisher. Among the better-known works he issued was a series of New York City views derived from original designs by Alexander Jackson Davis (1803–1892). His productivity as a painter seems to have all but ceased after 1827, when he was listed in local directories exclusively as a lithographer.[4]

The Junction of Broadway and the Bowery at Union Square in 1828

1885 (depicting 1828)

ALBERTIS DEL ORIENT BROWERE
(1814–1887)
Oil on canvas, 23 × 40
Signed lower right: *A. D. O. Browere 1885*
The J. Clarence Davies Collection, 29.100.1323

THIS SCENE, painted from memory, records the sparsely settled intersection of Broadway and the Bowery at Union Square (called Union Place until 1832) as it appeared in 1828. The building boom that would bring fine residences, elegant hotels, exclusive boarding schools, and, subsequently, theaters and commercial enterprises to the square lay twenty years in the future. At this date the area was considered merely a northern outpost of New York City, which was still clustered south of 14th Street.

Union Place, first called the Forks to describe the junction of the Bowery, Broadway, and University Place at 14th Street,[1] originated as a burial ground for indigent people.[2] As the city continued to grow, the cemetery was transformed into a park, making Union Square a desirable location for the elegant homes of those wealthy New Yorkers who constituted the vanguard of the northward migration.

A map in the collection of the New-York Historical Society, dating from 1750 but otherwise unidentified, shows the depicted area bordered by farms, including those belonging to the prominent Stuyvesant and Brevoort families, Henry Spingler, Thomas Burling, and Cornelius Tiebout. (Despite its then-remote location, Union Place was the city's chosen site for welcoming General Washington on November 25, 1783, one day after British troops evacuated New York.) In 1822 the Manhattan Bank constructed the four-story white building at the left to use as its temporary business headquarters during the yellow-fever epidemics that raged in the city almost annually from 1791 until the late 1820s. The city itself is visible in the distance to the south.

Albertis (some references spell the name "Albertus") D. O. Browere was born in Tarrytown, New York, a son of sculptor John Henri Isaac Browere, who executed a well-known series of life masks of distinguished figures of the period, including Thomas Jefferson and the Marquis de Lafayette. The younger Browere studied at the National Academy of Design, where he exhibited his first painting at the age of seventeen. The American Art-Union also exhibited his work. His subjects included illustrations from Washington Irving's stories, historical and genre subjects, and landscapes featuring the scenery around Catskill, New York, where he resettled about 1841. Browere supported himself primarily with sign and wagon painting; family tradition states that every shop sign in nineteenth-century Catskill bore his initials. In 1852, and again in 1858, Browere went to California to paint and to prospect, unsuccessfully, for gold, but he returned to live out his years in Catskill. He is also represented in the collections of the Museum of the City of New York by a painting from 1842 entitled *Fire at the Tombs* (see plate 13).

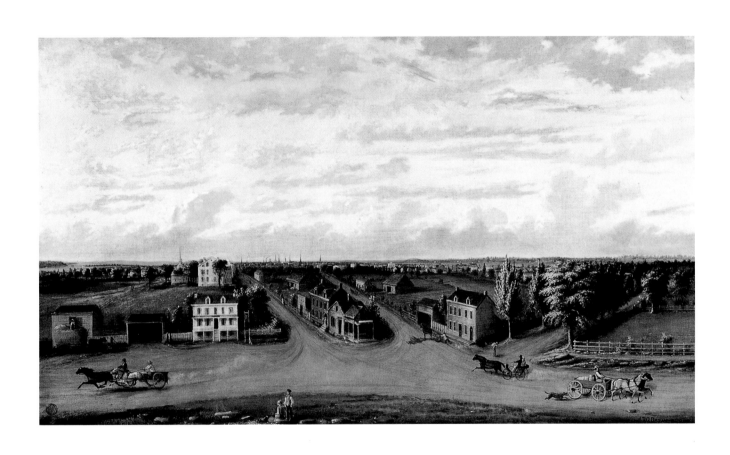

American Theatre, Bowery, New York, November 25th, 1833, 57th Night of T. D. (Jim Crow) Rice

n.d. (depicting 1833)

Artist unknown
Oil on canvas, 27 ⅓ × 36 ⅓
Gift of Mr. Carl F. Grieshaber,
32.483

THIS UNATTRIBUTED painting, presumed to date from the early twentieth century, is part of a larger holding of oils and watercolors in the Theater Collection of the Museum of the City of New York depicting New York City playhouse interiors and urban-themed set designs. The scene derives from a lithograph—almost a century old when the painting was donated in 1932—recording the extravaganza of Thomas Dartmouth Rice's fifty-seventh performance "jumping" and singing the role of Jim Crow to an overflow crowd at New York's American Theatre. The performance memorialized here probably took place on January 8, 1833, rather than the November date indicated as part of its title.[1]

The origins of this blackface song-and-dance routine ("Turn a-bout and wheel a-bout, an' do jis so / An ebery time I turn about I jump … Jim Crow!") are legendary, if imperfectly documented.[2] Thomas Dartmouth Rice (1808–1860), born in New York, had been an itinerant performer of unexceptional reputation until 1828, when (according to the most recurrently cited sources) he stumbled upon the caricature concept for Jim Crow by observing the antics of an elderly and deformed African American stable hand in Kentucky. Rice appropriated the man's tunes, odd gait, costume, and mannerisms for a theatrical act. The novelty of that sketch not only regaled audiences but also catapulted Rice into a headliner, whose "Jim Crow" bookings quickly propelled him east from Louisville to engage-ments in Philadelphia, Washington, and Balti-more, and eventually landed him at the Amer-ican Theatre in New York City on November 12, 1832.[3]

Braced by shrewd advance promotion, his billing there drew capacity crowds and box-office receipts that immediately legit-imized Rice as the country's leading "Ethiopian delineator," the term preceding "minstrel per-former." Rice's perennial Jim Crow tours through the United States and Great Britain brought the performer wealth, celebrity, and new opportunities for years thereafter.[4] The act's popularity also matured Jim Crow into a perdurable racist stereotype, the term itself becoming wedged into the language as a ref-erence to segregation codes endemic to the postbellum American South.

In the stratified world of New York City theaters, with their implicit class associations, the American Theatre, at the corner of Canal Street and the Bowery, was considered a mid-dlebrow house. Designed by Ithiel Town with the innovative use of gas jets for interior light-ing, it had opened in 1826 and, by the date of Rice's engagement, had been twice remodeled after fires. Three thousand patrons could be accommodated within its large central pit and four tiers of galleries, which reached across the house and down each side almost to the stage. In the Jacksonian era, urban theaters like the American Theatre had assumed new impor-tance as democratic gathering spaces, in which ticket holders could not only relax but also

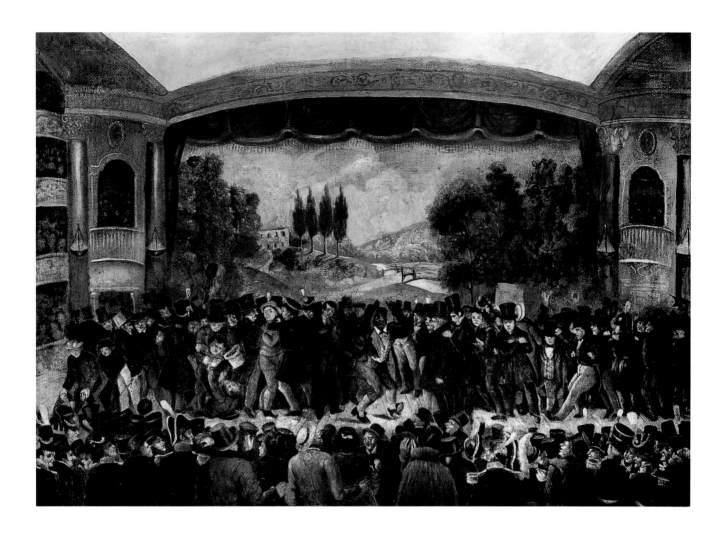

vent political opinions publicly and intermingle with allies and enemies seated, depending on allegiances, in the more boisterous pit or costlier boxes. Ungovernable audiences often interrupted performances, with hilarious results in the case of Rice's curtain call.

This painting and its parent lithograph probably depict the final moment of a benefit performance featuring the incongruous pairing of Jim Crow with Shakespeare early in the 1833 season, when the American Theatre's management had booked the tragedian Junius Brutus Booth in a repertoire that included the battle scene from *Richard III*. Near anarchy erupted when hundreds of playgoers, joined by cast members dressed as soldiers for the fifth act's battle scene, scrambled forward to encircle Rice during his interact skit, tampering with the scenery and evidently breaking into fisticuffs.[5] The image creates a powerful, paradoxical association between the burnt-cork-faced impersonator of a jocular black man and white male aggression as personified by the urban ruffians and gentry who have surged onto the theater stage.

**Nightfall, St. Thomas Church,
Broadway, New York**

c. 1837

GEORGE HARVEY (1801–1878)
Watercolor on paper, 8 ⁵⁄₁₆ × 13 ⁵⁄₈
Bequest of Mrs. J. Insley Blair
in memory of Mr. and Mrs.
J. Insley Blair, 52.100.11

PAINTER, architect, and writer George Harvey, who at age twenty-eight immigrated to the United States from England, traveled for two years in the American West before settling in Boston to work as a miniaturist. In 1834 he moved from there to Hastings-on-Hudson, New York, where his architectural activities included designing his own "picturesque"-style cottage and planning the renovation of Washington Irving's Sunnyside from a simple cottage to an outstanding example of domestic Gothic Revival. From the mid-1840s until his death, Harvey was to move back and forth between England and the United States, returning for a time to Boston, where he resumed miniature painting.

When he lived in Hastings-on-Hudson, Harvey's fascination with the differences in light and atmosphere between his native and adopted countries led him to undertake a series of forty atmospheric watercolors of American scenery. For this project, he attempted to capture these distinctions artistically by depicting particular seasons of the year or, in the case of this twilight scene on Broadway, specific times of the day.

On Sunday, October 12, 1823, a new Protestant Episcopal congregation was organized in a meeting room at 44 Broome Street. In December of that year, ten New Yorkers—including William Backhouse Astor, known as "New York's landlord"; Charles King, a future president of Columbia University and a son of Rufus King; and William Beach-Lawrence, an

internationally known jurist—met to discuss plans to build a church above Canal Street in what was then considered the country. In July 1824 the cornerstone for the new building was laid at the intersection of Broadway and Houston Street. Construction moved quickly, and the new St. Thomas Church was consecrated in February 1826. In 1844 the building was remodeled, probably to accommodate a congregation that had grown rapidly as Manhattan's population spread northward. On March 2, 1851, the church burned, but a new sanctuary rose on the site just over a year later.

Josiah R. Brady (c. 1760–1832) was the architect of the first St. Thomas Church, described upon its completion as "the best specimen of Gothic in the city."[1] Interestingly, Alexander Jackson Davis (1803–1892), later a major proponent of the Gothic Revival in both public and vernacular architecture, had worked in Brady's office for a year during the period of St. Thomas' construction. An engraving of the church after a watercolor painting by Davis appeared in the *New York Mirror* on June 20, 1839.[2]

John B. Ryer's saddler's shop, seen in Harvey's painting on the corner opposite the church, was first recorded in New York City directories in 1837, listed at 612 Broadway. Ryer seems to have prospered in this undertaking, for he opened a second shop, and both businesses remained active at least until the 1860s.

In July 1831 William Niblo, proprietor of Niblo's Garden, located one block south of

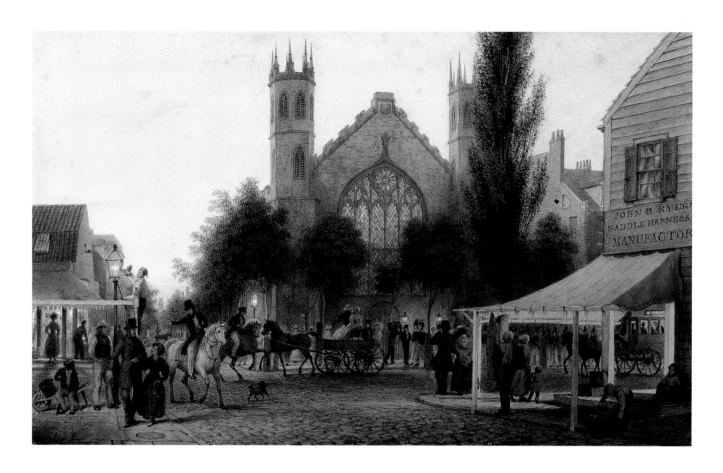

this site at Broadway and Prince Street, announced the inauguration of an omnibus, the *Lady Clinton,* scheduled to run every evening from seven o'clock until ten o'clock between his popular entertainment emporium and the City Hotel on Broadway. The press described the vehicle as "by far the handsomest and most commodious Broadway coach yet produced."[3] Filled with passengers, it is visible just beyond the porch of Ryer's establishment.

Adding to the scene's veracity are numerous acutely observed vignettes, which convey the district's overall liveliness: the workers at the saddler's shop are preparing to close for the day; the lamplighter proceeds with his task

of making the darkening streets safer for area residents; the wheelbarrow pusher rests for a moment, observing the activity around him; vehicles, horseback riders, and evening strollers crowd the street. By 1866, this once cosmopolitan quarter of the city had degenerated into an anchorage for cheap dance halls and "concert saloons," causing St. Thomas' worshippers to abandon their original site for a more reputable location uptown at Fifth Avenue and 53rd Street, where the present St. Thomas still stands.[4]

**View of New York, Brooklyn, and
the Navy Yard, from the Heights
Near Williamsburg**

c. 1835–1840

Nicolino V. Calyo (1799–1884)
Gouache on paper, 28 × 36
Signed on barrel at right: *N C*
Gift of Mrs. Arthur Douglas
Farquhar, 87.41

This vantage point, popular with artists in New York during the first half of the nineteenth century, encompasses landscape elements, water, and the drama of one of North America's busiest working harbors. In this scene, the Brooklyn Navy Yard and the distant city fringed with ships' masts attest to the growing vibrancy and importance of the Port of New York after the War of 1812 and the subsequent opening of the Erie Canal. The artist's main focus, however, is the activity taking place at the pier in the lower-right foreground, where a schooner is being prepared for launching. Two men aboard the ship raise the anchor, while another unfurls one of the sails in preparation for raising it.

Nicolino Calyo, employing a meticulously rendered topographical style learned at the Academy in his native Naples, frequently painted richly colored scenes of New York City seen across water. Often, these were based on drawings made on the spot. A series of Calyo's New York City views are from the vantage point of Williamsburg, whereas others are from New Jersey, but all share the format of a foreground genre scene with figures engaged in various activities against a cityscape background. While the ship-laden shorelines of Brooklyn and Manhattan emphasize New York's active port, the intimate quality of the foreground figures—a hunter with his dogs on the left and the three men launching the boat on the right—convey the still-bucolic nature of Williamsburg. Like many Neapolitan *vedute* (view painters), Calyo's preferred medium was gouache, an opaque watercolor heavily applied to paper in the manner of oil paint.[1]

The painting was originally owned by Admiral James E. Jouett, who entered the navy in 1841, graduated from the United States Naval Academy in 1847, and took part in both the Mexican War and the revolt in Panama. Jouett gave the work to his neighbor in Sandy Hook, Maryland, Miss Ellen Farquhar, from whom it descended to the donor.

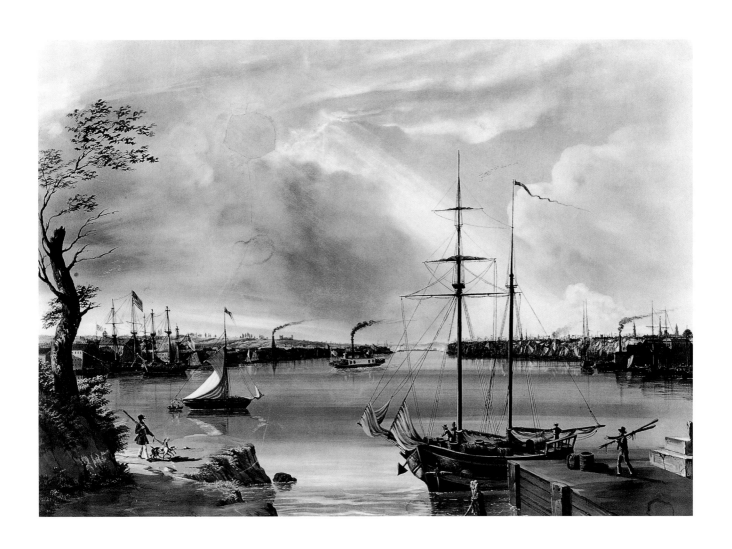

Burning of the Merchants' Exchange, New York, December 16th & 17th, 1835

1835

Nicolino V. Calyo (1799–1884)
Gouache on paper, 20 × 30
Signed lower left: *Painted on the spot by / Nicolino Calyo*
Bequest of Mrs. J. Insley Blair in memory of Mr. and Mrs. J. Insley Blair, 52.100.7

The Great Fire of 1835 broke out on the night of December 16 and, raging for more than fifteen hours, destroyed virtually the entire downtown business district, including the Merchants' Exchange, the Post Office, and more than half the city's insurance companies. This and earlier catastrophic fires caused so much destruction in New York that by mid-century none of the city's earliest Dutch buildings remained standing. Surpassing the earlier disasters, the Great Fire of 1835 not only lasted longer but also caused unprecedented physical damage and resulted in sweeping reform of the city's fire-fighting methods, building codes, and fire insurance practices.

The fire started about nine o'clock on a wintry evening in a store filled with dry goods and hardware. The bitter December cold froze the water in the fire hoses and in all nearby cisterns and wells. The resulting water shortage, combined with a fierce northerly wind that whipped the flames from building to building and block to block, hampered the heroic efforts to combat the disaster. By the time it was finally brought under control, the fire had demolished 674 buildings in the city's commercial heart, an area that extended from the East River nearly to Broad Street and from Coenties Slip to Wall Street.

In a night of enormous losses, the destruction of the Merchants' Exchange, symbol of the energetic growth of New York's business community, seemed particularly crushing. "The splendid edifice," wrote diarist and New York mayor Philip Hone, "… one of the ornaments of the city … is now a heap of ruins…. When the dome of this edifice fell in, the sight was awfully grand. In its fall it demolished the statue of Hamilton executed by Ball Hughes, which was erected in the rotunda only eight months ago by the public spirit of the merchants."[1]

New York's insurance industry staggered under these losses. A short time later, banks suspended payment, resulting in many bankruptcies. The general inability of the volunteer fire-fighting units to contain the blaze led the Board of Assistant Aldermen to adopt a statement declaring "the absolute necessity of establishing a more perfect and proper organization of the Fire Department, and … the necessity and propriety of being better prepared to resist the ravages of fire." Along with the reorganization of the fire department to minimize time-wasting competition among the volunteer companies, the Assistant Aldermen rewrote the building codes to allow fire wagons easier access through the streets and to impose more fire-resistant construction methods. The preeminent need for an improved water supply served to expedite development of the Croton Water System (see plate 20). This major engineering feat solved more than one problem in an era when fire, dirt, and disease were endemic to urban living.

Nicolino Calyo, a Neapolitan painter who arrived in New York shortly before the Great Fire, probably found the drama of this

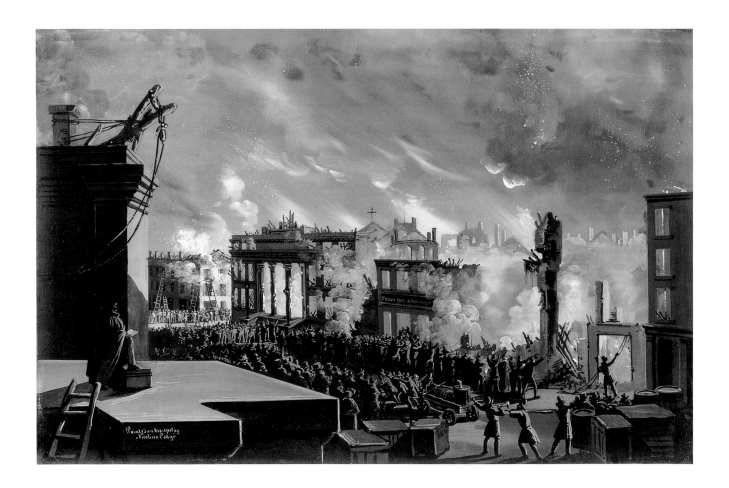

disaster reminiscent of the fiery eruptions of Vesuvius that had traumatized generations in his native country. In the lower-left corner of this colorful view the artist depicted himself, muffled against the cold, at an easel situated on a rooftop affording him a perch from which to study the panoramic conflagration. The resulting image was one of a series of highly dramatic Great Fire views by Calyo, several of which provided the basis for William J. Bennett's aquatints published soon afterward.

Calyo was one of a number of émigré painters to nineteenth-century New York whose concern for local color and genre scenes helped to generate a new interest among America's art audience in paintings of everyday subjects. A pristine set of Calyo's *New York Street Cries, Chanters and Views* (a series of thirty-six watercolor portrayals of New York street vendors) resides in the Museum's collection, as do some of his richly colored panoramic gouache views of New York from various harbor and riverside vantage points.

Hanover Square

c. 1835

Attributed to J. Ackerman
(possibly James Ackerman
[b. 1813; active 1848])
Oil on wood panel, 59 ⅕ × 73 ⅕
The J. Clarence Davies
Collection, 29.100.1334

Angry flames, courageous volunteers, marvelous machinery, and theatrically smoldering ruins dominate the popular imagery of nineteenth-century urban fires. This scene takes a more unusual approach by dramatizing the economic catastrophe suffered by citizens as a consequence of the Great Fire of December 16, 1835, which devastated the heart of Lower Manhattan's business district and caused more than 15 million dollars' worth of property damage. The setting is Hanover Square, ground zero for the blaze. The artist, detouring predictable formulas for pictorializing disasters, focuses on the pragmatic pluck shown by New York merchants and their employees who gathered at their former workplaces the morning after the fire to assess their losses and confirm the survival of metal company safes containing ledgers, valuables, and, for the truly fortunate firms, fire insurance contracts.

A boy atop a safe, hat held high, appears to offer a jubilant signal of discovery to his companions, probably fellow messengers in companies located in the area. On the charred grounds of their former shops and counting houses, gentlemen owners and agents are seen examining the contents of strongboxes and conducting solemn conversations, presumably already planning for the restoration of their businesses. The vignette confirms contemporary press reports of the remarkable resiliency shown by New Yorkers in the face of this calamity: "Our merchants and others who have suffered are in good spirits and fully

determined to promptly redeem their loss," reassured the pamphleteer of the quickly issued *Account of the Conflagration of the Principal Part of the First Ward of the City of New York.* "All despondency if it ever existed, is at an end. Smiling faces and cheerful countenances meet us at every corner, and demonstrate that there is an elasticity in the character of our people which always enables them to rise above the most overwhelming evils."[1]

This estimate of the city's mettle may seem immoderate, but within two years of the Great Fire, the burned district had been largely reconstructed, investors having evidently seen virtue in the destruction of the older commercial buildings and profit in the opportunities to modernize in the fire's aftermath. A number of affected businesses had even expanded, despite the setbacks of property and inventory losses and the financial "panic" that was rocking the city and nation in 1837.

This large panel painting, acquired by J. Clarence Davies, arrived at the Museum of the City of New York with crudely mended splits and heavy dirt discoloration, suggesting its previous exposure to weather stresses. Repeated efforts to disguise damaged areas through retouching and overpainting were also evident. Its physical condition may be at least part of the reason for the work's attribution to New York lithographer James Ackerman, which dates to its cataloguing in 1929 as part of the extensive gift of urban-scene paint-

ings that Davies presented to the Museum that year. Signed prints and book illustrations by Ackerman confirm his activity as a lithographer during the second quarter of the nineteenth century. Periodically, examples of his hand-colored lithographs were exhibited at local venues, such as the American Institute. Between 1838 and 1865, however, he was also in partnership with Edward A. Miller, operat-

ing a sign- and banner-painting business that also produced block letters.[2] The speculation arises whether *Hanover Square* might have been a signboard painted as a demonstration of Ackerman and Miller's skills as topical illustrators, or as a promotion for a vendor of safe-deposit boxes.

Fire at the Tombs

n.d. (depicting 1842)

Attributed to Albertis Del
Orient Browere (1814–1887)
Oil on canvas, 30 × 25
The J. Clarence Davies
Collection, 29.100.1308

THE CITY prison officially known as the Halls of Justice drew respectful reactions from contemporary observers as it rose on the site of the former Collect Pond, bounded by Leonard, Franklin, Lafayette, and Centre Streets. "It promises to be one of the handsomest of our public buildings," opined the *Evening Post* in 1837. "It is in the Egyptian style, a style well suited by its massiveness, severity and appearance of prodigious strength to edifices of this kind. We have no other examples in this city."[1]

Designed by architect John Haviland, a specialist in penitentiary commissions, the fortress-like building, constructed in granite, stood ready to house New York's criminal population by August 1838 with a newly acquired name: the Tombs. This dramatic painting documents an incident associated with the incarceration of a well-to-do professional man, John C. Colt, brother of Samuel Colt, inventor of the revolver.

Colt, convicted of the gruesome hatchet murder of a local printer in 1841, was sentenced to die on November 18, 1842.[2] He prepared for the event by marrying his paramour in jail the day before his scheduled hanging, then he stabbed himself through the heart just hours before the execution was set to occur. In the confusion surrounding the suicide and its discovery, a lamp or candle evidently triggered a fire that traveled to the building's cupola, burning it down and destroying portions of the roof in the process. A fire-alarm bell had been ordered for installation in the tower structure the preceding April, but reports vary

as to whether it was in place or operating when the conflagration erupted.

The scene shows flames consuming the tower above the Centre Street entrance to the Tombs. The prison's distinctive portico of four massive columns, with palm-leafed capitals, lofty two-story windows, and other decorative details are portrayed accurately.[3] The picture emphasizes, however, the valiant, well-orchestrated labors of Southwark Engine Company 38, a volunteer troop organized under this banner in 1840, then stationed at Nassau Street near Cedar Street. Featured at center is the company's handsome, newly purchased extension-lever hand-engine, made in Philadelphia, which could throw water a horizontal distance of 180 feet. Activating the apparatus required forty-eight firemen—two rows standing on the ground, two positioned on fold-out platforms descending from the truck called "pumping brakes"—whose combined force compelled water out of a central tank through an attached goose-neck hose. The reach of the stream privileged Southwark Company as the local engine unit best equipped to extinguish flames on high, the predicament posed by the Tombs fire.

Other characteristics of fire brigades in this volunteer era of urban fire fighting are recognizable: the foreman's use of a brass fire trumpet, which often doubled as a megaphone; the fitted jackets and leather helmets with long back brims worn by company members, acquired at their own expense; and the spit-and-polish condition of the engine, with its burnished fittings—an object of unique deco-

ration, lavish maintenance, and great company pride.[4] The engine, drawn to the fire's location by four horses owned by the Adams Express Company, was subsequently pulled by hand into proximity with the blaze to be extinguished.[5] Apparently, this situation's urgency has allowed several newcomers, lacking signature uniforms, to infiltrate the pump teams or has caused several company recruits to respond, hatless, in their haste. In the distance, other concerned citizens dash toward the scene of the disaster.

Based on other signed fire views that are close in style, Albertis D. O. Browere seems a likely candidate as painter. The engine of Southwark Company 38 appears in another canvas by Browere documenting a fire on Broadway in 1842, one of more than 2,500 fires that plagued New York City between 1837 and 1848.[6] As with other of his "retrospective" urban views (see plate 7), Browere probably improvised the scene some years after the 1842 event.

Auction in Chatham Square

1843 (depicting 1820)

E. Didier (active 1843)
Oil on canvas, 28½ × 35½
Anonymous gift, 51.222.1

Painted twenty-three years after the last auctions in Chatham Square, this canvas depicts accurately the setting of the open-air sales. The square, formed by the jagged confluence of Chatham Street (laid out in 1759 and renamed Park Row in 1886), East Broadway, the Bowery, and James, Division, Mott, and Worth Streets, was probably "assigned [by the Common Council] as a Horse Market" as early as the mid-eighteenth century.[1] Later, household goods and lumber were also auctioned there, and in 1805 the council, the city's legislative body established in 1675, permitted the sheriff and other officers to run auctions there and in several other locations.[2]

In 1810, as Chatham Square became more built up, the Common Council issued rules restricting the cantering and galloping of horses being exhibited for sale "within the limits of the Curb-Stone around said Square." The following year, a fence was ordered to enclose the square, and horse and carriage auctions were reassigned to the ground near the arsenal at Anthony Street.[3]

The kinds of cheap household goods displayed in this view—the apparently new crockery, baskets, and furniture among them—predominated at these *vendues* (as auctions of both new and used items were then called), but this did not prevent successful auctioneers from amassing fortunes. Philip Hone, New York's mayor from 1826 to 1827, retired from business life as a wealthy man in 1817, only twenty years after launching an auction business with his elder brother, John.[4] Yet the city's "merchants & Storekeepers … formed Societies for preventing Sales by Auction," and by March 1820 all Chatham Square auction permits were revoked.[5]

Following the ban on the spirited open-air auctions, Chatham Square gradually deteriorated. *King's Handbook of New York* in 1893 described the district as "a veritable 'Chinatown,' with all the filth, immorality and picturesque foreignness which that name implies."[6]

E. Didier, the artist of this work, exhibited watercolors and paintings, including this one, at the Academy of Design during the mid-1840s. This painting may be the work of the Eugene Didier listed in the 1843 city directory as an importer and commission merchant at 73 William Street, a short distance from Chatham Square, and with a home on Greenwich Street.[7] W. N. Seymour and H. Kipp and Company, the furniture businesses depicted on the far side of Chatham Square, are also listed in directories of the period. These details, along with the woman urgently tugging at the auctioneer's coattails and the red flag, an emblem hung out to attract potential buyers to an auction,[8] are realistic elements at variance with the caricatured faces of the auctioneer and various individuals in the crowd.

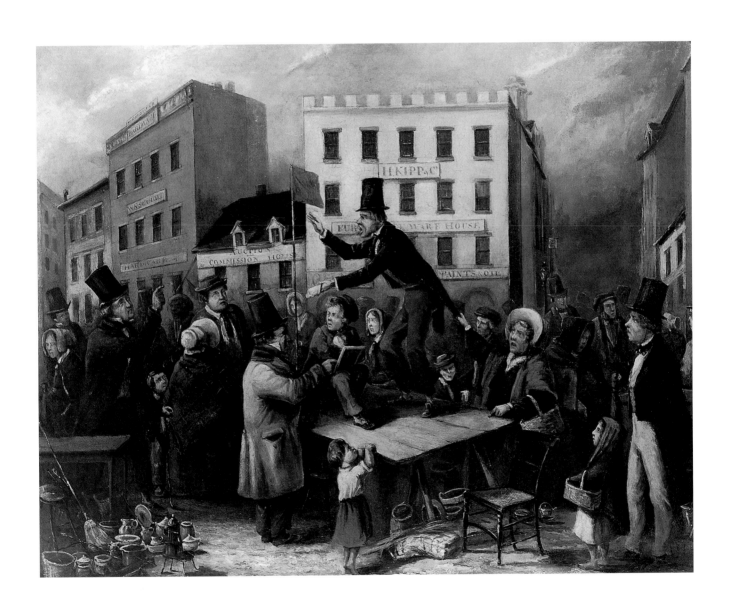

99

Old St. John's Church on Varick Street

1905 (depicting 1840s)

Edward Lamson Henry
(1841–1919)

Oil on canvas, 28 × 24

Signed lower left: *E. L. Henry*
1905

Bequest of Mrs. Ellen P. Moffat,
60.77

St. John's Chapel was designed by John McComb, Jr. (1763–1853), in 1803 for the vestry of Trinity Church to accommodate its expanding Episcopalian congregation.[1] The chapel's hewn-oak spire reached more than two hundred feet in height, while a curved stairway to the pulpit and carved acanthus-topped fluted pillars lent elegance to its airy, open interior.

The Trinity parish planned to offer ninety-nine-year leases on land it owned around the perimeter of what was then Hudson Square, expecting fine homes to be built. But upper-class New Yorkers of the period found the area too far uptown, and the long leases seemed onerous. By the 1820s, when the northward push of the city made Hudson Square a desirable place to live and the parish decided to sell rather than lease the property, attendance at the chapel increased.

In 1827 Trinity parish granted use of the square to owners of the surrounding land. Befitting a neighborhood rapidly gaining renown for the wealth of its residents and the grandeur of their houses, St. John's park came to be thought of as one of the finest, with specimens of both American and foreign trees.[2]

In 1866, however, when New York's relentless expansion north rendered the neighborhood less fashionable, Trinity parish sold the park for four hundred thousand dollars to Commodore Cornelius Vanderbilt, who promptly built a freight depot on it for the Hudson River Railroad. Although St. John's gained respite from its financial problems by this transaction, it now faced the walls of the depot's warehouses and also opened itself to criticism for abandoning one of the few parks available to the poor left behind by the northward migration of New York's more affluent citizens.

St. John's Chapel was demolished in 1918–1919. The announcement of its impending closing once more exposed Trinity parish to public censure. Others defended the action: "In closing this chapel Trinity parish is not, as has been implied in some quarters, deserting the people of one of the poorer regions of this city, and leaving them without the ministrations of the Church.... in view of the movement of the population the work of Trinity parish for this region must be done from a center near to the present site of St. Luke's Chapel.... the work can be done more strongly and effectively from this one center."[3]

Edward Lamson Henry's *Old St. John's Church on Varick Street* depicts the church and park as they appeared in the 1840s. Henry often developed his paintings from old photographs or sketches, as he has done here, and also collected antique vehicles, clothing, and other artifacts, using them as models for meticulously rendered scenes of earlier times. According to his biographer Elizabeth McCausland, Henry's commitment to the preservation of venerated sites and buildings, such as St. John's Chapel, is documented in letters he wrote to public officials and newspapers and inspired some of his paintings.[4] In addition to their documentary value today, Henry's works had great popularity as lithographs published by New York City printer C. Klackner.

Youle's Shot Tower

1844

Jasper Cropsey (1823–1900)
Oil on canvas, 24 × 20 ½
Gift of Mrs. Josephine Barker, 81.4

In 1821 George Youle built his first shot tower on the banks of the East River just north of 53rd Street, but a few months later it collapsed.[1] The replacement depicted in this painting, built in 1823, was probably designed by John McComb, Jr. (1763–1853).[2] It was so strong that demolition was difficult a hundred years later.[3] The small inlet in front of the tower provided a landing place for boats conveying prisoners and hospital patients to the Charity Hospital, Alms-House, Work-House, and other institutions on Blackwell's Island.[4]

Jasper Cropsey received architectural training in the New York office of Joseph Trench. He worked as an architect before his 1844 election as an associate of the National Academy of Design turned him toward a highly successful career as a landscape painter (he was elected full academician seven years later). This early example of his work in oils combines his knowledge of architecture with the respectfully realistic representation of nature typical of America's second-generation Hudson River School painters, among whom Cropsey emerged as a leading figure. Four similar views of the tower (including this one and another in the Museum's collection) by Cropsey, as well as many prints of the site, indicate the popularity of the pastoral setting among artists of the period.[5]

View of Hudson River

c. 1840–1845

VICTOR GIFFORD AUDUBON
(1809–1860)

Oil on canvas, 44 ½ × 69

Inscribed on reverse: *View of
the Hudson River at about
134th St. from a painting by
Victor Audubon, a son of
Audubon the naturalist, who
is sitting on a rock in the fore-
ground (about 1840–1845).*
Gift of Miss Alice Lawrence,
38.188

THE PROPERTY commemorated in this view by Victor G. Audubon belonged to John Burling Lawrence, great-grandfather of the painting's donor and the man to whom the artist gave the canvas. Manhattanville, as the area around 125th Street and Broadway was then known, was established in 1806 along the Hudson. By mid-century the village, which had grown to about five hundred residents, sported an Episcopal Church, a mill, a brewery, and a backdrop formed by the natural beauty of the then-untouched Palisades. Victor Audubon, the elder son of the noted naturalist and painter John J. Audubon (1785–1851; according to the inscription on the reverse of the painting, Audubon senior is the figure seated on a rock at the foreground of the painting), lived with his family at "Minnielands," their home overlooking the Hudson River at 155th Street, about two miles north of this scene. In the early nineteenth century, this area of Manhattan became a summer setting for the country homes of wealthy New Yorkers who lived downtown the rest of the year.[1]

Since the 1850s, deposits of excavated earth from New York City's burgeoning building projects have contributed to the expansion of Manhattan's shoreline along both the East and Hudson Rivers, thereby obliterating the beach in this view. Audubon depicted other elements in the scene with great attention to detail. The sailboat in the right center is a Hudson River gaff-rigged sloop, favored for transporting both freight and passengers along the river; the boat with furled sails is a schooner. The fishermen's equipment lying on the beach—notably the cotton fishing net and the basket of split white oak—appear close in style to those in use for river fishing today. Among the identifiable fish lying on the beach are striped bass, bluefish, and fluke, all species readily available in the Hudson River at the middle of the nineteenth century but later eradicated by industrial pollution. The hauling of nets that the men in this canvas are performing would have taken place at first light during low tide. The shadows cast on the beach by the rising sun and the down-river position of the moored boat's stern reflect those circumstances. The choppy water indicates that a stiff breeze is blowing, probably making for a cool early morning and explaining the layers of clothing worn by the figures in this scene.[2]

New-York from Fulton Ferry, Brooklyn

1848

THOMAS THOMPSON (1776–1860)

Oil on canvas, 18 ½ × 77 ½

Museum purchase from the

Thompson family, 56.33

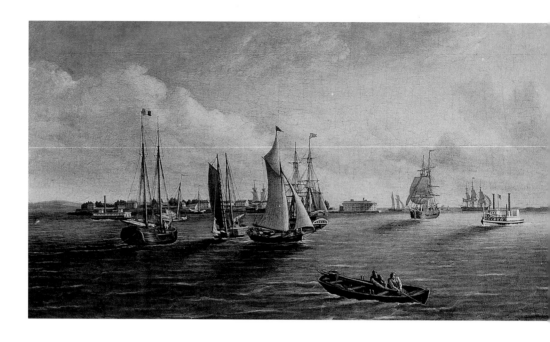

THE BUSY mid-nineteenth-century New York Harbor is viewed here from the Fulton Ferry terminal in Brooklyn. The craft arrayed on the water, their sheer numbers suggesting the harbor's activity, include a small fisherman's rowboat, a ferry headed from Brooklyn to Manhattan and another nearing Governors Island, several pilot boats, and a number of packet ships, including the one at the center. The preponderance of sailing ships illustrates their continued popularity in New York long after steam-powered vessels replaced sailing craft in most other places.

Along the horizon near the painting's left side can be discerned Castle William's round shape and other military buildings on Governors Island, an army post dating from the Revolution. At right, clusters of tall masts partially obscure the mid-nineteenth-century Manhattan "skyline." The fourth tall structure from the right is the United States Hotel (formerly Holt's), its six stories qualifying it as Manhattan's highest building.[1]

The crisp delineation of vessels and shore elements, the low horizon, and closely observed skies reveal Thomas Thompson to be an artist versed in the tradition of marine painting introduced to his native England by seventeenth-century Dutch artists. He studied under Sir Joshua Reynolds and regularly exhibited his artworks (largely portraits and miniatures) at the Royal Academy, London, between 1797 and 1810. In 1818 he moved his family to the United States.

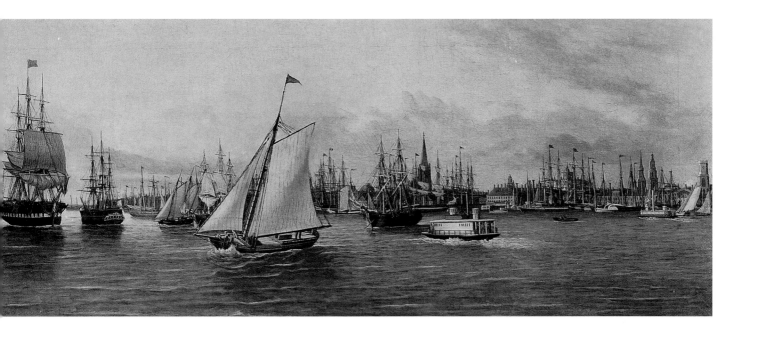

After living for some years in the Susque-
hanna Valley, Thompson moved to Baltimore
and then to Philadelphia before settling in
New York in 1831, the year he is first recorded
to have exhibited at the National Academy of
Design. Three years later he became an associ-
ate member of the Academy and continued
showing in almost every annual exhibition
there until his death. His prodigious output of
sixty-five paintings during those years in-
cluded a few portraits, several landscapes, and
many marines, including this work, which was
shown the year he painted it.[2] Thompson also
exhibited frequently at New York's American
Art-Union from 1833 until its demise in 1853,
and also showed at the Pennsylvania Academy
of the Fine Arts and the Brooklyn Institute of
Arts and Sciences. In 1848, the year he painted
this view, Thompson moved to Brooklyn,
where he lived for the rest of his life. In addi-
tion to being a painter, he was a lithographer
and the publisher of one of the largest early
American lithographs known, *Battery and
New York Harbor,* based on his own painting
of the same name.[3]

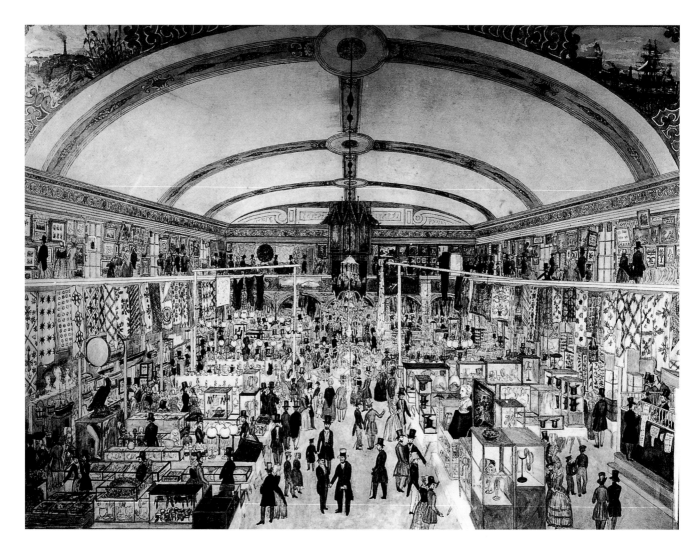

Annual Fair of the American Institute at Niblo's Garden

c. 1845

Benjamin Johns Harrison
(1834–1903)
Watercolor on paper,
20 ¼ × 27 ¼
Bequest of Mrs. J. Insley Blair
in memory of Mr. and Mrs.
J. Insley Blair, 51.119

Niblo's Garden, located at the intersection of Broadway and Prince Street, was one of the city's great places of recreation in the 1840s. Beginning in 1828, William Niblo developed what had been a private promenade into a public summer garden, where he offered evening entertainments — singers, dancers, and variety performers. As part of this venture, he enclosed the garden to form an indoor hall, one part of which later became a theater frequented by "the first fami-

lies of the city."[1] Niblo's, as the complex was known, became the site of the American Institute's annual fairs from 1834 until 1845.

The American Institute was incorporated in 1829 "for the encouragement of agriculture, commerce, manufactures, and the arts."[2] Housed in the west end of City Hall, the institute operated a public reading room that included a library and models of contemporary machinery. Through its annual fairs, the organization endeavored to promote domes-

tic industry by exposing workers and manufacturers to new ideas and inventions, such as daguerreotypes. In the first volume of its journal the institute defined its "social influence" in bringing "together men of all conditions in society, and all vocations." The article further described goals of educating mechanics that might then enter "the most refined and respectable circle of society known in our country."[3]

The many couples shown in this watercolor examining art, home furnishings, and clothing underscore the fair's importance to New York consumers before the opening of large department stores along "Ladies' Mile" in the 1870s. Attendance statistics (the 1845 fair drew thirty thousand people, or one out of every twenty New Yorkers) emphasize the event's influence in establishing taste and promoting the desire for new goods. In the words of someone identified only as Judge Baldwin, "The effects of a display and public exhibition of the various specimens of the articles of consumption…promotes that competition … benefit[ing] the consumer and purchaser."[4]

Two small vignettes in the upper corners of the painting—the left one representing High Bridge (see plate 20) with a train crossing it (even though trains never ran on High Bridge) and the right one depicting ships, wharves, and lighthouses—celebrate New York City's modernity and energy. These elements were not part of the actual decor of Niblo's Garden but were fabricated by the artist.

Benjamin Johns Harrison was born in London in 1834 and came to America at age fifteen "in order to be free of the Church of England."[5] Views of the 1844 and 1845 fairs executed by this amateur watercolor painter are listed in the *American Institute Catalogue* for those years and for 1856. Harrison conveys his apparent delight in the abundance of material goods with his meticulous visual inventory of the items on display, from mundane buckets to densely hung prints and paintings. As an inventor and energetic businessman (his patent for a folding chair became the foundation of his successful manufacturing business), he must have been particularly engrossed by the paean to American ingenuity expressed in these annual expositions.

High Bridge

c. 1850

Artist unknown
Oil on canvas, 24 × 31
The J. Clarence Davies Collection,
29.100.1305

Bridges linking the island of Manhattan to New Jersey, Long Island, and southern New York State have been part of the iconography of New York City from the earliest days of settlement. The first bridges spanned the Harlem River, linking the northernmost part of the island to southern Westchester County, an area that became the borough of the Bronx after its 1895 annexation to the city of New York.

High Bridge, New York City's oldest surviving bridge, was widely extolled as the engineering marvel of its time. As a preeminent example of Yankee ingenuity in conquering tremendous technological obstacles, it assumed an enduring place in the pictorialization of New York's urban advantages. John Bloomfield Jervis (1795–1885) designed the bridge and oversaw its construction between 1838 and 1842. Jervis' work on the construction of the Delaware and Hudson Canal and the Chenango Canal, and of various railways, had earned him a reputation as an accomplished engineer. Managing to overcome problems of varying land levels and difficult rock formations on both sides of the river, he created a Roman aqueduct to carry the Croton Aqueduct pipes over the Harlem River from Aqueduct Avenue at 170th Street in the Bronx to High Bridge Park, east of 175th Street and Amsterdam Avenue in Manhattan.[1]

Construction of the bridge began in 1839. The completion of the Croton project in 1842 gave New Yorkers cause for celebration, ranging from parades and fireworks to the composition of a special ode. The significance of the Croton enterprise was immense. The introduction of water from an upstate source gave a rapidly growing New York City a new source of unpolluted water and a reliable water supply to fight the frequent fires that burned out of control when wells and pumps ran dry. Not all New Yorkers were enthusiastic, however. George Templeton Strong recorded in his diary: "There's nothing new in town, except the Croton Water, which is all full of tadpoles and animalcule, and which moreover flows through an aqueduct which I hear was used as a necessary by all the Hibernian vagabonds who worked upon it. I shall drink no Croton for some time to come."[2]

Such unpleasantries as Strong's bigotry and the severe unemployment following the financial panic of 1837 are in no way reflected in the bucolic view of this new wonder, which, along with the rest of the Croton project, did indeed provide work for many Irish immigrants. Urban tensions and problems and the people most affected by them had no place in art of the period.

The beauty of the bridge and its innovative technology made it an appealing subject for many nineteenth-century artists. *Miller's New York as It Is* (1882) recommended the site to tourists for the carriage ride or promenade across the top.[3] Even in the early twentieth

century, artists chose the locale for its still-bucolic appearance, which offered a pleasant alternative to densely built downtown. In 1927, however, the bridge's aspect was sharply altered by the removal of two of its arches to allow for the passage of large ships through the Harlem River from the Hudson to the East River.

The Museum of the City of New York owns six paintings of High Bridge, as well as several drawings and prints and many nineteenth- and early twentieth-century photographs.[4] This view, looking at the bridge from the east, was probably derived from a print by Currier and Ives, *The High Bridge at Harlem, N.Y.,* issued in 1849. The existence of another nearly identical painting bearing the signature "Burleigh, Waterville Maine," suggests that widespread interest in this nineteenth-century marvel gave rise to the popularity of the print.[5]

Steamer "Hartford" Capt. LeFevre, Bound for California, Sailed from New York February 1849

1849

JOSEPH B. SMITH (1798–1876)
Watercolor, 25 ½ × 38 ½
Signed lower left: *J. B. S.*
Bequest of Mrs. J. Insley Blair
in memory of Mr. and Mrs.
J. Insley Blair, 52.100.3

THIS VIEW of the steamship *Hartford* leaving her East River pier documents an important aspect of the Gold Rush of 1849: the eager exodus of easterners to the fabled gold fields of California, where gold had been discovered in January 1848. Delayed communications kept the news from New Yorkers until the announcement appeared in the *New York Herald* on August 19, 1848. "Gold Rush fever" resulted almost instantaneously, and by March 1849 more than 140 ships from the East Coast had embarked on the rough, dangerous passage around Cape Horn to California.[1] After her first voyage, lasting nearly a year, the *Hartford* arrived safely in San Francisco harbor, only to be demolished in an accidental explosion on March 3, 1851.[2]

Although most New Yorkers failed to strike it rich in the California gold fields, evidence of their presence there is found in names of such places as New-York-of-the-Pacific, a promoter's town, and the New York Ranch; names of such mining companies as Manhattan Bar and Empire State Mining Company; names of such volunteer fire companies as the Knickerbocker and the Manhattan in San Francisco; and in the many mining town stores bearing the name "New York."[3]

The *Hartford* appears to carry no women, which was typical of California-bound vessels during the initial Gold Rush era. (Later, shiploads of women—wives joining husbands, mail-order brides, and prostitutes—would travel west to join the gold seekers.) Poignant vignettes enacted among the throng

of figures on the pier suggest the significance of such departures in a period of difficult travel and sparse communications. On the left edge of the pier sits an elderly man with a younger man bending over him in a comforting manner, suggesting that the older man has bid farewell to someone aboard the ship—perhaps a son or younger brother—whom he does not expect to see again. To the right of the small dog at the center foreground, a man appears to be consoling a woman.

Attention to factual detail is characteristic of Joseph Smith's work as a cityscape painter, exemplified by the carefully delineated Brooklyn shoreline seen across the East River. He has depicted many of the steeples that gave mid-century Brooklyn the title "City of Churches," and the wharves and buildings of the Navy Yard underscore the city's ties to the sea and ships. The accurately rendered boats confirm Smith's competence as a marine artist as well.

Smith, who lived for a while in New York City, moved to Brooklyn in 1852 and remained there until at least 1862. During some of those years he worked with his son William. They listed themselves at different times as either marine artists or portrait painters. Four of their joint paintings—the *Adelaide, Great Republic, Ocean Express,* and *Red Jacket*—became the basis for an 1855 series of prints of clipper ships issued by Currier and Ives. Joseph's best-known works, executed early in his career, depict the John Street Methodist Chapel, the first Methodist church in America.[4]

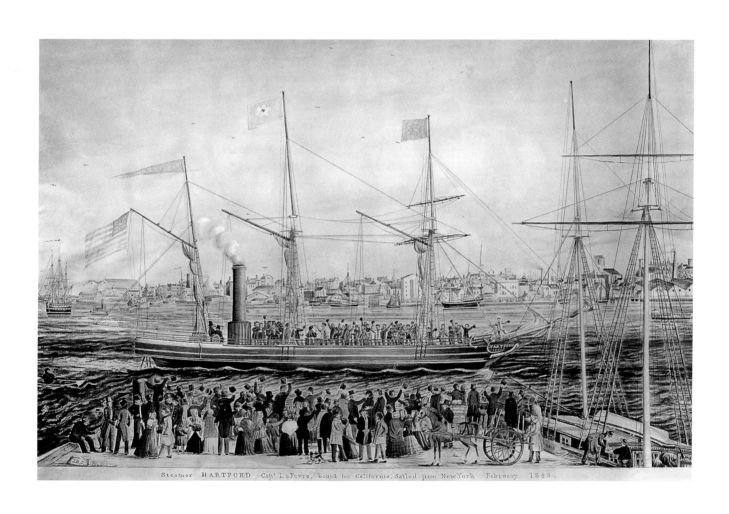

Steamer HARTFORD Capt LeFevre, bound for California, Sailed from NewYork February 1849.

The Stage Coach "Seventy-Six" of the Knickerbocker Line

c. 1850

HENRY BOESÉ (1824–after 1893)
Oil on canvas, 24 × 48
Signed lower right: *H. Boesé*
Stamp on canvas verso: *prepared by Edw. Dechaux New York*
Gift of Herbert L. Pratt, 40.178

IN NINETEENTH-century New York, as in other American cities, a wide range of civic improvements occasioned paintings celebrating these breakthroughs and, by implication, the foresight of their inventors and investors. *The Stage Coach "Seventy-Six,"* one of three known mid-century oils by Henry Boesé paying homage to the omnibus, portrays a festive turnout associated with the advent of this mode of transportation along Myrtle Avenue in the newly chartered City of Brooklyn.

Omnibus travel was not a novelty when the artist executed his canvas. The concept of conveying passengers in a covered, horse-drawn vehicle along a fixed inner-city route for a flat fare had been pioneered in Manhattan by Abraham Brower in 1827, with important innovations in coach design and manufacture following in 1831.[1] "Omnibuses, exceeding a hundred in number, roll incessantly over the paved streets, administering equally to the purposes of business and pleasure… forming an object of such prominent attraction, as to cause New York not inaptly to be termed 'The City of Omnibuses,'" claimed a proud writer for the *New-York Gazette and General Advertiser* on August 5, 1834. Yet areas lying outside these downtown routes, initially clustered around the Broadway artery running from the Battery to Bond and Bleecker Streets, did not feel the benefit of facilitated commuting until later, after veteran companies like the Knickerbocker Stage Line extended service and multiplied orders for coaches.[2] By 1850

entrepreneurs were financing branch lines to developing neighborhoods, thus expediting travel within and to the ever-expanding limits of metropolitan New York.

Boesé's painting depicts the Knickerbocker Stage Line's coach "Seventy-Six"—which appears newly minted—advancing along Myrtle Avenue as spectators admire it. Under ordinary circumstances, the omnibus would have been drawn by a two- or four-horse team. Here, ten well-matched horses commanded by a whip-curling driver indicate an exceptional occasion—probably the debut of a dedicated stage service traversing this section of Brooklyn, easing access to the East River waterfront and contiguous villages within Kings County. On the "Seventy-Six," up to thirty passengers could enter at the Fulton Street Ferry and exit in the northwestern neighborhood of Greenpoint. Nestled in a grove of trees at center is the Greek Revival homestead of Jeremiah (or Jeromus) Johnson, Jr., which stood on the northeast corner of Kent Avenue. Johnson, a prominent citizen and son of former Brooklyn town mayor General Jeremiah Johnson, was a co-proprietor of the new line in partnership with Thomas D. Hudson, a local merchant and alderman of the 7th Ward.[3] They may be among the threesome riding atop the omnibus, an uncommon practice for routine travel but a perch well suited for honored passengers receiving salutations from their community. The backs of the other guests glimpsed inside

the coach denote the use of longitudinal passenger seats that were featured on omnibuses.

By the 1840s, growing competition motivated companies to baptize their coaches with evocative names. The "Seventy-Six," probably a reference to 1776, joined a group of coaches named for Revolutionary-era American characters, such as the "George Washington" and the "Lady Washington." Owners of coach companies also vied for riders by enhancing the upholstered comforts of vehicle interiors and by commissioning decorative panel paintings to spotlight individual coaches. Boesé has taken care to illustrate the pictorial image—believed to represent a Revolutionary War battle scene—framed by drapery swags that embellished the side of the latest addition to the Knickerbocker Line.

Boesé, son of a hosiery merchant, was born in New York, and in 1860 census takers recorded him as a thirty-six-year-old married father of six. Directories list him at various addresses within the city until 1893, and exhibition records and other signed works by him (sometimes erroneously read as H. "Beese") confirm his activity as a landscape painter in the Hudson River School tradition.[4] Despite the absence of surviving examples, Boesé was also credited as a portrait artist. The trio of stagecoach paintings that Boesé executed between 1849 and 1856 suggest that economic need may have compelled him to step outside the traditional groove of fine arts practice and supplement his income by painting omnibuses. Like *The Stage Coach "Seventy-Six,"* Boesé's other two paintings—reportedly commissioned by Montgomery Queen, founder of King County's first efficient stagecoach lines—offer minutely observed views of the panel scenes brightening the sides of the omnibus.[5] The artist may have intended them as coy reminders of his availability as a coach decorator, or as references to his professional oil landscapes, which he wished to publicize.

The Metropolitan Hotel

c. 1852

Attributed to J. Mulner
Oil on wood panel, 55 × 65
The J. Clarence Davies Collection,
29.100.1321

When it opened on September 1, 1852, the Metropolitan Hotel was judged the most magnificent modern hostelry on lower Broadway. The neighborhood was fast becoming an area of international stature housing palatial retail stores, theaters, lodging establishments, and fine restaurants, most built from marble, brownstone, or decorative cast iron. All the latest amenities had been incorporated into the new brownstone-sheathed hotel, including steam heat, speaking tubes, and bathrooms on each of the six floors. Soon after the hotel's debut, the *New York Herald* commended its trend-setting comforts, noting a bounty of four hundred beds "made upon spring mattresses, with hair mattresses over them." The lobby and common spaces inspired lengthy descriptions laden with superlatives. "On the first floor are ladies' reception room, gentlemen's lounging room, dressing rooms, and apartments for the reception of guests, prior to assigning them rooms," began one enthusiastic report, which proceeded to inventory the opulent decor found in the dining room, public parlors, and other suites in the establishment. The tally of attractions included mantles made of rare marbles, polished oak banisters, Wilton carpets, rosewood furniture upholstered in rich brocatelle, silk damask curtains, and stained-glass windows with heraldic motifs. "Suffice it to say," the reporter concluded, "it is quite dazzling and confusing."[1]

Designed in an L-shape, the Metropolitan Hotel occupied a three-hundred-foot frontage on Broadway and two hundred feet on Prince Street. Along Broadway, it accommodated eight street-level stores with broad areas of glass for displaying goods. More notable was its connection to William Niblo's new "Garden" on the Crosby Street side of the property, with a main access to the entertainment complex retained at 578 Broadway, next to the hotel's entrance at 580 Broadway.[2] Both enterprises stood on land owned by Stephen Van Rensselaer, who undoubtedly realized the benefits of linking the hotel and pleasure garden, hence catering to patrons' needs for lodging, food, and amusement on one site. Realization of the overall plan had been entrusted to architects Joseph Trench and John Butler Snook, a firm recommended in all likelihood by A. T. Stewart, a stockholder in the hotel and owner of the nearby department store bearing his name.[3] Both the hotel and Stewart's marble emporium were constructed in a grand commercialized style reminiscent of Roman palazzos.

This large, detailed view emphasizes not only the imposing exterior of the hotel facing Broadway but also the activity that engulfed it on the adjacent city streets and sidewalks. These are filled with smartly dressed people and assorted conveyances, including horses. Individual vignettes within the scene illuminate information about urban culture during this period. The pair of women without male escorts in the center foreground suggest the growing acceptability of shopping trips as a

pastime for refined ladies, spurred by the opening of new department stores like Stewart's. An image peddler, on the sidewalk approaching the street corner at the viewer's right, carries on his head a tray of plaster figures for sale to passersby. A bagpiper clad in kilts steps briskly in the opposite direction, patrolling the hotel entrance area while awaiting the occasion to welcome any arriving dignitaries. The scene's bustle underscores the heterogeneous traffic gravitating to this section of Broadway by the middle of the nineteenth century, thus validating the location as a prime one for investors in the new Metropolitan Hotel complex.

Nothing has been found to explain the circumstances that brought this painting to life, nor can the identity of the presumed artist, J. Mulner, be substantiated.[4] Several prints in the collection of the Museum of the City of New York, related to period advertisements and guidebook illustrations for the hotel, appear to derive from this large panel painting. Possibly it was commissioned by the hotel's owner for display in the new facility. From the outset, hotel management rights had been leased to the Leland Brothers, acknowledged leaders in the business of managing American hotels. In their business literature, the Lelands featured an image of the Metropolitan closely related to the painting.

During the Lelands' tenure, A. T. Stewart acquired the property. Following the depar-ture of the Lelands from the establishment in 1871, the hotel was leased to a succession of less capable managers—Richard Tweed, son of the infamous William Marcy "Boss" Tweed, among them. With a tarnished reputation and no longer able to compete for the upscale clientele that had shifted allegiance to newer, uptown hostelries, the Metropolitan Hotel closed and was demolished in 1895. Stewart's estate sold the property for construction of office buildings.[5]

Broadway and Rector Street

c. 1850

JOHN WILLIAM HILL (1812–1879)
Watercolor on paper mounted
on cardboard, 14 ½ × 20 ¾
Signed lower right: *J. W. Hill,*
New York
Gift of Forsyth Wickes, 38.19

IN THE middle of the nineteenth century, New York City's residential and commercial districts were pressing ever northward along Broadway. This acutely observed mid-century watercolor captures some of the unusual juxtapositions engendered by this movement. The massive new Empire Building opened in the early 1850s to house both offices and stores (it replaced the earlier Grace Church, which by 1843 had voted to follow its parishioners who were building fine homes in the Union Square neighborhood).[1] The Empire Building stood in sharp contrast to the tranquil cemetery of Trinity Church. Former New York mayor Philip Hone, an avid diarist, recorded that Grace Church had sold in 1845 for $65,000, "to be converted into stores below and the upper part into a splendid museum of Chinese curiosities." The lack of any known record substantiating these plans for the deconsecrated Grace Church suggests that they never progressed.

Located at 71 and 73 Broadway, at the corner of Rector Street (named for the succession of eighteenth-century rectors of Trinity Church who lived on the site before Grace Church was built there in 1807), the Empire Building housed several dry-goods merchants at street level and various business offices in its upper stories.[2] In 1896–1897 a newer, taller Empire Building replaced the commercial structure depicted in this view, which then received the appellation "Old Empire Building."

From the early eighteenth century forward, Trinity Church cemetery, on the corner opposite the Empire Building, had served as the final resting place of many notable Americans, including Francis Lewis, signer of the Declaration of Independence; inventor Robert Fulton; financier-statesman Alexander Hamilton; and William Bradford, founder of New York's first newspaper, *The New-York Gazette.*[3]

While the painting's composition allots equal space to the Empire Building and the graveyard, the sheer size of the new structure gives it prominence, suggesting the significance attached to a modern edifice of commerce in a city that was rapidly evolving into the center of American business enterprise. The pedestrians and vehicles along Broadway show the variety of traffic. Many elegantly attired men, women, and children saunter along the sidewalks; a more modestly dressed family (possibly visitors from the country) can be discerned at the extreme right; and two boys are seen going about their business, one (near the corner of the Trinity graveyard fence) bearing a package he may be delivering, and the other (at bottom center) apparently approaching people with something to sell. The artist may have intended to compare the old cemetery's appearance of repose with the dynamic street scene and the commercial energy typifying the modern New York cityscape.

John William Hill, son of the engraver John Hill, was born in London and immi-

grated with his family to the United States at the age of seven, initially residing in Philadelphia and then moving to New York City in 1822, where he served a seven-year apprenticeship to his father. In 1828 Hill began to exhibit work at the National Academy of Design. Five years later he was elected an associate member, and he continued to exhibit fairly regularly there until 1873. He was employed as a topographical artist for the New York State Geological Survey from 1836 to 1841, after which he worked for Smith Brothers, a publishing firm, where he was employed to sketch North America's developing cities. From the mid-1850s on, Hill was greatly influenced by the tenets of the Pre-Raphaelite movement and devoted himself largely to painting from nature.[4] This work, with its strong attention to tonal values and contrasts of light and dark and its acutely observed architectural detail, demonstrates the influence of his earlier experience in the employ of printmakers. To a slightly lesser extent, the same qualities inform Hill's landscape paintings.

Reception of General Louis Kossuth at New York City, December 6, 1851

1851

E. PERCEL (active c. 1850)
Oil on canvas, 44 × 63 ½
Gift of Colonel Edgar William and Mrs. Bernice Chrysler Garbisch, 66.2

BEGINNING IN the late eighteenth century, New York City became a favored backdrop for public celebrations in the form of parades honoring individuals and events of civic, and even national, interest. As the city established parks and squares, which in turn became venues for commemorative sculpture and arches, Manhattan provided an ideal setting for these "civic performances."[1]

Lajos (Louis) Kossuth, leader of a short-lived Hungarian rebellion in 1848, arrived in the United States in 1851 for a triumphal tour that would raise money for the cause of Hungarian independence. In this painting Kossuth is represented as the figure in a beaver hat and riding a white horse in the parade that followed his landing at the Battery on December 6, 1851. In addition to the parade depicted here, Kossuth was welcomed to New York with a monumental torchlight parade, a municipal dinner, banquets, and rounds of receptions. His popularity was so great that fashionable young men began to wear wide-brimmed, soft felt hats in imitation of his.[2] In 1928 the city's Hungarian community erected a statue memorializing him. Several American cities have been named after Kossuth.[3]

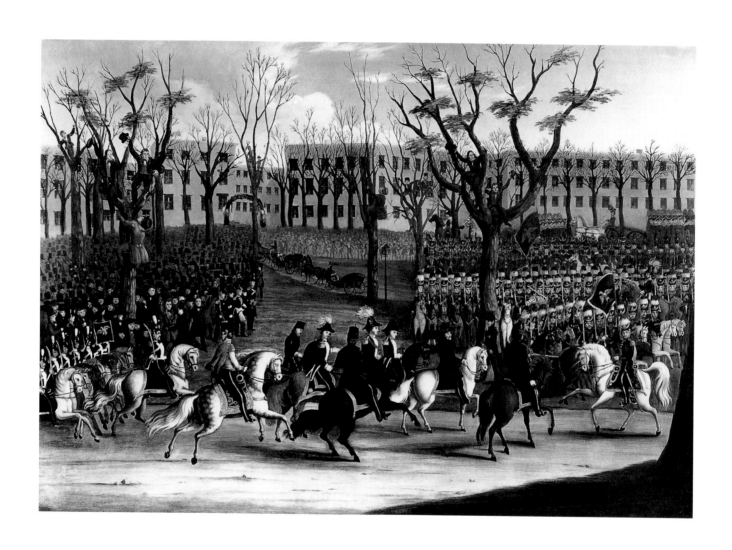

Clipper Ship "Sweepstakes"

1853

FITZ HUGH LANE (1804–1865)
Oil on canvas, 26 × 48 ½
Signed lower right: *Fitz Henry
[sic] Lane / Gloucester, Mass /
1853*
Bequest of Theodore E. Blake,
M50.5

IN RESPONSE to the demands for rapid passage to California after the discovery of gold in 1848, 1853 was a peak year for the construction of United States clipper ships, which were designed for speed. The *Sweepstakes* was one of forty-eight built that year and the last to be built by the renowned Westervelt shipyard. The economic depression of 1857 reduced the demand for ships and hastened the demise of New York's wooden ship-building industry.

The diary of Robert Underhill, which records his 1856 travels on the *Sweepstakes,* reveals that Jacob Westervelt, whose sons Daniel and Aaron owned the yard that built the ship, was also traveling on this voyage to San Francisco and the Orient.[1] Underhill's entries make clear that the older Westervelt, retired from active participation in his family's business, recognized the economic situation facing the port of New York and was seeking other possible venues for the family business.

The *Sweepstakes,* depicted here in New York Harbor, was owned by Chambers and Heiser, and for her first four voyages she sailed under the command of Captain George E. Lane, a distant cousin of the artist.[2] Though black-hulled like other clippers, she bore a stripe of gold found on only a few others and was distinguished for "her graceful model and trim rigging … elegant cabins … [and] … the comfortable and airy quarters provided for the crew, replacing the old forecastle, whose middle-passage horrors have tasked the pens of our nautical writers."[3] *Sweepstakes* gained celebrity for her record-breaking seventy-four-day run from New York to Bombay in 1857.

Fitz Hugh Lane was born in Gloucester, Massachusetts, and probably taught himself to paint before going to work in 1832 as a lithographer, first in Gloucester and then in Boston. By 1841, having returned to Gloucester, he began exhibiting his paintings in Boston and New York, and by 1850 he had developed his distinctive and innovative style of luministic marine paintings, strongly influenced by the English marine painter Robert Salmon.[4] Lane's visits to New York provided him with a way to earn money by filling commissions from ship owners, builders and captains with standard, though highly competent, portraits of their vessels. The peculiar signature on this painting is not unique.[5] Lane did not sign every painting. His executor and close friend Joseph L. Stevens signed some after his death, and several variations of his signature can be found.[6]

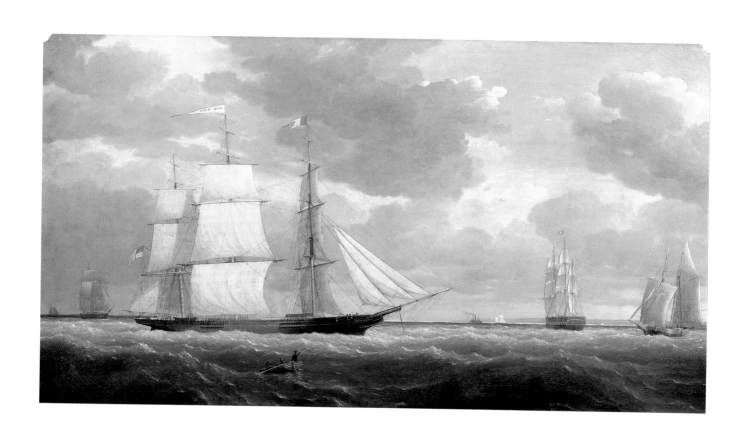

United States Barge Office

c. 1850

Marie-François-Régis Gignoux
(1814–1882)
Oil on canvas, 26 ¾ × 21 ¾
Gift of Maurice M. O. Purdy in
memory of his wife, Alice-Jean
Purdy, 70.35

The picturesque United States Barge Office on the wooded shore at the southeast corner of Battery Park served from about 1830 to 1880 as offices and short-term residences for customs officials. It also overlooked the dock for the flat-bottomed barges that agents dispatched to inspect incoming ships before allowing them to berth. The wooden pilings visible in the right foreground mark the Staten Island Ferry terminal (a new terminal now stands where the barge office was). In the far-left center background is Castle Clinton, built to protect New York Harbor from British invasion during the War of 1812, a function never required.[1] The U.S. Customs flag flying from the barge office cupola indicates that an inspector is on duty. Because of the uncertainty of ships' arrival times, the barge office was staffed around the clock. The laundry drying on the roof probably belongs to an officer on duty.

In 1880 the barge office depicted here was torn down to make way for a more commodious building to accommodate the expanded customs inspection staff needed to serve the Port of New York, which by that time was handling more than half the national value of all export and import commerce. Room for this larger structure was created by the expansion of the Battery as landfill taken from Manhattan construction sites was deposited offshore. In 1907 the U.S. Customs Service relocated to a new Beaux Arts facility designed by noted architect Cass Gilbert, where it remained until its 1974 move to the World Trade Center.

Régis Gignoux, to use the shortened name preferred by the artist, was born in Lyons and studied at the Ecole des Beaux-Arts in Paris. Immigrating to the United States in 1840, Gignoux settled in Brooklyn. His interest in landscape painting grew through his friendship with Robert Weir, a drawing instructor and painter of the Hudson River School. Drawn into the New York art world, Gignoux exhibited extensively, gained election to the National Academy of Design, and taught private students, including George Innes. Among Gignoux's most famous works are landscapes painted on travels through the mountain ranges of New York, the coast of Maine, and other wilderness areas in North America. In 1869 Gignoux returned to his native France, where he continued to exhibit until his death in 1882.

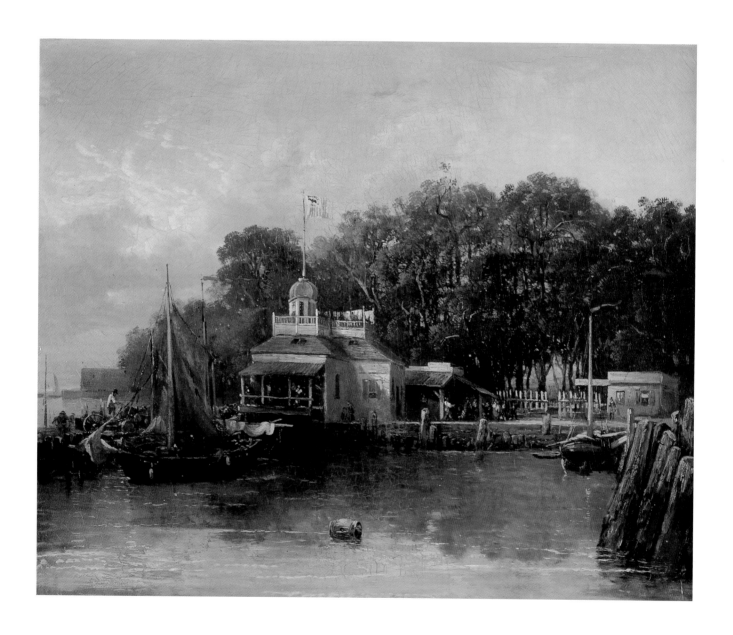

View of New York from Staten Island

c. 1850

<small>Artist unknown</small>

Oil on canvas, 24 ¾ × 33 ½

The J. Clarence Davies Collection, 29.100.1311

THE ROLLING hills and tranquil aspect of rural Staten Island, located five miles southwest across the Upper Bay from Manhattan, were popular subjects for nineteenth-century artists, resulting in many painted and printed views of similar character and composition. No precise print source for this view has been established, however.[1] Like others drawn to the area, the unknown painter of this scene depicted the island's indented shoreline, its clean white country houses, and, from left to right in the distance beyond New York's Upper Bay, the New Jersey shoreline of the Hudson River, Manhattan, Governors Island, and Brooklyn.

The road indicated in the left foreground led to Pavilion Hill, a 130-foot high point that commanded a panoramic view of the bay and was the site of the Pavilion Hotel, one of Staten Island's many fashionable resort hotels catering to prominent Manhattanites, wealthy southerners escaping steamy summers, and notable foreign visitors. The ships lying offshore indicate the presence of Staten Island's seagoing community, including many ship captains who preferred the convenience of mooring their vessels close to home rather than in the berths lining Manhattan's East River.

By 1850, as a result of an increasing number of new enterprises (including New York Fire Brick and Staten Island Clay Retort Works, which used local clay deposits) and an influx of German and Irish immigrants to provide labor for them, Staten Island's population was more than five times its 1800 figure of 4,564. The smokestack and buildings nestled in the trees of Tompkinsville, the village seen at water's edge, suggest some of these new industries. Other institutions also encroached on Staten Island's rural nature. For example, the Quarantine Hospital, where ship passengers suspected of carrying contagious diseases were isolated, had relocated to Tompkinsville from Governors Island in 1799, and the Sailors' Snug Harbor and the Seamen's Retreat were established as havens for disabled, aged, or indigent sailors in 1831 and 1834, respectively.[2]

Although a century would pass before the opening of the Verrazano Narrows Bridge (in 1964) erased Staten Island's remaining bucolic quality, this painting portends that future by depicting the advent of industry into the setting of fishing villages, farms, and elegant resort hotels.

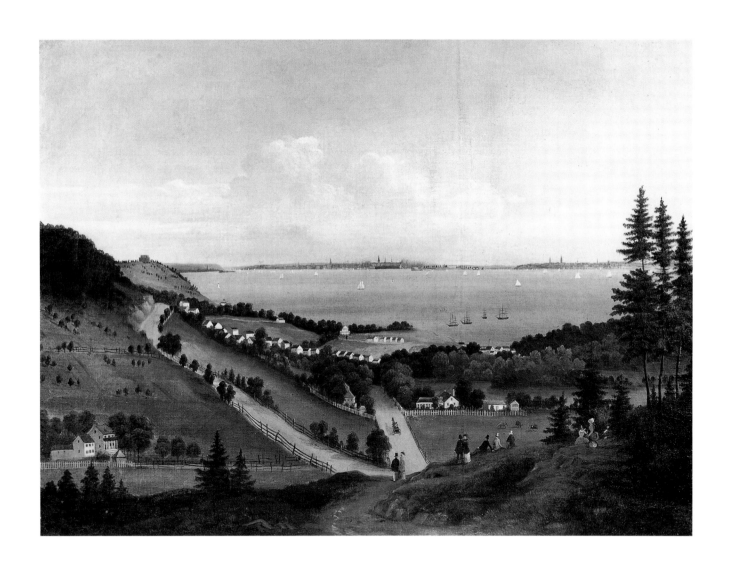

View from Montague Street, Brooklyn

(also exhibited as *View of Brooklyn from Montague Street* and *View of Brooklyn from Pierrpont Street*) c. 1850

ARTIST UNKNOWN
Watercolor, 15 $\frac{4}{5}$ × 20
The J. Clarence Davies
Collection, 29.100.1318

LONG RECORDED as an 1830s view of New York Harbor and Manhattan Island from the end of Montague Street in Brooklyn, this scene has been newly identified as depicting the building of a stone arch erected in the early 1850s across Montague by Minard Lafever (quite possibly the elegantly attired gentleman at the right, pointing at the arch).[1] Lafever, designer of Brooklyn's Church of the Saviour, Holy Trinity Protestant Episcopal Church, and Packer Collegiate Institute, and of Manhattan's Old Merchant's House and St. James Roman Catholic Church, died in 1854.[2] Because the painting shows no evidence of a landing slip for the ferry between Wall Street in Manhattan and Montague Street, established in 1852, this view and the arch it depicts probably were both made slightly earlier, about the time Montague Street took definite form (it had previously been a series of smaller paths crossing private estates).[3]

In the foreground, a top-hatted, coatless stone-cutter works on one of the large slabs assembled for the arch. Perhaps he is shaping the keystone that will brace the small arch, allowing removal of the temporary wooden support shown in place. Or he may be trimming a stone for the unfinished wall along the right side of the street, where it descends to the shore of the East River. Atop the arch, three men appear to work on some other aspect of the construction.

Beyond the busy harbor can be seen the Manhattan shoreline, along which the identifiable buildings are the large white United States Barge Office (see plate 27) and, at the southernmost tip, Castle Clinton. Further in the distance are the hills of New Jersey along the west shore of the Hudson River.

**Wall Street, Half Past Two
O'clock, October 13, 1857**

1858

JAMES CAFFERTY (1819–1869)
AND CHARLES G. ROSENBERG
(1818–1879)

Oil on canvas, 50 × 40

Signed lower left on stair risers:
CAFFERTY 1858 / ROSENBERG

Gift of the Honorable Irwin
Untermyer, 40.54

ON OCTOBER 13, 1857, a series of events set in motion two months earlier culminated in the suspension of specie payments by all but one of New York's fifty-eight banks, resulting in a financial panic. Banking did not resume until December 12 of that year. Unemployment rose sharply and real estate values fell precipitously; railroads, banks, and brokerages failed; and new construction in the city all but ceased. The crisis (or "revulsion," as contemporary terminology labeled it) typified the boom-and-bust cycles to which Wall Street and the nation's other financial markets were subject. The Panic of 1857 put nearly half of Wall Street's brokers out of business, altered trading styles, and led to a period of wild speculation.[1] A reporter for the *New York Herald* observed: "By 1 o'clock P.M. everybody in business, and a great many out of business or with no business, rushed to Wall Street, which soon became densely crowded and streams of people could be seen entering and emerging from the various banking houses."[2] This is the scene dramatized by artists James Cafferty and Charles G. Rosenberg.

Other than the great crowd of people in the street and a few anxious faces, nothing in the action or composition conveys the panic of the occasion. The view is along Wall Street, looking west from William Street to Broadway, where the clock of Trinity Church displays the notorious moment frozen for all time. To the right is the Bank of America, at the northwest corner of Wall and William Streets;

two doors to its left is the Merchant's Bank; the Doric-style Custom House (now the Federal Hall National Memorial) stands at the intersection of Wall and Nassau Streets; and on the far left is the Insurance Building. Most of these impressive new structures were built to house banks and other businesses. They exemplify the emergence of specialized commercial areas as the city grew in population and complexity. These edifices suggest the metamorphosis of the New York Stock Exchange itself from an informal street-corner affair started by twenty-four self-proclaimed "brokers" into a dominant enterprise in the district, with suites of offices, a constitution, and perhaps as many as two hundred broker members.[3] Originally a residential area and then one of mixed-use buildings, Wall Street by the mid-nineteenth century was home to only a single "family."

Although the key that once identified the foreground figures in the painting has been lost,[4] several people active in the 1857 crisis are recognizable: Cornelius Vanderbilt, arguably the era's most significant manipulator of markets, on the extreme right; Jacob Little, a major figure in the country's mid-nineteenth-century railroad expansion, in the center wearing a light gray drovers' topcoat; Frederick Hudson, managing editor of the *New York Herald* and the brother of E. W. Hudson, who commissioned this painting, visible next to the bearded man on the left; and the bearded man himself, a self-portrait of the

artist Cafferty.[5] The prominence given to the figures of the unknown newsboys reflects the mid-nineteenth-century interest in artistic representations of common people and occupations, a marked change from earlier painters' preoccupation with historic subjects, landscapes, and portraits of affluent patrons. Cafferty frequently depicted working children, whose condition he viewed as part of the harsh realities of urban life.[6] The involvement of the artists' patron in news dissemination might also have contributed to the focus on newsboys.

Wall Street, Half Past Two O'clock, October 13, 1857 was exhibited at the National Academy of Design in 1858. The combined effort of two artists is uncommon but not unknown. James Cafferty, who worked largely as a portraitist, and Charles G. Rosenberg, who pursued a dual career as an author and painter, collaborated artistically on more than one occasion. In the past, it was thought that Cafferty painted the figures while Rosenberg executed the architectural elements, but recent research indicates that Rosenberg may have painted some of the figures as well. He was, according to critics of the period, an accomplished artist, lauded for his "effective use of light, masterly grouping of figures, and skillful character studies."[7] As for Cafferty, his exhibition entries at the National Academy of Design over a twenty-year period list landscapes, genres, and still lifes as well as portraits, including those of fellow artists Jasper Cropsey, John M. Falconer, Samuel Raymond Fanshaw, and Thomas Dow Jones.

Broadway in Winter

1855

Hippolyte Victor Valentin
Sebron (1801–1879)
Oil on academy board, 11 ¾ × 17
Signed lower left: *H. Sebron New
York 1855*
Museum purchase, 40.107

Sebron, a native of Caudebec, France, was one of a succession of nineteenth-century European artists who ventured to the United States in order to develop its scenic attractions into paintings geared for sale in their homelands. Crossing the Atlantic in 1849, he spent six years traversing the eastern half of the country from New Orleans to Niagara Falls, supporting himself as a painter of dioramas, landscapes, and occasional portraits.[1] New York City proved a wellspring for commissions, and during a fruitful stay there in 1854–1855, Sebron executed a number of views of lower Broadway, arguably the nation's leading cosmopolitan avenue by that date. This compact study looks south from a point near Barclay Street, showing an urban artery astir with traffic despite evidence of a recent snowfall.

Jutting prominently into the composition at the right, with Greek Revival portico, is the five-story Astor House designed by Isaiah Rogers. A trend-setting hostelry when it opened in 1836, it featured shops at street level; 309 guest rooms, each with individual locks to ensure privacy; and the innovative luxuries of running water in every bed chamber and seventeen "bathing rooms." Glimpsed one block south is the distinctive Georgian-style facade of St. Paul's Chapel between Vesey and Fulton Streets. Almost ninety years old when Sebron memorialized it in this view, it was even then considered a venerable landmark by New York standards. The masterful Gothic revival steeple conceived by Richard Upjohn for the rebuilt Trinity Church (1846) commands the picture's midpoint, where Broadway recedes from sight near Wall Street. Across Broadway

to the east, behind some winter-stripped tree branches, is the commercial block that housed various import-export businesses and the publishing offices of Thomas Y. Crowell and Company. Heading south, at the corner of Ann Street and identified by its fluttering flags, is P. T. Barnum's American Museum, New York's incomparable headquarters of hoax and continuous, captivating entertainment. Colorful flags, banners, and exterior signboards were part of Barnum's strategy to entice customers to the establishment, as was his installment of powerful entrance lights and a live band playing music from the building's balcony overlooking Broadway.[2]

Sebron details the undeterred motion of wintertime Broadway, animated as usual with the bustle of assorted vehicles and intrepid pedestrians. By this date, enterprising uses of horse-drawn sleighs—most exposing passengers to the open air—had solved the problem of negotiating streets clogged with deep snow. One of the large, white, open-shell sleds used by the Broadway omnibus line under such weather conditions is shown rushing up the west side of Broadway loaded with riders.[3] The speed and recklessness of these drivers were notorious enough to cause all other contenders for street access to retreat quickly from their path at the sound of the bell collars worn by the approaching six-horse teams. Opposite the public sleigh, Sebron indicates the journeys down Broadway of several smaller, privately owned sleds, three seen filled with

hay that, in combination with blankets, would provide some degree of warmth to those seeking relief from the biting air.

A monumental canvas produced the same year (1855), alternatively titled *Broadway, New York (Winter)* or *Broadway Line,* now on deposit at the Château de Blérancourt in France from the Rouen Museum, dramatizes a nearly identical scene. It made a powerful impression at the Philadelphia Centennial Exposition in 1876 when exhibited along with several other works by Sebron. The early provenance of the Museum's painting, which was purchased in 1940, is unknown, but it carries a partial stencil in French (illegible except for "fils" and "artis") on the backing board.

The Bay and Harbor of New York

c. 1853–1855

Samuel B. Waugh (1814–1885)
Watercolor on canvas,
99 ⅕ × 198 ¼
Gift of Mrs. Robert L. Littlejohn,
33.169.1

Monumental painted panoramas, comprising individual sections sewn together, were a popular entertainment form for much of the nineteenth century. Produced on the same linen canvas used by theatrical set painters, they were typically unrolled within a stage proscenium, creating movable narratives that mesmerized audiences. In October 1849 Samuel B. Waugh's fifty-scene panorama *The Mirror of Italy* made its exhibition debut in Philadelphia before embarking on a tour to New York City and Boston. Sometime thereafter, the artist returned to the episodic painting, adding a dozen revised "chapters" to it. Under the name *Italia*, this expanded tableau (about eight hundred feet long) was shown at bookings around the nation, including a featured appearance in 1859 at New York City's New Hope Chapel just below 8th Street.

A descriptive handbook accompanied *Italia*, identifying each of its sixty-two segments and attributing the project's genesis to "sketches taken by the artist during a residence of several years in Italy."[1] *The Bay and Harbor of New York*, the concluding scene of this "grand tour," depicted the homecoming

of passengers to New York Harbor. Waugh recorded this vista from a point just above the Battery. The companion notes explain its contents: "On the left lies Castle Garden, and off the Battery, the Chinese Junk, *Keying,* which visited the United States in 1847. In the distance are Brooklyn, Governors Island, and Fort William; and on the right, an Emigrant Ship, discharging, while the wharf, in the foreground, is crowded with the passengers, their property, and friends."

The painting's precise dating has been a matter of some confusion owing to Waugh's inclusion of the *Keying,* a teak-hulled junk from China (visible offshore, with conspicuous upswept ends), in the same composition as the ship discharging passengers and the line of immigrants filing into, or out of, Castle Garden. As the first vessel from the "Celestial Empire" to visit New York, the *Keying* met with great fanfare when it moored at the Battery in July 1847.[2] Its arrival presumably would have been fresh in Waugh's mind when he conceived *The Mirror of Italy.* The disembarkation vignettes, however, more likely associate the canvas with Waugh's later, enlarged panorama of 1854–1855. In that case, artistic license probably accounts for his retention of the exotic *Keying,* which helped to emphasize New York's internationalism. It was only in 1855 that Castle Garden (previously an entertainment center) was converted into a new immigration depot.[3] Here, Waugh recognizes the landmark's recent change in function.

The foreground scene emphasizes the volume of human cargo offloading into New York by the mid-nineteenth century. In 1860 there were 105,123 immigrants admitted at Castle Garden, of whom 47,330 were Irish, 37,899 German, and 11,361 English. Unlike their predecessors, who were vulnerable to waterfront fraud and other abuses, "greenhorns" arriving on the piers near Castle Garden now benefited from police surveillance and the assistance of emigrant aid societies. The reforms in the landing experience at New York Harbor also may have been a factor in Waugh's choice of dockside subject.

Through careful costuming, the artist authenticates the mix of nationalities and social classes both disembarking from ships and greeting travelers. The crowd contains a well-dressed element, although it is unclear whether these figures represent fashion-conscious New Yorkers or newcomers dressed in their Sunday best. Even though Eastern Europeans would not emigrate to the city in significant numbers until the later nineteenth century, a few passengers appear in the black garb and wide-brimmed hats traditionally worn by Jewish men. Most voyagers, however, reflect the predominantly Irish composition of immigrants streaming through Castle Garden in the years following the Great Famine. The ethnic prejudice faced by rural Irish entering this country is indicated in the trunk in the lower right labeled "Pat Murfy for Ameriky" and in the almost simian carica-

tures of the Irish farm boys attired in worn frock coats, peaked hats, and outmoded knee pants.[4] Cluttered around the trunk are kitchen utensils typical of simple hearth-prepared meals. A shawled woman resting on the trunk as she gazes out at the harbor, with children on her lap and at her side, appears more poignant, the pose perhaps alluding to the *Mise Eire* figure symbolic of Ireland's bereavement over her exiles.[5]

Waugh, a Pennsylvania native, also painted romantic landscapes and portraits. His primary acclaim, however, rested on his panoramas based on an eight-year stay in Italy but produced largely in a studio he maintained at Bordentown, New Jersey. Waugh was elected an associate of the National Academy of Design in 1845 and termed an "honorary" academician in 1847, just as the *Mirror of Italy* was nearing completion. His wife and children, most notably his son Frederick Judd Waugh, also pursued careers as painters. Waugh's 1854–1855 panorama remained in the family's possession until early in the twentieth century, when Harriet C. Bryant of West 47th Street purchased a number of its segments. She in turn sold *The Bay and Harbor of New York* segment to Mrs. Robert Littlejohn, who donated it to the Museum.

"Mary Powell," Steamer

1861

JAMES BARD (1815–1897)
Oil on canvas, 30 × 50
Inscribed across bottom:
M. S. ALLISON. BOAT BUILDER. NJ.
FLETCHER, HARRISON ENGINE,
BUILDERS JOHN E. BROWN JOINER
NY. ROGERS, PAINTER. NY PIC-
TURE DRAWN & PAINTED BY.
JAMES. BARD. NY 1861 / 162
PERRY ST.[1]
Gift of Josephine C. Allison,
M32.354.1

THE *Mary Powell*, often called the Queen of the Hudson, was perhaps the most famous and best loved of nineteenth-century Hudson River steamers. Respected for her "family atmosphere,"[2] she appeared frequently in period paintings and prints, and later in photographs, books, and articles. Mary Ludlow Powell, for whom the ship was named, was the widow of Thomas Powell, a prominent Newburgh businessman and founder of the Hudson River Day Line. The *Mary Powell* was built by M. S. Allison (father of Josephine C. Allison, who donated the painting to the Museum) in 1861 for Captain Absalom L. Anderson and his associates for service along the Hudson between New York and Roundout. The vessel, launched the same year this painting was made, served various owners, including the Mary Powell Steamboat Company from 1884 until 1902.[3] Between 1861 and 1920 she traveled an estimated 1.15 million miles, carrying about 150,000 passengers annually.

The *Mary Powell*, a day boat, offered no overnight accommodations but more than compensated for this omission with elegant interior fittings and amenities. Prominent among these was "the forward part of the promenade deck … left unobstructed to permit the full enjoyment of scenery and fresh air," a feature probably designed in response to Captain Anderson's known admiration for the Hudson River vistas.[4] The vessel also boasted a ladies' saloon on the main deck, another smaller saloon on the promenade deck,

and elaborate decor including polished wood paneling in the interior rooms, glass doors for sightseeing, and portraits by Matthew Brady and other local photographers of famous Hudson River Valley personalities (among them General Winfield Scott, Samuel F. B. Morse, John J. Audubon, Washington Irving, Matthew Vassar, Thomas Powell, and Mary Powell herself) transferred onto the glass panels of the clerestory windows.[5]

A guidebook, probably dating from the turn of the century, details the boat, her amenities ("Meals Served at All Hours … Table D'Hote Dinner, 75 Cents"), and her schedule (five and a half hours from the Desbrosses Street Pier to Roundout). It enticed passengers with promises of the route's scenic splendors ("Highlands of the Hudson by daylight") and described the various connections offered along the route: "At Newburgh by electric railroad to Orange Lake and Walden, by ferry and electric cars to Fishkill Landing, Matteawan, Groveville, Glenham and Fishkill Village. At New Hamburgh with stage to Wappingers Falls. At Poughkeepsie with evening trains for the North on the Hudson River Railroad, ferry for Highland, and electric railway for New Paltz, etc. At Roundout with Ulster & Delaware Railroad, for all points in the Catskill Mountains."[6]

Working first with his twin brother, John (1815–1856), and then alone, self-taught marine painter James Bard portrayed the steamboats and small sailing vessels of New York

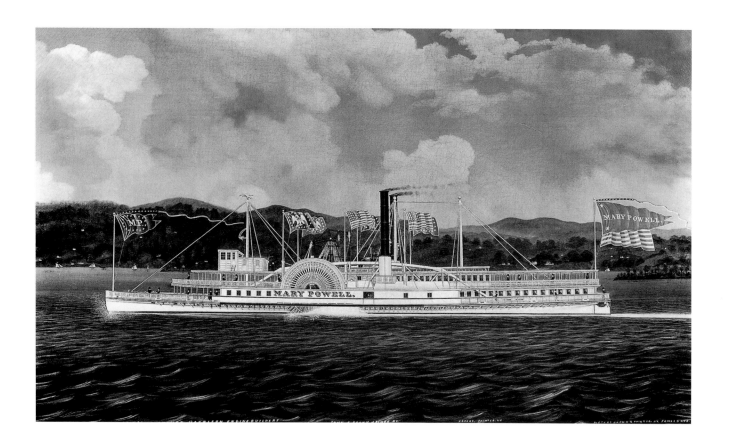

City, the Hudson River, and Long Island Sound. His precision in recording these vessels, with both architectural elements and exterior mechanical parts executed so accurately that shipbuilders claimed they could build the vessel without blueprints, contrasts oddly with the stiff, out-of-scale figures depicted on the ship's decks and the distant boats and houses in the background.[7] Most of Bard's boat paintings, some vessels rendered in more than one version, were done on commission for the Fletcher Boat Yards or, as in this instance, for others involved in the development or management of the ships portrayed. In 1975 Andrew Fletcher, last of the Fletcher family to own the boatyard bearing the name, presented to the Museum of the City of New York twenty-one paintings by James Bard of ships the firm had "engined," along with many other marine paintings and lithographs, maps, blueprints, and extensive records from the firm. The engine designs were transferred to the South Street Seaport Museum, while other detailed material went to the Mariners' Museum in Newport News, Virginia. Upon Fletcher's death in 1977, six more paintings, including two by Bard, were bequeathed to the Museum. Bard's work endures as an invaluable document of a vital river era in American water-transportation history.

The "Emma Abbott," First Floating Hospital

1876

Julian O. Davidson
(1853–1894)
Oil on canvas, 44 × 73
Signed lower right: *Julian O. Davidson / 1876*
Gift of St. John's Guild, M45.17

In 1866 a group of parishioners of St. John's Chapel on Varick Street (see plate 15) established St. John's Guild to help the city's impoverished and "to alleviate the squalor and inhumanity of their living conditions."[1] Guild volunteers carefully interviewed prospective recipients of their largesse. Reports of these interviews provide a glimpse of the era's tenement-house poverty. One interviewer cited "a widow with four children whom she is unable to provide with food or clothing; they are absolutely naked and crying with hunger," and described the case as one "of extreme destitution" demanding "immediate aid for all these wants."[2]

After eight winters of providing food, clothing, fuel, and similar necessities for poor families, the guild expanded its work to address the problems of New York's unbearably steamy summers. Speculating that fresh air, sunshine, and simple, healthy food would counteract the ill effects of the "noisome dens in which so many live,"[3] in 1874 the guild chartered a barge for children's seagoing excursions.[4] Benefits of the trips proved so great that on May 19, 1875, the guild ordered from Lawrence and Foulks a ship to accommodate twenty-five hundred sick children and their mothers. The twenty-thousand-dollar vessel was underwritten by Emma Abbott (1850–1891), a singer noted for her role in popularizing opera in the United States. Exactly two months later, her namesake began its first season of three weekly trips along New York's

rivers and harbors. Beginning in July 1881 the *Emma Abbott* carried sick children, deemed by the ship's doctor to require more prolonged treatment than a day at sea, to the guild's newly constructed Seaside Day Nursery in Staten Island. In 1887 the Floating Hospital added nurses to the staff in its Staten Island facility, changed its name to Seaside Hospital, and began to treat convalescing adults as well as children.

Having carried a total of 909,104 patients during a twenty-seven-year career, the *Emma Abbott* served until 1902, when it was replaced by the more modern *Helen C. Julliard* and subsequent ships. When St. John's Guild disbanded in 1980, their Floating Hospital incorporated independently, with its own board of trustees. Today, continuing its role of service to the poor, the Floating Hospital moors the *Lila A. Wallace* in the East River. Programs include free health clinics emphasizing preventive medical education, social services, and entertainment programs run by trained adult volunteers for the benefit of senior citizens and families. The Floating Hospital's earlier mission has been expanded to focus on such problems as AIDS, child abuse, and substance abuse.

Julian O. Davidson, who wrote of himself that at seventeen he "quite literally ran away to sea," was a painter, engraver, and illustrator of ship's portraits and marine battles that reflect the influence of earlier Dutch, French, and English marine painting styles in their adroitly

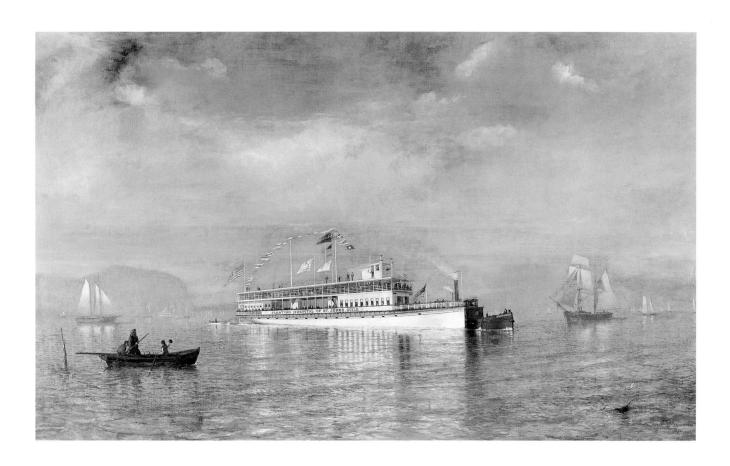

depicted skies, accurately rendered water, and carefully delineated ships' details. He was born in Cumberland, Maryland, traveled extensively, and served a two-year apprenticeship in his father's New York civil engineering office. Renouncing an engineering career, in 1872 Davidson became a student of Mauritz F. H. DeHaas. By 1874 he had taken a studio of his own at 788 Broadway. Davidson exhibited frequently at the National Academy of Design from 1877 until the end of his life and provided many marine subjects for periodicals including *Harper's,* the *Aldine,* and *Century.* Responding to the ascendancy of steamships as the age

of sail waned, Davidson captured the power and seeming invincibility of these mammoth new vessels.[5] In his rendering of the *Emma Abbott,* the sheer size of both canvas and ship seems to suggest the bounteous nature of nineteenth-century munificence to the "deserving poor." No record has been located regarding the circumstances of his commission to paint this ship's portrait.[6]

Woodruff Stables

1861

Johannes A. Oertel
(1823–1909)
Oil on canvas, 24 ¼ × 40
Gift of Harris Fahnestock,
34.340

In the mid-nineteenth century, Hiram Woodruff (1817–1867) was considered New York City's preeminent dealer, trainer, and rider of fine horses. Woodruff had been born into a family of horsemen that included his father, John, and uncle, George, who ranked among the outstanding horse trainers of their day. John Woodruff also managed the Harlem Course, Manhattan's first official trotting track at Harlem Lane (now St. Nicholas Avenue), and a tavern named the Red House, both highly popular with owners of fine horses. By age fourteen Hiram was winning saddle races.

In 1866 Jerome Avenue opened to allow access through the Bronx to the Jerome Race Track, in Westchester County.[1] The track also served as home base for the American Jockey Club. Stables and inns catering to horse and racing devotees dotted the avenue, making this thoroughfare an ideal venue for Woodruff's business. Such wealthy customers and equine connoisseurs as Commodore Cornelius Vanderbilt, August Belmont, Jay Gould, theatrical producer Lester Wallack, and political leader Ogden Livingston Mills patronized Woodruff Stables, paying as much as thirty thousand dollars for a choice horse.

The scene accurately depicts the clutter and movement of the stable yard, with skillfully rendered dogs, horses, and men in various standing and moving postures.[2] The still-rural nature of the Bronx is evinced by the trees, arbor, and picket fence visible in the background. Oertel's painting of Woodruff's

enterprise became the basis for an advertisement for Brewster and Company, carriage makers, in which the three Brewster partners— Henry Brewster, James W. Lawrence, and Jonathan W. Briton—are identified in the lower margin.

Johannes Oertel, born in Fürth, Germany, served an apprenticeship with an engraver in nearby Nuremberg. Following the 1848 German revolution he emigrated to the United States, settled in Newark, New Jersey, and became a drawing teacher.[3] His subsequent career combined painting, engraving for banknote companies, and twenty years of service as rector of various Protestant-Episcopal congregations in Florida, North Carolina, and other southern states. Oertel's works included religious subjects, landscapes, and animals. In 1857 he was among the artists who decorated the Capitol in Washington, D.C.

Fifth Avenue at 89th Street in 1868

1868

Ralph A. Blakelock
(1847–1919)
Oil on canvas, 15 ¾ × 23 ¾
Signed lower right: *R. A. Blakelock*
Gift of Archer M. Huntington, 32.333

By the end of the Civil War, Fifth Avenue north of Washington Square to 59th Street boasted more than 340 private residences, among which stood many of the city's largest and most extravagant homes. By the dawn of the twentieth century, the avenue had become synonymous with wealth, high fashion, and architectural elegance. While the gentry of nineteenth-century New York built urban villas on mid-Fifth Avenue, wide open stretches of the boulevard north of 60th Street had been settled by African Americans and German and Irish immigrants. These residents operated truck farms and kept goats, chickens, and pigs but were powerless to hold onto their tracts in the face of such politically charged real estate developments as Central Park or, subsequently, the enormous price rises of the residential areas created at its borders. As late as 1905, when millionaire Andrew Carnegie erected his mansion at Fifth Avenue and 91st Street, his nearest neighbors were living in dwellings like the principal structure depicted in this view, which has been described as clearly related to an Irish architectural prototype, particularly because of its roof, which is apparently being thatched.[1] Although *shanty* has come to suggest a rough, makeshift dwelling for those unable to command anything more substantial, the word originally described this type of more solid structure.[2]

Blakelock's canvas, with his typically thick paint, depicts a cluster of these "shanty" structures near 89th Street. It is one of a series

of paintings and drawings recording similar settings in upper Manhattan that Blakelock executed between 1860 and 1880. Blakelock, unlike most of his artist contemporaries, was attracted by the picturesque aspects of these simple domestic buildings with their weather-beaten textures and solidly designed features.

Records suggest that Blakelock was almost entirely self-taught. Although not elected to the National Academy of Design until 1913, he exhibited there frequently from 1868 until 1899, when, after several bouts of recurring mental illness, he suffered a severe and disabling breakdown, which curtailed his productivity.

Blakelock's work as an urban-scene painter records areas of the city on the verge of enormous physical changes. His moonlit landscapes are considered central to his career and perhaps best represent his moody artistic vision.[3]

147

Coney Island

c. 1862–1865

Sanford Robinson Gifford
(1823–1880)[1]
Oil on canvas, 11 × 21½
Signed lower left center:
S. Gifford (signature followed by
illegible date, c. 1860s)
From the collection of the late
Claudius Conant, lent by his
daughter Sarah Conant Ostrom
(Mrs. Homer Irvin Ostrom),
1935, and by his granddaughter
Virginia Ostrom, 1942, L1449

The sandy strip that became New York City's playground belonged originally to Gravesend, a town established in 1643 by a band of English colonists. Their individual holdings were divided and re-divided among descendants, farmers who paid scant attention to the five miles of non-arable beach to the south.[2]

In 1829, with construction of a shell road, a bridge from the mainland to the island, and an inn named the Coney Island House, New Yorkers began to regard a trip to Coney Island, especially one aboard a breeze-cooled steamer, as an enticing summer escape from the city. At first the domain of the wealthy and prominent (early visitors included Washington Irving, Jenny Lind, and Walt Whitman), Coney Island's further development inevitably brought social changes. By the beginning of the Civil War, it had become a place for romantic assignations and a destination for boatloads of day-trippers of dubious social standing who often behaved rowdily. The opening in 1869 of the earliest train connection, the Brooklyn, Bath and Coney Island Railroad, enabled more visitors to travel there at cheaper rates, assuring the resort a continuous summer flow of middle-class New Yorkers.

In this view of one of America's earliest seaside resorts, probably taken from further east on the island, Sanford Gifford used a horizontal format to emphasize the gently curving beach and lapping waves of the summer seascape. The arrangement of sea, sky, and beach, with only the distant buildings (hotels, bathing pavilions, and other resort delights) for vertical accent, represent elements of Gifford's approach to his many representations of the south-shore beaches of Long Island in the 1860s and 1870s. The softly diffused atmospheric illumination, the great expanses of sea and sky resonant with the effects of light and atmosphere, and a carefully plotted geometric composition combine to achieve the illusion of a motionless moment.

Lion Brewery

c. 1875

N. F. Rosenberg (active 1875)
Oil on canvas, 33 ¾ × 50
Signed lower left: *N. F. Rosenberg*
Gift of Paula Murray (Mrs. Frederic R. Coudert, Jr.), 43.227

New Yorkers had been quenching their thirst with English-style beer since Colonial times. As water quality deteriorated in the rapidly growing city, however, so did the flavor of the drink. The opening of the Croton Aqueduct in 1842 brought not only a safer water supply to the city but also a significantly improved taste to its water and the beverages made from it. In 1850 August Schmid and Emanuel Bernheimer, recently arrived from Germany, established the Costanz Brewery at East 4th Street near Avenue B, filling the demand of their fellow immigrants for the familiar lager beer of their homeland. By 1852, the great success of that enterprise encouraged them to build a second Costanz Brewery at Four Corners in Staten Island, then home to a sizable community of German immigrants. Eight years later, Bernheimer became the partner of another German immigrant, James Speyers, in his Lion Brewery, established in 1857.[1]

The Lion Brewery, depicted here, occupied a site bounded by Eighth and Tenth Avenues (today, Eighth Avenue becomes Central Park West north of 57th Street, and at the same point Tenth becomes Amsterdam Avenue) and extending from 107th to 109th Streets. The background view includes Central Park, with a glimpse of the Blockhouse, a relic from the War of 1812. During this period, Manhattan's Upper West Side, a relatively open area offering inexpensive land, accommodated numerous public institutions, among them the adjacent Leake and Watts orphanage at 110th Street and Broadway and the Bloomingdale Insane Asylum at 116th Street and Broadway (now part of the Columbia University campus). Also clustered in the neighborhood were the shanty homes of at least five thousand people (and perhaps as many as ten thousand) displaced by the formal opening of Central Park in 1859. The combination of shanties, public institutions, and such foul-smelling industries as breweries explains why the Upper West Side failed to develop the real estate value of other areas bordering Central Park until the early twentieth century.

The imposition of a one-dollar tax on each barrel of American-made beer, marking the establishment of the Internal Revenue Act in 1862, helped to finance the Union government during the Civil War and drove many small breweries out of business.[2] Larger operations, such as the Lion, flourished through improved financing and marketing and by encouraging the saloons that were licensed to sell their beer to become cleaner and more attractive. The Lion continued to operate at the 107th Street site until 1941, when the business folded. Today, apartment houses occupy the brewery's former location. Rosenberg's painting is valuable for the record it provides of a time when the Upper West Side was home to one of Manhattan's major manufacturing establishments and not the densely populated neighborhood it is today.

The New York City directory of 1875 lists a Frederick Rosenberg, painter, living at 115 East 118th Street. He may have been the artist of this work, but no other information about the artist's identity has surfaced.

AS EARLY as 1833, William Cullen Bryant, editor of the *New York Evening Post*, began to advocate for setting aside a sizable chunk of undeveloped land before urban growth engulfed the whole of Manhattan Island.[1] In July 1844, through the editorial page of his newspaper, Bryant made an appeal for a public park of the size and scope already found in major European cities. Debate and political maneuvering ensued,[2] culminating in the state legislature's authorization in 1853 for the city's purchase of a centrally located parcel of 760 acres bounded on the south by what would become 59th Street, on the north by 106th Street (later extended to 110th Street), on the west by Eighth Avenue, and on the east by Fifth.[3]

Those favoring development of a park described the tract as a "wasteland" populated by "squatters" living in "shanties," thereby establishing the traditional view justifying the takeover of what was in reality Seneca Village, a poor but cohesive community of mostly African American farmers and workers, many of whom owned their homes and land, paid taxes, and maintained three churches, a school, and a cemetery.[4] Also within the 760 acres were other less organized communities, home to Irish pig farmers and German day laborers; these, too, were uprooted for the realization of what came to be known as the Greensward Plan, designed by the landscape design team of Frederick Law Olmsted and Calvert Vaux,

to develop the tract into "the culmination of England's picturesque landscape tradition molded to American vision."[5]

New York's citizens eagerly awaited the benefits of this enormous undertaking. Rather than wait for the whole enterprise to be finished, the public put each segment of the park to use as it was completed. Although the formal opening of the entire park would not occur until 1865, by 1862 the Ramble, the first three-and-a-half miles of roadway, the Mall, and the Lake annually attracted 2 million visitors on foot and seven hundred thousand by carriage. The roadways, smoothly graveled, encouraged more residents to take up horseback riding, while the Lake's first winter of good ice stimulated new interest in ice skating (see plate 40).

In this view, executed in 1862, the newly planted trees allow a wide-ranging view of the unfinished park, in particular the roadways that appear to meander but in fact were planned to carry both east-west and north-south traffic. On the horizon glimmer the far-off city buildings, their reduced scale emphasizing the new delights of the acres of swamps, rocks, hog farms, and slaughterhouses transformed by Vaux and Olmsted into a multi-faceted urban pleasure ground that *Harper's Monthly* hailed as "the finest work of art ever executed in this country."

Expatriate artist George Loring Brown's

romantic, atmospheric landscapes established him as one of mid-nineteenth-century America's most prominent painters. Studies in Paris had introduced him to the academic landscape compositions of Claude Lorrain, whom he copied so often and so convincingly that he earned the nickname "Claude" Brown. Although he lived in Italy, the artist often crossed the Atlantic to undertake commissions in Boston and New York.

Skating in Central Park

1865

JOHANN MENGELS
CULVERHOUSE (1820–c. 1891)
Oil on canvas, 19 ¾ × 35 ⅛
Signed lower right: *J. M.
Culverhouse, 1865*
The J. Clarence Davies
Collection, 29.100.1301

THIS CRISP and lively panorama of skaters at the Lake near the center of Central Park was painted only seven years after Frederick Law Olmsted and Calvert Vaux submitted their "Greensward Plan" to New York's City Council. The Lake's twenty-acre setting proved congenial to this winter recreation, and in 1863 Central Park's commissioners, departing from their usual neutral prose, issued a congratulatory report noting the aesthetic consonance between skating and the park's landscaping: "The movements of a throng of skaters, on a clear day, chasing each other over the crystal ceiling of the imprisoned lake,… the dusky foliage of the fir and pine on the adjacent heights, wrapped with wreathes of fleecy white; leafless branches strung with a fairy network of icy pearls … form in our midst a winter scene unmatched by that of any capital or country of modern times."[1]

Johann Mengels Culverhouse, born and raised in Rotterdam, immigrated to New York City sometime before 1849, when he began to exhibit genre subjects, largely rustic tavern and marketplace scenes, at important art venues in New York and several other cultural capitals on the East Coast. Although he resumed his art career in Europe during the Civil War years, he was back in New York by the mid-1860s, associating himself with a local publisher of engravings while selling his oils and showing periodically at the National Academy of Design. Culverhouse's partiality for moonlit scenes and artificially illuminated interiors led to his reputation as a deft "candlelight painter" in the Dutch and Flemish traditions.

Another marketable talent that Culverhouse brought to New York was his expertise as a painter of skating scenes. Between 1865 and the late 1870s he produced many pleasing variations on the theme of decorous crowds testing their abilities on ice—by day and after dark, on urban ponds and on country creeks, in picturesque American locales and in such foreign surroundings as the Bois de Boulogne and the canals of his homeland. His landscapes of Central Park in winter, of which this late-afternoon view is a prime example, demonstrate the acuity of details and romantic temperament that merge in this ice-skating series.[2] Here, practitioners perform the well-rehearsed rituals of gliding, coaching, observing, and occasionally falling in a pastoral theater betraying few clues, beyond the skaters' fashionable attire, of its city situation. The golden pink rays of approaching twilight, and the dusting of snow that mutes the park's surrounding terrain and support structures, heighten the scene's gaiety. The warming house, partly visible at far left, marks the site where the Terrace and Bethesda Fountain would soon take form. On the hillside to the left is a rustic summerhouse, which no longer exists. In the distance, the arch of Bow Bridge is discernible, supporting its original ornamental vases atop end posts, which were later removed.

Culverhouse's painting was featured, together with several other canvases by him, in the fall 1877 exhibition of the Brooklyn Art Association. Little is known about his life thereafter, but it was peripatetic if the wide range of his place-specific landscapes is a reliable measure. He is presumed to have been actively working in the United States until around 1891.[3]

Moonlight Skating—Central Park, the Terrace and Lake

1878

JOHN O'BRIEN INMAN
(1828–1896)
Oil on canvas, 34 ½ × 52 ½
Signed lower right: *J. O'B. Inman*
Anonymous gift, 49.415.2

LONG PRACTICED as a sport in Holland and Scotland, ice skating developed as a popular pastime in the United States after the Civil War. The lakes and ponds incorporated into urban parks of the period played an important role in the spread of the sport and proved ideal for the new skate, invented in 1850, which provided the wearer with greater control and speed. Skating in Central Park began in December 1858, when part of the unfinished lake south of the Ramble was flooded and froze, beginning a social revolution that reinforced the democratic ideas of landscape designers Frederick Law Olmsted and Calvert Vaux, who had conceived the park as an arena for instilling concepts of beauty and order in those who visited it.[1] For women, whose exercise had previously been limited to ladylike promenades, skating not only presented an opportunity for vigorous yet graceful movement but also offered a new kind of freedom for social encounters in an approved setting.

The novelty of "ice preserved day after day in good order and order preserved day after day on good ice" attracted the interest of thousands of skaters, thereby stimulating the rapid improvement of every aspect of ice skates.[2] Better skates and the park's new twenty acres of ice led to enormous popularity for the sport. Very soon, skating clubs for the affluent sprang up all over the city, leaving Central Park Lake to the less prosperous. For some, however, just the cost of transportation to the park put skating there out of the realm of possibility.[3]

When the ice was hard enough for skating, a red ball would be hoisted from a bell tower on Vista Rock, where Belvedere Castle stands today. The site's attractions included calcium reflectors for night skating and temporary warming huts at lakeside.[4] Artists were quick to respond to the pictorial possibilities of this new sporting resort, which challenged them to record the gliding motion of the colorfully clad skaters traversing the lake. John O'Brien Inman, perhaps influenced by his exposure to nocturnes during a twelve-year European sojourn from which he had returned in 1878 (the year he executed this painting), chose to depict this activity at night. Beneath the moonlight, skaters crisscross the lake against a background of the Terrace north of the Mall, with Bethesda Fountain looming at the lake edge.

Inman was the son of the artist-portraitist Henry Inman, with whom he studied. He traveled through the South and West, executing portraits, and periodically returned to New York, where he was an associate of the National Academy of Design.[5]

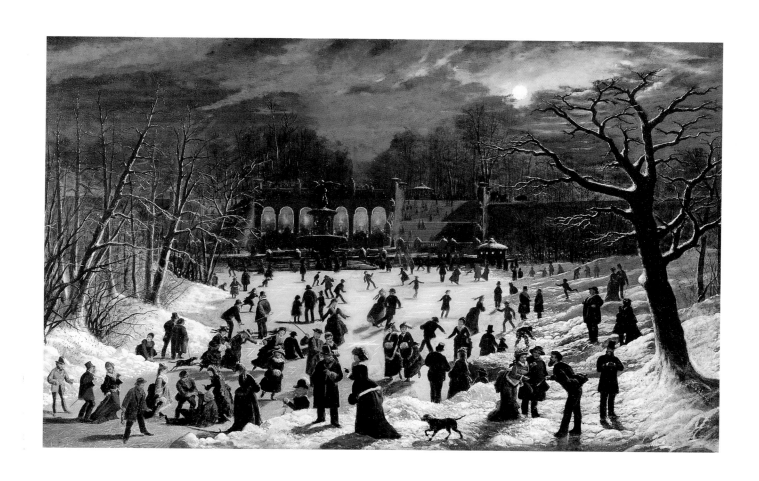

**Frank Work Driving a Fast
Team of Trotters**

c. 1892

JOHN J. MCAULIFFE (1830–1900)
Oil on canvas, 25 ½ × 35
Signed lower right: *J. McAuliffe*
The J. Clarence Davies
Collection, 29.100.1312

THE ELEGANTLY attired sportsman Frank Work (1819–1911), shown here driving a pair of fine matched trotting horses, came from a poor family of Chillicothe, Ohio. At eighteen he arrived in New York City, where hard work and an association with Commodore Cornelius Vanderbilt enabled him to become one of the richest members of the New York Stock Exchange. At his death in 1911, he left an estate of $15 million.[1] Work's great passion was for good horses, which he housed in an elaborate private stable on West 56th Street. Work's daughter, in the style of American heiresses of the day, married a member of the Anglo-Irish nobility. Work's great-great-granddaughter through this linkage was the late Princess Diana of England.[2]

This view depicts the site where drivers gathered to run their horses and to compete with each other. The locale can be identified by the gambrel-roofed, cupola-topped "White House" built as a summer residence by the De Lancey family about 1828, later known as the Watt-Pinckney house. To the left, just above the line of low hills, are the apartment buildings built in 1891 in what is now the St. Nicholas Historic District, between West 137th and West 138th Street and Seventh and Eighth Avenues.[3] In the 1920s and 1930s, after the American Negro Theatre produced a play about the people—mostly African Americans—who strove for upward mobility by living there, this group of well-designed houses was called "Strivers' Row."[4]

In the era when men like Frank Work and Commodore Vanderbilt drove fine trotting teams, this stretch of Eighth Avenue above the intersection of 110th Street was a soft dirt road, considered best for racing. There were daily speed parades along this route, the drivers for the most part attired as elegantly as Work is in this painting.

Irish-born John McAuliffe came to the United States in 1847 and settled in New York as a house painter.[5] However, his fascination with horses and his ability to draw and paint them provided him with a new career in an era when New York City, home of both the first trotting track and the first trotting club, was enamored with the sport. His best patrons were wealthy men who took great pride in their horses and their ability to drive them well. Nineteenth-century clothing catalogues date Mr. Work's derby about 1892, thereby establishing an approximate date for the painting.

**The Bauern Haus and Carousel
(Rockaway Beach)**

c. 1880

ARTIST UNKNOWN
Oil on canvas, 28 ⅛ × 31
Gift of Mrs. Bertha Schildt
Hornbostel, 52.323

THE CAROUSEL depicted in this engaging work was brought from Germany to Rockaway Beach before 1880 by its owner, Frederick Schildt, who also built and ran the Bauern Haus (Farm House) Hotel seen behind the carousel. Schildt's portrait adorns the carousel, the top of which displays colorful drawings of what appear to be storks, fantastical figures, and various other animals. A sequence of human labor, horse power, steam power, and finally electricity propelled the carousel before its destruction in a large fire that devastated Rockaway Beach in September 1892.

In addition to bringing the first such amusement to Rockaway Beach, Schildt invented boats for use on a merry-go-round. In the *Rockaway Journal* for 1884, he advertised his hotel as "The German Castle and Carnival, First-class rooms for boarders," boasting a restaurant "on the European Plan," a dancing hall, and a well-supplied bar.[1]

The Bavarian-style architecture of the hotel, with its nesting stork and indications of a thatched roof, is verified by a print recording the complex in the collections of the Queens Historical Society. In that engraving, the buildings bear signs in German; undoubtedly Schildt was trying to attract the patronage of New York City's sizable German-speaking community, who often organized Sunday outings to such entertainment spots. The open structures to the right and left of the carousel can be identified from the related print as pergolas for sheltering visitors.

Rockaway is a long narrow peninsular beach that runs along the southern mainland of Queens.[2] Like Coney Island, its inaccessibility in pre-railway times assured its exclusivity as a resort. Railroads from New York City to Rockaway were constructed in 1868, 1872, and 1878. These lines and an accompanying building boom made the area more accessible, drove society leaders further east to the Hamptons, and by 1900 had turned Rockaway into a lower-middle-class summer refuge.[3] Now a year-round residential community of both private houses and apartments, Rockaway still draws summer crowds to its amusement park, boardwalk, and five miles of beaches.

According to Frederick Schildt's daughter, who donated this work to the Museum, the artist of this painting and of Schildt's portrait was a hotel guest.[4] The seaside holiday atmosphere is expressed by the animated carousel riders and those observing the fun, and by the lively drawings decorating the top of the carousel. The briskly fluttering German and American flags and the use of bright colors enhance the festive feeling. Whereas both the decorative drawings and Schildt's portrait demonstrate some artistic capability, mastery of perspective seems to have eluded the artist.

Brooklyn Bridge Celebration, May 1883

1883

Warren Sheppard (1858–1937)[1]
Oil on canvas, 24 × 40
Signed lower left: *Warren Sheppard. / 1883.*
Lent by Edward C. Gude, L779

The Brooklyn Bridge, officially named but rarely called the East River Bridge, is one of New York's premier landmarks. An example of the highly regarded nineteenth-century American engineering ingenuity, it took nearly sixteen years to finish and caused the death of twenty men, including designer and engineer John Roebling (1806–1869), and was also responsible for the permanent ill health of his son and heir to the project, Washington Roebling.

Brooklyn's population doubled from four hundred thousand in 1869 to more than eight hundred thousand in 1890. Before the bridge was built, the many Brooklynites who commuted to Manhattan jobs were dependent on ferries, which were often rendered unreliable by inclement weather. After the particularly severe winter of 1867, the long-debated plan to bridge the East River was approved by the state legislature, and the New York Bridge Company was formed for the purpose.

In addition to being a brilliant feat of engineering, the Brooklyn Bridge was emblematic of the unification of Brooklyn and Manhattan in the 1898 consolidation of Greater New York. Upon its opening, various modes of over-the-bridge transportation made Brooklyn's unsullied shoreline and open green spaces accessible to Manhattanites.

The Brooklyn Bridge set a new world record for size in a suspension bridge. All similar structures that followed it were larger, but none added to Roebling's technological inno-

vations, including his inventive uses of steel— both artistic and structural—with the resultant realization of its capabilities for high-rise construction. These developments introduced new building possibilities to a city seeking ways to accommodate a rapidly expanding population.[2]

The bridge's roadbed included two sets of railway tracks, a pedestrian promenade, and two carriageways, one of which was closed to all but pedestrian traffic on holidays and Sundays, when city dwellers turned out in vast numbers to admire the views from the city's newest and highest vantage point, dubbed the "Eighth Wonder of the World."[3] The towers (276 feet above high tide) and center span (1,595 feet) set records for height and length, but the spun steel cable slung from the two granite towers represented the greatest technological advance and gave the bridge its singular appearance.

On May 24, 1883, following a day of formal ceremonies that included President Chester A. Arthur's leading a procession of dignitaries across the bridge, military bands and salutes, three hours of speeches, and formal receptions, "at 8 o'clock precisely … the first flight of 50 rockets … [was] sent from the center of the bridge … the excursion boats were anchored in the stream…. Fountains of gold and silver stars were set in motion on the towers and from the western roadway of the bridge Japanese shells were fired…. These shells soared to a height of about 800 feet and

then burst, scattering gold and silver rain, stars of gold, blue, emerald, and red, and writhing serpents…. The East River was one blaze of light for the next hour, and the vessels anchored in the river were as clearly outlined against the dark background of the sky as they would have been in a bright sunshiny day."[4] The sensational fireworks exhibition by pyrotechnists Detwiller and Street was chosen by the Executive Committee of the Bridge Company, in their last official act, as an unsurpassable finale for an unforgettable day. Fourteen tons of fireworks, comprising more than ten thousand items, colored the night sky and were reflected in the river for an hour.[5]

Although images of Brooklyn Bridge abound, this nocturne uniquely captures the exuberant celebration of its opening. Warren Sheppard's painting differentiates among the lights of the fireworks that streaked the skies over the East River, the glowing lights of the boats, and the gleaming lights of the city. Sheppard, a distinguished marine painter with an ability to capture moments of haunting beauty and historical significance, found the perfect instant for this work.

Statue of Liberty Enlightening the World

(also exhibited as *The Unveiling of the Statue of Liberty*), 1886

EDWARD P. MORAN (1829–1901)
Oil on canvas, 49 ½ × 39 ½
Signed lower left: *Edward Moran 1886*
The J. Clarence Davies
Collection, 34.100.260

THE STATUE of Liberty, one of the world's paramount landmarks, was presented to the people of the United States by the people of France at a gala unveiling ceremony in New York Harbor on October 28, 1886. Since the time of its official acceptance by President Grover Cleveland, "the Lady with the Lamp" has become the distinctive symbol of welcome to New York Harbor and the United States, as well as a beacon to oppressed émigrés to whom the figure personifies democracy, freedom, and opportunity.

The idea for this epic monument began in 1865, inspired jointly by the end of the American Civil War and the abolition of slavery in the United States, and intended to honor Franco-American friendship and express the admiration held by France's citizens for the constitutional democracy of the United States.[1] The sculptor of the statue, Frédéric-Auguste Bartholdi (1834–1904), worked tirelessly to develop the concept for this magnum opus (recruiting the technical advice of Gustave Eiffel, engineer of the Parisian iron tower that bears his name).[2] He also devoted enormous energy to raising money to enable the work's realization in New York Harbor. Bartholdi sold French businesses the rights to use his Liberty figure for use in their advertising, while in the United States publisher Joseph Pulitzer used his newspaper, the *New York World,* to print the names of those who donated funds to build the pedestal for the statue.[3]

For this romantic scene, marine painter Edward P. Moran chose the dramatic moment when a twenty-one-gun salute was fired to welcome President Grover Cleveland onto Bedloe's Island from the small launch transporting him from the Battery. This event (which, according to news accounts, took place in the rain, not the clearing skies of Moran's painting) and the ensuing ceremonies on the island followed in the wake of one of New York Harbor's more spectacular marine parades. The procession, as reported in the *New York Times,* featured "fore-running tugs, snorting and coughing," followed by three stately steamers and many smaller pleasure craft, including "scows plebeian and yachts aristocratic; dredges fresh from delving; nondescripts fished from some aboriginal canal; proud warriors of the sea; ferryboats; freighters, coasting steamers and river craft—everything that could float."[4] Also part of the day's program were reciprocal speeches in French and in English, uplifting contributions from military bands, and, at a wrongly timed but nonetheless memorable moment, the actual unveiling of the statue by the artist himself.[5]

The statue was erected on Bedloe's Island, named for its eighteenth-century owners from whom the State of New York purchased it in 1796. The state ceded the island to the federal government in 1800 for the construction of Fort Wood, part of the harbor defense system installed in anticipation of the War of 1812. The star-shaped fort that preceded Bartholdi's gargantuan figure is partially visible beneath the statue's base.

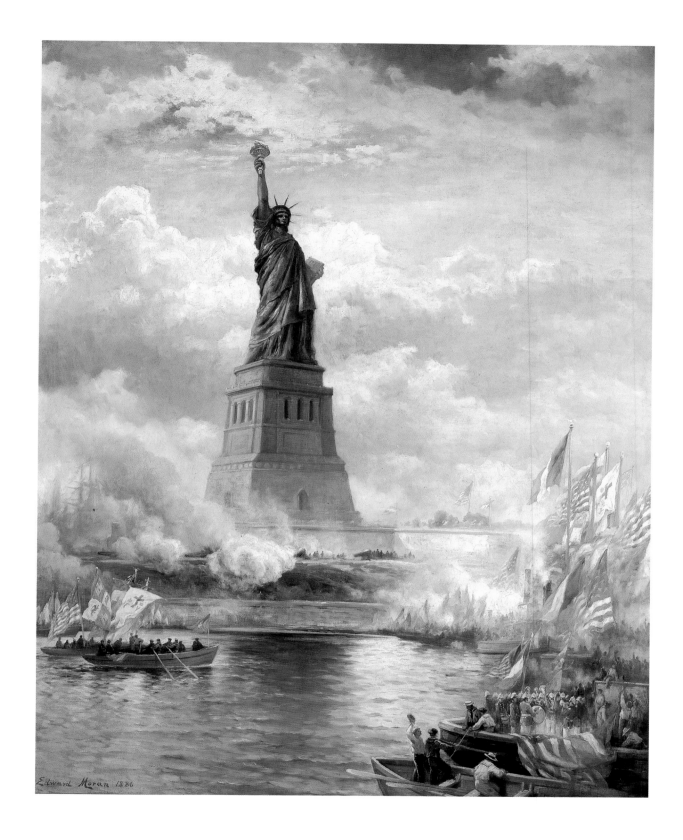

Laying the Tracks at Broadway and 14th Streets

(also exhibited as *Laying Cable for the Broadway Surface Railroad at Union Square*), c. 1891

HUGHSON HAWLEY (1850–1936)
Gouache on paper, 20 × 30
Signed lower right: *Hughson Hawley*
Gift of Colonel Thomas Crimmins, 42.323.104

THE ARRIVAL of cable-powered cars in 1890 marked an improvement in speed, comfort, and service over earlier systems of intracity transport, and necessitated the replacement of outdated equipment with new cable-driven apparatus. This scene records the construction at Union Square of that new cable system for the Broadway Surface Railroad—one of twenty-four firms operating railways in New York at the time.

Irish immigrants and their American-born sons held a broad spectrum of jobs associated with the city's nineteenth-century street railway business. By the 1880s, Sicilian-born laborers had also entered local construction trades, and the two groups' collective contributions to urban transit receive recognition in this tableau.[1]

As a packed commuter car recedes into the distance of Union Square, the workers modernizing the railbed tend to the business at hand, some pausing to confront the artist commemorating their toil. Depicted supervising his employees (at far left) is the formally attired, derby-hatted contractor John D. Crimmins (1844–1917). The son of Thomas Crimmins, an émigré from County Limerick, Ireland, he was born in New York City and became a partner in the family-run Crimmins Construction Company, one of the city's largest and most profitable contracting firms, noted for its ubiquity in municipal and state public-works projects.[2]

Hughson Hawley, an Englishman who immigrated to New York in 1879, arrived with experience as a painter of theatrical scenery and initially applied his talents to work for the Madison Square Theatre. By 1880 his primary professional focus had shifted to the expanding field of architectural rendering. So convincing were the details, coloration, and pictorial perspective of Hawley's building illustrations that leading commercial architects were soon competing for his expertise. Eventually, his prodigious output would tally close to eleven thousand drawings, with Hawley's genius often overshadowing the names of the architects whose structures he had delineated.[3]

Laying the Tracks at Broadway and 14th Streets demonstrates two of the elements of training that Hawley had mastered as a scene painter and illustrator, which would combine to inform his large-scale architectural drawings: keen graphic control enhanced by a sensitivity to tonal values and compositional balance, and the ability to animate the urban backdrop of his main subject with realistic details and action. This richly developed gouache was adapted as an engraving for *Harper's Weekly* (September 26, 1891).

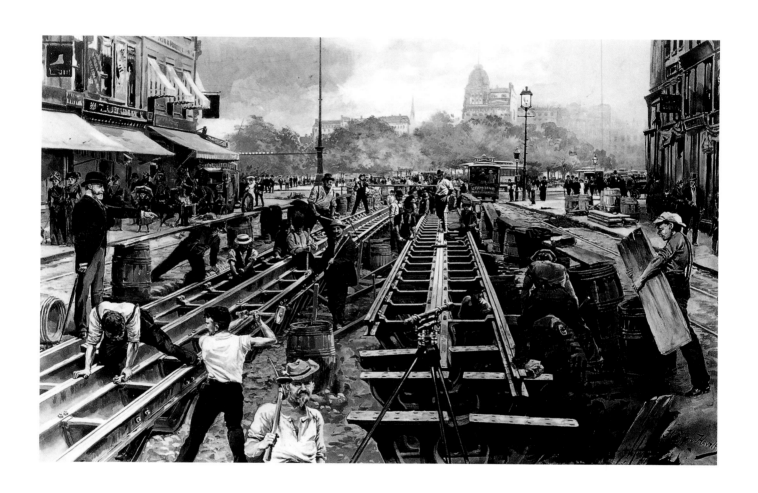

47

Gapstow Bridge

1895

John M. Slaney (active 1890s)

Watercolor, 7 ¾× 9 ½

Signed lower right: *J. M. Slaney / 1895*

The J. Clarence Davies Collection, 89.4.1

In this tightly executed watercolor, the figures standing on Central Park's Gapstow Bridge have been identified as men dressed in the traditional garb of Orthodox Jews. The coloration of foliage in the foreground indicates the season as Rosh Hashanah, the Jewish New Year, when the deeply observant perform the ritual of *Tashlich*. This prayer, recited at the start of Rosh Hashanah, signifies the "casting away of sin" and must be recited near a body of water containing live fish (fish, whose eyes never close, are a reminder to the devout that the Almighty continuously watches over all).[1] The appropriation for religious purposes of so public a space—particularly of Central Park with its extensive rules of use—was probably unusual in this late-nineteenth-century period.[2]

The picturesque Gapstow Bridge was designed by Calvert Vaux both to span the Lake and to frame nearby landscape scenes. Built of wood with cast-iron railings in 1874, it had worn beyond repair in slightly more than twenty years. It was demolished in 1896 and was replaced by a bridge of the stone called Manhattan schist.[3]

The Museum owns several accomplished watercolors, some depicting other vistas and intimate corners of Central Park, by John Slaney, about whom little information has been found other than his consecutive listing as an engineer in the New York City directory from 1889 to 1892.[4]

The 1892 Columbian Parade, Washington Square

1895

Henry Pember Smith
(1854–1907)
Oil on canvas, 36 × 48
Signed lower right: *Henry Smith 95*
Gift of the Rhinelander Real Estate Company, 91.5

The reputation of Henry Pember Smith, a self-taught painter and member of the American Water Color Society, hinged on his New England and Mediterranean landscapes.[1] This detailed urban scene, a departure from Smith's preferred subjects and medium, represents one of the gala public events held in New York City to mark the four hundredth anniversary of Christopher Columbus' landfall in the Americas.

Based on the march route indicated here, Smith's painting probably documents the School and College Parade on October 10, 1892, which inaugurated the city's various Columbian pageants.[2] Celebratory activities occupied much of the week of October 9–15, 1892. On October 11, New Yorkers witnessed a naval spectacle that sailed from Gravesend Bay up the Hudson River to 126th Street, followed by an evening parade of local Catholic societies. Dedication ceremonies for the new Columbus Monument at 59th Street and Eighth Avenue were scheduled for the next day, as was a "grand military procession" uniting soldiers, sailors, police, and firemen in an eight-hour parade that served as the holiday's climax.

The parade shown here, composed of company units drawn from public, military, and Catholic schools, divided twenty-five thousand male students into twenty official regiments, each "commanded" by a grammar school principal.[3] Augmenting the ranks were representatives from local colleges and graduate schools, assembled into a "College Division." Marching bands were interspersed throughout the file. Starting on Fifth Avenue at a point slightly north of a triumphal arch at 57th Street that functioned as one of the centerpieces for the Quadricentennial observances, the marchers flowed south toward Greenwich Village into Washington Square, eventually disbanding at Fourth Street. Fireworks and gun salutes from the Brooklyn Bridge concluded the day.

Smith has captured the participants, with a phalanx of uniformed police in the lead, advancing toward Washington Square Park, nearing a reviewing stand topped by a striped canopy outside the venerable Rhinelander Mansion at 14 Washington Square North—one of four Rhinelander properties along the park's prestigious northern border. The commodious seating area for invited guests had been erected for the Columbian Week proceedings by philanthropist William Rhinelander Stewart.[4] Appropriately festooned with American flags and bunting, the Rhinelander townhouse on the west row of Washington Square North had been designed by Richard Upjohn in 1839 as a home for William C. and Mary Rogers Rhinelander (whose marriage had combined two inheritances, from real estate and sugar refinery interests, into one of nineteenth-century New York's major family fortunes). Occupied by descendants continuously until 1914, the building was owned by Serena and Julia Rhinelander

when the Columbian parade tramped past it. Their nephew, fellow heir, and lawyer William Rhinelander Stewart lived at number 17, a neighboring family-owned townhouse. Active in many causes and institutions dear to Greenwich Village's patrician community, Stewart had initiated the campaign to replace the square's temporary Washington Memorial Arch with a permanent marble version, the bulk of which was in position by Columbus Day 1892. The completion of that project in 1895 solidified Stewart's local renown as the "Father of the Arch."

Smith's painting records both the festivity and the formality that attracted nearly one million people to the city's Columbian observances. "New York was a garb of bridal richness," remarked the *New-York Tribune;* "her houses were veiled with red, white, blue, yellow and green. Her streets were vistas of many colored delights."[5] The School and College Parade, like New York's other Quadricentennial processions, was conducted with full military rigor, enlisting marshals, commandants, and adjutant generals to supervise this impressive show of student patriots. Twelve-year-old Henry Noble MacCracken, a son of the chancellor of New York University, marched with his schoolmates, wearing "Columbus buttons" and "red, white and blue ribbon over one shoulder." "We kept right on down Fifth Avenue," he recalled in his later autobiography. "When we got down to Wash-ington Arch, there was papa and mama waving a flag."[6]

While dignitaries and the paying public could survey Washington Square's Columbian events from several elevated, tented grandstands, the general throng was left to jostle for viewing space at street level. The sun-dappled scene conveyed by Smith, however, suggests little discomfort among those assembled. Nor has the police presence deterred a girl (spotted in the left foreground) from approaching an unaware officer to pick his pocket.

The Bowery at Night

c. 1895

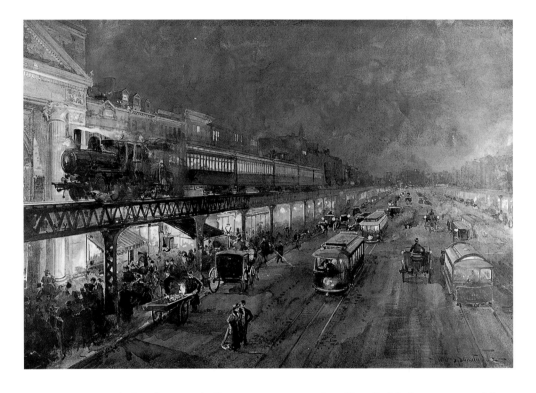

BEFORE ASSUMING its Dutch name, the Bowery, which runs east of Broadway from Chatham Square to St. Mark's Place, is thought to have been a trail used by the local Native Americans. It subsequently acquired a name descriptive of the access it provided to Dutch governor Peter Stuyvesant's seventeenth-century farm, or *bouwerji*. Over the next century, as the farms that lined it gave way to commercial establishments for shopping and entertainment, the Bowery gradually lost its rural aspect. Following a period of fashion and elegance from around 1860 to 1875, the Bowery

emerged as New York's theater center. Many theatrical "firsts"—the first New York performance of a blackface minstrel group, the first stage version of *Uncle Tom's Cabin*, and the birth of Yiddish theater in New York— occurred here.[1] A portion of the famous facade of the last Bowery Theatre, four times destroyed by fire and rebuilt at the corner of the Bowery and Canal Street, is visible at the painting's extreme left.

As the end of the nineteenth century neared, the Bowery experienced a period of decline as an array of saloons, dives, scan-

dalous museums, and cheap auctions contributed to an image of depravity captured in a line from a period song: "The Bowery, the Bowery ... I'll never go there any more!"[2] Cheap tenements built to accommodate the masses of immigrants pouring into the city rapidly sprang up in the area. The construction in 1878 of the Third Avenue Elevated, known familiarly as the "El," further precipitated the decline of this famous thoroughfare. The noise and shadows of the elevated trains eroded real estate values wherever they were built.

This lively nocturne, however, belies the Bowery's shoddy image at the end of the nineteenth century. The bright lights from the open shops and the overhead train illuminate sidewalks thronged with pedestrians, while the roadway itself bustles with an inventory of urban conveyances, from pushcarts and horse-drawn carriages to early motor cars and electric-powered trolleys. Sonntag, employing a wide-angle view of the street, created a theatrical setting in which the energetic thrust of the train emphasizes the drama of the scene. The vibrant nighttime street scene disguises any evidence of underlying tawdriness.

According to his widow, Louis Sonntag, the son of a prominent artist, was an untrained artist, although he no doubt observed his father at work.[3] He frequently depicted the city at night, when artificial light imparts a sense of glamour and excitement to the cityscape and the evening conceals harsher aspects of urban life. Sonntag's work was considered good enough to be accepted for three exhibitions at the National Academy of Design. His premature death at age twenty-nine terminated a promising artistic career.

Rainy Late Afternoon, Union Square

(also exhibited as *Rain Storm, Union Square*), 1890

FREDERICK CHILDE HASSAM
(1859–1935)
Oil on canvas, 35 ½ × 43 ½
Signed lower right: *Childe Hassam / 1890.* Inscribed on back: *Rainy late afternoon, Union Square.*
Gift of Miss Mary Whitney Bangs, 69.121.1

ESTABLISHED AS Union Place under the Commissioner's Plan of 1807, the area later known as Union Square extended from 10th Street north to 17th Street and from Broadway east to Fourth Avenue. The name of the square derived from "the great number of principal streets and avenues" which "united here [more] than at any other square in the city," as reported in a mid-nineteenth-century guidebook to New York.[1] By 1890 the square had undergone transitions typical of other New York neighborhoods as the city spread north, evolving from the crossroads of a farming community to a manicured residential park, a fashionable commercial center, and the city's rialto or theater district.

Union Square remained sparsely settled until 1831, when neighboring landowners, eager to create a new oasis for elite New Yorkers, pressured the Common Council to fulfill the earlier promise of a park. The city acquired additional land between 14th and 18th Streets, Fourth Avenue and Broadway, and developed a residential park design inspired by the Rue de la Paix and the Place Vendôme in Paris. In 1842, with the opening of the Croton Aqueduct, a new fountain added to the charm of Union Square. By 1849 the square, then considered to be very much "uptown," had emerged as a fashionable site for elegant hotels, exclusive boarding schools, and the homes of wealthy New Yorkers.[2] During the 1860s, the well-to-do migrated away from the

area in search of more desirable modern living quarters to the north. Businesses gravitated to the square; eventually the dominant firms were those supplying services to the area's burgeoning theater industry.

In 1882 a demonstration for an eight-hour workday took place in Union Square. The 1893 edition of *King's Handbook of New York City* described the plaza there as "a favored place for large outdoor mass-meetings," implying that its use was evolving.[3] By the early twentieth century, the square had gained a reputation as a spot for politically charged gatherings, which sometimes became confrontations between participants and police. In 1891 the Parks Commissioners granted permission to the Market Florists Association to exhibit and sell flowers and potted plants along the north and east sides of Union Square during the early morning hours.[4] Hassam's placement of several clay pots in the painting suggests that this activity pre-dated the permit.

Beginning in 1886, the painter Childe Hassam spent three years studying, working, and exhibiting in Paris, where he absorbed the canons of Impressionism. After returning to New York City in 1889, he lived at a succession of addresses while painting scenes of American cities akin to those he had done of Paris. In these compositions a densely packed middle ground provided a backdrop to an open, largely vacant foreground stage occupied by more solitary figures isolated from the scene's

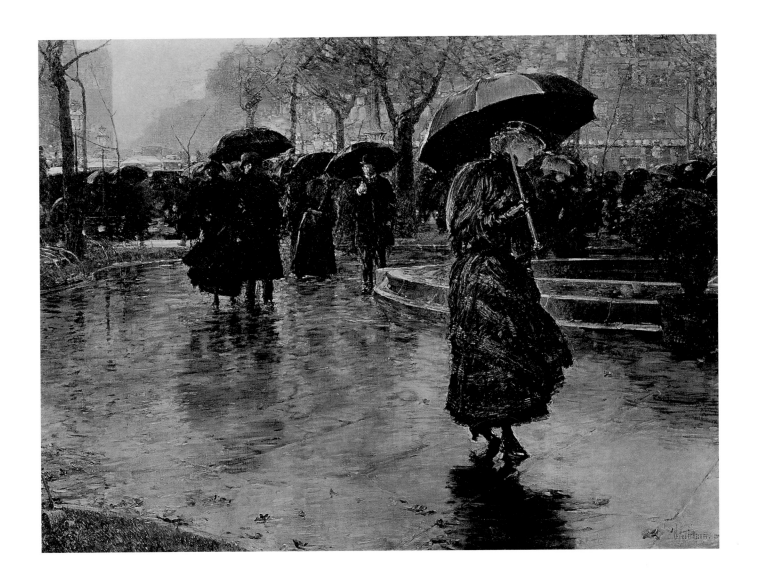

main activity.[5] By placing the compositional elements of the pavement on a diagonal, the artist has used the plaza's open space to push the crowd away from the picture plane, allowing the isolated mid- and foreground figures to stand out.

In an interview in 1892, Hassam spoke of his propensity for studying urban crowds and of waiting to make sketches until "the vehicles or people disposed themselves in a manner more conducive to a good effect for the whole." He also expressed his partiality for depicting rain-soaked street pavements, which he thought "very pretty when … wet and shining, and caught the reflections of passing people and vehicles."[6] In *Rainy Late Afternoon, Union Square* the artist combined these elements with movement and crowds to create a peculiarly urban mood. The approach of sunset is indicated by the fading glow of the distant sky glimpsed between rows of buildings. The dense crowd moving west at the far edge of the plaza and the throng of cabs on what is probably 14th Street suggest a post-matinee crush of theatergoers. A small drama seems to be taking place between the fashionably dressed woman in the foreground and the man standing near the fountain steps, who studies her as she walks away. The viewer can only speculate about the relationship between them.

Although landscapes and shore scenes are also represented in his extensive oeuvre, Hassam clearly welcomed the challenge of painting urban scenes. He produced many views of Parisian street life but particularly valued the New York cityscape as a theme, believing that "the thoroughfares of the great French metropolis are not one whit more interesting than the streets of New York. There are days here when the sky and atmosphere are exactly those of Paris, and when the squares and parks are every bit as beautiful in color and grouping."[7] *Rainy Late Afternoon, Union Square* exemplifies Hassam's deft application of his European training to the American cityscape. Although he is considered an important American Impressionist, it is significant that his style never surrendered realistic representation to the conspicuously loose, spontaneous, often indistinct brushwork of his French counterparts.

Scene on the East River with the Ferry "Queens"

(also exhibited as *New York from the Long Island Shore*), 1890

CHARLES HENRY MILLER
(1842–1922)
Oil on canvas, 33 × 66
Signed lower right: *Chas. H. Miller*
Gift of Mrs. Hiram C. Bloomingdale, 54.140

DEPICTED crossing the East River is the *Queens County*, built in 1859, one of four double-ended ferryboats active on the route between 34th Street and its docking station at Hunter's Point, Queens. Commuters going to Manhattan jobs rode the ferry, as did Manhattanites headed for a day at Long Island's racetrack, connecting at Hunter's Point to the Long Island Railroad. Competition from the opening of various rapid transit tubes and train tunnels under the East River, as well as the 1909 completion of the Queensboro Bridge, closed down this ferry line in 1925.[1]

The artist, Charles Miller, wrote to the painting's first owner, Mr. Lyman G. Bloomingdale, that "the view is ... seen by millions of New York citizens passing to and fro—from Queens—Brooklyn and Manhattan."[2] In the same letter, Miller related that the work, exhibited at the 1892 World's Columbian Exposition in Chicago as *New York from the Long Island Shore*,[3] was "one of a Metropolitan series of Old New York landmarks," including both significant Manhattan sites and views of Manhattan from other shores.

The distinctively tall structure on the Manhattan shore at the left is probably Youle's Shot Tower (see plate 16). The round turrets and long, narrow-windowed wall behind and slightly to the left of the ferry are part of the Blackwell Island penitentiary. The Algonquins called the island Minnehanock; when the Dutch bought it, they named it Varcken ("Hog") Eylandt. With the British takeover of New Amsterdam, the name changed to Perkins Island. In the late eighteenth century the Blackwell family took possession of the property, then sold it to New York City in 1828. Reflecting the presence of many public institutions, the name changed to Welfare Island until 1973, when the island was renamed in honor of President Franklin D. Roosevelt. Today extensive upper- and moderate-income housing covers most of Roosevelt Island's 150 acres.

Charles Miller, trained as a doctor and financially independent, gave up medicine to become a painter in the mid-1860s, pursuing formal studies with Adolph Lier at the Bavarian Academy in Munich.[4] By 1870 he had established a studio in New York City, where he was elected an associate of the National Academy of Design in 1873 and a full academician in 1875. Two years later he joined the Society of American Artists, a group protesting the Academy's conservative exhibition policies, which excluded younger, innovative painters.

In contrast with his Manhattan views, many of Miller's scenes depict rural, agrarian Long Island. In an 1884 review, the art critic S. G. W. Benjamin described Miller's work as picturesque, which he defined as "whatever suggests the dramatic element ... [and] the destiny of man." This quality, Benjamin maintained, was to be found in the older parts of the nation's urban centers as much as in its farms and small villages.[5]

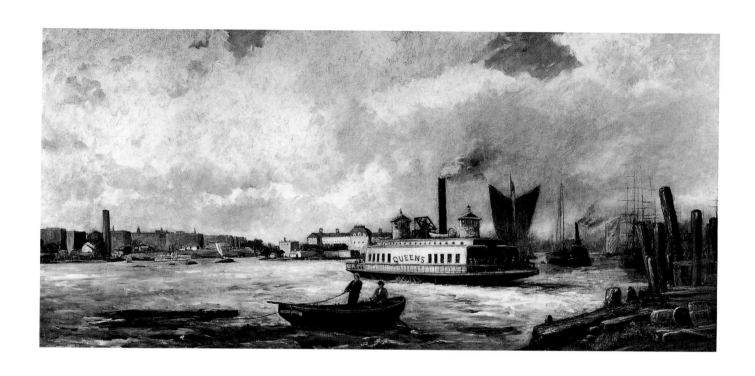

**Sampson and Schley Leading
the Fleet into New York
Harbor, August 20, 1898**

c. 1898

Fred Pansing (1844–1912)
Oil on canvas, 19 × 42 (framed)
Signed lower right: *Fred Pansing*
Gift of Dwight Franklin,
M31.94.7

This naval parade, which traveled north from the Narrows through New York Harbor to this point in the Hudson River, honored Admiral William Thomas Sampson (1840–1902) and Commodore Winfield Scott Schley (1839–1911). The gala procession followed their victory over the Spanish at the battle of Santiago, Cuba, on July 3, 1898, and follows the long-standing New York tradition of celebratory arrivals in the city, whether on land or on water.[1] The fleet, accompanied by numerous police vessels, tugboats, and passenger-bearing excursion boats, is shown steaming past Manhattan's west shore, where Grant's Tomb, built in 1897, can be seen.

Admiral Sampson's flagship, the cruiser *New York*, heads the line, followed by battleships, first the *Iowa* and then the *Indiana*. The fourth ship is the cruiser *Brooklyn*, Commodore Schley's ship, followed by the *Massachusetts*, the *Oregon* (both sister ships of the *Iowa*), and the *Texas* and several other unidentifiable vessels.[2] On the day following the parade, the *New York Times*, in a lengthy article describing the event, emphasized the populist spirit that predominated. Headlines noted "Cheers for Sailors" and "Tenement Residents Particularly in Evidence among the Spectators," while the article described "a welcome to the white-uniformed sailors ... the ones who did the hard work, the unnamed heroes It was peculiarly a day for the common people, afloat and ashore."[3]

Grant's Tomb was the landmark for the end of the parade route, and there a twenty-one-gun salute was fired before the *New York* turned to lead the fleet back downriver. The artist chose to represent the moment the salute was fired (11:37 a.m., according to the *Times*), depicting puffs of smoke at the gun ports of the first three ships.

The bright, clear day, the flags, and the enthusiastic observers on the small vessels enhance Pansing's conveyance of patriotic zeal. The viewpoint at water level accentuates the forward momentum and power of the ships. Pansing's skill in capturing the details of the vessels, found as well in his painting *The Plymouth* (also in the Museum's collection), is intensified by his overall artistic competence in using light, color, and viewpoint to create a stimulating depiction of a major historical event. His skillful rendering of ships in frontal and three-quarter views gives the vessels a less static appearance than the more conventional port-side views.[4]

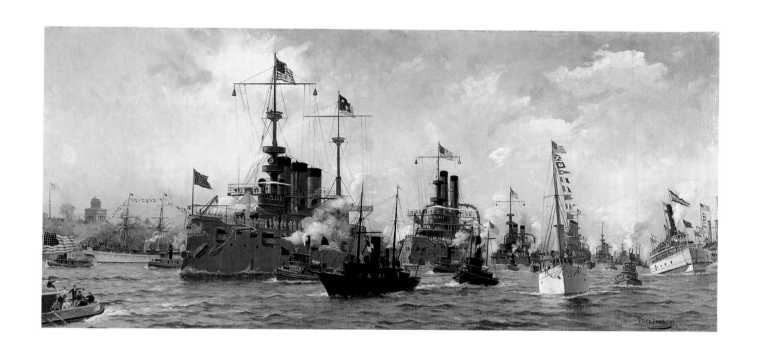

Madison Square

1900

Joseph Oppenheimer
(1876–1966)
Oil on canvas, 30 × 34
Signed lower right: *Jos.*
Oppenheimer
Gift of the artist, 50.165

THE SEVEN-ACRE Madison Square, bounded by Fifth and Madison Avenues, Broadway, and 23rd and 26th Streets, opened on May 10, 1847.[1] Having served as a paupers' burying ground and a military parade ground before its nineteenth-century metamorphosis into a gracious park, the tract became the object of extensive improvements. Between 1847 and 1851, the Common Council voted funds to supply Madison Square with new grading and lawn seeding, an enclosing fence, benches, and gas-fired street lamps. In 1857 a granite monument honoring General William Jenkins Worth, by Henry Kirke Brown (1819–1886), was installed on a small plot on Fifth Avenue opposite Madison Square. In 1876 two bronze statues were dedicated: one, the work of Augustus St. Gaudens (1818–1907), honoring Admiral David G. Farragut, and another, by Randolph Rogers (1825–1892), in memory of William H. Seward.[2] In 1867 a fountain spraying water from the Croton Aqueduct system was moved from City Hall Park to Madison Square. The handsome area rapidly became a stylish locale for the homes of wealthy New Yorkers.

As with most fashionable New York neighborhoods, the infiltration of commerce into Madison Square forced its residents to seek ever-more-northerly residential outposts. By the 1890s a multitude of shops along the side streets and Sixth Avenue encroached on the elegant homes around the square. Construction of the Metropolitan Life Building in 1890–1893 and Stanford White's Madison Square Garden in 1890 (the "Garden" is the twin-turreted white building visible above the trees at the extreme right of the square) gave the square an increasingly commercial aspect.

In 1902, when the Flatiron Building replaced the row of buildings seen along the right side of the painting, this view of the square from the south became something of a historical curiosity. Thereafter, artists—painters, printmakers, and photographers—tended to position themselves on the north side of the square in order to incorporate a view of this new, oddly shaped skyscraper.

Joseph Oppenheimer was born in Würzburg, Germany, and studied at the Munich Academy of Art from 1892 to 1894. He then traveled for several years in Europe and the Middle East and made his first trip to New York in 1900, the year this painting was executed. The source for the painting, a photograph in the family archives in Montreal, appears to have been taken from the studio Oppenheimer rented at Fifth Avenue and 23rd Street.[3] In Germany, Oppenheimer frequently exhibited portraits, landscapes, still lifes, and interiors. Some cityscapes, the fruits of his travels, also appear. His European Impressionist training enabled him to take full advantage of the compositional possibilities offered by the open spaces of Madison Square. He used a muted palette to depict a winter storm–softened cityscape in which the more vivid yellow of the centrally placed trolleys provides a contrasting focal point.

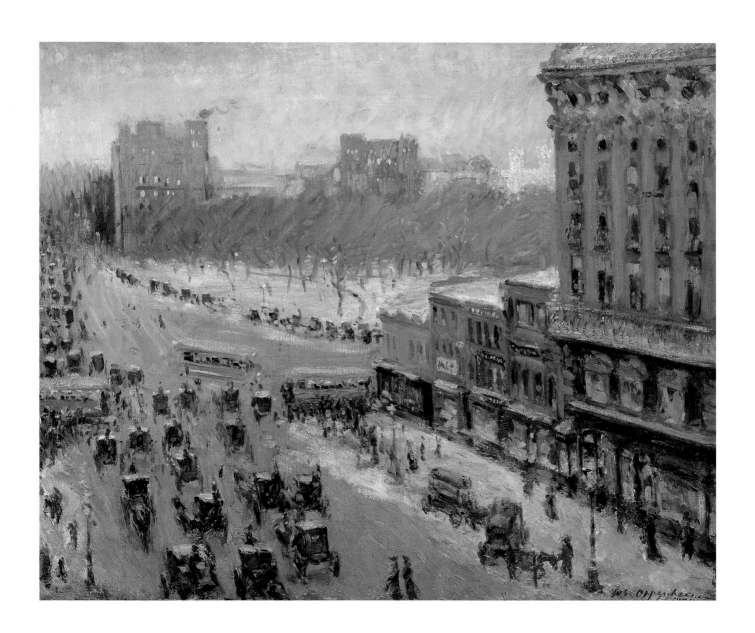

Roof Garden (Study No. 2 for "Sur les toits")

1904

CHARLES CONSTANTIN JOSEPH
HOFFBAUER (1875–1957)
Oil on canvas, 19 ⅞ × 30
Signed lower right: *Hoffbauer*
The Robert R. Preato Collection,
91.76.13

BEGINNING IN the 1880s, rooftop restaurants and cabarets emerged as New York's version of the summer entertainment gardens found in the inexpensive outskirts of European cities. In the absence of such accessible perimeter land, New York City's ever-taller buildings, with their strengthened foundations, steel framework, and passenger lifts, were developed to provide elevated recreational spots.[1] New York's initial roof gardens were located atop theaters, which, before the advent of air conditioning, closed down during the city's hot summers. Probably the earliest was opened in 1882 on the roof of the Casino Theatre, at Broadway and 39th Street, by the theater's resourceful manager.[2] It featured light refreshments, lively musical entertainment, and a few tables and chairs for lounging. Its commercial success quickly spawned imitators along Broadway and elsewhere in the city, notably hotel and apartment-building rooftops that could be converted into garden-like settings offering refreshments and entertainment. The popularity of public dancing led to the conversion of many such sites into cabarets. These alfresco theaters flourished from the early 1880s to the 1920s, when Prohibition, interior cooling systems, and the onset of the Depression combined to render them obsolete.

The European Charles Constantin Joseph Hoffbauer had not visited the United States before a 1903 trip to Rome, where he happened to see photographs depicting New York

City at night. These images provided inspiration for his signature canvas *Sur les toits*. In preparation for the work, which received critical acclaim when exhibited at the 1905 Paris Salon, he created a series of studies, including this one. The scene, though sketchy, reflects the artist's fascination with the legendary magical quality of nighttime New York as experienced by the urbane people relaxing in a luxurious setting. Hoffbauer's meticulous working methods entailed the construction of tiny wax models of the diners, tables, and chairs, from which the studies were composed.[3] The painting is now in the National Museum in Sydney, Australia.

Hoffbauer was born in Paris, where he studied with Gustave Moreau at the Ecole des Beaux-Arts. He traveled and painted extensively in Egypt, Greece, Italy, Holland, and England during the early 1900s, and in 1906 came to the United States to execute several commissions. In 1941 Hoffbauer became an American citizen, settling first in California and then in Massachusetts, where he remained for the rest of his life.

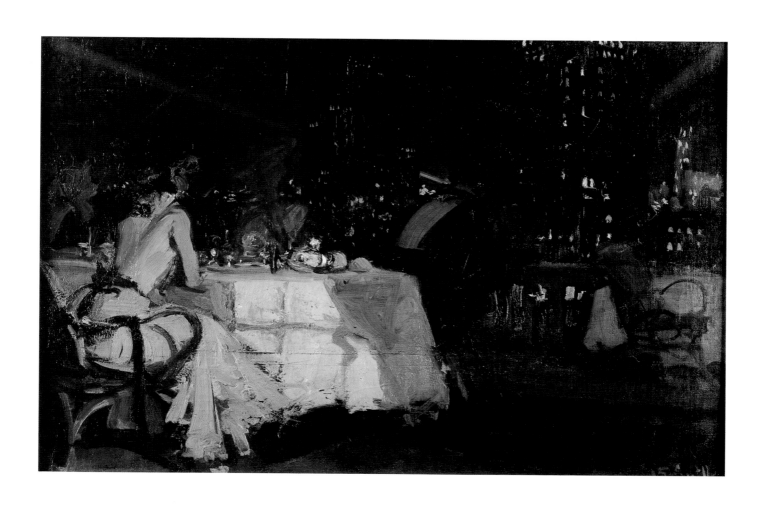

Steeplechase Park

c. 1898–1906

LEO McKAY (dates unknown)
Oil on canvas, 51 × 80
Gift of Mrs. George C. Tilyou,
54.167

CONEY ISLAND has provided New Yorkers with summer recreation and respite from the city's sweltering heat since the 1820s (see plate 37). With the introduction of rides and other boardwalk attractions in the late nineteenth century, Coney Island blossomed into a vast seaside amusement park. By 1905 there were, in addition to Steeplechase Park, the brilliantly illuminated Luna Park (1902) and the whimsical Dreamland (1903).

Steeplechase Park opened in 1897 at Ocean and Surf Avenues and West 16th Street. It was named after a mechanical racecourse (visible here at right center) that sped passengers, clinging to gravity-driven horses, along a half mile of curving tracks in less than thirty-five seconds. The ride concluded on a dark indoor stage, where jets of air blew up women's skirts, to the delight of onlookers. The park's creator, George C. Tilyou, who promoted himself as the "first impresario of controlled chaos," recognized that people in such disconcerting situations were amused, and that at the same time they entertained themselves and each other.[1] He provided wild, raucous rides that produced the surprise effects he intended.

Coney Island's amusement parks represented the recreational use of industrial technological developments, a prime example being the Steeplechase ride. To develop it, Tilyou purchased the U.S. and Canadian patents to William Cawdery's carousel in 1897 and made improvements to it; in 1899 one million people visited the Steeplechase.[2]

Technology also made transportation to Coney Island's attractions cheaper and thus available to a larger segment of the population. Development of large passenger steamships enabled people to travel to Coney Island from New Jersey and other shore points. Tilyou built the Iron Pier to accommodate these vessels. In 1895 trolleys began operating from all over Brooklyn to Coney Island, carrying hoards of fun-seekers, especially on weekends.

The atmosphere of Coney Island encouraged carefree enjoyment. Women with little spending money viewed a trip to Coney Island as an opportunity to travel. Factory girls dressed up as though they were more prosperous stenographers and secretaries. In this relaxed environment, Victorian proprieties yielded to unsupervised courting, and the roller coaster and tunnel of love promoted contact between couples.[3]

The artist, McKay (his first name is uncertain), was probably employed as a scenic painter at Steeplechase Park sometime between 1898 and 1906.[4] Nothing further is known about him.

Washington Square

1900

Paul Cornoyer (1864–1923)
Oil on canvas, 18 × 24
Signed lower left: *Paul Cornoyer*
Gift of Mrs. Farrow Harrow,
49.299

Washington Square, at the base of Fifth Avenue, emerged in the Victorian era as one of New York City's most fashionable neighborhoods. Projecting dignified calm and cosmopolitan charm, the square drew favorable comparisons to similar patrician precincts in nineteenth-century London and Paris. To Henry James, born on nearby Washington Place, Washington Square (where his grandmother lived) had "a riper, richer, more honorable look than any of the other ramifications of the great longitudinal thoroughfare—the look of having something of a social history."[1]

Originally a marshland drained for use as a potter's field and public gallows in the late eighteenth century, Washington Square underwent its upscale metamorphosis in the mid-1820s, when the area was converted into a military parade ground and subsequently reconfigured as an eight-acre public park, complete with fountain and intersecting pedestrian paths. In 1837 New York University established its headquarters on the square's east border. Affluent downtowners soon gravitated to this newly developed section of Greenwich Village, moving into the stately Federal-style townhouses constructed at the park's perimeter. By the century's end, a monumental arch designed by Stanford White and built from Tuckahoe marble dominated the northern edge of Washington Square. Largely financed by the well-heeled homeowners who lived on the square, this imposing structure replaced a temporary portal erected in 1889 to commemorate the centennial of George Washington's inauguration as the nation's first president.

Washington Square Park proved a subject of special appeal for painters influenced by the aesthetics of late nineteenth-century Impressionism. The French-trained artist Paul Cornoyer, noted for his atmospheric cityscapes, recorded the square's handsome architecture and genteel street life in a series of oils produced at the turn of the century. Working outdoors, he sought to capture the subtle effects of seasonal light and climatic conditions on the park and its encircling residences. Here, Cornoyer suggests the warm autumnal glow of late-afternoon sun illuminating the square's distinctive brick row houses. The famous arch, portrayed from an oblique angle, gleams against the gathering shadows of evening. In the foreground, pedestrians stroll casually through the park, some lingering at benches. The elongated silhouettes of the park's trees coax the eye upward to the leafy, sun-dappled branches that canopy the common and which, through the effect of the artist's loose brushwork, seem to rustle under the play of a gentle wind.

A nostalgic impulse may have prompted Cornoyer's homage to Washington Square, for as the new century unfolded, this aristocratic preserve was undergoing a dramatic transition. By the 1890s, various economic and demographic changes had conspired to trigger the flight of upper-class families from Green-

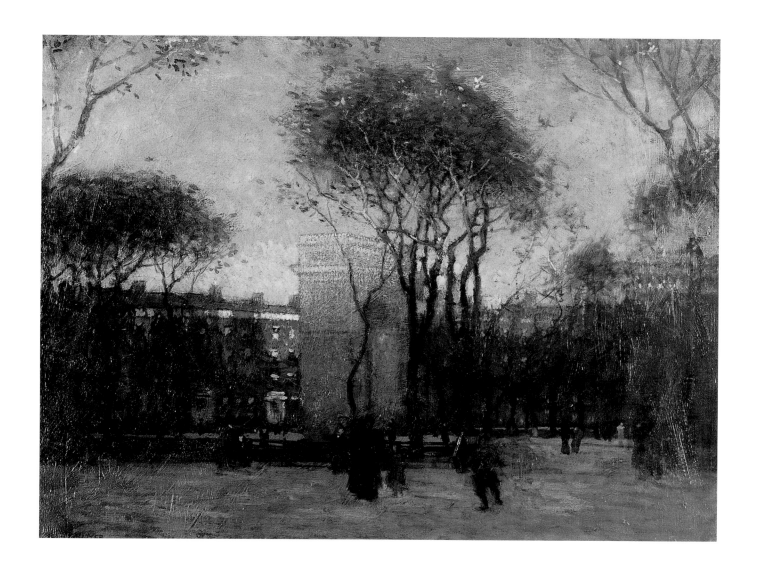

wich Village: much of the district's housing stock had grown dilapidated, real estate values and per capita income began to plummet, local church congregations started to migrate north, and slum tenements and drab factories were encroaching the side streets running east and south of Washington Square. An intriguing international shabbiness descended on the southern border of Washington Square with the arrival of predominantly Italian immigrants and bohemian newcomers, who staked claim to the transient lodging houses and subdivided flats created by the recent outflight of concerned homeowners. Despite these developments, however, Washington Square North remained the fortress of such "old guard" holdovers as the Rhinelanders, the Van Rensselaers, the Delanos, and the Joneses, preserving its reputation as a ceremonial stage for the display of "cleanliness, good citizenship, and self-respect," according to a contemporary columnist for *Harper's Magazine*.[2] Not surprisingly, prospects of the square looking north, featuring the tidy facades of these proudly kept residences as well as the impressive contours of the Washington Memorial Arch, were preferred vantage points for late nineteenth-century landscape painters. The ethnic pushcarts and disorderly lines of drying laundry visible to the south would inspire the generation of urban realist painters who succeeded them.

**View from Queensboro
Bridge During Snowstorm
on St. Patrick's Day**

1910

Sebastian Cruset (1859–1943)
Oil on canvas, 14 ⅛ × 18 ⅛
Inscribed and signed lower left:
*Painted from Queensboro bridge
during snowstorm of St. Patrick's
day 1910. S. Cruset*
Gift of Fong Chow in memory
of his grandfather, Sir Shouson
Chow, 73.228

Sebastian Cruset's penchant for representing the New York skyline from unusual vantage points epitomizes the urban taste for views from high places and exemplifies the new "offshore" viewpoints of the expanding skyline provided by the high bridges built in the late nineteenth century. The novel perspective of this painting, which looks down at the Queens shoreline and at Brooklyn in the distance, with a sliver of the Queensboro Bridge visible at the extreme left, is explained by the location of the artist's studio in the upper "balcony" of the Bridge's Tower 3, located on the east shore of Roosevelt (earlier named Blackwell's, then Welfare) Island.[1] According to an article in the *New York Times* of June 27, 1914, Sebastian Cruset had a permit from the Bridge Commissioner to use the space for an annual rent of five dollars. From there he painted city views, including a mural of the New York skyline, which, the *Times* reported, was stolen by "an agile burglar [who] had climbed up the 200-foot ladder leading to this tower balcony." In this view, executed barely a year after the bridge opened to traffic on March 30, 1909, Long Island City remains largely rural, with only traces of industrialization.

In 1830, when the burial grounds in downtown Manhattan reached capacity, with no land available for new ones, parish and commercial cemeteries were established in the open spaces of Queens. The area's flat land also proved suitable for racetracks. By 1874 there were fifteen such tracks on Long Island,

where fine resorts had developed along the shoreline. Access to Long Island, however, required a ferry crossing of the East River and a subsequent connection to either a train or a horse-drawn vehicle.

Consolidation of Queens with Manhattan in 1898 had been promoted by the promise of easier transportation to Manhattan, and construction of the Queensboro Bridge fulfilled that pledge. After the bridge opened, the bucolic atmosphere of Long Island City quickly vanished. Auto makers (among them Ford, Packard, and Pierce Arrow), food processors (American Chicle and Loose Wiles' Biscuits), Ever-Ready Batteries, and other industries built factories on inexpensive land. The New York Architectural Terra-Cotta Company can be seen here immediately to the right of the bridge. Jobs in these factories attracted European immigrants, who found in Queens more space, cheaper rents, and easier proximity to work than crowded Manhattan afforded them.[2] Today, ethnic communities remain a distinguishing feature of Queens.

The building of the Queensboro Bridge took eight years; for a short time after its completion, it was the longest cantilever span in the Western hemisphere. Like the Hell Gate Bridge (see plate 64) and the Manhattan Bridge, its final design was the work of engineer Gustave Lindenthal (1890–1935) and architect Henry Hornbostel (1867–1961). Their innovations for the Queensboro included an elevator at each end of the bridge and one at

Blackwell's Island to accommodate farm wagons, testimony to the still-rural nature of Queens.

The new span was built for foot traffic, vehicles, elevated and subway cars, and trolleys. In 1912, in an inaugural trip demonstrating the easy, inexpensive access from Queens to midtown Manhattan and celebrating the bridge's role in promoting travel between the municipally joined boroughs, a Third Avenue Railway Company trolley car traveled from Queensboro Plaza, Long Island City, over the bridge to Third Avenue, along 42nd Street, to the North River, and then back to Queensboro Plaza.[3] Statistics for the period bear out the importance of this role. Roughly 3.5 million passengers used the bridge in 1909; by 1911 this number had increased to just under 19 million.[4]

In an ancient technique brought from Spain to New York by an immigrant named Rafael Guastavino and his son, the vaulted arches under the Manhattan shore span of the bridge are lined with thin, flexible tiles strong enough to support the weight of such a load.[5] The space at the bridge's footing had developed into a thriving farmer's market by 1914. In 1916 the space was glazed to provide year-round access. The Depression, however, closed the enterprise. Renovations are now under way, and the Bridge Market is expected to reopen in late 2000 or early 2001.

Sebastian Cruset taught at the University of Barcelona in his native Spain before immigrating to the United States, where he taught perspective drawing, produced magazine illustrations, and worked as a designer of textiles.[6] Cruset's enthusiasm for depicting the city from high vantage points continued throughout his life. The Museum of the City of New York also owns two other paintings by Cruset, executed toward the end of his life, probably from a high floor of the Flatiron Building. One scans Manhattan to the south, the other looks north.[7]

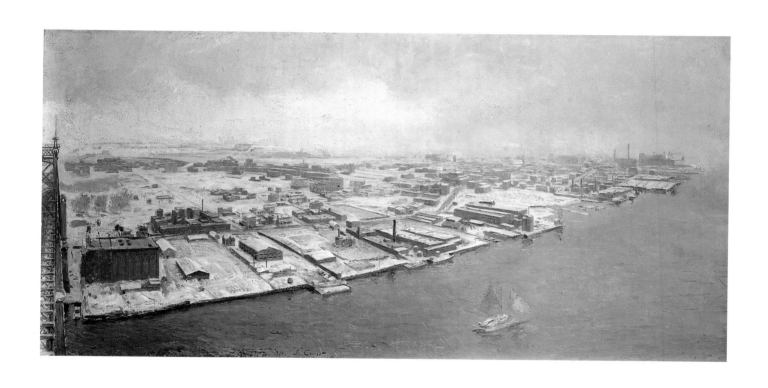

193

Triangle Fire: March 25, 1911

c. 1944 (depicting 1911)

VICTOR JOSEPH GATTO
(1893–1965)
Oil on canvas, 19 × 28
Signed lower right: *Victor Joseph
Gatto*
Gift of Mrs. Henry L. Moses,
54.75

THE FIRE that raced through the Triangle Shirtwaist Company late in the afternoon of March 25, 1911, was extinguished in less than fifteen minutes. Its death toll was catastrophic, however. In the pandemonium unleashed by the fire, 146 workers—mostly immigrant Italian and Jewish women between the ages of thirteen and twenty-three—were fatally burned or crushed to death as they attempted to escape from the flames, which erupted in the sweatshop's eighth-floor cutting room and were quickly fueled by fabric scraps and machine oils. The shock of the incident left an indelible impression on the nation's social conscience, ultimately leading to long-overdue reforms to safeguard workers from dangers inherent in the industrial workplace.[1]

The Triangle tragedy was rife with ironies. Located on the northwest corner of Washington Place and Greene Street, the ten-story stone-and-brick Asch building, which housed the factory on its top three floors, had been considered a model of modern fireproof construction when it opened ten years before the disaster.[2] But by the time Pump Engine 20 and Ladder Company 20 responded to the call, charred bodies of victims prostrate on the sidewalks impeded access to the site. Safety nets that were rushed to the scene failed under the weight of those hurling themselves from on high. The horror was compounded by the restricted reach of the fire department's ladders, which extended only to the sixth floor. Overloaded with evacuees, the rear fire escape

of the loft collapsed, eliminating an escape route. Workers trapped inside then stormed the elevators; a few rode to safety, but most died from smoke inhalation or from falls down the shaft as they attempted to slide down the cables when the elevators ceased operating.

For New York's labor movement, the Triangle Fire proved especially galvanizing. Two years before they perished, the factory's employees had been locked out by company owners for joining the International Ladies Garment Workers Union. In protest, the ILGWU and the Women's Trade Union League called a strike. The ensuing walkout, which spread to other local shops, paralyzed the industry and won gains for workers in more than 350 factories. The Triangle's management, as it so happened, managed to crush the union at the very company where the strike had started. In the fire's aftermath, investigators learned that the factory's exit doors had been bolted by supervisors in an effort to deter employee theft and prevent early departures from shifts. Despite the deplorable practices that contributed to the deaths, the factory owners, when brought to trial, were acquitted. The public outcry triggered by their legal exoneration quickened efforts, particularly by the ILGWU, to organize the city's garment industry and to secure legislation for improving health and safety conditions in factories.

Victor Gatto, eighteen years old when the event occurred, witnessed the fire from near-

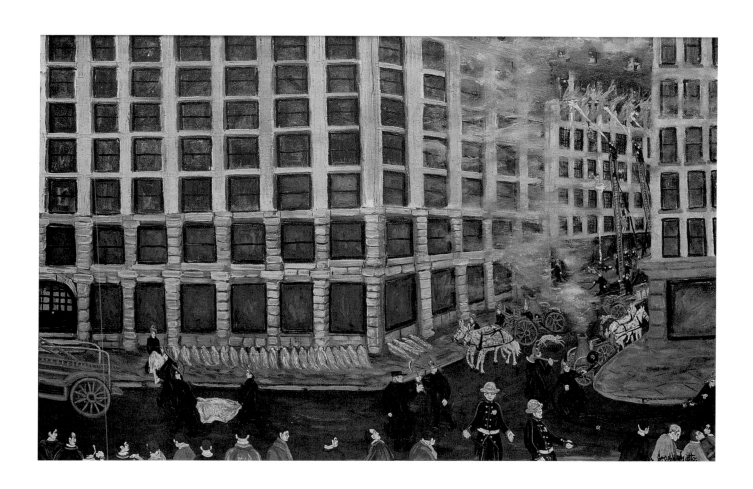

by Washington Square. Years later, he summoned his memories of the historic disaster to produce this vivid pastiche. Perhaps wishing to surpass the visual record bequeathed to history by news photographers, who detailed the fire's grotesque aftermath, Gatto skewed his perspective to enhance visibility of the unfolding events and employed carefully chosen colors to simulate the ongoing drama. Along the painting's bottom border, a line of spectators gravitating to the scene is being detained by policemen. Chaos along the Greene Street block takes form as leaping red flames, spewing brown smoke, churning pump engines, and the blurs of firemen maneuvering equipment clearly ineffectual to fight the inferno. The outline of one worker, with clothes ablaze, can be distinguished falling near the midpoint of the forward ladder. In chilling contrast to this disorder, a row of shrouded bodies methodically arranged on the Washington Place sidewalk spills around the corner to Greene Street.[3] Gatto's dense composition, deprived of sky and greenery that would offer relief from the relentless cityscape, suggests the tragedy's suffocating sensation. The small, wrapped corpses appear oddly insignificant in comparison to the monolithic gray masonry and uniform window indentations of the surrounding commercial architecture.

As background facts emerge about this little-known artist, it seems tempting to read the painting as an admonition of the perils of capitalism when allowed to triumph over the welfare of American labor. Gatto, born to immigrant parents in New York's "Little Italy," took up painting in his forties and was proud of his eventual classification as a self-taught "primitive."[4] A maverick, he had supported himself until then as a steamfitter, plumber, and occasional featherweight boxer and claimed to have turned his casual sketching interest to profit only after seeing the prices charged for similar "handiwork" at an outdoor art show in Washington Square in the late 1930s. Gatto's politics are a matter of speculation. His working-class origins, time spent as a laborer in an ammunition plant and various shipyards, and economic hardship during the Depression probably disposed him toward the ideological branch of Social Realist art that took root in the 1930s and advocated the betterment of life for ordinary American citizens. In this context, the painting fulfills the purpose of alerting a younger generation to the Triangle fire's enduring meaning.[5]

The donor of *Triangle Fire* bought the painting in 1945 from the Charles Barzansky Galleries on Madison Avenue, venue for the publicized breakthrough exhibition that enabled Gatto to concentrate exclusively on art. Although biblical subjects represented a major vein in his oeuvre, Gatto, whose memory of past events was considered remarkable, also drew on his earlier New York City experiences for numerous other paintings.

Bryant Park

1914

THERESA BERNSTEIN (b. 1895)
Oil on canvas, 21 × 17 ⅛
Signed lower left: *T. Bernstein, 14*
The Robert R. Preato Collection,
91.76.1

ALTHOUGH a product of the artist's early career, *Bryant Park* exhibits the rapid, fluid brushwork, innovative color play, and fresh sensations of direct optical encounter that earned Theresa Bernstein praise in 1919 as "a woman painter who paints like a man."[1] Ill-considered as that tribute seems today, the comparison acknowledged her solid footing as a member of the Ash Can School of urban realists whose work was garnering critical esteem in the second decade of the century and from whom Bernstein crafted her own variant of a "virile" sensibility to chronicle contemporary New York on canvas. Never a formal student of Robert Henri, she nonetheless embraced his philosophy of depicting the city's everyday drama "with guts," heeding his advice as well to preserve the "vivacity of your first impression."[2]

Bernstein brought the sum of her academic training and visual knowledge of art to the cityscapes she began to generate in the aftermath of the 1913 Armory Show, which seemed again to disorient modern painting only five years after the "Eight" had made their initial splash in New York's art world. Born in Philadelphia to cultured, middle-class immigrant parents, Bernstein studied at the Philadelphia School of Design for Women, from which she graduated in 1911 with an award for general achievement. From Daniel Garber, her most memorable teacher, she carried forward a delight in plein-air landscape painting and flirtations with startling color contrasts

and bright accents of light. After a brief enrollment at the Art Students League in New York, where she took life and portraiture classes with William Merritt Chase, she traveled for a second time to Europe with her mother, her first trip abroad having been made in 1905. Exposed during both tours to the latest adventures in modernism being investigated in these foreign art capitals, Bernstein was strongly impressed on this 1912 visit by the work of Franz Marc, Edvard Munch, and Wassily Kandinsky, admiring their antinaturalistic palette and novel departures from other eye-pleasing painting conventions. She returned to New York emboldened in her ambition to record the larger, expressive power of the city, rather than to dilute that visual confrontation into finely tuned details.[3] Bernstein gravitated to subjects where urban spaces fostered the intersection of citizens from all strata of New York society: scenes commonplace to the waterfront, streets, trolleys, and centers of public recreation ranging from theater lobbies to Coney Island. Bryant Park, a verdant six-acre enclave stretching west behind the newly completed main branch of the New York Public Library at Fifth Avenue between 40th and 42nd Streets, offered Bernstein the double virtues of a distinctive setting in which to test her accumulating ideas about painting and a guaranteed cross section of New Yorkers seeking air, light, and company.

In 1914 the park, named in honor of poet, newspaper editor, and parks advocate William

Cullen Bryant, was enjoying a relatively recent makeover prompted by the library's opening in 1911, with landscaping that featured criss-crossing paths in the English style. It occupied the site of the former Croton distributing reservoir, drained in the 1890s, and had once accommodated the Crystal Palace, the mid-century exposition hall ruined in a flash fire in 1858. With efficient brushstrokes that re-sist individual detailing, Bernstein suggests the varied populace who animate the park: groups of men locked in conversation, some sailors on shore leave relaxing on benches, and a friendly twosome wearing the latest in ladies' millinery shown chatting in the picture's lower foreground. The amiable mood seems to con-firm the popular allusion to Bryant Park as midtown's green "living room."

Bisecting the mid-horizon is the arma-ture of the Sixth Avenue El. Behind it loom the geometric silhouettes of the multi-story build-ings framing the park view. Bernstein, reveal-ing the adventurous color sense she often brought to her cityscape studies, startles the eye with splashes of chartreuse-toned lawn and foliage and a vivid salmon sky portending twilight's onset. Showing her independence from customary landscape formulas, she in-trudes the dark trunk and sinuous branches of a plane tree into the middle of the scene, caus-ing viewers to oscillate their attention be-tween its assertive and curious forked shape, and the balance of compositional elements that together establish its narrative context.

Bryant Park—one of several paintings by the artist in the Museum's collection—be-longs to a group of city vignettes dating from 1912 to 1919 that attracted notice to Bernstein as a vigorous new talent on the rise in New York.[4] She has lived in the city, working from a studio on the Upper West Side, for eight decades since. While retaining an interest in urban genre scenes, she expanded her subject repertoire in later years to include musical personalities and events (many informed by the rhythms of jazz) and the seacoast area around Gloucester, Massachusetts, where she summered with her husband, the artist William Meyerowitz (1887–1981). As of 1999, well past her centennial, she was still divid-ing her time between the city and Gloucester and granting occasional interviews about her career as a painter.

The Municipal Building

c. 1915

EVERETT WARNER (1877–1963)
Oil on canvas, 50 × 40
Signed lower left: *Everett Warner*
Gift of the artist, 41.182.1

As A consequence of the consolidation of Greater New York in 1898, space was needed to house additional administrative offices and services for the expanded city. The architectural firm McKim, Mead and White won the 1908 Municipal Building competition with their design for the forty-story building that opened in 1914. I. N. Phelps Stokes, the respected New York City iconographer who was also an architect, said of the resulting building: "If not actually the prototype of the...upward tapering type of skyscraper with highly accentuated vertical lines, [it] at least marked an important step in that direction and had a far-reaching effect upon the design of the modern skyscraper."[1] Furthermore, the Municipal Building exemplified the large new "purpose-built" structures developed to accommodate the newly enlarged city's increasingly complex needs, both civic and commercial.[2]

The building's open U-shape encompasses the two triangular blocks bounded by Park Row, Centre, and Duane Streets and straddles Chambers Street, thus forming what has been called the "gate of the city."[3] This view looks west toward the early modern emblem of the "progressive city," which towers over the lower profile of Peck Slip, a vestige of nineteenth-century New York's former maritime dominance.

Among the first agencies housed in New York's Municipal Building were the city-owned and -operated radio station WNYC, a new reference branch of the New York Public Library, and the city's marriage license bureau. A sunny wedding chapel decorated with potted palms and flowered wallpaper was also incorporated into the building plan. The area around Foley Square, which quickly developed into a modern center of governmental activities, formed a marked contrast to the timeworn neighborhoods that bordered the area.

The tower visible in Warner's painting is surmounted by Manhattan's largest statue, *Civic Fame*, commissioned by the architects from Adolph Alexander Weinman (1870–1952). Weinman, a pupil of Augustus Saint-Gaudens, executed other commissions for McKim, Mead and White, most notably the clock and figures over the entrance to the old Pennsylvania Railroad Station.[4] The sheet-copper figure on the Municipal Building measures twenty-five feet in height and forms part of a sculptural program conceived by Weinman for the entire building. The classicism of the sculpture complements the building's references to Roman triumphal arches and to Bernini's colonnade in St. Peter's Square.[5]

At various times, Everett Warner lived and worked in New York City; Old Lyme, Connecticut; and Pittsburgh, where he taught at the Carnegie Institute of Technology. The elements of the New York cityscape he once cited as the most inspirational were "the daily commercial activity, the smoke and steam,

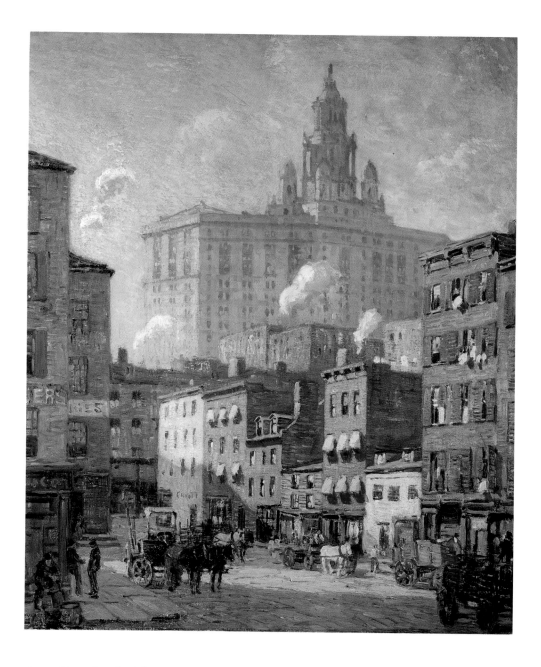

the softly colored eighteenth [sic] century buildings... and the modern buildings that thrust up behind the old streets."[6] In this view, Warner captured the essence of New York City as one century yielded to another and the modern urban scene developed. Here, using a palette and style strongly influenced by the Impressionists of Old Lyme, he contrasts nostalgia for the old with admiration for the new, avoiding any sense of endorsement of one over the other.

Washington Square, Looking North

c. 1913

THIS IMPRESSIONISTIC view of Washington Square in winter, looking toward its namesake arch and the stately row of warm red-brick homes lining its northern perimeter, encompasses a glimpse of the bronze statue of Italian patriot Giuseppe Garibaldi installed in the square in 1888, and the blurs of a horse-drawn sleigh and some stalwart pedestrians attempting to negotiate a landscape blanketed with snow.

While typical of the numerous picturesque studies inspired by Washington Square Park and its architecture, the painting is distinguished by its specificity of vantage point from the third-floor window of Katharine Branchard's boarding house, where artist Carton Moore-Park had improvised a studio. In the 1890s, Madame Branchard had assumed title to a run-down rowhouse at 61 Washington Square South, formerly maintained as a single-family residence.[1] She then converted the property into an inexpensive rooming house appealing to boarders pursuing dreams of success. Aware of Greenwich Village's renown as a precinct cordial to artists and writers struggling to launch their careers, Branchard also capitalized on Washington Square's allure as a historic address in the heart of New York's nascent Latin Quarter, which offered various options for low-cost housing.[2]

The painting's estimated date of creation, around 1913, is significant because it was during the years before World War I that Greenwich Village burst into full bloom as a bohemian stronghold and that Branchard's establishment received its celebrated baptism as "the House of Genius," reflecting the succession of creative, often eccentric tenants it sheltered on their way to fame. During Moore-Park's brief residence in the prewar years, fellow boarders included the aspiring poet Alan Seeger, destined to die in the battle of the Somme, and the illustrator-writer Rose O'Neill, better known for designing the Kewpie Doll. For painters aspiring to become professionals, however, such bargain-rate living arrangements—reminiscent of their rollicking student years—grew irksome, and many quickly exited the Village to lease space in the modern studio buildings on West 55th and 57th Streets, New York's latest magnets for artists.[3]

Moore-Park, who was born in New Brunswick, Canada, attended the Glasgow School of Art and subsequently settled in London, where his decorative, calligraphic technique was refined. His drypoints of animals, many conceived for children's books or demonstrating his passion for horse sports and zoology, attracted early critical praise for their economy of rhythmic line and bold, asymmetrical composition.[4] Upon arriving in New York, Moore-Park branched out into portraiture and figure painting and also investigated the media of pastels and aquarelles. His stay

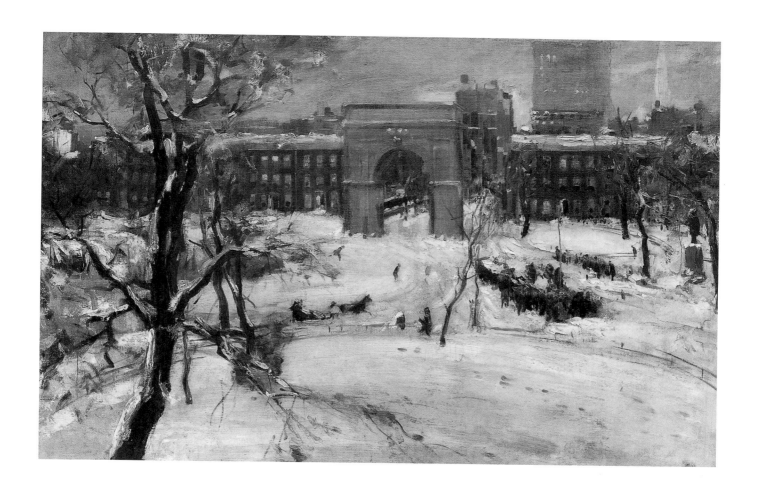

at Branchard's boardinghouse proved a brief layover on his way to securing entree into New York's established community of graphic and easel artists. Local directories record a series of later Fifth Avenue and midtown Manhattan addresses for the artist and list him as a "collector and connoisseur."

Victory Arch at Madison Square

1919

Jane Peterson (1876–1965)
Oil on canvas, 14 ½ × 18 ¼
Gift of Mr. Stuart P. Feld,
75.220

This monument, conceived during World War I both to spur enlistment in and patriotic support for America's military efforts overseas and to memorialize New York City's war dead, became mired in committee politics long enough for the November 1918 armistice to have ended the war. Accordingly, the structure was transformed into a municipal Victory Arch, using temporary materials and a design by architect Thomas Hastings (1850–1929). The project took form with all the speed earlier denied it, and was completed in time for the triumphant homecoming of New York's 27th troop division in late March 1919.

Subtlety was not the concern of such grand civic gestures. Modeled after the ancient Arch of Constantine, the arch featured tripartite construction and an honor court displaying allegorical figures of Peace, Justice, Power, and Wisdom. Relief panels commemorated important battles, war service organizations, and the contributions of American industries, such as shipbuilding and munitions manufacture. Rising to a stunning height of 100 feet, the white archway's ample form straddled 125 feet of Madison Square at the intersection of Broadway, 24th Street, and Fifth Avenue. The purposeful siting probably reminded many New Yorkers of a similar arch, also made of plaster and wood, erected at this location in 1899 to salute Admiral George Dewey's victory over the Spanish at Manila Bay in 1898.

Like its predecessor, the Victory Arch enlisted volunteer talent from the National Sculpture Society and was constructed with the expectation that it would be rebuilt in some permanent form. However, just as the earlier "imperishable" monument had failed to materialize when subscriptions lagged and Dewey's popularity ebbed, plans for the World War I memorial erupted in controversy over the commission's choice of artist and the proposed iconography. As debate escalated over the necessity of perpetuating this "Altar of Extravagance," as Fiorello La Guardia branded the project in 1919 when campaigning for the presidency of the Board of Aldermen, the arch joined New York City's growing registry of demolished commemorative structures.[1]

The production of such ambitious tokens of civic power, thanksgiving, and virtue challenged artists to record these short-lived embellishments to the cityscape. Painters were particularly alert to the fleeting compositional impact of such landmarks on their settings and also appreciated their gleaming white bravado, invariably effaced by urban pollutants. Jane Peterson, trained in Paris and Madrid, preserved her impression of Madison Square's Victory Arch as part of a larger pictorial chronicle of the city's patriotic activity and appearance during the World War I era.[2] For this painting, she combined energetic brushwork with a luminous palette in a style that fused her firsthand knowledge of French Im-

pressionism, Fauvism, and Post-Impressionism, and which paid debt to her studies with painter Joaquin Sorolla y Bastida. A widely traveled artist who moved fluidly through international art circles, Peterson maintained ties to New York City as an occasional resident and instructor at the Art Students League.[3]

Victory Arch at Madison Square, acquired by the donor from Peterson's estate, dates from the artist's period of involvement in the city's postwar recovery, possibly from the summer of 1919, when she leased an atelier in the Sherwood Studio Building on West 57th Street.

Red Cross Parade, Fifth Avenue, at 41st Street

1918

GRACE RAVLIN (1873–1956)
Oil on canvas, 25 ¼ × 30
Signed lower left: *G. Ravlin 18*
Gift of the Women's Association of the Brick Presbyterian Church, 56.90

FOLLOWING the United States' entry into World War I in April 1917, parade activity along Manhattan's Fifth Avenue accelerated, demonstrating support for the American war effort overseas and the home-front activities being mobilized on its behalf. The avenue's status as one of the country's most impressive and important urban boulevards made it the ideal stage for such expressions of patriotic solidarity. Indeed, before President Woodrow Wilson's formal announcement of war, Fifth Avenue had been enlisted for a massive "preparedness" march held in May 1916. As host of four later "liberty loan spectacles" conceived to stimulate sales of government war bonds, the thoroughfare earned the honorific "Avenue of the Allies."

As local parades supporting the U.S. campaign increased in number and complexity, special committees, often headed by artists, orchestrated the programs of decorative bunting for Fifth Avenue and its side streets.[1] Painters on the New York City home front—including a disproportionate number of women, who were exempt from conscription—also produced colorful impressions of the show of patriotism exemplified by these civilian processions. Many, including Childe Hassam in his exuberant "flag" series, documented the American Red Cross parade held on Fifth Avenue in May 1918, the magnificent capstone event for a larger War Fund Week

to solicit monies and volunteers for the nation's mounting military needs.

Led by President Wilson, the Red Cross parade attracted seventy-five thousand participants who filed down Fifth Avenue to urge replenishment of those accounts earmarked for the humanitarian relief organization lauded as "our second line of defense," whose stricken clientele now included American soldiers.[2] For the event, Fifth Avenue was dressed in Red Cross flags. Adding color were the distinctive American stars and stripes flying from buildings edging the avenue, joined by the smaller flags of the allied countries to symbolize the organization's international reach. Spectators crowded sidewalks, balconies, and bandstands, cheering most vigorously for the heroic fifteen thousand women marching the two-mile course—veterans of foreign field service, nurses awaiting assignment to the front, and auxiliary members and affiliate groups who performed invaluable clerical and morale-boosting duties stateside.

Illinois native Grace Ravlin, an artist based in Paris who stationed herself in the United States during the peak period of hostilities, spent part of 1918 working in New York City, where she observed the varied proceedings of War Fund Week and the emotional pageantry of the Red Cross parade. From an elevated prospect opposite the New York Public Library—the institution's flag-

pole and the flank of its marble facade are discernible in the upper right—looking toward the intersection of Fifth Avenue at West 40th Street, Ravlin depicts the ranks of white-uniformed volunteers being heralded by a unit of 150 women wearing scarlet scarves over their heads, who flowed south in a human red-cross formation.[3] The gathered onlookers, more soberly attired, create a diagonal border offsetting the dramatic configuration of the moving red cross and white columns of marchers trailing it. The dominance of the vivid flags within Ravlin's composition accentuates their festive impact on the war-era cityscape; the bright lime-green foliage specifies the season as spring. Anchoring the corner immediately south of the library is the multi-story commercial building then occupied by the Knox Hat Company.

Ravlin, who had studied at the Art Institute in Chicago and with William Merritt Chase at the Pennsylvania Academy of the Fine Arts, traveled abroad for the first time in 1906 and, before the outbreak of World War I, made frequent trips through France, Belgium, Spain, Tunis, and Morocco. She remained devoted to the European continent and North Africa as landscape subjects throughout her subsequent career. In Paris, her preferred residence, Ravlin had sought out painter Simon-Menard Cour for individual training, exhibited with the Peintres Orientalists Français, and became an associate of the Société Nationale des Beaux-Arts. She also achieved gratifying recognition of her abilities from the French art press, which was impressed by her inclusion in select salon exhibitions and by the French government's purchase of five of her sunlit and decorative plein-air canvases, one acquired for the Luxembourg Museum in Paris. In the United States, soon after painting *Red Cross Parade,* Ravlin became personally engaged in New York City's Red Cross Corps. She signed on for nurse's-aide training and was issued orders in December 1918 to proceed to Paris for dispatch to a Red Cross canteen assisting troops returning home after the armistice.[4] Her life after the war remained international in orientation, although she devoted greater lengths of time to painting in the United States, particularly in the southwest and near Cape Ann, Massachusetts. In 1921 Ravlin returned to Manhattan, intermittently painting New York City scenes until she left for Mexico City in 1925. Critics often compared the results to modern French Post-Impressionist landscapes, praising her "sprightly eye," fresh use of color, and expressive, fluid brushwork. "Were it not for certain familiar landmarks, we might think some of her New York street scenes French parks or boulevards," observed the *Brooklyn Daily Eagle,* which also remarked on the artist's "absorption" of the

"dry, staccato touch which is frequently used in France."[5] In January 1924 a selection of these cityscapes were featured at the MacBeth Galleries together with recent paintings by the inimitable urban realist Robert Henri. This incongruous aesthetic pairing worked to Ravlin's disadvantage, but a consensus prevailed that her compositions had a notable tempo, and that her manipulation of viewpoint and liberties of palette were pleasing, if not entirely innovative. One painting dated 1922, representing a military parade at the junction of 42nd Street and Fifth Avenue but probably conceived in a serial relationship to the earlier *Red Cross Parade,* drew favorable comments about Ravlin's "flair for processions" and her ability to re-create their sense of stirring movement and color.[6]

New York Connecting Railroad Bridge at Hell Gate

c. 1916–1917

Jᴀᴍᴇꜱ Mᴏɴʀᴏᴇ Hᴇᴡʟᴇᴛᴛ
(1868–1941)
Oil on canvas, 35 × 60 ¼
Inscribed lower left: *Palmer and Hornbostel Architects;* inscribed lower right: *Gustave Lindenthal Engineer*
Gift of Mr. Lloyd Hornbostel and Mr. Caleb Hornbostel in memory of Mr. Henry Hornbostel, 62.117.1

Tʜᴇ ᴍᴀꜱꜱɪᴠᴇ beauty and advanced technology of the Hell Gate Bridge (more properly the New York Connecting Railroad Bridge) contrast sharply with nineteenth-century descriptions of the channel that it spans. Named for the dangerous rocks and perilous waters at the confluence of the East and the Harlem Rivers, Hell Gate is surrounded by Manhattan, Queens, and three islands: Wards, Randalls, and Roosevelt (formerly called Blackwell's, then Welfare). Philip Hone (1780–1851), writing of an 1844 visit there, described "the delightful scene: the clumps of fine old trees clothed in the gorgeous foliage of autumn, the lawn still bright and green, the mild, refreshing breeze, the rapid waters of Hell Gate covered with sailing vessels and steamboats—all combined to present a picture of consummate beauty."[1]

The construction of the Pennsylvania Railroad tunnel under the Hudson River and into Pennsylvania Station replaced the time-consuming and expensive water route for New York–bound passengers and freight from New Jersey and points south. Hell Gate Bridge—from the Sunnyside Yards in Queens across the Hell Gate to Wards Island, then across the Little Hell Gate to Randalls Island, and then over the Bronx Kill to the Bronx— was built to complete the linkage of the New York, New England, and Long Island rail lines with the Hudson River crossing. Together, tunnel and bridge created a direct route over the Bronx Kill to the Bronx.

The longest, heaviest, strongest steel arch bridge in the world at that time and the only four-track long-span railroad bridge ever built,

Hell Gate Bridge marks the apogee of American railroad power and prosperity. Government regulation, poor management, and a proliferation of alternative methods of transportation—private cars, trucks, buses, and airplanes—eventually undercut the railroad's primacy.

Engineer Gustave Lindenthal (1850–1935) and architect Henry Hornbostel (1867–1961) had previously been responsible for the redesign of both the Manhattan and Queensboro Bridges. Lindenthal, who served in 1902–1903 as Commissioner of Bridges, firmly believed that a bridge could be both technologically sound and aesthetically pleasing. Despite his accomplishments and success, Lindenthal probably had no formal training in his chosen profession but apparently possessed "the extraordinary intelligence, energy, and self-discipline that enabled him to teach himself mathematics, engineering theory, metallurgy, hydraulics, estimating, management, and everything else a successful bridge designer had to know."[2]

Architect James Monroe Hewlett was probably better known for his mural paintings than for his building designs. The half-moon shape of his painting echoes the distinctive arch of the bridge. Rather than expressing regret for the gentle beauty of the area at an earlier time, Hewlett conveys enthusiasm for the industrialized waterfront, where even the factory smoke has become an aesthetic element of the painting. His depiction of the construction area corresponds closely to the way it appears in a photograph dated October 11, 1916.[3]

NEW YORK CONNECTING RAILROAD BRIDGE AT HELL GATE

211

High Bridge

1920

Samuel Halpert (1884–1930)
Oil on canvas, 33 × 39
Signed lower right:
S. Halpert—20
Anonymous gift, 48.221

Samuel Halpert painted this view of High Bridge from the Bronx side of the Harlem River, thirty years after the bridge had ceased to serve as a conduit for New York's water supply. The conditions of the area around the Harlem River and the bridge, as Halpert recorded them in 1920, contrast sharply with those evidenced in an earlier, more bucolic view of High Bridge (see plate 20). A locomotive rushes west along the riverbank; a supporting tower for electric lines beside the railroad tracks echoes the older water tower at the far end of the bridge; and a tugboat scurries southeast toward Hell Gate.

Even greater changes befell the bridge after Halpert's 1920 painting. With the outbreak of World War I, the U.S. War Department and the Army Corps of Engineers had pressed for removal of the bridge because its narrow arches prevented the passage of large cargo ships and military vessels. The American Institute of Consulting Engineers, the New York Chapter of the American Institute of Architects, the American Society of Civil Engineers, the American Institute of Fine Arts, and preservation-minded citizens who opposed the destruction of such an icon jointly confronted the government agencies and managed to elicit a compromise. In 1927 two of the graceful arches were replaced with a steel arch, altering the structure's original symmetry but saving the bridge.[1]

In the first decades of the twentieth century, the Bronx side of the Harlem River succumbed to railroad blight. The Manhattan cliff and High Bridge Park prevented similar urban decay on the Bridge's south side. In the painting, the figures traversing the viaduct, whose graceful design was taken from Roman aqueducts, signify the continued popularity of High Bridge's scenic walkway.

Samuel Halpert was born in Russia and brought to the United States as a young child. His early artistic talent was recognized and encouraged by teachers Jacob Epstein and Henry McBride at the Educational Alliance in New York City. After three years of traditional study at the National Academy of Design, he traveled to Paris to work with Leon Bonnat (1883–1922) at the Ecole des Beaux-Arts. While in France, Halpert was strongly influenced by his exposure to the works of the French modernists, especially Paul Cézanne (1839–1906) and Henri Matisse (1869–1954), and by his colleagues Fernand Léger (1881–1955) and Jean Metzinger (1883–1957).[2] From 1905, which coincided with the first favorable review of the Fauvists' daring use of color, until 1911, Halpert participated in the annual Salon d'Automne in Paris, one of few Americans to be so recognized.[3] His signature use of solid, thickly outlined block-like forms, as evidenced in this composition, reflects his Paris experiences.[4]

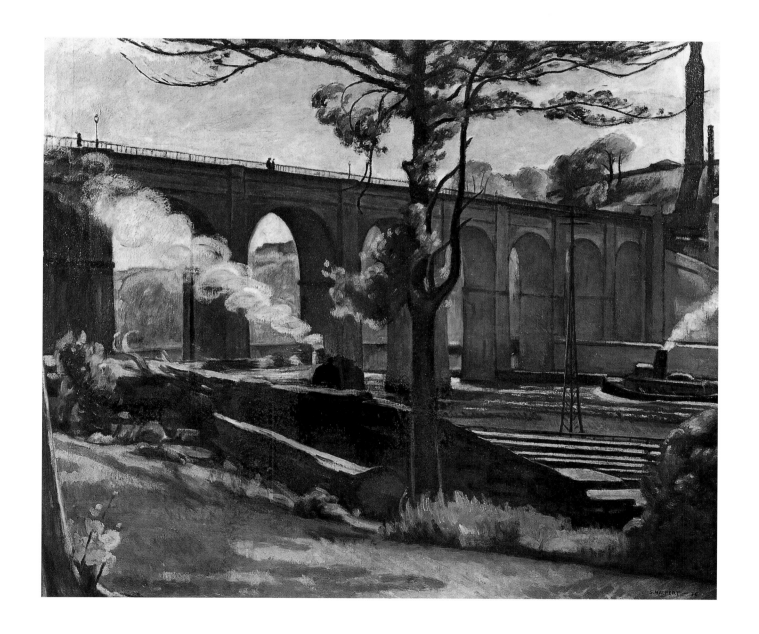

Brooklyn Bridge

c. 1927–1930

Benjamin Eggleston
(1867–1937)
Oil on canvas, 48 ⅛ × 38
Signed lower left: *Benjamin
Eggleston*
The Robert R. Preato Collection,
91.76.7

In spite of its title, the actual subject of Eggleston's nocturne is the striking aggregate effect of downtown New York's crenellated skyline. As recorded from a vantage point on the far side of the East River, the view illustrates the advice about modern skyscrapers offered to cityscape artists by Childe Hassam in 1913, who, discounting their individual beauty, rhapsodized about the impact of their grouped silhouette against the sky. This effect, argued Hassam, was "more beautiful than many of the old castles of Europe, especially if viewed in the early evening when just a few flickering lights are seen here and there and the city is a magical evocation of blended strength and mystery."[1]

The Brooklyn Bridge (with its Manhattan tower discernible at the extreme right), icon of the previous century's technological genius, plays a subordinate role in this composition, as a bordering device for lower Manhattan's densely constructed shoreline, which overruns the horizon line in defiance of its framed perspective. The vertical orientation of the canvas dramatizes the skyward thrust of the sixty-story Woolworth Building at 233 Broadway. This soaring structure, completed in 1913, not only took the title of world's tallest skyscraper away from the ornate Singer Building further south on Broadway (visible at far left) but also won a gold medal at the 1915 Panama-Pacific Exposition as the "most beautiful building in all the world erected to commerce." Other rec-

ognizable landmarks are incorporated in the view, including the distinctive pyramidal roofline on the recently constructed (1926–1927) Transportation Building at 226 Broadway, to the lower left of the Woolworth tower. The artist's objective, however, was to create a tonally harmonious whole. Here, a blue-tinged river scene merges seamlessly with the shadowed wharves of the East River. That foreground yields in turn to the architectural hillside of downtown New York, whose individualized elements seem to flicker in and out of focus, drawing the eye back to the dramatically ascending spire and golden glints of F. W. Woolworth's "Cathedral of Commerce," symbolic of New York City's corporate drive and power.[2]

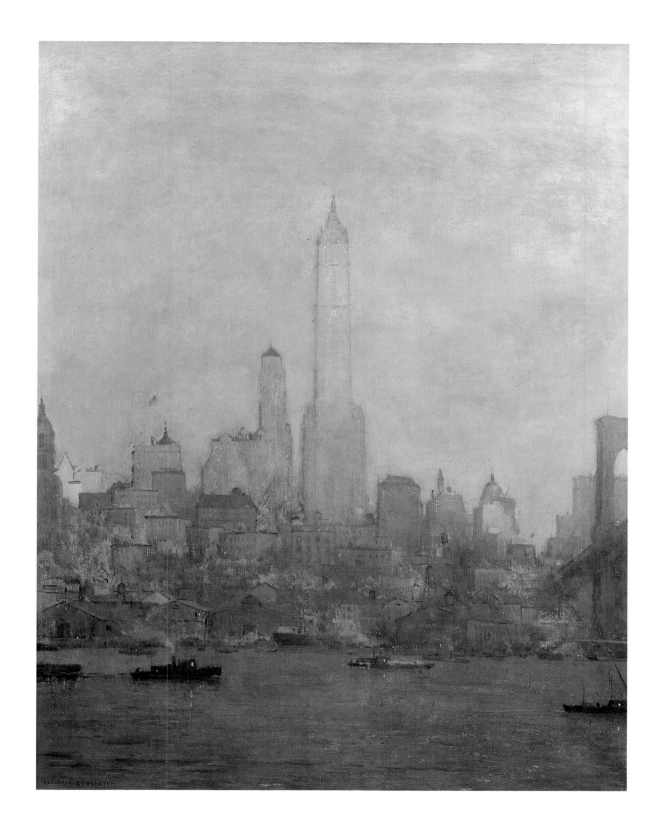

Elevated Station

c. 1929–1930

Ruth Carroll (b. 1899)
Oil on canvas, 25 × 30 ¼
Signed on shop awning, lower
left: *Ruth Carroll*
Gift of the artist, 80.163.1

In 1878 the newly reorganized Metropolitan Elevated Railroad (known formerly as the Gilbert Elevated) opened several new transit lines in New York, including a prime route on Sixth Avenue running between Rector Place and Central Park. To design the line's passenger stations, the railroad directors enlisted Jasper F. Cropsey (1823–1900), a renowned Hudson River School landscape painter who had studied architecture years before (see plate 16). For the project, Cropsey retrieved his knowledge of the Gothic Revival style that had been in high vogue when he had visited London in the late 1840s to further his art education.[1] That influence, still evident in this view dating from the brink of the Great Depression, resulted in a series of picturesque "Hudson River Gothic" bungalows that may have appeared quite ordinary on the ground but created a striking impact when hoisted into the air to adjoin the elevated train tracks.

Cropsey solved the problem of access to the track platforms by having passengers enter and exit the system through covered pavilion staircases that rose in graceful tiers to each station's enclosed waiting room. From the sidewalk these stations—with their peaked gables, quaint cupolas, and lacy balustrades—resembled welcoming gingerbread cottages. The cheerful effect, enhanced by the stations' color scheme of fresh apple-green paint with darker hunter-green and maroon trim, did much to mitigate the gloom that the track superstructure cast over the underlying streets. Although their facades called to mind rustic wood carpentry, the El stations were principally made of iron, an innovation presumably adopted as an effort toward fireproofing.

With her richly toned palette, Ruth Carroll constructs a view of Sixth Avenue at 8th Street, looking west, that preserves a sense of the chromatic contributions the El's stations made to the immediate areas they served—in this case, an otherwise ordinary neighborhood thick with tenements, warehouses, small shops, and time-worn row houses and abutting the West Village. A strong interest in color values and geometry, noticeable in the play of shadows within the cityscape as well as in Carroll's patterned brushstrokes, informs the composition. The scene includes its share of narrative details: a streetcar, a truck, and an automobile sharing pavement with what seems to be a horse-drawn cart; a hurdy-gurdy man who, at the approach of bad weather, finds convenient shelter under the El so he can continue entertaining; a passenger ascending the final tier of steps into the station's waiting room, soon to join another solitary figure waiting on the platform track. The comparative quiet of Carroll's vignette suggests a weekend morning, for the traffic on the Sixth Avenue El during weekdays was typically heavy.[2] A whimsical touch is the shop awning sign visible in the painting's lower-left corner, which bears the artist's name.

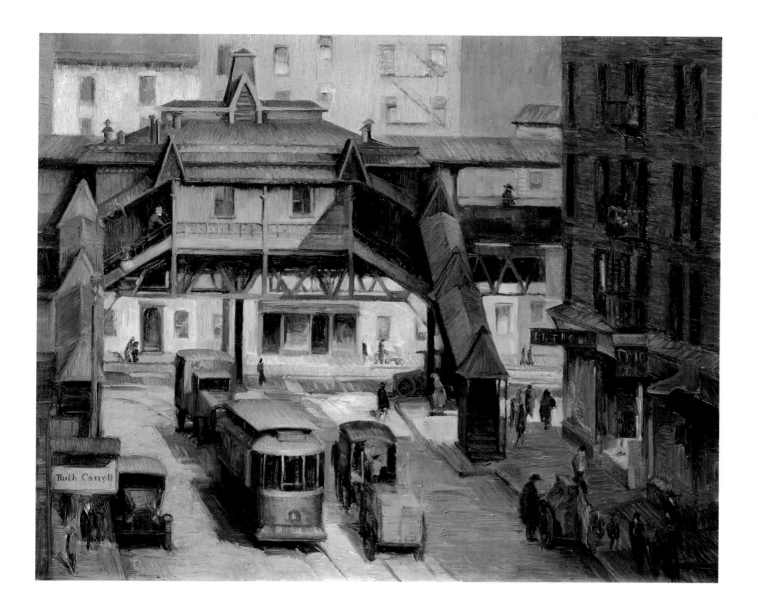

Ruth Carroll graduated from Vassar College and thereafter established roots in New York City, where she pursued training at the Art Students League under Cecilia Beaux, Charles Bridgman, and Andrew Dasburg, the last of whom probably influenced her Cézannesque approach to painting. In the 1920s her work was exhibited at the Newark Museum and the Pennsylvania Academy of the Fine Arts. She later changed course within the art field, developing a career as an author-illustrator of children's books. From 1936 through the end of World War II, she had a staff position at King Features Syndicate, creators of the popular *Popeye* cartoons, among other series.[3]

Holing Through

1929

DA LORIA NORMAN (1872–1935)
Oil on canvas, 29 × 46
Signed lower left: *da Loria
Norman / 1929*
Gift of the artist, 33.42

ON MARCH 14, 1925, at St. Nicholas Avenue and 123rd Street, work began on the Independent (IND) Subway, the last major addition to the New York City subway system.[1] This first portion of the Eighth Avenue line, running from 207th Street and Broadway to Vesey Street (now the location of the World Trade Center), opened on September 10, 1932. By 1940, additional sections of the line extended into Brooklyn, Queens, and the Bronx, replacing some of the old elevated lines, opening new areas of the city to rapid transit, and improving existing service to parts of Queens and Brooklyn.[2]

This view depicts the critical moment when the two teams of workers (frequently referred to as "sand hogs" because of the soft dirt they worked in), tunneling from opposite ends as they built the fifty-nine miles of the IND line, broke through the wall of earth remaining between them. Despite the dangerous conditions suggested by the extensive structure of supporting beams, the workers appear nonchalant as they prepare the tunnel bed for the new transit facility. The somber underground setting is illuminated by naked light bulbs.

Born Belle Elkin Mitchell in Leavenworth, Kansas, da Loria Norman was a self-taught artist. From the mid-1880s to 1914 she lived in England, where she began to paint in earnest after the dissolution of an unhappy marriage. Her work includes book illuminations and miniatures executed in watercolor and gold leaf; large murals on both plaster and canvas; landscapes and mystical paintings in oil and watercolor; fine-silk picture embroidery; and illustrations for magazines and books. She also taught art in New York City.

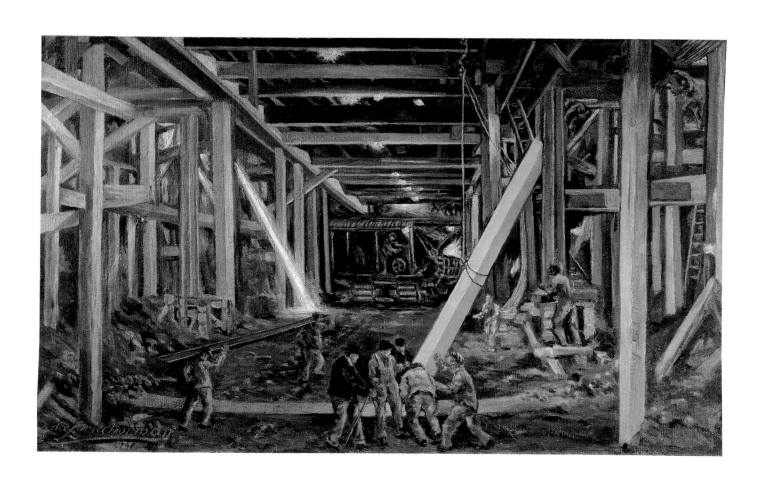

Riot at Union Square

c. 1947 (depicting 1928–1930)

PETER HOPKINS (b. 1911)
Oil on canvas, 37 × 48
Signed lower right: *Peter
Hopkins*
Gift of the artist, 66.82

CONTRARY to popular belief, Union Square was not named for its notoriety as a stronghold of New York's radical labor movement. Nevertheless, the area became associated with working-class causes as early as 1882 with the launch of what evolved into America's traditional Labor Day Parade: on September 5 of that year, twenty-five thousand marchers, gathered under a banner of the Knights of Labor, circled the square to demonstrate their support for an eight-hour work day and a ban on child labor. Toward the end of the nineteenth century, immigrants from the nearby blocks of the Lower East Side tended to assemble on the plaza at Union Square for open-air debates on issues vital to their economic livelihood. The square's reputation as a pro-labor locale was further solidified in the 1920s, when it became home to the Amalgamated Bank, the nation's first labor-owned bank; to headquarters of both the Amalgamated Clothing and Textile Workers Union and the Communist Party (lodged one block south on East 12th Street) and its newspaper, the *Daily Worker;* and to various other progressive agencies and relief organizations, left-wing book shops, and bargain stores. Artists also drifted into the neighborhood in this period, sketching the proletariat crowds and the intriguing subculture of loiterers, soap-box prophets, and anarchist agitators.[1]

A more explosive atmosphere infused Union Square as rallies by political dissidents, unemployed workers, and communist sympathizers increased in number and darkened in mood. These led to a series of clashes pitting the participants against New York's police force. In August 1927 angry crowds who had packed into Union Square to await news of the Sacco-Vanzetti execution were roughly dispersed by the police. On May 18, 1929, a demonstration against police brutality, led by the Communist Party, ended similarly when police charged the crowds to make arrests and injured several marchers. These confrontations erupted into uglier violence on March 6, 1930, when a mass protest at Union Square, calling for government action against unemployment, deteriorated into a melee after demonstrators—many of them jobless—resisted police efforts to prevent them from marching south to City Hall. The ensuing tumult resulted in one hundred injuries and thirteen arrests. This riot was the turning point in galvanizing public opinion against such acts of unnecessary police coercion, and city officials were subsequently pressured to guarantee the right to free assembly in Union Square.[2]

Peter Hopkins, a recent enrollee at the Art Students League when the March 6 demonstration occurred, witnessed the proceedings from a window overlooking Union Square. Seventeen years later he recalled the scene in *Riot at Union Square,* reworking some of the facts-of-record in order to create a more dramatic composition. The perspective captures the action at ground level looking south from 17th Street toward Union Square West (Broadway). The facade of the Park Pavilion,

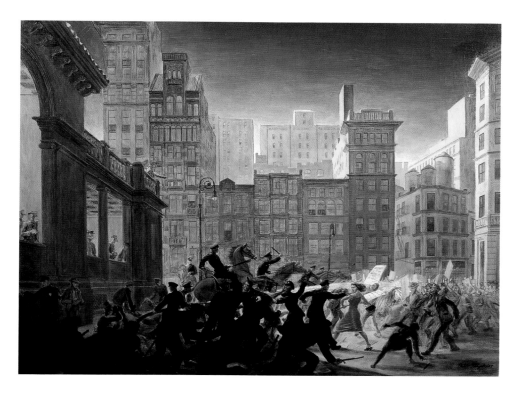

thrusting into the picture from the left, directs the viewer's eye to the unfolding drama at center, in which the onrushing police, menacing in their dark uniforms, deploy clubs, lunging horses, and the force of a water hose to quell the throng of demonstrators clad in buff-colored street wear. (A back-up battalion of firemen and street cleaners on hand to clear litter from the square were ordered to aim powerful streams of water into the crowd in an effort to stymie their movement.)[3] A brunette in a sun dress, its vivid red color no doubt a reference to the "Red Rally's" ties to the Communist Party, holds her ground, mustering strength to strike her placard at an officer preparing to grab her. Reporters scribble notes on the sidelines.[4] The buildings edging Union Square form a grand architectural enclosure for this urban spectacle.

The artist, raised in New York City, enjoyed an eclectic career, working as a writer, dishwasher, dog breeder, actor, teacher, portraitist, and theatrical scene painter. Hopkins'

formal studies at the Art Students League were punctuated by a seventeen-year hiatus. Having briefly taken courses there under George Bridgman in 1928, he returned for four years of intermittent instruction following his service in the U.S. Army Air Corps Meteorological Service during World War II. *Riot at Union Square,* painted during this period of renewed association with the league, suggests the influence of his teacher, Reginald Marsh, whose studio happened to overlook Union Square. In 1950 this painting was one of eleven works by Hopkins featured in an award exhibition presented by the American Academy and Institute of Arts and Letters.[5] Although he continued to paint and draw after 1950, Hopkins focused his later career on teaching and lecturing about art at New York City area colleges. A longtime resident of Greenwich Village, he has remained there since his retirement.

East River Waterfront

1932

Maurice Kish (b. 1898)
Oil on canvas, 44 × 36
Signed lower left: *Maurice Kish*
Gift of the artist, 72.41

The Trinity Coal Company at the foot of East 70th Street provided the setting for this somber February view. As barges and tugboats ply the East River's strong tides and choppy waters, the Trinity plant and other nearby smokestacks discharge their begriming vapors into New York's overcast skies.

From this dockside vantage point are seen the strong arch of the Hell Gate railway bridge and the delicate turrets of the Triborough Bridge where it spans Randalls Island. The East River, though crucial to the city's flow of commercial maritime vessels, posed a major obstruction to interborough transportation, requiring construction of many costly bridges and tunnels to connect Manhattan with Queens and Brooklyn. From the mid-nineteenth century until 1956, the Welfare Island ferry operated from a slip just to the north of this site at the base of East 78th Street, providing access to the island's municipal welfare institutions. Welfare Island itself (formerly called Blackwell's island and now known as Roosevelt Island) can be seen across the river. The visible municipal buildings may have been part of Metropolitan Hospital, one of New York's largest hospitals of that period, which provided free medical services to the city's needy.[1] The massive apartment buildings of Roosevelt Island now replace most of the earlier structures.

Trinity was one of many coal yards located along Manhattan's shoreline until the demand for coal was reduced by the World War II–era development of a process for extracting oil from coal and the emergence of diesel-fueled ships' engines. Today, the Franklin Delano Roosevelt Drive (East Side Highway) covers the East River shoreline, and buildings in the New York Hospital complex now occupy the point where East 70th Street meets the river.

Maurice Kish was born in Russia and came to the United States in his teens. For a long time he lived in the Brighton Beach section of Brooklyn. He was a student at the National Academy of Design and Cooper Union and later was a member of the allied Artists of America and the Brooklyn Society of Artists. He exhibited extensively in the New York area during the 1930s, 1940s, and early 1950s. For further discussion of his career, see plate 89.

Opening Night, Ziegfeld Follies

c. 1926

Howard A. Thain (1891–1959)
Oil on canvas, 16 ⅛ × 20 ⅛
Signed lower right: *Howard
Thain*
The Robert R. Preato Collection,
91.76.15

Blazing lights, a crush of people on the sidewalk, and a sea of automobiles are deployed in this scene to convey the excitement of an opening night on Broadway. The event of record, on June 24, 1926, at the Globe Theatre on Broadway and 46th Street, was impresario Florenz Ziegfeld's show *No Foolin'*. From 1907 until 1925, Ziegfeld (1867–1932) treated New York to an annual musical revue first produced under the title *Follies* and then, beginning in 1911, under the title *Ziegfeld Follies*. Ziegfeld's *Follies* have been called "undoubtedly the most revered and long-lived of Broadway's musical revues."[1] Glamour and opulence were the keynotes of Ziegfeld's extravaganzas, to the extent that "Ziegfeld" has become synonymous with lavish splendor. To create these fantasies, Ziegfeld negotiated contracts with the nation's most beautiful women (Paulette Goddard and Louise Brooks among them), outfitting them in elaborate costumes designed by such artists as Erté. He also hired the best creative talents of the period: set designer Joseph Urban; composers Jerome Kern, George Gershwin, Irving Berlin, and Rudolph Friml; and such outstanding stage personalities as comedians W. C. Fields, Bert Williams, Will Rogers, and Fannie Brice. One critic of the period commented: "Out of the vulgar leg-show, Ziegfeld has fashioned a thing of grace and beauty, of loveliness and charm; he knows quality and mood."[2]

The year 1926 presented Ziegfeld with something of a problem; pending litigation

with two of his partners had prohibited use of the highly recognized *Ziegfeld Follies* title on the Globe's marquee. The letters in the upper-right corner of the canvas denote the solution he devised: "zieg no f" is part of "Ziegfeld's *No Foolin'*." "glo," beneath, refers to the Globe Theatre, where the show opened, and, below, "glorifin ameri" is part of the line "Glorifying the American Girl," the well-known theme for all of Ziegfeld's *Follies*. This production was the first by Ziegfeld to play at the Globe. Previously, his shows had been housed in the New Amsterdam Theater at the corner of 42nd Street and Seventh Avenue before they departed New York on road tours. After the event commemorated in this painting, "Flo" Ziegfeld offered two more, in 1927 and 1931. Upon his death, the Shubert organization purchased rights to the name and presented several editions, which were considered lacking in the imagination and taste of Ziegfeld's work.[3]

The diagonal arrangement of this tripartite composition—buildings featured above, vehicles in the middle, figures at the bottom—directs the eye to the heart of the work: the theater's lit marquee. The repeated pattern of men's hats and noticeably similar postures of the figures give much of the work a static aspect, countered by the animation of the flickering letters, the bright facades of the nearby buildings, and the spotlights that have been brought in to shine on the theater. The density of the composition infuses the scene with a

sense of excitement and anticipation as Broadway prepares to measure another new show.

Howard Thain was born in Dallas, Texas, where Vivian Anspaugh was his first teacher. About 1912 he moved to St. Louis, Missouri, where he studied at the Washington University School of the Arts. He later matriculated at the Chicago Art Institute under the Russian painter S. Ostrowsky, who had been a pupil of Jean-Paul Laurens. When Thain came to New York City in 1919, he enrolled at the Art Students League, studying with Frank Vincent DuMond, Robert Henri, and John Sloan. In New York his work moved away from the Impressionist influence of his earlier Chicago canvases, becoming more conservative. He lived in several sections of the city, supporting himself with commercial work but constantly sketching New York's buildings and urban activities, particularly scenes found in the theater district and in New York's poorest blocks. Eventually he moved his family to New Jersey and worked as an art director for a lithographic company until illness required his retirement in 1956, when he returned to Dallas.

Street Carousel

1936

JEROME MYERS (1867–1940)
Oil on canvas, 18 × 24
Signed lower left: *Jerome Myers*
1936
Gift of Francis P. Garvan,
76.112

THE ARTIST Jerome Myers observed that when immigrants "merge here with New York, something happens that gives vibrancy."[1] The kaleidoscope of activity found in New York's immigrant neighborhoods reflected that vibrancy, captured by Myers in a low-keyed palette applied with quick, expressive brushwork and suffused with a golden haze. His many scenes of life in New York's Lower East Side emphasize whatever fleeting moments of happiness the often-difficult lives of new arrivals allowed.

Like other artists of his period, including those of the Ash Can School, Myers had a predilection for sentimentalizing slum children. Possibly his own unstable childhood, attributable to Myers' often-absent father, seriously ill mother, and several years spent in an orphanage, moved him to observe and record the happy times and cheerful spirits of the slums rather than their oppressive conditions. He frequently depicted clean, well-dressed children engaged in games or other pleasant distractions. In this view, children accompanied by several adults enjoy the colorful entertainment offered by a tiny traveling street carousel, one of the forms of urban entertainment that provided a meager living for their itinerant owners.

By 1936, the Restrictive Immigration Act imposed in the 1920s had severely reduced the annual flow of foreigners into New York City's ghettos. This decline did not, however, diminish the variety of newcomers, among whom were represented—in addition to the Irish, Germans, and Jews of preceding decades—Poles, Greeks, Slovaks, Turks, Russians, Romanians, and Italians.

Myers studied for a year at Cooper Union before enrolling in the Art Students League, where George de Forest Brush was one of his teachers. To support himself during his student years, he worked as a photoengraver, a theatrical scene painter, and a decorative painter. Although the league's traditional training provided a solid foundation, after eight years there Myers found himself "more interested in character than in pose."[2] Drawn to the realities of life as he saw them on the Lower East Side and similar neighborhoods around the city, he followed his personal bent in rendering what he found. Myers was friendly with John Sloan and his circle, was represented at the 1910 exhibition of the Independent Artists, and worked on the early plans for the 1913 Armory Show.[3]

7th Avenue Subway

1931

James W. Kerr (1897–1994)

Signed lower left: *James W. Kerr / NYC 1931*

Oil on canvas, 26 × 40

Gift of the artist, 77.16.4

Subdivision of the farms and villages of the Bronx as far north as Van Cortlandt Park transformed that borough into an appealing, affordable, and convenient place to live. The northward expansion of New York's metropolitan transit system, here represented by the Broadway–Seventh Avenue subway, a branch of the Interborough Rapid Transit (IRT), opened the way for much of this development during the first quarter of the twentieth century. When extended in 1905, the line covered a route running from Van Cortlandt Park at 242nd Street in the Bronx, through Harlem, the Upper West Side, and Greenwich Village, to South Ferry at Manhattan's southern tip. Two northern branches end at 148th Street in Manhattan and Wakefield in the East Bronx, while certain southbound trains veer off to Flatbush and New Lots Avenues in Brooklyn, making the subway line New York's longest. The mélange of passengers featured in this vignette signifies the varied neighborhoods served by the train's route.

In the 1930s the city's three subway systems carried a daily passenger load of 5.5 million, most of whom composed a rush-hour crowd of "commuters just arrived from the suburbs over New York Central and New Haven trains … and … others from the city," largely en route to or from work. A complex of underground shops and facilities—phone booths, lunch counters, hotels, shoeshine stands—connected by the subway lines had created a subterranean second city,

and a New Yorker could "live a rather rounded life without once venturing into the street." During the Great Depression, homeless people slept in the subway and used it as a shelter during the coldest days, beginning a sad but long-standing tradition that continues today.[1]

For most city residents, the subway represented a convenient, inexpensive means of traveling about town without becoming paralyzed in traffic jams endemic to the streets. Many New York City artists set out to examine the uniquely urban experience of traveling in close proximity to strangers beneath the streets. James Kerr here portrays a typical cross section of riders, reflecting disparities of age, occupation, class, and ethnicity. The fur collar and cuffs and well-fitted gloves worn by the woman seated third from the right contrast sharply with the battered felt hat of the tieless African American man two seats to her left. The small girl with dangling feet holds fast to the woman at her side. Except for the men absorbed in their newspapers and the bespectacled woman who has just glanced up from her book, Kerr's characters stare vacantly ahead, adhering to the urban etiquette of eluding eye contact with fellow passengers and retreating into private thoughts in order to block out the drab, noisy subway system.

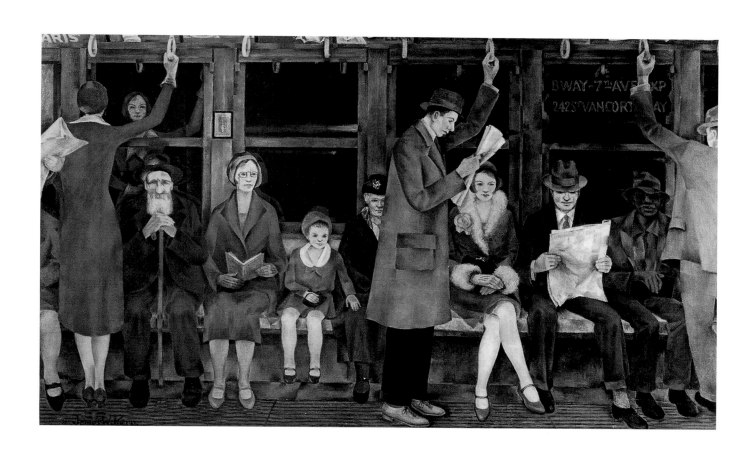

New York Amusements

c. 1933–1934

William C. Palmer (1906–1987)
Tempera on artist's board,
33 ¼ × 20 ⅛
Permanent deposit, Public
Works of Art Project through
the Whitney Museum of
American Art, L1226.1

When New York City emerged from the Great Depression in 1941, William Palmer left to accept simultaneous appointments upstate as artist-in-residence at Hamilton College in Clinton, New York, and director of the Munson-Williams-Proctor Institute's School of Art in Utica, a position he held until his retirement in 1973.[1] His departure left a gap in the metropolitan art community because by 1940 Palmer was a reigning specialist in mural painting, noted for both his depth of practical experience with and his historical knowledge of this challenging art form.

Palmer had honed his skills at fresco painting during a year's study at the Ecole des Beaux-Arts in Fontainbleu, France, in 1927, where the methods of the modern French master Puvis de Chavannes informed instruction. New York City, however, was the primary laboratory where Palmer's expertise developed. An Iowa native, Palmer had left America's heartland in 1924 to study at the Art Students League, placing himself under the formative influences of such legendary teachers as Kenneth Hayes Miller, Thomas Hart Benton, and Boardman Robinson. He later returned to the league, assuming instructional responsibilities there from 1936 to 1941. Official administrative positions and memberships held during the 1930s attest to the artist's increasing authority as a muralist. In 1933 he was elected to the National Society of Mural Painters; in 1935 he became director of the Mural Department of the Beaux-Arts Institute; in 1938 he provided advice on murals as a participant in the Collaborative Council

of the New York World's Fair. The following year he assumed the supervisor's position for the mural department of the New York City Division of the WPA Federal Art Project.

Concurrent with these professional involvements, much of Palmer's own art production had centered on mural commissions. In the late 1920s he designed murals, decorative furnishings, and scenic paintings for private homes as well as for several theatrical and institutional clients. After 1929 the plummeting economy largely eradicated this source of income, but the New Deal's succession of relief programs for artists re-energized mural making to Palmer's benefit. Notable among his WPA-sponsored projects were *The Development of Medicine* (1934–1938), an ambitious eight-segment mural cycle conceived for the newly constructed Queens General Hospital, and several other regionalist American scenes developed for post-office walls in Washington, D.C.; Arlington, Massachusetts; and his native state of Iowa.

New York Amusements, together with a pendant scene titled *New York Transportation,* most likely dates from 1933–1934, when Palmer was participating in the Public Works of Art Project (PWAP), a federally subsidized pilot initiative to gather decorative program proposals for public buildings.[2] In operation for only six months before its transformation into the WPA Fine Arts Program, the PWAP generated more than 15,600 works by 3,749 affiliated artists nationwide. Regional committees subsequently awarded commissions based on designs submitted in open competitions. Many,

American Life

1934

Anatol Shulkin (1901–1961)
Oil on linen canvas, 50 × 338 ½
Signed lower right: *Anatol
Shulkin 1934*
Gift of Mr. and Mrs. Daniel
Cowin, 80.172

Russian émigré artist Anatol Shulkin painted *American Life* as a statement about the cultural incongruities plaguing his adopted country during the Great Depression. By the mid-1930s, Shulkin perceived New York City as center stage for these forces, allusions to which he wove through his twenty-eight-foot mural as a series of tabloid-like vignettes depicting an urban society brewing with unrest, glamour, corruption, and tumultuous energy. The provocative results, all the more noteworthy because the piece represented the artist's trial venture into mural painting, demonstrate the fusion of powerful design, compelling social content, and heroic scale that boosted popular interest in mural painting during the 1930s.

The privileged position that murals would claim over the decade was aided, to a large degree, by federally financed programs offering relief to unemployed artists while securing decoration for the walls of public buildings. Shulkin's commission, however, fell outside

that network of government patronage. The main dining room of the Barbizon-Plaza Hotel at 106 Central Park South, erected in 1930, was the seemingly unlikely backdrop for *American Life*. Although the specific circumstances of the mural's arrival within the establishment's stylish Art Deco interior are unrecorded, its placement may be attributable to the hotel's receptivity to contemporary art, inferred by its billing as New York's "first fully equipped music-artist residence center," complete with two concert auditoriums, a library, art studios, and exhibition rooms catering to creative tenants.[1] The work's installation in 1934 coincided with Shulkin's own residency there. More significant was the Barbizon-Plaza's concurrent service as host to An American Group, an organization activated in 1931 to arrange show space for "individualistic" artwork with "something to say" and consequently foreclosed from traditional gallery venues.[2] The hotel facilitated exhibitions for the group for three seasons before its mem-

portation facility providing commuter access to public amusement areas.[3] Using low-keyed colors, the artist depicts in whimsical cross section a stack of densely trafficked urban attractions. A crush of couples swaying to band music and a few seated onlookers inhabit a subterranean cabaret, probably inspired by the covert speakeasies that flourished in New York during Prohibition. At street level, crowds queue for a theater spectacle promising love, mystery, and "great casts of 500 girls and boys in person." Above, searchlights, flickering signs, distant skyscraper towers, and the festooned contours of a roller coaster lure patrons inside a celestial play zone featuring such attractions as "a Leap of Death" and a whirling swing ride.

Palmer's handling of figures is similar to the work of contemporary muralist Edward Laning, another student of Kenneth Hayes Miller's at the Art Students League. The playful mood, urban content, and spatial treatment of the scenes also evoke a striking springtime tableau of Washington Square that Palmer painted as a four-panel folding screen around 1929.[4] Around the same time he painted *New York Amusements,* Palmer was developing Midwestern scenes as a category of pictures, prompted in part by his respites on Lake Ontario and in his hometown, Des Moines, during the early 1930s. These trips resulted in a subgroup of "amusement" paintings depicting summer lakeside pleasures and, later, golfing, a favorite recreation of Palmer's.

including Palmer's two studies, were never realized beyond conceptual renderings.

The intended placement of Palmer's painting is unknown, although its theme, and that of the associated sketch, seem compatible with a theater, recreational arcade, or trans-

76

Eight studies for a mural intended for the Central Park Casino

1934

BEN SHAHN (1898–1969)
Permanent deposit, Public
Works of Art Project, through
the Whitney Museum of
American Art

76 *W.C.T.U. Parade*
Egg tempera and gouache on
masonite, 31¾ × 16⅛, L1226.3e

77 *Bootleggers*
Egg tempera and gouache on
masonite, 16⅜ × 15⅞, L1226.3d

78 *Village Speakeasy, Closed for
Violation*
Egg tempera and gouache on
masonite, 16¼ × 47⅞, L1226.3c

79 *Speakeasy (Interior)*
Egg tempera and gouache on
masonite, 9½ × 24, L1226.3g

80 *Federal Agents Pouring Wine
down a Sewer During
Prohibition, Destroying Wine*
Egg tempera and gouache on
masonite, 16¼ × 11¼, L1226.3a

81 *Parade for Repeal*
Egg tempera and gouache on
masonite, 31¾ × 16½, L1226.3b

THE EIGHTEENTH Amendment to the Constitution (known as the Volstead Act) banned the manufacture, distribution, sale, and use of alcoholic beverages in the years between 1920 and 1933, the era of Prohibition. When it quickly became apparent that strict enforcement of such legislated social change would be impossible to achieve, New York City became a prime source of demand for bootleg alcohol. This illegal system mainly supplied the estimated thirty-two thousand speakeasies—double the number of legitimate saloons in the city before 1920. By 1933, recognizing the political and social costs of "the Noble Experiment" and the ineffectiveness of its enforcement, Congress passed the Twenty-first Amendment, thereby repealing Prohibition.

Ben Shahn made these studies for a mural intended for the Central Park Casino, which had been designed in 1870 by Calvert Vaux as a Ladies Pavilion but which, by the time of Mayor Jimmy Walker's tenure during the "roaring twenties," evolved into a rendezvous for boisterous cafe society. Using architectural details, public signage, popular slogans, and human drama, Shahn conceived this ultimately unrealized mural as an essay on the folly of Prohibition. The well-meaning ladies of the Women's Christian Temperance

Union appear resolute in their mission as they parade "for God, for Home, for Native Land" (plate 76). Their modest attire and dour faces under dowdy hats form a humorous contrast with the images in the other panels: bootleggers wearing imaginative devices for concealing liquor on their bodies to circumvent the law (plate 77); chagrined customers of a closed liquor supplier on Bethune Street (next to Shahn's residence at the time) (plate 78); well-heeled patrons in a speakeasy (plate 79); men under the supervision of a stern law enforcer destroying wine in an alley behind a closed bootleg outlet (plate 80); and dapper, derby-hatted Mayor Walker, rumored to be part-owner of a number of illegal Greenwich Village bars, leading a parade of flag-waving men seeking repeal (plate 81).

Born in 1898 in Kovno, Lithuania, then a province of czarist Russia, Ben Shahn immigrated to the United States in 1906. A highly motivated and accomplished student in many academic areas, Shahn received limited formal training in art. From 1913 to 1917, while attending school at night, he served an apprenticeship in Hessenberg's Lithography Shop at 101 Beekman Street in Manhattan. Subsequently he was able to support himself off and on as a printer until he became established as an artist.

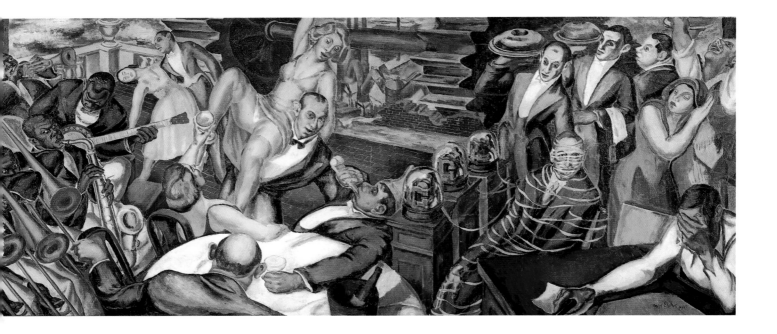

Critics tracking Shulkin's progress on the mural applauded its daring concept, "masculine style," and, when finished, his generally successful plastic integration of figures into the complex architectural background.[4] The art press reserved special praise for the work's subtle color harmonies, some of phantasmagorical effect, which they compared favorably to the work of contemporary muralists Thomas Hart Benton and Diego Rivera. Shulkin admired the politically charged frescoes then being executed by Rivera, and it is worth noting that Shulkin's creation of *American Life* overlapped with the much-publicized removal at Rockefeller Center of Rivera's controversial murals invoking Communist leaders.[5] Before the debut of this work, Shulkin was known principally as a skillful easel painter.[6] After studying at the Art Students League and the National Academy of Design in the 1920s, he had pursued additional instruction from George Bellows, Leon Kroll, and Charles Curran, whose technical advice and color theo-

ries were combined influences on Shulkin's emerging style. By 1933 he had joined the faculty of Cooper Union as an art instructor and had savored the success of several solo exhibitions of his oils, first at the Art Centre Gallery and then at the newly opened Midtown Galleries, both in Manhattan.[7] At this juncture, Shulkin seems to have fallen under the spell of the Mexican mural movement. Under the patronage of the Works Progress Administration, he executed mural studies and won commissions for post-office projects, and later he produced wall paintings for private homes. During the mid-1940s, he taught painting at the Newark School of Fine and Industrial Arts in New Jersey. At the time of his death, Shulkin's work had been purchased for the permanent collections of the Whitney and Metropolitan Museums of Art and featured in prestigious exhibition venues across the United States.

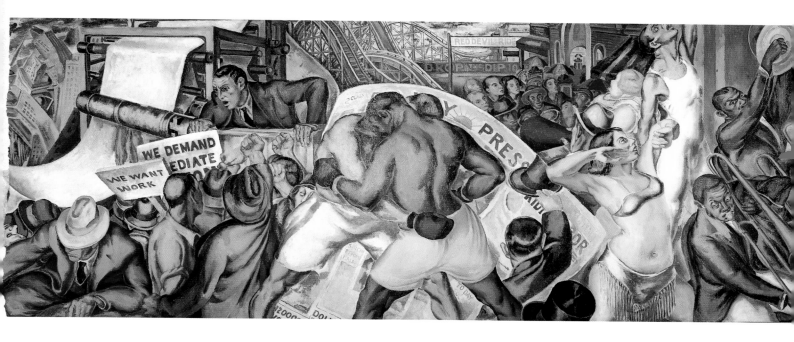

bers opted to turn their programs over to professional gallery management. The provocative mood of Shulkin's mural, though not necessarily suited to whetting patron's appetites, apparently was more tolerable for a hotel than the American Group artists, to whom uncensored expression was paramount.[3]

For his grand opus, Shulkin marshaled figures and symbols that embodied the polymorphic culture of Depression-era New York. These he welded into a dense, rhythmical design that delivers a cumulative portrait of the decadence, confusion, and economic and racial strains afflicting the city. Framing the composition, at far left, a trio of Salvation Army volunteers tries, futilely, to attract attention to their cause outside the well-guarded entrance of a pleasure resort. Inside—as the eye shifts right—a porcine politician, or "swell," appears to be accepting a bribe. A gangland killing emerges from the page of a newspaper, shocking a stolid, seated woman but arousing curiosity from a bevy of chorus

girls above her. Below the distorted skyline inset of St. Patrick's Cathedral and the partially constructed Rockefeller Center, laborers demanding work raise angry fists at a man epitomizing white-collar authority. At center, the mural depicts a prize fight under way against the foil of a tabloid featuring at least one discernible report of a balked suicide. The boxers locked in contest, who seem to be archetypes rather than specific figures, may refer to the undercurrent of racism encapsulated in various championship bouts between black and white fighters during the 1920s. Above them, Coney Island amusements, including a "Red Devil Ride" alluding to the strengthening presence of the Communist Party in New York, blends into the high-priced debauchery of nightclub revelers. The unreal frivolity of these images gives way, at far right, to dramatizations of the despair of those ruined by the 1929 stock market crash: a businessman enmeshed in tickertape and a broken spirit on the verge of suicide, clutching a gun.

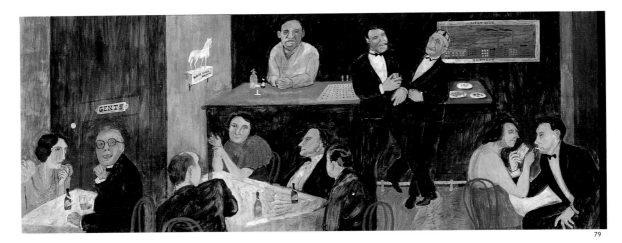

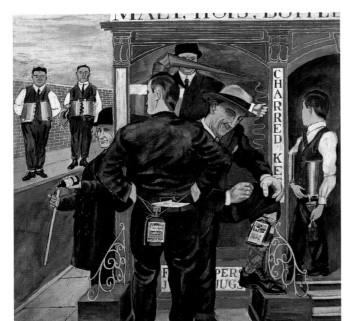

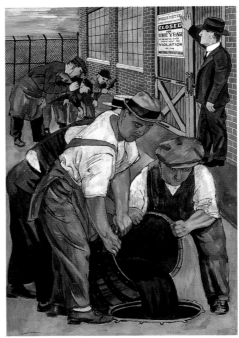

In the early 1930s, with the encouragement and technical advice of Walker Evans, who shared his Bethune Street studio, Shahn began taking photographs all over New York City. Shahn himself viewed his camera work only as a device for gathering ideas for future paintings, but the architectural backgrounds of the Prohibition series studies, derived from his photos, help to anchor figures that might

otherwise seem merely caricatures.[1] Just before undertaking these works, Shahn had assisted Diego Rivera (1886–1957) on the mural the Mexican artist had been commissioned to paint for Rockefeller Center. Rivera's controversial depiction of actual personalities, including the Communist leader Vladimir I. Lenin, and of contemporary events clearly influenced Shahn's approach to the Prohibi-

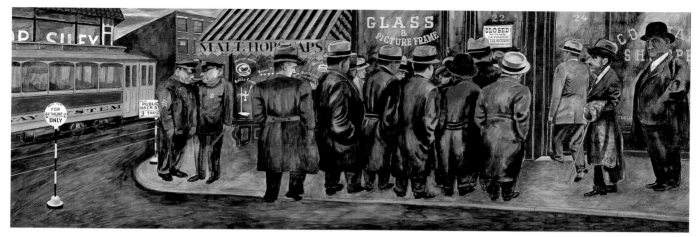

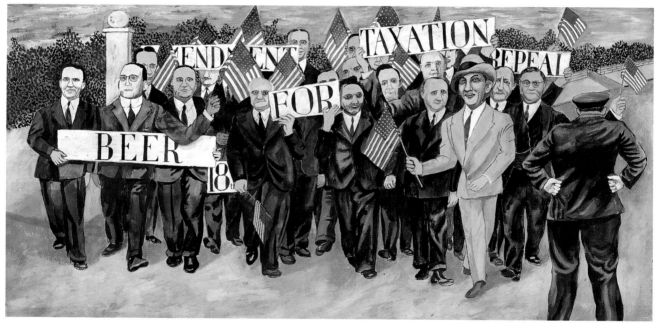

tion series conceived for the Central Park Casino.[2]

One of the reasons Shahn was attracted to mural painting was the broad audience commanded by such public art forms. Political infighting scuttled his ambitions for reaching a popular audience through this project, however. Shortly after the proposal was submitted, the city's newly appointed Parks Commis-sioner, Robert Moses, perhaps motivated by his animosity for Mayor Jimmy Walker (who by 1933 had been forced out of office on corruption charges) and his belief that the casino's prices had risen beyond the reach of ordinary New Yorkers, ordered the casino demolished.[3] Despite the disappointing outcome of the Prohibition series, Shahn continued to paint murals.[4]

View of St. Andrew's Church

c. 1935

MAURICE KORANIEVSKY
(active c. 1935)
Oil on canvas, 37 ½ × 47 ¼
Inscribed on back of canvas:
*"Old New York" / by / Maurice
Koranievsky*
Gift of Mrs. Marie Koranievsky,
wife of the artist, 75.7

ST. ANDREW'S, the first Protestant Episcopal congregation in Harlem, was organized in 1829 and opened its first church on Fourth (now Park) Avenue between 127th and 128th Streets the following year.[1] Several additions enlarged the church before fire destroyed it in 1871. The next year, the congregation broke ground on the same site for a new church designed by Henry M. Congdon (1834–1922).[2] The Gothic-style building was completed in 1873.

St. Andrew's grew along with Nieuw Haarlem, a village established in 1658 by Peter Stuyvesant and bounded by the Harlem River, Morningside Heights, 110th Street, and 155th Street. In the 1830s a horse-drawn car line, the first in Manhattan, began operating along Fourth Avenue from City Hall to the Harlem River, and this, with the arrival of the Harlem Railroad in 1832 and the Third Avenue horse railroad (known as the Palace Horse Car) in 1853, helped Harlem grow from a rural community of rich estates to a thriving village.[3] The 1873 annexation of the village by New York City, followed in 1880 by the advent of elevated rapid transit lines, turned Harlem into a fashionable neighborhood with easy access to lower Manhattan.

Because of the congregation's steady growth and the noise and smoke of the railroad along Park Avenue, a larger building on a different site was deemed necessary for St. Andrew's. In 1888 the building firm of Mahoney and Watson was hired to dismantle the church, brick by brick, and to reassemble and enlarge it on its present site, the east side of Fifth Avenue between 127th and 128th Streets.[4] The larger building, depicted here, accommodated congregants from the "aristocratic apartment houses and the popular brownstones" of the neighborhood, populated primarily by Germans and Irish and graced by such amenities as Oscar Hammerstein's Harlem Opera House on West 125th Street.[5]

In this painting, no evidence is visible of the urban growth that changed Harlem well before the date of this Depression-era view. The horse-drawn vehicle on the left suggests Harlem's more rustic past. Nothing in the scene depicted here reflects the influx of southern blacks who migrated there in search of work beginning in World War I and crowded into the overpriced housing made available to them by avaricious landlords.

No biographical information about the artist has been found.

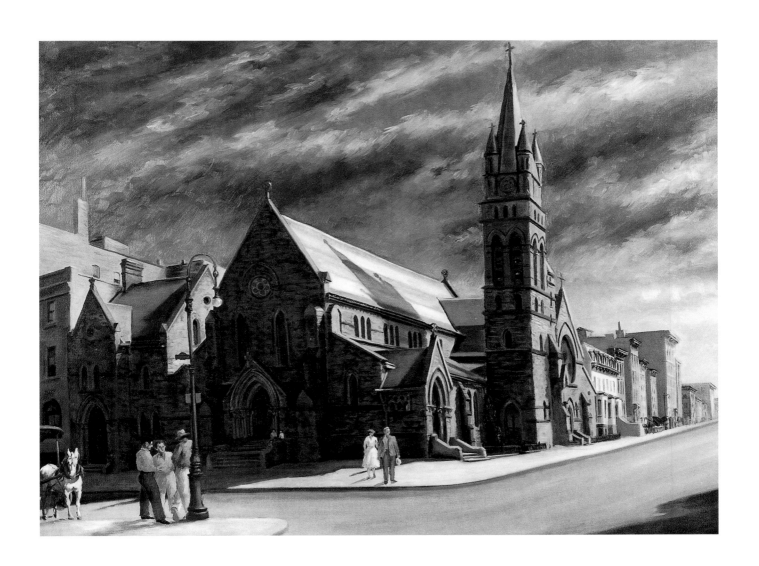

235

The Life Cafeteria

1936

Vincent La Gambina
(1909–1994)
Oil on canvas, 42 ¾ × 42 ¾
Signed lower right: *Vincent La
Gambina, 1936*
Gift of the artist, 88.10.1

Like most Greenwich Village artists on tight budgets during the Great Depression, Vincent La Gambina patronized the bohemian restaurants clustered around Sheridan Square. Offering cheap nourishment, easy credit, and congenial company, these unpretentious eateries also functioned as neighborhood social clubs. "For the price of a cup of coffee and a roll, one could sit for hours and hear everything from poetry to politics discussed over the course of an evening," La Gambina recalled. "Unemployed painters, writers, actors, and teachers gravitated there for warmth, friendship, and a bit of fun."[1]

Once a relatively tranquil Village crossroads, Sheridan Square—the intersection of Seventh Avenue and West 4th Street—evolved into a bustling tourist hub after its connection to the IRT subway system in 1917–1918. Popular periodicals promoted Sheridan Square as the nerve center of the "New Bohemia," contributing to the area's invasion by outsiders. National magazines like *Vanity Fair, McCall's,* and the *Ladies' Home Journal* carried feature articles about the colorful species of "bird stick varnishers, budding Bolsheviks, and smock designers" who ran tea rooms and trinket shops in the vicinity.[2] The extension of Seventh Avenue South below 11th Street after World War I also increased traffic volume through the square. In the bloom of this publicity, the neighborhood's prewar identity as the unhurried preserve of local artists and left-wing radicals surrendered to that of a parade

ground thronged by sightseers pursuing the offbeat. The cozy vest-pocket cafe, long a trademark of Sheridan Square dining, succumbed to the fast-food canteen with enamel-topped tables, electric lights, and a clattering, impersonal service counter.

La Gambina's painting documents the interior of the Life Cafeteria, one of the square's busiest establishments, catering to a transient as well as neighborhood clientele. Built in the late 1920s at the junction of Christopher Street and Seventh Avenue, it stood a short walk away from Washington Square, where La Gambina operated an art school in the early 1940s. Dominating the foreground is a trio of stylishly dressed women, one preoccupied by an unseen subject to the right, another powdering her cheek as she reads, and the third peering over her companion's shoulder to share the contents of her book. The confidence with which they occupy their table, bearing evidence of meals already consumed, suggests the women's status as regular patrons. In the background, several solitary customers ponder the cafeteria's fare or carry trays into the dining hall. The glint of stainless-steel coffee urns and food counter equipment provides a cool contrast to the muted warmth of La Gambina's palette.

Of the thousand or more self-service restaurants opened in Manhattan during the 1920s, those in Greenwich Village managed to preserve some of the avant-garde ambience that patrons expected to encounter in New

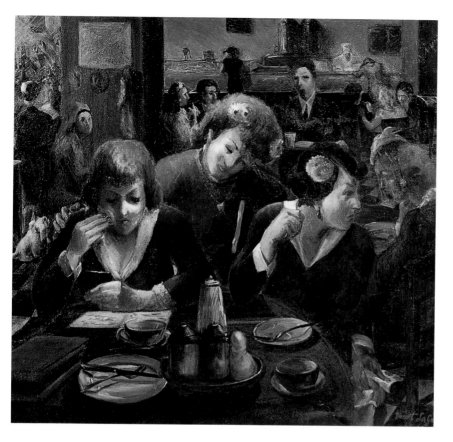

York's Latin Quarter.[3] Art exhibitions, jazz recitals, and poetry readings were among the attractions that contributed to their bohemian flavor. The Life Cafeteria conformed to local pattern. Although uptown shoppers and curious suburbanites frequented it by day, a more exotic clientele assembled at its tables after dark, including male prostitutes and others from the Village demimonde. "In the evenings," observed *The WPA Guide to New York City* (1939), "the more conventional occupy tables in one section of the room and watch the 'show' of eccentrics on the other side."[4] When the restaurant's management hired police to patrol its restrooms and pressure patrons into vacating their seats once meals were consumed, the Life Cafeteria—tagged "Arrestaurant" by Village writer Maxwell Bodenheim[5]—lost the local trade

necessary to stay in business. After the restaurant closed, the building was subdivided into stores that sold everything from baloney to books.

La Gambina, an avid observer of the Village scene, often dropped by the Life Cafeteria to meet friends and survey its notorious clientele. Born in Sicily in 1909, the artist had immigrated to New York in 1920. He was orphaned shortly after his arrival and turned to painting as a means of support. Initially he sought training at the Da Vinci Art School in Manhattan and later earned scholarships to the National Academy of Design and the Art Students League. In the 1930s he participated in the Depression-bred easel- and mural-painting programs of the Works Progress Administration and subsequently opened his own teaching facility, the Washington Square Art School, which folded when he enlisted for duty in the armed forces during World War II. As a resident of Greenwich Village during its heyday of intellectual and social ferment, La Gambina found a rich source of inspiration in the district's theatrical street life, which he recorded in a succession of canvases between the mid-1930s and 1960. Loose, vigorous brushwork and bold chiaroscuro typify these cityscapes, as do strong draftsmanship and the interplay of brilliant color against a more sober-keyed palette.

Chinatown Scene

c. 1935

SELMA GUBIN (1903–1974)
Oil on paper, 14 ¾ × 20
Gift of Joan Gubin Tolchin,
92.76

THE BUILDINGS lining this narrow, curved roadway—probably Doyers or Mott Street—look very much the same today as they did in the 1930s, when Selma Gubin painted this artfully composed study of Chinatown thinned of its typically dense pedestrian traffic. According to local history, the district that became New York City's Chinatown in the 1930s, a district bound by Bayard and Baxter Streets, Park Row, and New Bowery, was established with the arrival of one Chinese individual in Doyers Street in 1855. By 1859 the number of Chinese in the area had increased to 150 residents. By the 1870s the number of Chinese residents had grown to more than 2,000.

These nineteenth-century arrivals found themselves packed as densely into dingy tenement buildings as other immigrant groups establishing themselves in New York. However, the buildings in what came to be known as Chinatown benefited from the practice of decorating building exteriors with adaptations of traditional Chinese architecture—pagodas and tile roofs—lending the area an exotic flavor that identifies Chinatown to this day.[1] In addition to such architectural flourishes, the many restaurants, curio shops, and grocery stores dealing in Chinese goods, and the well-publicized threat of rival *tongs*, or gangs, created a district that was both tantalizing and fearsome to outsiders as late as the 1940s.[2] The tong wars in the early decades of the twentieth century led to the city's highest murder rate within a limited geographic area. By the 1930s,

however, these gang-like societies had restructured themselves into organizations dedicated to helping immigrants.[3]

Selma Gubin was born in Kiev, Ukraine, and settled with her family in New York in 1908. Even though few women were successful in the city's contemporary art world, her father encouraged her pursuit of formal art training. After studying art at Hunter College, Gubin joined the Art Students League in 1924, where faculty members Raphael Soyer, Philip Evergood, and Chaim Gross influenced her developing style. Although obliged to work at a variety of office jobs in order to support herself, Gubin remained an active member of the New York Artists Equity Association and the National Association of Women Artists and exhibited widely during her lifetime. In this painting, the faceless figures and pockets of shadow in the street combine with the distorted perspective of street and buildings to give the scene an almost ominous air, an aspect emphasized by the strong but jarring coloration.

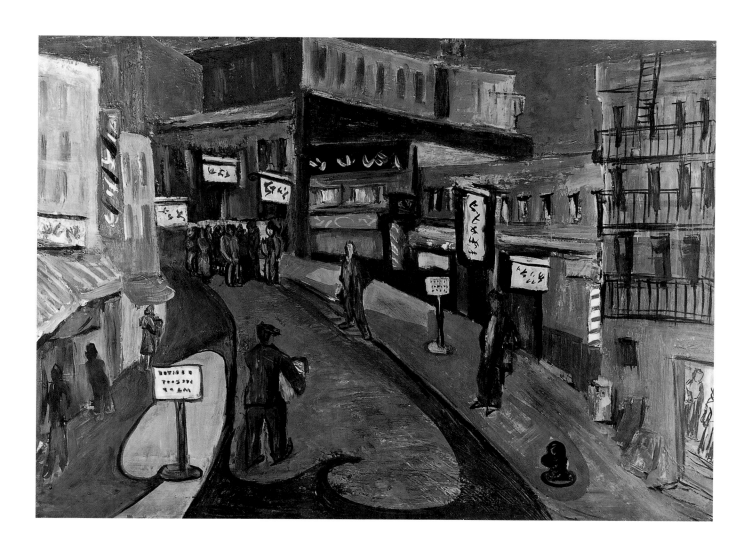

The Queensboro Bridge

c. 1935

BLENDON REED CAMPBELL
(1872–1969)
Oil on canvas, 40 × 54
Signed lower right: *Blendon Reed
Campbell*
Gift of Mrs. Alice C. Flenner,
71.121

"THE CITY seen from the Queensboro Bridge is always the city seen for the first time, in its first wild promise of all the mystery and the beauty in the world …. 'Anything can happen now that we've slid over this bridge … anything at all.'"[1] Campbell's painting, which presents the 1909 Queensboro Bridge as an entryway into a park-like waterfront and an immaculate, orderly cityscape, concretizes F. Scott Fitzgerald's description in *The Great Gatsby* (1925). With his use of muted, pastel colors, Campbell further depicts Fitzgerald's portrait of "the city rising up across the river in white heaps and sugar lumps all built with a wish out of non-olfactory money." By arching the bridge against this exciting background as it soars above the clearly industrialized but tidy Queens shoreline in the foreground, Campbell emphasizes the linkage created by the bridge between Manhattan, Welfare Island in the middle, and Queens. It also imparts Fitzgerald's sense of dazzling promise. Campbell's optimism is difficult to fathom, given that he created the work in the depths of the country's worst depression. Stylistically it clearly relates to its period, in the nearly Precisionist rendering of the elements of structures, boats, and vehicles, reflecting the efforts of an American painter to follow modernist trends. The painting was shown at the Pennsylvania Academy of the Fine Arts during the 1930s in an exhibition titled *The Bridges of New York*.[2]

Blendon Reed Campbell, born in St. Louis, studied in Paris with James McNeil Whistler in his short-lived art school, and with Paul Albert Laurens and Jean-Joseph Constant. Campbell's work included illustrations for newspapers and magazines, printmaking, and portrait and landscape painting. During the Great Depression years, he executed prints and paintings for the artists' programs of the Public Works Administration.

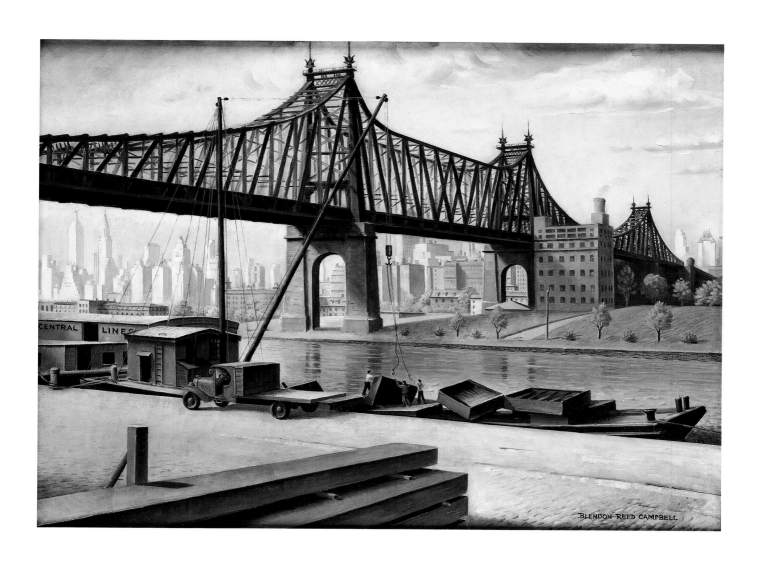

BLENDON REED CAMPBELL

Summer Electric Storm

(also exhibited as *Storm Over Manhattan*), 1938

CECIL C. BELL (1906–1970)
Oil on canvas, 25 × 30 ⅛
Signed lower right: *Cecil C. Bell 38*
The Robert R. Preato Collection, 91.76.21

CECIL BELL, having worked primarily in watercolor and gouache prior to 1934, turned to oils in the mid-1930s under the influence of John Sloan, his teacher at the Art Students League. Bell found that the shift in medium energized his ongoing efforts to capture New York's robust charm. "I want principally to get down life as I see it and if it turns out to be Art, so much the better," he told an interviewer in 1939, in the spirit of his Ash Can School mentor.[1] Bell's Depression-era vignettes were informed by a creative sensibility that acknowledged New York City as its life-giving force. Although a day job in commercial art was his financial backbone, Bell explored the city in his independent work for almost forty years.[2] His cityscape paintings, especially those dating to the later 1930s and 1940s, present a fundamentally benign place full of human incident: an urban theater of lush colors, energy, and endlessly diverting forms.

This rooftop scene records the pyrotechnics accompanying a thunderstorm passing over Manhattan on a sweltering summer night. The setting is the roof of a typical old multi-family dwelling found in Greenwich Village, probably near, if not on, the apartment building at 19 East Ninth Street where the artist then resided. (Bell often ascended to his roof with sketchpad and easel, relishing the breezes and vantage points.) The figures are several of the building's working-class tenants. Positioned in the foreground like theatergoers preparing to take seats in the front row, a couple gazes up at the erupting sky. The two have probably escaped to the roof from a poorly ventilated apartment below. Another suffering neighbor, emerging through the stairwell exit carrying a newspaper, will intrude on their privacy. Weather reports attest to the stifling heat that plagued New York during the summer of 1938, breaking half a century's worth of records and causing numerous sudden, severe thunderstorms.[3]

Although Bell's rooftop audience is preoccupied with the blazing lightning and ominous liver-brown clouds overhead, the composition also features two dramatic attractions of the Greenwich Village skyline. Protruding up toward the angry firmament is the conspicuous stepped-back pinnacle of 1 Fifth Avenue, a modern, twenty-seven-story brick apartment house that had been completed on Fifth Avenue and the southeast corner of 8th Street in 1929. In the distance, at the lower left, the distinctive campanile-style tower of the Judson Memorial Church at 55 Washington Square South is visible, crowned with its perennially illuminated cross. The painting's main attraction, however, remains the power of nature as it momentarily humbles Bell's indomitable city.

Following Bell's death in 1970, this canvas entered the art market under the title *Storm Over Manhattan* and was exhibited as such in the 1992 tribute installation mounted at the Museum of the City of New York in honor of

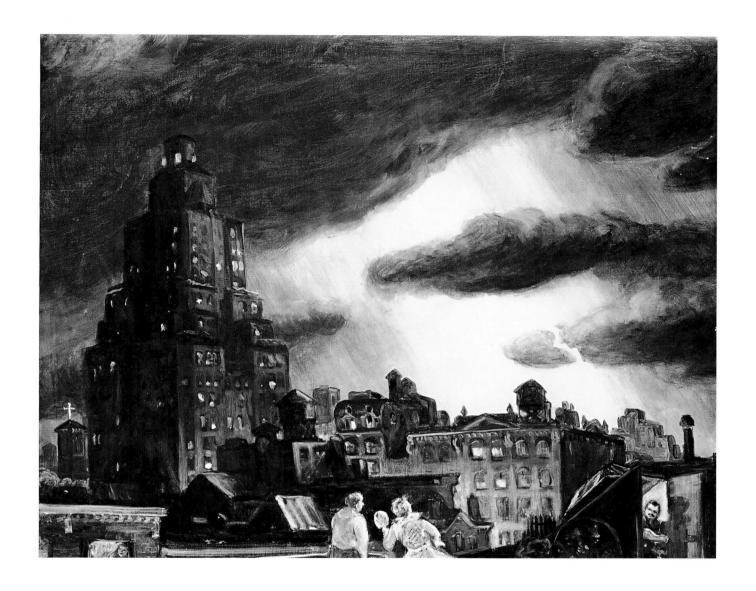

the Robert R. Preato bequest.[4] Loan records predating 1992, however, indicate that the Museum had borrowed this same work, then cited as *Summer Electric Storm,* from Bell's widow in 1973 for *The Vanished City,* a retrospective of the artist's New York scene paintings. The inscription "Summer Electric Storm" appears on its stretcher in what seems to be the artist's handwriting, prompting the reassignment of this earlier title to the painting.

Metropolis Movement

(also exhibited as *New York of Yesterday*), 1939

BEYS AFROYIM (1893–1984)
Oil on canvas, 94 ¼ × 55 ½
Signed lower right:
Afroyim / 1939
Gift of Dr. and Mrs. Jerome Krant in memory of Rebecca Krant Afroyim, 94.60

IN HIS arresting cutaway view of 1939 midtown Manhattan, Beys Afroyim has represented three levels of urban transit: the underground subway, street-level vehicular traffic, and elevated railway tracks. As backdrop to this multi-level drama of diagonals, he has employed the contrasting verticality of New York's skyscrapers, the most recognizable being the recently opened Empire State Building. Hard-edged geometric shapes in muted colors crisscross the canvas, conveying the solidity and immensity of New York's burgeoning steel and concrete infrastructure. Work of this sort earned Afroyim the label "radical modernist."

Afroyim, born Ephraim Bernstein in Riki, Poland, immigrated to the United States in 1912 and became a naturalized citizen in 1926.[1] He studied at the Chicago Art Institute and at the National Academy of Design with Charles Hinton and had his first one-man show at the Jewish Institute in New York in 1922. That same year, Alfred Steiglitz maneuvered Afroyim's inclusion in the first annual exhibition of the forward-looking Society of Independent Artists. *Metropolis Movement* was exhibited at the society's Silver Jubilee. In 1927 Afroyim opened the Afroyim Experimental School of Art in New York City.

Afroyim subsequently worked and exhibited in Europe, Cuba, and Mexico, returning to New York in the 1930s to participate in various WPA-era art projects. His work includes portraits of noted politicians and literary and artistic figures, sculptural reliefs in copper, and artistic responses to symphonies and other compositions, called "visual music."[2] In 1950 he established a studio in the Israeli art colony of Safad, and until his death he divided his time between Israel and his residence on Staten Island.

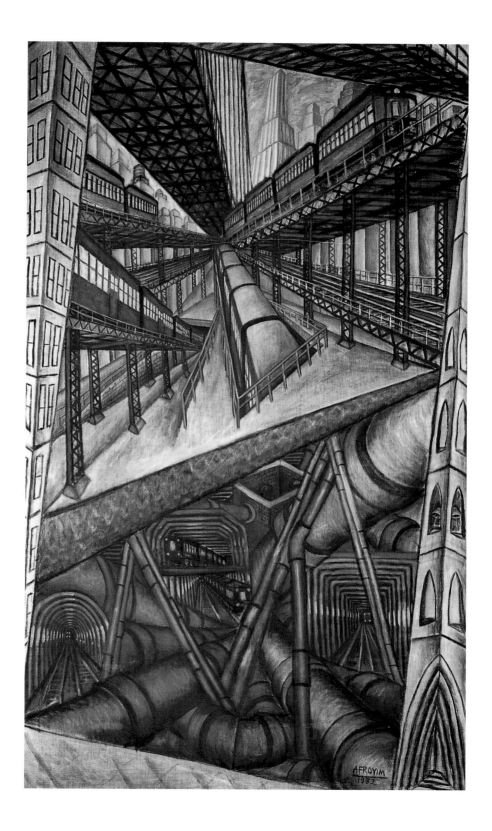

Manhattan Skyline

1939

<small>Attributed to Teng Hiok</small>
<small>Chiu</small> (b. 1903)
Oil on canvas, 30 ⅛ × 25 ⅛
Signed lower left: *Teng*
(additional words illegible)
The Robert R. Preato Collection,
91.76.8

<small>Manhattan experienced</small> an enormous surge in construction of state-of-the-art high-rise buildings in response to the heated economy that enlivened the city following World War I. Many of these projects were luxury hotels erected in the years before the 1929 stock-market crash. On the eve of World War II, the British- and American-trained Chinese artist Teng Hiok Chiu rendered this aerial view of New York's array of new "skyscrapers" clustered along Fifth Avenue in the upper 50s, apparently from a vantage point on 55th or 54th Street just west of Fifth Avenue. In this way, he typified the change of artistic focus from lower Manhattan to this upper midtown location as it transformed.

The 1927 Heckscher Building is impressionistically rendered. Designed as a retail and wholesale buying center for women, it is visible in the left middle, with its triangular rooftop (in actuality a water-tank enclosure) topped by a rooster finial. Many of its patrons were affluent guests of the three nearby Fifth Avenue hotels also depicted by Chiu: the Sherry-Netherland (at 59th Street), recognizable by its triangular roof surmounted by a steeple-like finial; the Pierre, immediately behind the Sherry-Netherland (at 61st Street); and the now-demolished Savoy-Plaza (occupying the entire block between 58th and 59th Streets), between the Sherry-Netherland and one of the area's step-sided buildings.[1]

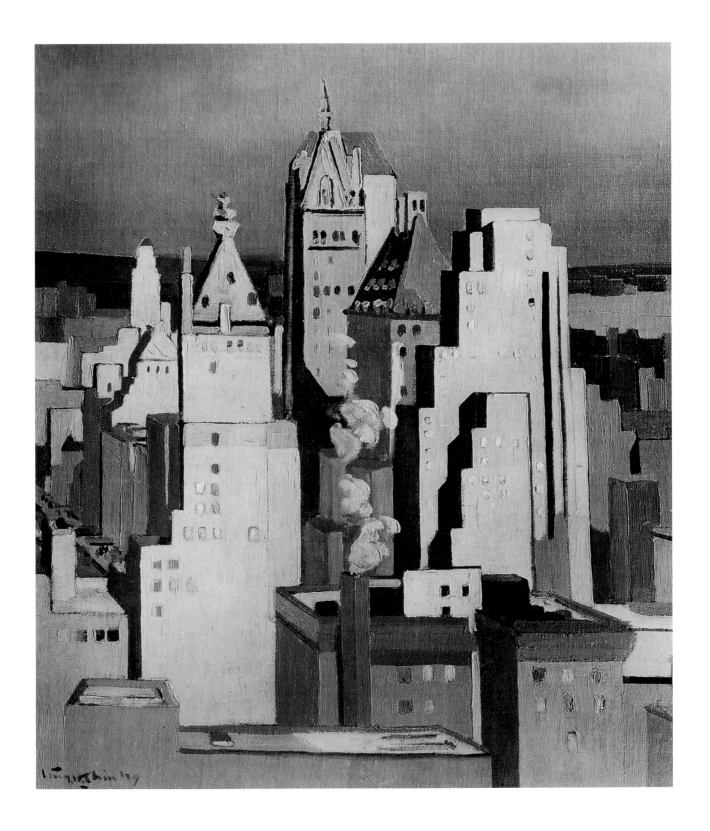

247

The End of an Epoch

1939

Maurice Kish (b. 1898)
Oil on canvas, 21 × 25 ⅕
Signed lower right: *Maurice Kish*
Gift of the artist, 73.35

New York City's elevated train system emerged in the 1870s as an efficient means of transporting commuters, avoiding Manhattan's congested streets. On Sixth Avenue, the accelerated travel offered by such steam-drawn elevated trains (converted to electrical operation by 1903) encouraged the spread of retail trade, entertainment, and comfortable residences north along the thoroughfare from 14th Street to Central Park. Ironically, the rising prosperity of Sixth Avenue triggered by this improvement in rapid transit was sabotaged early in the twentieth century by the advent of even more efficient subways, which contained the noise and dirt of train travel underground. By 1910, fashionable stores and smart clubs were deserting Sixth Avenue for airier parallel boulevards not inconvenienced by the grime and rattle of an overhead El.

In 1912 property owners, alarmed by this exodus, banded together as the Sixth Avenue Association, aiming to reclaim their avenue's promise by pressuring legislators to demolish the overhead liability that the El now seemed to represent. Their efforts, facilitated by Mayor John F. Hylan,[1] succeeded in 1924 with a bill authorizing the system's dismantling, quickly effecting the removal of the spur of tracks running above Sixth Avenue from 53rd to 59th Streets. Further work was delayed until the second half of the next decade. In the interim, however, the value of real estate located on these six liberated blocks had doubled, a fact used by the association as leverage to press for

elimination of the remaining system stretching south. Victory arrived on December 20, 1938, when Mayor Fiorello H. La Guardia, who had actively supported the campaign, donned goggles and with an acetylene torch personally attacked a steel El girder on Sixth Avenue at 53rd Street. Beyond the new vistas and opportunities for redevelopment created by the destruction of the unsightly structures, the banishment of overhead trains from the avenue also led to the completion of the IND Sixth Avenue subway line, making the El immediately obsolete.

The End of an Epoch commemorates the dismantling of the El tracks on Sixth Avenue, ushering out an era in the city's public transportation and unleashing conflicting emotions among the system's riders. Whereas many had cheered the announced demolition, camera-toting New Yorkers thronged Sixth Avenue's El during its final days of operation to preserve memories of its unrivaled views of the city (and outlooks into private apartments adjacent to its tracks). Other sentimentalists took souvenirs, pillaging fixtures along with their bolts.[2] The painter's focus, however, is on the complex enterprise of removing the doomed landmark, here at the juncture of West 27th Street. Proceeding span by span, the operation involved burning out rivets from the columns supporting the system and removing overhead longitudinal beams with cranes situated on the remnants of the track trellis, which lowered the beams and cross gird-

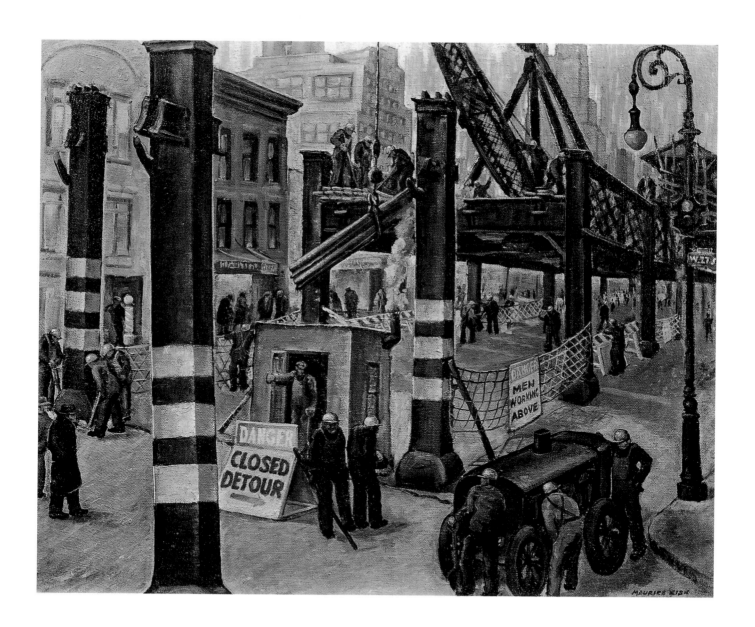

ers to the pavement below. After disassembling the metal skeleton with blow torches, workers loaded its parts onto trucks and hauled them away to be sold as scrap. During the process, any exposed steel pillars posing a danger to traffic were marked to alert drivers to detour around them when the construction crews had quit the site after dark.

Although the scene's primary action is the maneuvers of the workers in hard hats, whose exertions have drawn interested onlookers, the indirect drama of Sixth Avenue's reappearance is also significant. As girders came down, street-level views of grimy nineteenth-century brownstones and small businesses forgotten in the shadow of the El were suddenly revealed. Their survival, however, was tenuous in the face of developers' ambitions for Sixth Avenue, intimated by the futuristic skyscrapers of midtown suggested in the distant picture plane.

Maurice Kish, born in Dvinsk, Russia, immigrated to New York in his teens. He pursued studies in art at Cooper Union and the National Academy of Design, gaining a foundation solid enough to support himself as a painter and to place his work in exhibitions, by the late 1930s, at such prestigious venues as the Corcoran Gallery of Art and the Pennsylvania Academy of the Fine Arts. Kish participated in a variety of local art associations in the period before World War II and thereafter became involved in the Educational Alliance, the American Veteran Society of Artists, and the Brooklyn Art Alliance, the last of which

was located in his home borough.[3] During the Great Depression, he was drawn to subjects heroicizing America's laboring class and their search for employment in the industrial Northeast. These fruitful themes often enabled Kish to incorporate keenly observed vignettes of New York City's blighted waterfront and factories in danger of closure (see also plate 70).

Times Square

1940

Stokely Webster (b. 1912)

Oil on canvas, 24 × 20

Signed lower right: *Stokely*

Webster

Gift of the artist, 75.40

The throbbing night life of Times Square, hailed as the country's nocturnal "amusement center," was the wonder of tourists by the time this painting was produced in 1940. Guidebook writers marveled at the ceaseless flow of people through it and considered the garish, synthetic glow of the Great White Way especially memorable. "The scene is cheap and tawdry, yet impressive and stimulating," waxed a typical description of the era aimed at sightseers, which went on to inventory the square's medley of attractions: theaters, movie houses, restaurants, shops, and "flashing, glittering, multi-colored light-pictures advertising the Nation's products."[1] Stokely Webster defied such predictable imagery in *Times Square*, however, by offering an impression of the district in a quieter, morning mood.

Looming in the distance, like the advancing prow of a gray battleship, is the New York Times building, with its moving belt of electric bulbs spelling out fast-breaking news temporarily extinguished. The construction in 1904 of this wedge-shaped corporate tower at the triangular intersection of Broadway, Seventh Avenue, and 42nd Street had been a catalyst in transforming the formerly undistinguished commercial locale known as Longacre Square into a pivotal crossroads of entertainment, transportation, shopping, and communication thereafter formalized as Times Square.[2] The marquee of Loew's State, the only theater in the square presenting regular vaudeville shows, is partially visible to the

left, its flickering lights also stilled. The bright red light of a streetcorner traffic signal, broadcasting its warning to absent throngs, underscores the square's curtailed pace of activity. Only a concession stand (in the picture's left foreground) appears awake for business, along with a few ghostly pedestrians whose reality is barely substantiated by the artist's fleshless brushstrokes. Without benefit of its nocturnal wardrobe, the famed hub assumes an intriguing air of drabness accentuated by the unforgiving effects of sunup on Times Square's jumble of commercial buildings, novelty stalls, darkened billboards, and lifeless theater facades.

As a child, Stokely Webster left his Evanston, Illinois, birthplace to travel with his family to Paris, where he was enthralled by the paintings of the French Impressionists and Post-Impressionists and embarked on his own fledgling efforts at plein-air cityscapes. After returning to America in 1924, he dedicated the next ten years to educating himself through a succession of art-school courses, studying architecture at Yale and spending two years in Chicago working as a textile designer. In 1936 he studied for six months with Robert Henri's disciple Wayman Adams, learning the rigors of portrait painting and honing his landscape technique, which combined the high-valued colors of Impressionism with the luxurious painterly means of Henri and John Singer Sargent. A one-man exhibition, which opened in New York the same year he completed *Times*

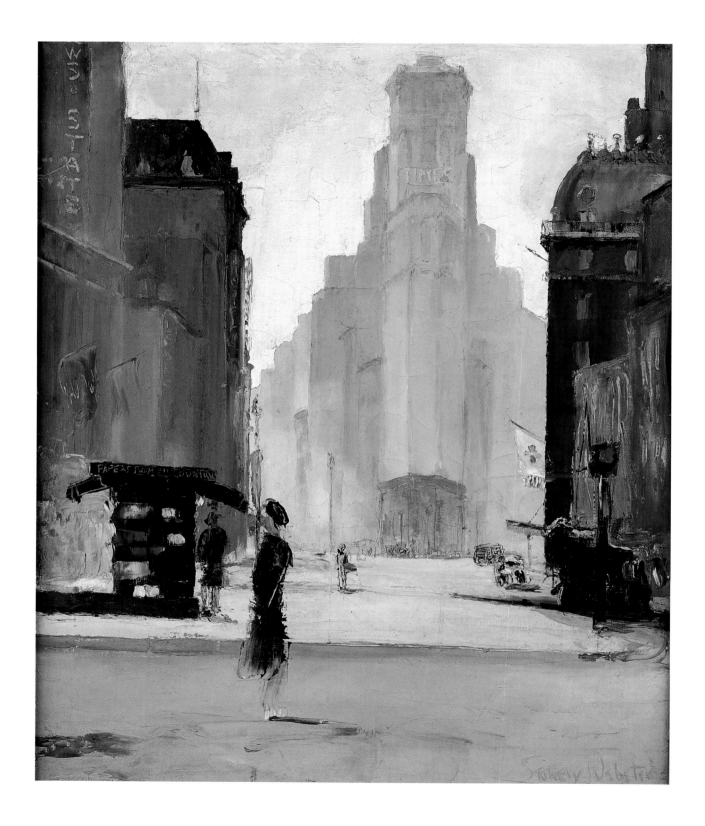

Square, rewarded him with gratifying reviews: "Mr. Webster paints in the way that at one time was thought the only way to paint, using the flowing strokes and well-thinned-out pigments that came to us through Sargent via Frans Hals and Velasquez," admired a critic in the *New York Sun*. A reviewer for the *New York Herald Tribune* endorsed that opinion, comparing Webster's technical skills to those of Sargent, while others praised his expertise at capturing the momentary impression of a place and his exceptionally convincing and precise use of light as the force defining its mood, climate, and urban disposition.[3]

Webster's joy at this reception, which buttressed his ambition to focus on painting full time, was savored only briefly. The outbreak of World War II had soon shifted him to the assembly line at Grumman Aircraft Corporation, leading to his pursuit of an engineering degree at Columbia University and seven years of steady employment designing airplanes. He returned to painting in 1948, having sublet a spacious studio, formerly owned by George Luks, in Manhattan. A freak fire ravaged this building four years later, however, destroying more than sixty of his canvases and cheating Webster of his successful re-entry into the city's art world. The incident prompted him to relocate to Huntington, Long Island, where he became involved as a designer, and then president, of a gyroscope manufacturing company. Webster's creative inclinations eventu-ally lured him back into active painting, and the decades of the 1960s and 1970s saw him creating both landscapes and figural studies and exhibiting that work internationally in an array of salons and galleries. During this time, Webster's paintings were acquired by, or donated to, museums in the United States.[4] His commitment to painting lyrical seascapes and city scenes in an Impressionist manner continued unabated, and museum exhibitions featuring recent work by the artist were still being organized into the mid-1990s.[5]

Harris Theater, New York

1940

Reginald Marsh (1898–1954)
Watercolor on Whatman paper,
27 × 40 ⅜
Signed lower right: *Reginald
Marsh, 1940*
Gift of the artist, 53.107.3

During his early career as an illustrator and cartoonist, Reginald Marsh took to prowling Manhattan's streets with sketch pad in hand. Humanity's urban species fascinated him, steering him to spots where New Yorkers paraded or commingled in all their irrepressible variety. Times Square, Coney Island, and 14th Street became familiar haunts, but promising material also issued from his forays into subway stations, Bowery dives, and burlesque parlors. The drawings accumulated from these rambles (sometimes supplemented by site photographs Marsh also produced) provided a fountainhead of impressions for the artist to rework later in his studio overlooking Union Square.[1] Combining ebullient draftsmanship, skillful caricature, and keenly observed detail, these vignettes often feigned a tabloid style to parody New York's social foibles and unbridled commercialism.

Harris Theater pokes fun at the public's growing obsession with the "silver screen." During the 1930s and 1940s, Marsh took note of the distinctive visual culture developing around New York City's proliferating motion-picture palaces. He was particularly intrigued by their charming ticket-booth clerks, flashing marquees, plastering of lurid posters and headlines, and lines of expectant patrons looking every bit as theatrical as the attractions they were priming to see. Marsh recycled these elements in a series of scenes devoted to Times Square's movie houses.

The Harris Theater, opened in 1914, had George M. Cohan and his partner, Sam Harris, as early tenants.[2] Like other movie theaters in the vicinity, it had enjoyed a run as a playhouse specializing in musicals and revues before management abandoned these pursuits to woo a new clientele preoccupied with Hollywood and continuous double features. The Depression triggered the conversion of many Broadway houses into inexpensive movie theaters in an effort to preserve patronage. Those traditional playhouses that remained found themselves increasingly relegated to the side streets off Times Square.

This busy watercolor depicts the sidewalk spectacle outside the theater's entrance at 226 West 42nd Street. The crowd milling in front, interspersed with several passersby, is typical of the proletariat figures that peopled Marsh's art. The women, dressed to please according to the latest gospel of working-class taste, flaunt their curvaceous charms. The men—coarser in appearance—tend to be caught more off guard, ogling "dames," slouching against walls, or shambling through a city of hollow employment prospects.[3] The billboard above the box office not only displays names of screen stars of the period but also provides wry predictions of the fate awaiting the unwary in Marsh's sexually predatory city. As if to test viewers' perceptivity, a comely duo walking past the theater at the far right confront us with curious or perhaps inviting

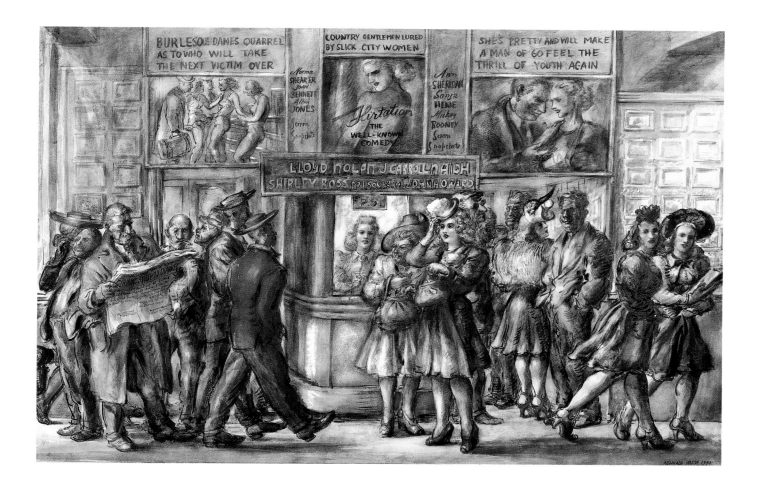

stares, reminding us of the scenarios that flirtatious dalliances lead to in Marsh's fictitious movie world.

Shifting among pen and pencil, egg tempera, watercolor, and oils, Marsh continually experimented with different media in his efforts to pictorialize New York. In the 1930s alone, he studied fresco and sculpture, purchased a Leica camera, refined his etching and lithography skills, and mastered the "Maroger medium," an emulsion technique derived from painting methods of the old masters. At heart a graphic artist who preferred fluid lines to disciplined color effects, he found Chinese ink the most versatile vehicle for conveying the

city's helter-skelter rhythms and sometimes used it, in combination with charcoal, washes, and other materials, to produce striking views of New York in grisaille. *The Bowery* (acc. no. 53.107.2) and *Steeplechase Park, Coney Island* (acc. no. 53.107.1), two large drawings dating to 1944 that Marsh presented to the Museum of the City of New York in 1953, demonstrate his bravura achievements in such mixed media.[4] The Museum's paintings collection also contains the artist's energetic preparatory studies for the United States Custom House fresco cycle, a series of eight vignettes executed in the late 1930s that depict New York Harbor in its international glory days.

On the Alert at Bryant Park, N.Y.C.

1941

MEYERS ROHOWSKY (1900–1974)
Oil on canvas over board,
20 × 15 ½
Signed lower left: *Rohowsky 41*
The Robert R. Preato Collection,
91.76.19

NEW YORKERS first heard the eerie blare of an air-raid siren around noon on December 9, 1941. Although this and two subsequent alarms sounded that week proved to be warning tests, they signaled the accelerating national efforts to mobilize a complex civil defense network— in this case, for the New York metropolis, a prime invasion target—as the implications of Japan's recent attack on Pearl Harbor and the formal entry of the United States into World War II took root. Mayor Fiorello La Guardia cast an ominous mood over the approaching holiday season by calling for twenty-seven thousand volunteers to develop and staff local preparedness systems. As the draft depleted the ranks of the city's police department, municipal security demanded recruitment of nonmilitary personnel to serve as air-raid wardens, to patrol locations vulnerable to attack or sabotage, and to help enforce blackout routines. "The war," La Guardia surmised gravely, "will come right to our streets and residential districts."[1]

An anti-air-raid observation post was quickly installed in Bryant Park, reflecting the sobering possibility of enemy penetration along America's eastern seaboard. The atmosphere of a military bunker created by the official troop-carrying truck, searchlight apparatus, and gun-toting guards recorded by Meyers Rohowsky may have seemed incongruous with this green preserve that doubled as a backyard for the adjoining New York Public Library. As one of the clear spaces in the heart of midtown Manhattan, however, the park offered a convenient storage place for defense equipment and vehicles as well as a strategic location for sky watching and surveying a vital communications and commercial section of the city.[2]

The raised terrace at the park's eastern end, situated at the rear of the library, provides the stage for the scene depicted. As searchlights scan the evening sky, two vigilant guards wearing khaki uniforms patrol the watch station's perimeter.[3] Countering the strange, vapor-like rays reaching skyward are the reassuring glow of illuminated offices and street-level stores, and the light burning from a solitary window in the library's otherwise darkened facade. The canvas-covered truck parked on the terrace obscures a view of the monument to poet-publisher William Cullen Bryant, for whom the park—once known as Reservoir Square— was renamed in 1896.

The artist took certain architectural liberties. Missing, for instance, is the ninth arched aperture from the tier of great windows that admit western light into the library's main reading room. The lower row of windows is incorrectly detailed, and the proportions of the actual Carrere and Hastings building have been compressed. The impact of Rohowsky's vignette is nonetheless strong. With his forthright style, realistic colors, and clarity of composition, he presents a convincing portrait of a watchful city adjusting to wartime precautions that might have seemed unimaginable only a year before.

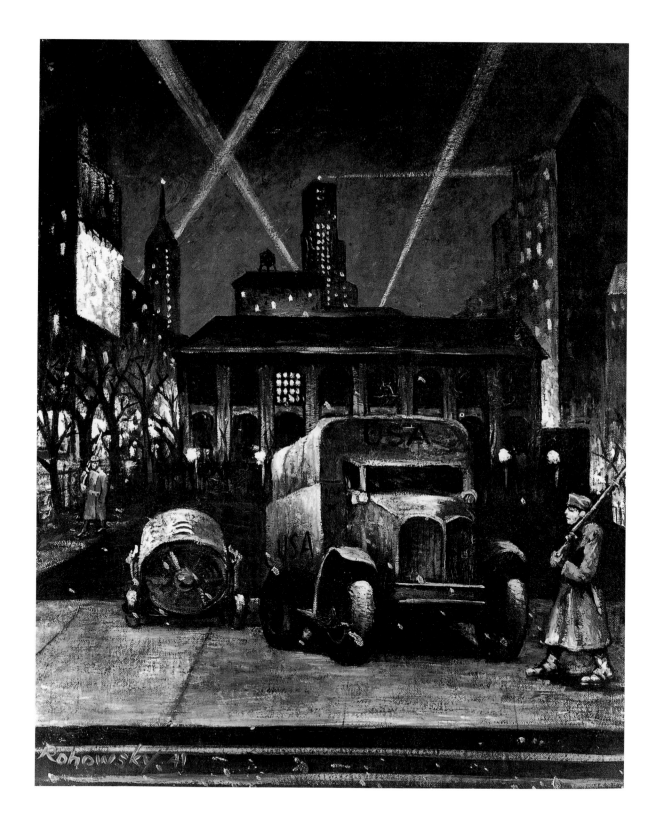

Times Square Dim-Out

1944

James W. Kerr (1897–1994)
Oil on canvas, 18 × 20
Signed lower left: *James Wilfred Kerr. 1944.*
Gift of the artist, 77.16.3

This evening scene of Times Square documents how blackout restrictions imposed an unusual, crepuscular glow on the Great White Way during World War II. Because New York City's normal nighttime light was intense enough to silhouette ships off Far Rockaway, heightening their vulnerability to German U-boat attack, security precautions included the unprecedented dimming of Times Square's "spectaculars," immense advertising signs girded in neon and colorful incandescent bulbs, which had been a hallmark of this entertainment crossroads for several decades.[1] The moving electric bulletins broadcast from *New York Times* headquarters at 43rd Street also went dark.

The temporary cessation of Times Square's famous "brighter-than-noon midnight" was part of a larger government action to curtail post-sunset use of electricity along the American East Coast. Times Square had been darkened to conserve electricity during World War I. However, the impact of World War II on this midtown section of New York City was especially pronounced, as many businesses closed, unable to meet costs. The sparkling marquees of theaters, movie palaces, and taxi dance halls were also subject to brown-outs, leaving as a standby light source the radiance filtering through the windows of street-level stores and restaurants.[2] As this painting by James Kerr demonstrates, the artificial glare projecting onto the dark sidewalks caused

pedestrians' forms to be outlined in sharp relief, returning a degree of individuality to the human sea flowing by. Under these diminished conditions, the carnival character distinctive of 42nd Street and Broadway at nightfall also appears subdued, creating a mood of intimacy on the crowded concourse.

Despite the irregularities of wartime, Times Square persevered as a homefront panacea by virtue of its many-layered amusements.[3] People continued to flock to 42nd Street, as they always had, although that traffic took on a new appearance. Women—alone, in pairs, and in groups—were seen in larger numbers than before military service had claimed their male contemporaries. The streets were also packed nightly with soldiers in uniforms representing all the countries warring against the Axis. A number of well-dressed women, self-assured in their high heels, can be distinguished in the promenade, some without escorts (such as the strolling figure clutching a purse who seems to move out of the painting's immediate foreground toward the viewer), others guided by sailors, soldiers, and civilians wearing homburgs. In a reminder of urban poverty oblivious to the hostilities overseas, an elderly beggar woman with a cane accepts a handout from a passerby. The younger blond standing alone near the storefront at left, clothed in a low-cut coat, calls to mind the impossibility of determining strangers' intentions in such a tran-

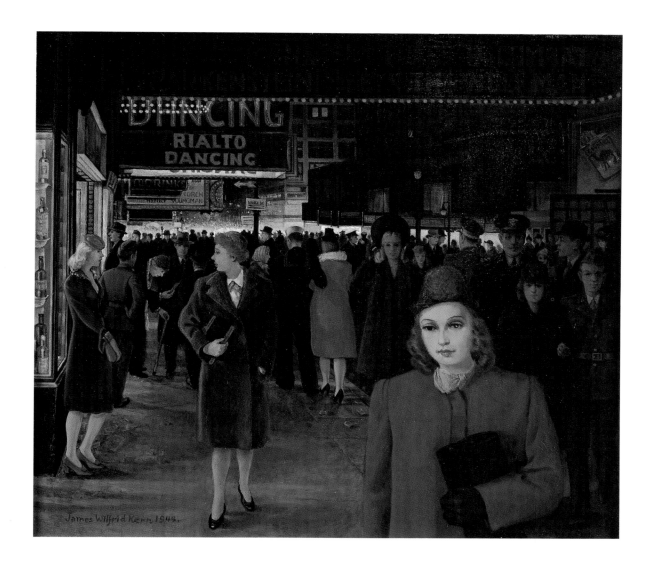

James Wilfrid Kerr, 1944.

sient milieu as Times Square. Is she waiting for a tardy friend, or is she hoping to land a quick date for pay?

With a keen eye for period detail, Kerr has reproduced not only up-to-date street wear but also familiar signage, like the darkened Camel cigarette logo (far right) and a marquee (at left) announcing comic Henry ("Henny") Youngman as a featured performer. Another teaser band at the top of the painting, with a pearl-like string of lit bulbs underneath it, may represent the artist's sarcastic summation of the ongoing war: "Human Monsters Clash in Combat … Frankenstein Meets the Wolf Man." Together with *Shootin' Gallery*, 1946 (fig. 25), and *Broadway Sovenirs*, 1946 (acc. no. 77.16.2), the *Dim-Out* is one of a trio of works by Kerr in the Museum's collection focused on the public culture and diversions of Times Square during the later 1940s.

Suburbia #5 (Flushing, Queens)

c. 1945

MAURICE SIEVAN (1898–1981)
Oil on canvas, 22 × 28
Signed lower right and on verso:
Sievan
Gift of Carolyn and Howard A.
Sievan, 92.84

IN 1940 painter Maurice Sievan and his wife, Lee Culik Sievan (1907–1990), an emerging photographer, moved from a Manhattan apartment into a new single-family home located in Flushing, Queens. The transition introduced Sievan to a pictorial theme that would pre-occupy him for more than a decade: the uncelebrated landscapes of this outlying residential borough of New York City, typified by tree-lined streets, low-rise housing, nondescript shopping areas, and ubiquitous automobile traffic. These moody and curiously depopulated pictures were the outcome of sketches and occasional photographs recorded by the couple from a battered Chevrolet that Sievan had improvised as a mobile studio. *Suburbia #5,* an unspecified Flushing streetscape dating from the mid-1940s, bears out the reputation—albeit unsought—that Sievan would acquire as the "poet laureate of suburbia."[1]

Sievan's Expressionist landscapes represented only one chapter in a long career marked by diverse stylistic adventures.[2] Arriving in Williamsburg, Brooklyn, from the Ukraine in 1906, Sievan became a U.S. citizen in 1913, the same year he left school for an apprentice job with a local lithographer. He subsequently took courses at the National Academy of Design, studying under the realist painter Leon Kroll. Following a brief tour with the merchant marines during World War I, he resumed evening studies at the Art Students League and the National Academy of Design while working by day as a commercial illustrator.

During his tenure as a "self-supervised" easel painter with the WPA's Federal Art Project, Sievan began to produce deft painterly sketches of downtown Manhattan and other vistas familiar from his successive apartment rentals in Greenwich Village and Brooklyn. During the war years Sievan began teaching in order to supplement his earnings from painting. Although the Greater New York area continued as the wellspring of his quietly inventive cityscapes, Sievan also captured views of Provincetown, the Massachusetts artists' colony he frequented during the summer. By 1956 he had shifted to wholly imaginary landscapes inspired by his first observations of earth from an airplane. Paralleling this output was a series of darker allegorical paintings, interpreted by some as Sievan's existentialist meditations about the horror of the Holocaust and the onset of the Atomic Age. Semi-abstract figural studies, effusing a rough and haunting vitality, preoccupied his later years.

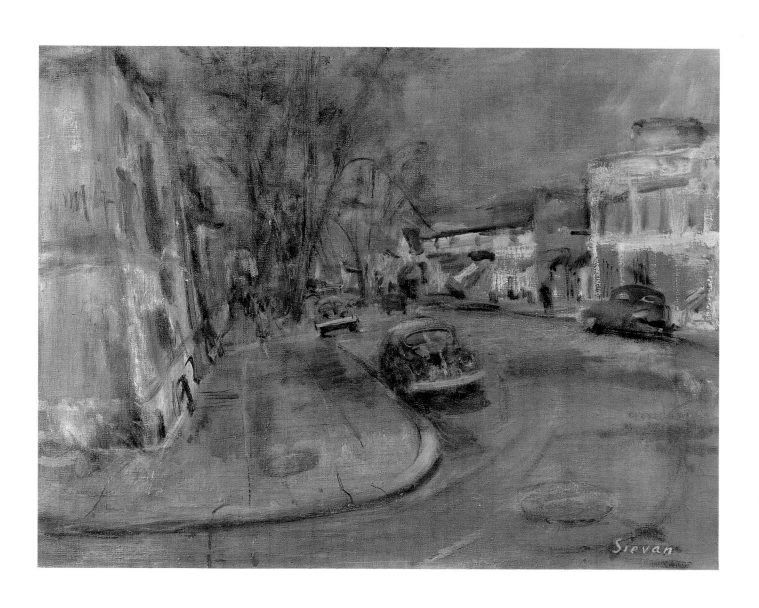

95

Rockefeller Center

1941

Israel C. Litwak (1867–1952)

Oil on canvas, 26 ½ × 40 ¼

Inscribed and signed lower right:
*Rockefeller Center—Israel
Litwak—1941*

Gift of Mr. and Mrs. Leo Treem,
86.56

In this naive depiction of one of midtown Manhattan's celebrated landmarks and tourist attractions, the artist has reduced the archetypal skyscrapers, which in actuality overshadow the skating rink, to a minor role and has magnified the rink to appear as the scene's dominant pictorial element. This inversion emphasizes the intended purpose of Rockefeller Center's plan—to use an open area to entice people into its complex of large buildings and shops.

Rockefeller Center was built during the Great Depression on a site bounded by 48th and 51st Streets and Fifth and Sixth Avenues, where, in 1802, New York's first botanical garden had been established by Dr. David Hosack. Hosack sold the fourteen-acre Elgin Garden to New York State in 1814, the same year the state granted the property to Columbia College in exchange for extensive acreage that Columbia held in New Hampshire.[1] When the Rockefeller Center outdoor skating rink opened to the public on Christmas Day, 1936, it earned the distinction of being the first artificial outdoor skating rink on Fifth Avenue. For three years thereafter, the freezing unit for generating ice was removed at the end of each season, making way for an outdoor cafe in warmer weather. In 1939 a permanent freezing unit was installed, buried within a terrazzo floor that also served as the cafe flooring, thereby ending the labor involved in converting the rink to a dining area. Anecdotal information suggests that the artist's roller-skating figures recall a brief period in the rink's history before its exclusive dedication to ice skating and its use as a summer restaurant.

Israel Litwak, who arrived in New York City from Odessa, Russia, in 1903, worked as a cabinetmaker until his retirement in the late 1930s. To occupy himself in retirement, he taught himself to draw, and when he considered his work enough improved, he offered two works to the Brooklyn Museum. Museum officials encouraged Litwak to continue and in 1939 opened an exhibition of thirty-six of his crayon drawings.[2] In addition to urban subjects, Litwak enjoyed depicting rural scenes, all of them from memory.

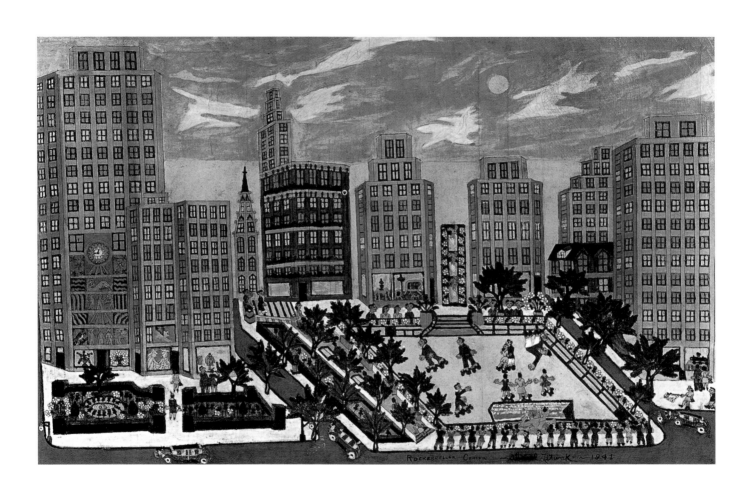

263

Storefront Mission

1943

Miklos Suba (1880–1944)
Oil on canvas, 14 × 16
Signed lower right:
Miklos Suba / 43
Gift of Susanna Suba, 88.45

THIS HUMBLE mission church at the corner of Dean Street and Classon Avenue in Brooklyn stands in sharp contrast to New York's more imposing religious edifices. With its painted (rather than stained-glass) windows, hand-lettered wooden signs, and storefront location adjacent to a small grocery store, its "mission" to the city's less affluent is clear. The *WPA Guide to New York City* describes how easily these storefronts were converted for religious use with the installation of rows of benches, a pulpit, and a minimal amount of decoration.[1]

The first mission church in New York was established at 130 Liberty Street by the Salvation Army, following the model developed in England for relieving the plight of the poor through a broad array of social services—medical and legal help, homes for children and down-on-their-luck adults, and care for the impoverished elderly. In areas abandoned by established churches following the exodus of their affluent congregants, these neighborhood-oriented institutions, often run by American evangelistic associations, raised and spent funds locally.[2]

Miklos Suba, trained as an architect in his native Hungary, painted countless views of Brooklyn, where he settled in 1924. This work is part of his 1940s series of paintings depicting local storefront churches and barbershops. The exact rendering of buildings and details—bricks, fire escapes, and even the sign announcing an upcoming gospel program—sometimes caused him to be grouped with the

Precisionists. Nevertheless, this Brooklyn corner scene, based on Suba's snapshots of it,[3] has a humble and warm quality (reinforced by the figures of children on the street) rarely found in the work of more orthodox Precisionist artists such as Georgia O'Keeffe, Charles Sheeler, and Charles Demuth.[4]

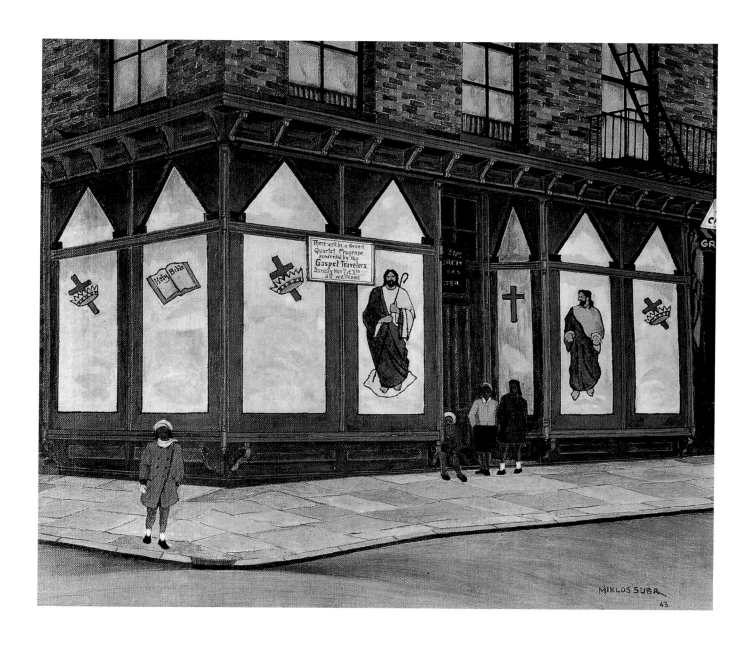

Bridge over Two Rivers

c. 1945

HUGH CONDE MILLER
(1911–1988)
Watercolor on paper, 14 × 19
Signed lower right: *H. Miller*
Gift of Francine and Thomas
Davidson, 93.94

IN AN ostensibly spontaneous style, clearly influenced by the work of Cézanne, Cubism, and Futurism (all of which he studied and absorbed while working abroad), Hugh Conde Miller reflected the pulsating vitality of New York City after World War II in a jitterbug of lines and brightly colored planes. This lively watercolor represents the Queensboro Bridge (completed in 1909; see plate 85), which spans the East River and Welfare Island (now Roosevelt Island), connecting Manhattan to Queens. The two rivers of the title are both segments of the East River resulting from the division around Welfare Island. Geometric forms and restless brushwork suggesting air, water, sailing vessels, and the institutions that gave the island its name at that period, animate the scene with a rhythmic, almost musical movement.

Miller, born in Louisville, Kentucky, studied at the Cincinnati Art Academy and at the Art Students League in New York with John Stuart Curry, George Grosz, Harry Sternberg, and Will Barnet. In the late 1930s he moved to France where, after the outbreak of World War II, he was stationed with the American armed forces. Miller continued to work abroad through the late 1940s and then returned to New York City, living in Brooklyn. At the same time he rented a studio on Houston Street at the Bowery and taught at the Brooklyn Museum School.[1] *Bridge over Two Rivers* is characteristic of Miller's best mid-career work: fresh, colorful explorations of New York's dynamic cityscape that seem on the brink of dissolving into abstraction yet retain a powerful underlying structure.

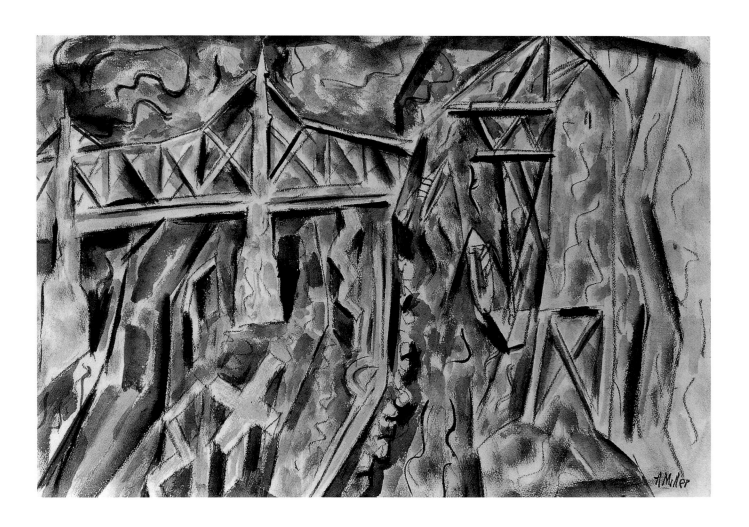

The Escalator

1943–1944

MARI-LOUISE VAN ESSELSTYN
(b. 1921)
Egg tempera on masonite,
15 ½ × 11
Signed lower right:
VAN ESSELSTYN
Gift of the artist, 98.152.1

DURING World War II, when Mari-Louise Van Esselstyn was a student at the Yale University School of Fine Arts—one of the first women admitted there[1]—she frequently took buses home to Montclair, New Jersey, by way of New York City. This painting is believed to represent the escalator in one of the small city bus terminals that pre-date the 1950 Port Authority bus terminal at 40th Street and Eighth Avenue.

"A painting of an escalator must achieve a balance between ascending and descending motion," Van Esselstyn has written, adding, "To create the illusion of movement one vanishing pt [*sic*] was placed beyond the crest of the ascending escalator & a second below the base of the descending escalator." The distorted perspective, the artist explained, "demanded a semi-abstract treatment of repeated shapes."[2] She employed a Cubist idiom, wherein geometric shapes form an overlay pattern on the curvilinear forms of the commuters and the escalator handrails. The sense of the escalators' movement is accentuated by the crosscutting light shafts emanating from the windows along the right side of the view. The faceless figures convey a sense of massed humanity moving rapidly through the automated setting. The subdued color palette, with occasional orange or red highlights, underscores the relationship of this work to the

Cubist aesthetic. In 1946 *The Escalator* was chosen in a Pepsi-Cola competition as one of the paintings of the year and was included in an exhibition that traveled to such venues as the National Academy of Design in New York City, the Syracuse Museum of Fine Arts (now the Everson Museum), and the Walter Art Gallery in Baltimore.

**First Night Game, Yankee
Stadium, May 28, 1946**

1969 (depicting 1946)

Paolo Corvino (b. 1930)
Oil on canvas, 36 × 48
Signed lower middle: *Paolo
Corvino*
Gift of the artist, 89.34

Forty years before their apotheosis as the Bronx Bombers, the New York Yankees, then a lackluster team called the New York Highlanders, played baseball at Hilltop Park on upper Broadway. Beginning in 1913, under the newly adopted name New York Yankees, the club shared a playing field in northern Manhattan with the Giants, their competitors and official landlords at the relocated Polo Grounds on the Harlem River at 157th Street. Mounting rivalry between the clubs led to the Yankees' ouster and their migration to a new ballpark built at River Avenue and 161st Street in the Bronx. On April 18, 1923, more than twenty thousand fans had to be turned away from the sold-out opening-day game at the novel, triple-deck Yankee Stadium—the first ballpark to boast the appellation of "stadium." Initially, many who ventured to the spacious new sporting facility were lured by the exploits of Babe Ruth, the phenomenal slugger recently signed by the club.[1] But the season proved renascent for the team as a whole and culminated in the Yankees' World Series victory over their former landlords—the first in a long line of championships that endeared the Bronx Bombers to baseball devotees and spiked attendance at their home games.

The war years challenged the team's management to find substitute talent for regular players lost to the armed forces and to consider ways of retaining attendance by attracting a broader spectrum of fans. Night games, considered controversial when first tested in the major leagues in 1936, were introduced gradually as a strategy to draw new working-class and family audiences to the sport. Not until the war's end, however, did lights arrive at Yankee Stadium. Combined with the return to the lineup of favorite players, the novelty of seeing games after dark paid off: in 1946 home attendance soared to nearly 70 percent over previous season highs.

Paolo Corvino was in the stands for that milestone debut on May 28, 1946, when the Yankees, under the glare of artificial lights, lost to the Washington Senators, 2–1. The event's impression remained vivid enough to elicit this painted re-creation of it some twenty-three years later.[2] The scoreboard indicates play under way at the bottom of the third inning. (Corvino has playfully altered the game's outcome by inverting the scores to the home team's advantage.) The roofless stadium appears ablaze with color: an unprecedented yellow radiance illuminates the park's patriotic bunting, its sponsor billboards, the rainbow blur of crowds packed into the curving stands, and the rich brown dirt of the infield diamond. More conspicuous is the artist's rendering of another innovation made to the facility that season under owner Larry MacPhail: the newly imported field of intensely green Irish turf. The spectacle is heightened by the viewer's position as a seat-holder witnessing this historic contest under lights.

Night View, St. Patrick's Cathedral

(also exhibited as *St. Patrick's Cathedral*), 1956

<small>Ernest Fiene</small> (1894–1965)
Oil on canvas, 35 ⅞ × 24 ⅛
Signed lower right: *E. Fiene. 56.*
The Robert R. Preato Collection,
91.76.4

<small>Critics have</small> grouped the late urban scenes of painter Ernest Fiene with a larger tide of haunting, hard-edged portraits of New York City that rose briefly to public notice after World War II. This body of work has been variously interpreted as pictorializing the inhumanity lurking behind Western civilization's facade, which the impersonal, steel-cage qualities of modern American cities seemed to epitomize, or as expressing the collective loss sensed by figurative artists like Fiene as they contemplated the dark shadow that Abstract Expressionism was casting on their timeless, representational vision. When interviewed in 1956 about the impact of such upstart styles on his own meticulous craftsmanship, Fiene, whose forty-four-year career had remained anchored to realism, surprised many by crediting non-objective art for its "cleansing effect" on painting: "It has made us more aware of color," he reflected. "It has cleared a certain mugginess out of art."[1]

Dating from that same year, *Night View, St. Patrick's Cathedral* reflects Fiene's willingness to return to a familiar subject—the built forms of midtown Manhattan—with eyes adjusted to modernist influences, which he grafted onto his own system of depicting New York.[2] Fiene borrowed from painters like Charles Sheeler the Precisionist's cool, distilled aesthetic as applied to the cityscape. His intense palette and his preference for opaque cerulean shades probably reflect his combined studies of New York's younger ab-

stract artists, the early twentieth-century Fauves, and Italian primitive painters, whose frescoes he had researched during a trip to Florence as a Guggenheim fellow.

The view, one of a series of New York nocturnes by the artist, synthesizes the architectural medley of Fifth Avenue near East 54th Street into a deceptively simple composition. On one level, the scene celebrates New York's postwar prosperity, when a profusion of department stores, commercial high-rises, social clubs, and churches jostled for space in the congested blocks of fashionable "Midmanhattan," the ascending hub of metropolitan culture, consumerism, and executive clout.[3] Between 1946 and 1957, a building boom had manufactured 36 million square feet of new office space with another 5 million on the planning boards, much of it concentrated from Third to Sixth Avenues between 34th and 59th Streets.

Having maintained a studio on East 55th Street in the 1940s, Fiene was well acquainted with the area's striking skyline. The austere rectangle visible at left, with stepped-back upper stories, is Best and Company, the venerable women's and girls' clothing retailer that had moved its flagship store to Fifth Avenue and 51st Street in 1947. At center, rising like a ghost, is the painting's namesake cathedral. Its Gothic spires and richly carved exterior appear dwarfed by the anonymous glass monolith towering behind the church, reflecting a night sky of deep indigo. The truncated sil-

houette of the nine-story DePinna Company (at far right), a retail operation styled like a Venetian palazzo, faces it across Fifth Avenue at the southwest corner of 52nd Street. Bordering the sidewalk, a long blue construction wall evokes New York City's ceaseless "creative destruction"—the cyclical outbursts of demolition and new construction sanctioned in the name of Progress. A modern office building known as 666 Fifth Avenue, designed by Caron and Lundin, would rise at the site in 1957.

Fiene, born in Germany, became a naturalized citizen of the United States in 1927, having spent the previous fifteen years studying art at various New York institutions and building his reputation as a painter of American scenes. A fixture on the faculty of the Art Students League, he was also a prolific artist with an oeuvre spanning many media, from etchings to frescoes. "He had an acute eye for the telling details of landscape and an equal perception of the pointless details that should be eliminated," one critic reflected in Fiene's obituary. "He shifted the ordinary world into a harmonious pattern, creating a world that was not so much idealized as purified."[4]

Los Proyectos—NYC

1958

Lorenzo Pacheco (b. 1933)
Tempera and watercolor on
board, 14 ¾ × 10
Signed lower left: *L. Pacheco /
1958*
Gift of the artist, 94.30

Los Proyectos (the projects) were built as part of a federally aided program implemented by the New York City Housing Authority in East Harlem during the late 1950s and early 1960s. The goals were to eradicate urban slums and provide improved housing and living conditions for New York's low- and middle-income families, sectors of New York City's population often overlooked in the general preoccupation with the city's extremes of wealth and poverty. The complex, which still stands, numbers nine buildings, each with nineteen stories. Its 1,470 apartments were planned to house approximately 5,335 people.

Named to memorialize Senator Robert A. Taft (1889–1953), a prominent congressional sponsor of the 1937 Housing Act, the project, one unit of which is depicted here, is bounded by East 112th and 115th Streets and Park and Fifth Avenues. This unpopulated scene, while documenting the newness of the projects, suggests the sacrifice of human scale endemic to these utilitarian structures, a criticism leveled at such bureaucrat-designed developments by city planner Jane Jacobs in her 1961 landmark study *The Death and Life of Great American Cities.*[1]

Italian Festa

(also exhibited as *La Festa di Santa Lucia*), c. 1960 (depicting c. 1930)

John Costanza (b. 1924)
Oil on masonite, 20 × 23 ¼
Signed lower right: *J. Costanza*
Gift of the artist, 96.190

The setting of this painting done from memory has been identified as East 12th Street between First Avenue and Avenue A, in the heart of New York's Lower East Side. The neighborhood, which has been home to wave after wave of immigrants representing a patchwork of nationalities, incorporates Chinatown, Little Italy, Tompkins Square, Astor Place, and Knickerbocker Village (a 1,600-unit housing development completed in 1934). As early as 1644, freed black slaves were given plots to farm in the area, forming the nucleus for the larger African American community that would take root there after New York State abolished slavery in 1827. By 1833 the city's first tenements were built in the same vicinity to house newly arrived Irish and then German immigrants, followed in the 1880s by an influx of newcomers from Italy and various Eastern European countries, including large numbers of Jews.[1]

By the early years of the twentieth century, the Lower East Side's enclave of Catholic Italian immigrants found themselves marginalized within the district's parishes, then heavily dominated by the earlier-arrived Irish majority. This friction led to the establishment of newer Italian-controlled parishes, where such practices as street fairs celebrating the annual feasts of patron saints conformed to the traditions of the peasant villages of Italy.[2]

In this recollected scene, John Costanza has depicted the annual August street fair held to honor Santa Lucia until the 1950s, when the local Italian population was depleted by the exodus of younger generations to metropolitan suburbia. Beneath multi-colored lights strung across the street, stalls and a truck arrayed along the sidewalks dispense various edible treats. A nearby storefront displays a brightly illuminated image of Santa Lucia. Apartment dwellers of diverse ages observe the activity from the open windows and fire escapes, while enjoying the music of a live band.[3]

Costanza lived with his family in Little Italy until his induction into the army at the start of World War II. During the 1930s he had studied art with Edward Glannon in classes sponsored by the WPA at the Gramercy Boys' Club. After the war he took advantage of the GI Bill to earn a Bachelor of Fine Arts at Temple University's Tyler School of Fine Arts and then studied with Thomas Hart Benton at the New York Art Students League. Later he pursued an interest in ceramics at Alfred University. Many of Costanza's colorful, animated paintings, including Kay the Tailor (acc. no. 99.8.1), a piece in the Museum's collection depicting a local business in the same neighborhood during the 1950s, are based on memories of his years spent on the Lower East Side.

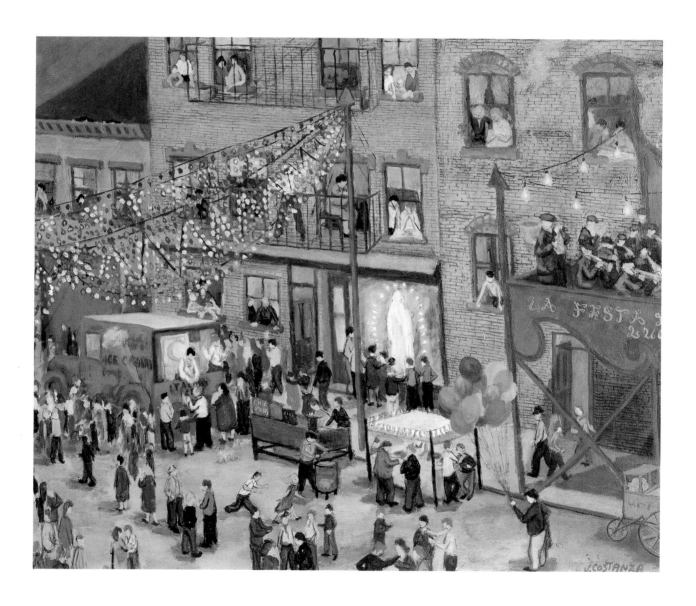

The Brooklyn Bridge in Snow

1964

CECIL C. BELL (1906–1970)
Oil on masonite, 35 ½ × 29 ½
Signed lower right: *Cecil C. Bell*
Gift of Mrs. C. C. Bell, 73.167

IN THIS view of lower Manhattan, just south of the familiar Brooklyn Bridge, the artist shows only the vestiges of nineteenth-century New York. A turn of 180 degrees would reveal to the viewer the contrasting modernism of lower Manhattan's Wall Street area.

Cecil Bell had an eye for the everyday. The tilt of a head or the contour of a body struggling under a burden delighted him as much as the juxtapositions of the city's built environment. In this scene, a horse-drawn vehicle contending with the cold, wintry conditions, an oil-drum fire, the buildings, the bridge, and the ornate lamppost, all from earlier eras, emphasize Bell's nostalgia for this corner of the South Street area (possibly Peck Slip).

Born in Seattle, Washington, Bell received his first art training at the Art Institute of Chicago. In 1930 he moved to New York, where he studied at the Art Students League under Harry Wickey and John Sloan. From Sloan he learned loose brushwork, the use of a lit area in a dark setting, and the compositional disposition of figures within a scene. At the league he absorbed the 1930s Social Realist aesthetic (if not its fervent espousal of social issues), to which he added a light-hearted sense of humor. Like Sloan, Bell frequently depicted large groups of people engaged in the same activity—working, swimming, celebrating. By contrast, in his views of urban settings centered around a few seemingly un-related figures, Bell recorded his ongoing romance with New York City. After several years in Greenwich Village, he and his wife, Agatha, moved to Tompkinsville, Staten Island. His studio overlooked the Narrows, the Bay, and the Staten Island Ferry, frequent subjects for his canvases.

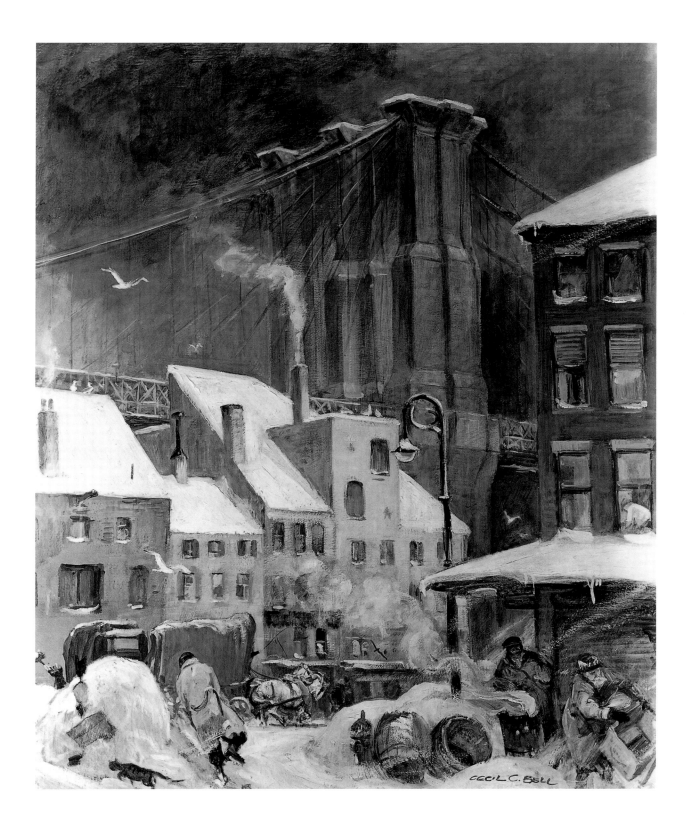

Harlem Parade (Adam Clayton Powell, Jr., Passing in a Car)

1971 (depicting 1964)

JOSEPH DELANEY (1904–1991)
Oil on canvas, 40 ½ × 50 ¾
Signed lower left: *Joseph Delaney 1971*
Gift of Mr. and Mrs. Robert Wallace Gilmore, 73.153.5

THIS VIBRANT crowd scene depicts the jubilant parade of 1964 to honor Adam Clayton Powell, Jr., Harlem's most prominent politician from the 1940s to the 1960s. During the Great Depression, the younger Powell successfully established an assortment of much-needed social programs in Harlem—a soup kitchen, a job bank, a nursery school, and youth programs—and organized protests that helped to break down some of the racial barriers that existed in Harlem and elsewhere in the city. In 1938 Powell succeeded his father as pastor of Abyssinian Baptist Church, one of the country's largest African American congregations. In 1941 he launched a highly successful, if subsequently controversial, political career by becoming New York's first elected black City Council member and later the first African American representative to the U.S. Congress from a northeastern state.

A skillful, often charming parliamentarian, Powell rose to the chairmanship of the House Committee on Education and Labor during the administration of President Lyndon B. Johnson (1963–1968). Powell used that post to help pass legislation important to Johnson's Great Society anti-poverty programs and to assure that African Americans, both within his constituency and nationwide, benefited from these initiatives structured to provide schools, housing, and jobs for the country's poor. Often flamboyant and outspoken in ways that alienated other politi-

cians, Powell was indicted for income tax evasion in the mid 1960s and eventually censured for that transgression by his congressional colleagues. Despite such problems, some of which mired him in lengthy legal battles, Powell managed to win reelection to eight terms in the House of Representatives, even though an outstanding warrant for his arrest precluded his entering New York City except on Sundays, when laws prevented such warrants from being executed. During those visits Powell preached to a packed congregation, striking chords of empathy with emotional sermons that stressed the importance of "black power," a phrase he coined in an address at Howard University in 1966.

The "hero's parade" shown here, occurring a month after the Democratic Party convention of 1964 had secured Lyndon Johnson's nomination for the presidency, included "a sixty-car caravan, [with] Powell riding in a shiny black Cadillac and pumping his fist in the air and toward the crowds lining the streets."[1] The varied, spirited people who are depicted enjoying the parade reflect the congressman's broad base of support within the Harlem community, ranging from the sober-hatted men seen in rows behind Powell's car to scantily dressed dancers performing on a passing float to a smiling mother holding her child in the lower-left corner of the scene to beaming policemen managing the traffic flow. The message scrawled repeatedly across the patch

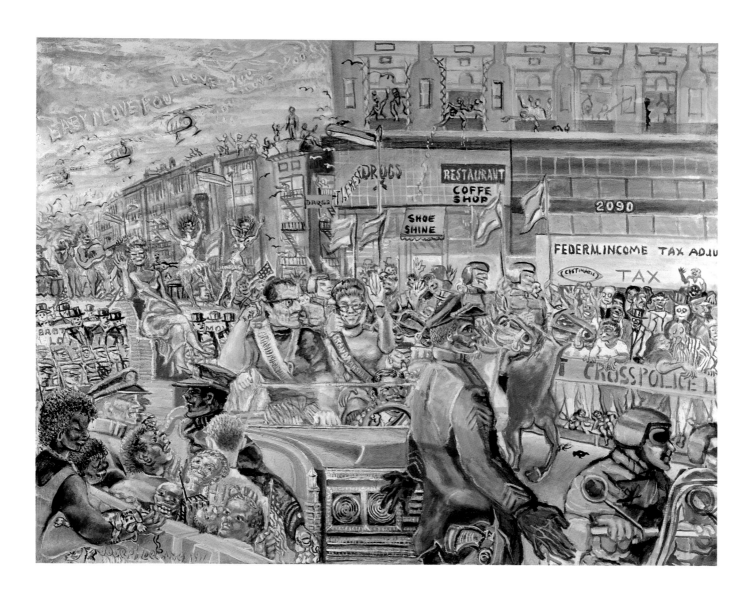

of sky at upper left, "Baby I love you," underscores the community's boundless support.

The African American painter Joseph Delaney was born in Knoxville, Tennessee, and learned to draw on his own before enrolling at New York City's Art Students League in 1930. His older brother, Beauford Delaney, a more celebrated artist, may have stimulated Joseph's curiosity about drawing. At the league Joseph studied with Thomas Hart Benton, from whom he absorbed an interest in Social Realism as it included figures within the American landscape; George Bridgeman, who taught him anatomy; and Alexander Brooke. Delaney made many portraits of famous people and other figures who interested him (Eleanor Roosevelt, Tallulah Bankhead, and Eartha Kitt were among his subjects). His Expressionistic scenes of urban events are noteworthy for the way his figures in crowds appear to respond in individualized ways— exuberantly, contemplatively, soberly, boisterously. From 1932 until 1971 Delaney often worked as a sidewalk portraitist in Washington Square and Brooklyn's Prospect Park. During the Depression he found employment in the Easel Program of the Federal Art Project, taught art, and executed drawings for the Index of American Design. His work has been exhibited at two world's fairs, galleries, and museums, among them the Whitney Museum, the Brooklyn Museum, and the Museum of the City of New York.

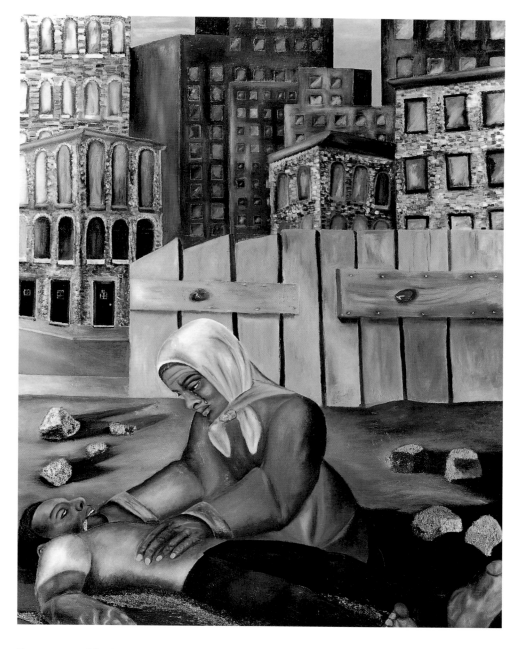

El dolor de una madre

(*The Sorrow of a Mother;* also
exhibited as *A Mother's Pain in
East Harlem*), 1972

Angel E. Allende (d. 1997)
Oil on canvas, 70 × 50
Signed lower right corner: *A. E.
Allende / 1972*
Gift of Mr. and Mrs. Robert
Wallace Gilmore, 73.153.3

To MARK its fiftieth anniversary, in 1973, the Museum of the City of New York organized an ambitious exhibition tracing the heterogeneous history of its East Harlem neighborhood. This multi-media project resulted in the first published survey of the community's long but inadequately studied past.[1] More significantly, it created a critical showcase for art produced by East Harlem's residents—an informal "school" of practicing painters and sculptors whose very existence seemed to startle the city's ordained annalists of contemporary art culture. Among the landscapes and portraits exhibited were a number of sobering views of local life on the mean streets of "El Barrio." *El dolor de una madre,* in

company with depictions of junkies, evictions, and property in crushing disrepair, was one of a half-dozen of those featured canvases acquired for the Museum's permanent collection.

A modernized pietà theme envisioned with a local audience in mind, Allende's painting represents a mother grieving over the corpse of her son, dead of a heroin overdose, in a litter-strewn lot off a bleak East Harlem street. The scene is touching in its allusion to the universality of maternal love while at the same time blunt in rendering the ugliness of drug addiction within an environment itself derelict and devoid of compassion—a concept underscored by the boarded-over windows of the empty tenements forming the scene's backdrop.

The incident memorialized was an outcome all too common for young men of color living in East Harlem by the late 1950s, when the progressive availability of French Connection heroin was wreaking havoc in America's northern urban ghettoes, finding its most vulnerable victims among minority teenaged boys. At a congressional hearing held that same decade, welfare officials detailed a particular three-block area of East Harlem as an exemplar of how drugs were infecting the "slums," testifying that heroin addiction among young male residents had reached "epidemic proportions" and enumerating twenty local establishments where illegal hard drugs were peddled—including an athletic club for teenaged boys.[2] In his autobiographical novel *Manchild in the Promised Land* (1965), Claude Brown took measure of heroin's deepening inroads through Harlem, noting, "It seemed to be a kind of plague. Every time I went uptown, somebody else was hooked, somebody else was strung out." In the meantime, neighborhood activists protested the slow public response to the escalating tragedy of local drug use and read this delay as a result of the profile of East Harlem's typical addict, whom statistics identified as young, black, poor, and lacking the cause or credentials to vote.

Angel Allende, born in Puerto Rico, immigrated to New York City in his youth. Few other biographical details are known about his life or exposure to art training. By the 1960s, however, he was participating in several ethnic heritage organizations that promoted communal bonds among East Harlem artists, such as the Grupo des Artistas Latino Americano and the Association for Puerto Rican–Hispanic Culture.[3] Contemporaries recall that Allende, who was probably aware of the market appeal of folk painting from the Caribbean Islands, styled himself as a self-taught artist in the native tradition.

**Old Chapel, Fresh Pond
Crematory**

1978

ANNA GOTH WERNER
(1953–1995)
Oil on panel, 15 ¼ × 20 ¼
Gift of the artist, 84.66.6

NEW YORK City's growing landmarks preservation movement encountered strong resistance in its efforts to recognize and protect sites of architectural significance in Queens during the tenure of former Borough President Donald R. Manes (1934–1986). Historical societies and agencies in the borough persevered in proposing local structures worthy of designation as landmarks, however, and the Fresh Pond Crematory and Columbarium at Mount Olivet Crescent and 62nd Avenue in Middle Village, erected in 1893, was among a varied roster of buildings so identified by the Greater Ridgewood Historical Society.[1] Anna Goth Werner, a sympathizer with the cause of preservation, had become aware of the area's vulnerable historical fabric while pursuing her Master's in Fine Arts at Queens College in the mid-1970s. In 1978, as a visual artist participating in the Cultural Council Foundation's CETA Project, she secured funding to produce a series of nine paintings documenting notable landmarks in the Queens neighborhoods of Maspeth and Ridgewood, including this interior view of the Fresh Pond Crematory's Old Chapel.[2]

During the nineteenth century, New York's surging population stimulated the growth of an important regional "burial needs" industry for Queens when a succession of ordinances restricted interments in the increasingly urbanized island of Manhattan. Cemetery developers as well as churches and synagogues ac-

quired rural acreage in Queens County and converted it into consecrated ground. By the onset of the twentieth century, a chain of cemeteries accommodating a wide spectrum of faiths punctuated the borough's suburban landscape. Their concentration along the Newtown Creek border of Queens and Brooklyn earned the area the sobriquet "City of the Dead." With them came monument works, flower shops, crematories, and other enterprises servicing memorial-park ventures. Even today, the borough retains a greater, more ethnically and theologically diverse concentration of cemeteries than any other in New York City.

Werner spent two weeks studying each location recorded in the Ridgewood series, sometimes standing on a folding table to gain a better perspective of the distinctive light and social atmosphere of the space. At Fresh Pond's Columbarium, she was surrounded by a silence she described as warm, reflective, and communal. "I felt encrypted as I painted," she recalled, and touched by the "sweetness of watching families come to quietly and gently place flowers, notes, lace or special objects into niches behind the glass doors."[3] The psychological tone of that experience is reflected in the mellow filtered hues and hushed ambience of the crematory's chapel, with its empty chairs seeming to beckon departed spirits to sit and share a memory with their bereaved visitors. Werner cited Caneletto, Vermeer, and

Vuillard as sources of inspiration for her interiors, believing that the dignified serenity of an unsung New York crematory merited the same painterly ambition and approach as a celebrated European cathedral.

Werner's Ridgewood paintings launched her interest in cityscapes, which she proceeded to develop in Manhattan and along the Hudson River waterfront during the 1980s. The series also signaled her emerging fascination with architectural spaces that she perceived as fugitive, despite their apparent substantiality, because of the inevitable changes in occupancy, public use, or governing aesthetic taste. Designer showrooms, corporate offices, and architect-commissioned art galleries were some of the "temporal" subjects outside the canon of remarkable places that Werner documented in more than fifty paintings using the classic medium of oil over egg-emulsion glazed panel.[4]

The Ballroom

1976

MARION PINTO (b. 1935)
Oil and acrylic on canvas,
96 × 168
Gift of Gregory Dawson, Lewis
J. Todd, and Steven Askinazy,
94.101

IN THE late 1960s, artists began flocking to the lower Manhattan neighborhood today known under its revitalized acronym Soho, referring to the blocks stretching "south of Houston" Street, with Crosby Street (east), Sixth Avenue (west), and Canal Street (south) as other defining borders. Once a thriving commercial and light-manufacturing district, the area had turned shabby after the turn of the century when its businesses departed for more fashionable midtown addresses offering newer facilities. Left behind was a concentration of vacant warehouses and lofts, often wearing ornate cast-iron facades, available at modest rents.

For cash-strapped artists emerging in New York's art world during the 1960s, these discarded buildings represented ideal studio space and living quarters, especially for those exploring large-scale installation work and relatively new forms of site-specific art. In defiance of local zoning regulations governing warehouse use, an enclave of creative newcomers took root (their lobbying subsequently persuaded officials to amend residential laws in this "Cast Iron district" of the city). By 1971 the New York press was announcing the debut of an adventurous new art scene in Soho, confirmed by the rush on the part of such prominent uptown dealers as Leo Castelli, Ileana Sonnabend, and John Weber to rehabilitate warehouses on West Broadway into stylish galleries. *The Ballroom,* created by Soho resident Marion Pinto in 1976, celebrates the neighborhood's coming of age as an artists' community.[1]

The circumstances of Pinto's commission for this ambitious Photorealist mural reflected the camaraderie and commercial ties binding Soho together as a distinctly modern New York art colony. Three years after opening an intimate restaurant-cabaret at 458 West Broadway, Gregory Dawson, one of the Ballroom's three co-owners, enlisted Pinto to execute a large painting to replace a worn abstract hanging above the club's semicircular stage. Aiming to secure a monumental portrait of the supper club's interior, he also conceived the work as honoring the local patrons who had made the Ballroom a success: the painters, sculptors, gallery owners, art dealers, and critics who had pioneered Soho's conversion into a community receptive to late-night dining, entertainment, and fresh voices of every creative stamp.

The *Spectator,* a London-based newsletter commenting from afar on the unveiling of Pinto's mural on March 22, 1976, likened Dawson's largess to that of the Medici princes who had engaged artists to decorate their palaces during the Renaissance.[2] Praising the "courage" of both restaurateur (for commissioning contemporary art of this scale) and Pinto (for her willingness to accept the unusual assignment), the writer predicted from this conjunction of art and commerce a rekindling of fruitful partnerships between fine artists and New York City businesses. Closer to home, critics generally commended Pinto's mural as the latest in a meritorious line of artwork commissioned for Manhattan restaurants, some leaguing it

with Howard Chandler Christy's murals at the Café des Artistes, Maxfield Parrish's mural at the St. Regis Hotel, and Ludwig Bemelmans' bar frieze at the Carlyle Hotel.

The illusionistic opus, which took Pinto six months to execute, drew on an archive of 450 photographs produced at the project's outset for documentation of sitters and the cabaret's decorative features. Nineteen prime movers in the Soho art world were first invited to the Ballroom to pose for individual portraits. Pinto subsequently arranged the photographs into groupings to form an ensemble composition, citing Edgar Degas' famous painting *The Cotton Exchange* as her inspiration. Pinto's method next entailed projecting the images onto photosensitive canvas and then duplicating that succession of pictures with oil and acrylic pigments, using painstaking brushwork so finely controlled that evidence of the artist's guiding hand seems erased from the final product.

Through Pinto's manipulations, the sculptor Marisol shares a table with pop-art enthusiast and collector Robert Scull; two leading Soho dealers, Paula Cooper and Max Hutchinson, converse with the "super-realist" Alex Katz; and neon artist Rudi Stern sits at the bar talking with painter Larry Rivers. Pinto inserted herself, with back toward the viewer, and resurrected the late Expressionist painter Adolph Gottlieb—a Ballroom habitué until his death—as a table companion for critic John Perreault and abstract painter Deborah Remington. Other personalities preserved for posterity include the painters Robert Indiana and Lowell Nesbit; wood sculptor Georges Radovanovitch; gallery owner Ivan Karp; dealers Louis K. Meisel and his wife, Susan; the Performing Group's director-producer Richard Schechner, and Michael Goldstein, founder of the weekly *Soho News,* launched in 1973.

Cityscape, 1975

1975

Max Arthur Cohn (b. 1903)
Oil on canvas, 20 × 24
Signed lower right: *M. A. Cohn*
Gift of Jane C. Waldbaum,
92.65

Max Arthur Cohn used jewel-like tones and a Cubist-influenced style to depict the McGraw-Hill Building as it appeared from his studio at 311 West 24th Street. In this view, part of an ongoing series of abstract and semi-abstract paintings of the city that he began in 1960,[1] Cohn ringed the McGraw-Hill Building with structures that actually stand closer to the 24th Street building where he lives.

Although no longer owned by McGraw-Hill Publishing Company, the building, located at 332 West 42nd Street, retains its original name.[2] Dating to 1930, it was the first skyscraper built west of Eighth Avenue on 42nd Street, at the edge of then-notorious Hell's Kitchen. It towered above the industrial and tenement buildings of the neighborhood, where the zoning accommodated McGraw-Hill's printing plant as well as its corporate offices. Despite the contemporary gentrification of Hell's Kitchen, known today as Clinton, few tall buildings have been added to the neighborhood, allowing the McGraw-Hill Building to continue dominating its immediate surroundings. Architect Raymond Hood's design for the building was distinguished for its strong simplicity of outline, featuring the set-back shape that Hood considered important for the grace of multi-story buildings.[3] With the McGraw-Hill Building, Hood also introduced New York to the striking effects of horizontal ribbon windows and

produced a bravura coloristic note in his use of blue-green glazed terra-cotta.

Max Arthur Cohn, born in London in 1903, was brought to the United States as a young child. His first summer job, at the age of seventeen, involved work in a New York City silk-screen studio, and he continued to practice silk screening through the end of the Works Progress Administration. During the 1920s he studied at the Art Students League with Boardman Robinson and John Sloan, the second of whom Cohn considers a great influence on his work.[4] In 1927, in order to broaden his knowledge, Cohn went to Paris, where he studied at the Académie Colarossi and absorbed the influences of modernism, particularly abstraction and Cubism, prevalent in the vanguard art circles of the French capital. During the Depression he was engaged in the Easel Project of the WPA. In 1942 he wrote a book entitled *Silk Screen Stenciling as a Fine Art*. In addition to his facility at silk screening and painting, Cohn is an accomplished printmaker.

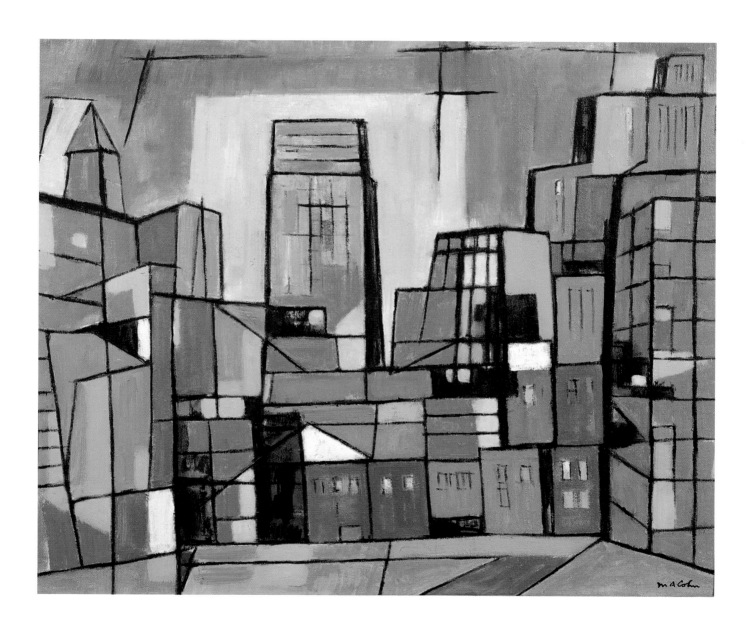

Yonah Schimmel Knish Bakery

1976

HEDY PAGREMANSKI (b. 1929)
Oil on canvas, 32 ⅛ × 22 ⅛
Signed lower left:
© H.Pagremanski 1976
Inscribed lower right: *Houston Street, New York City*
Gift of the artist, 79.50

ABOUT 1890 Yonah Schimmel, a Jewish immigrant and part-time Hebrew teacher, used a pushcart to start his knish bakery on the Lower East Side, New York's traditional home to new immigrants.[1] When business expanded, Yonah and his cousin, Joseph Berger, rented a small store on Houston Street. Two years later Yonah returned to teaching Hebrew, while Joseph and his wife (Yonah's daughter, Rose) took over the business, retaining the original name. In 1910 the Bergers moved the business to the opposite side of Houston Street, where it remains to this day, still under the family's management.[2] It is as much a landmark as an eatery and has frequently been an artist's subject.

Hedy Pagremanski has carefully rendered details of modern-day—and probably traditional—tenement life: a stick propping open the third-story window, tenants' use of the fire escapes as a balcony, and plants flourishing in window boxes. She has also portrayed the diverse population of the area. The clusters of young and old, white and non-white gathered around Yonah Schimmel's implies that the knish, a specialty of Eastern European Jews, has, like other ethnic foods, permeated the diets of many immigrant groups. Her accuracy extends even to copying the name *Shimmel* as it appears on the shop sign, misspelled by a sign painter who did not know the correct spelling, *Schimmel.*

As in many of Hedy Pagremanski's works, the figures here are portraits of actual New Yorkers who live or work in the setting. Incorporating these likenesses is as important to the artist's sense of realism as are her detailed renderings of the founder's portrait, visible in the extreme right window of the shop, and the sign of the adjacent monument maker, out of business since the mid-1980s.

293

Pussycat Theatre

1982

Philip Lawrence Sherrod
(b. 1935)
Oil on canvas, 23 ¾ × 30¼
Museum purchase, 84.58.4

In 1977 Philip Sherrod founded the Street Painters, an informal alliance of eight artists dedicated to recording the urban scene directly, while immersed in the ruckus of city life outdoors. Conscious of the work of the celebrated "Eight," whose everyday cityscapes had jolted the art public with their bold immediacy some six decades earlier, the Street Painters shared a commitment to picturing New York City's fierce sense of power and employed an equally diverse range of styles to convey those unfiltered impressions.

Sherrod had gravitated to streetscape painting while attending the Art Students League soon after moving east from Oklahoma in 1960. Although his work drew on that taproot of formal art instruction, he became frustrated by the inhibitions that the academic method posed to spontaneous expression. He preferred stalking his subjects on the sidewalks, where inspiration was visceral and round-the-clock and where his easel stood ready to capture it. "I went to the street to get free of the studio dilemma that most artists end up with," stated Sherrod, in reflecting on the dangers of adhering to a "programmed, overly intellectual approach" to painting that negated honesty and vibrancy.[1]

Pussycat Theatre documents an exotic cinema house, now defunct, located on Broadway between 48th and 49th Streets, one of the many pockets of peep shows, massage parlors, and pornographic bookstores that gave the surrounding area notoriety as New York's crossroads of sleaze. Sherrod's brash palette projects the neon energy of this nighttime adult entertainment district. His animated, textural brushstrokes also suggest the distinctive kinetics of Times Square—a quality of constant motion derived from the raw collision of crowds, colors, lights, advertisements, sounds, and smells.

During the 1970s the mayoralty administrations of John Lindsay and Abraham Beame harnessed the Office of Midtown Enforcement and nuisance abatement legislation as instruments to curtail, if not uproot, some of the hundreds of topless bars, massage parlors, and erotic movie houses that were now congregated in this neighborhood thick with tourists. Although the crackdown on massage salons proved effective, the area's depressed real estate values lured few reputable businesses to relocate there and, accordingly, the disbanding of the square's adult entertainment industry foundered. In the wake of Times Square's relapse into a retail vice zone, Sherrod felt compelled to pay homage to the weed-like resilience of establishments like the Pussycat Theatre.

Sherrod's cityscape oeuvre is extensive. His paintings of New York's underbelly, in particular, have been widely exhibited and collected, and are charged with an exuberant frenzy. The artist has been the recipient of numerous purchase awards and creative arts grants, including a Rome Prize Fellowship from the American Academy in Rome. A body of poetry and writings by Sherrod also evokes his devout interest in urban tumble.[2]

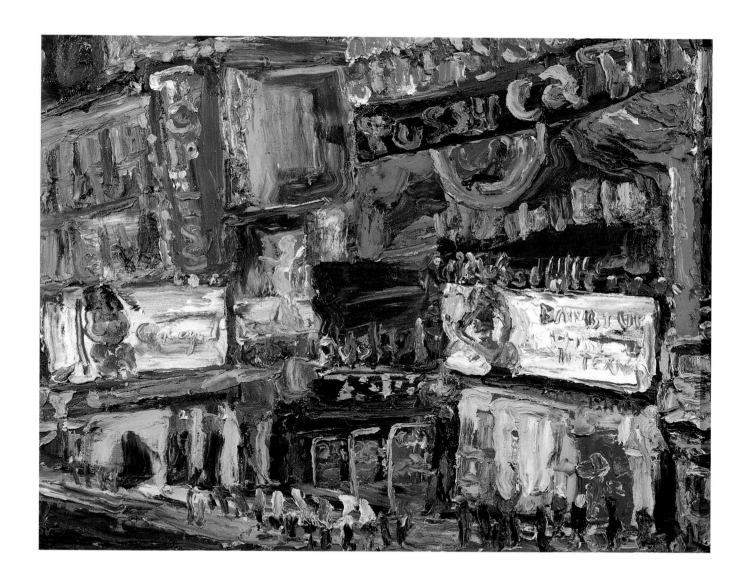

Murder on Clinton Street

1982

Nedra Newby (b. 1949)
Acrylic on canvas, 54 × 42
Gift of the artist, 84.40

Nedra Newby received her education in visual arts at Georgia State University and the State University of New York at Albany before studying for an advanced diploma in printmaking at the Central School of Art and Design in London on a Fulbright grant. She returned from England in 1979, intent on pursuing her career in New York City. When prohibitive rents extinguished her hopes of settling in the newly fashionable artists' district of Soho, she adjusted her search to the Lower East Side, locating a studio at 71 Clinton Street. Newby's middle-class values conflicted at once with the alien street culture of this rough, run-down, arson-scarred neighborhood. She began to draw her surroundings as a way to come to terms with the ills of poverty, crime, and drug addiction that impinged on her everyday experience of the cityscape. By 1982 a series of diaristic paintings was evolving from her meditations on "the social structure, and the people and places of this troubled and hostile but sometimes beautiful environment."[1]

Abandoning traditional urban realism, Newby employed her canvases as blackboards that she superimposed with decorative, lexigraphic statements reflecting her impressions of the Lower East Side. A few cartoon-like figures, appearing as black, outlined blocks scratched from a ground of underlying color bands, humanized these terrains of words. The interaction of chromatic typography with such anchoring forms—all etched in a patchwork of neon hues—seems at once nervous, playful, and schematized, suggesting the safeguard that formal color and graphic studies offered to Newby as a strategy for ordering the neighborhood's darker actualities.

Murder on Clinton Street is a fantasy inspired by the violence that tarnished Newby's daily travels through the Lower East Side. The composition is moored by the images of a prostrate woman (revealed as the artist) and an attentive dog (her protector and companion) enmeshed in a local street map of intercrossing colored lines on a dark, intimidating background. Within this grid, a density of place names gives way to occasional narrative phrases like "NEVER NEVER LAND" and "LIFE ON THE LOWER EAST SIDE." Just as the Times Square Zipper flickered late-breaking news to curious onlookers, Newby conveys the painting's subplot in the illuminated, message-bearing silhouettes of the two interlocked characters: "NEDRA LAYS DEAD ON CLINTON STREET SHOT DOWN BY BULLETS FROM A SPEEDING CAR / THE RIVINGTON DOG LOOKS ON IN DISMAY / THE RIVINGTON DOG WONDERS WHY WHY WHY." A pool of words spelling "blood," a cluster of which expose a vivid red understripe, spills onto the pavement from the figure's head. Given the locational context of this imagined incident, one could read Newby's word bulletins and psychedelic palette as allusions to the blights of graffiti and drug trafficking that riddled the Lower East Side during her period of residence on Clinton Street.

Through teaching and the increased exposure of her work in local group and juried exhibitions, Newby endured in her ambition to support herself as an artist. She continued to develop her "scratch-through" figures and writing as colorful patterns that activated the surface of her canvases, often in compositional series that used consistent pictorial elements differentiated by their unique bands of underlying color. By the late 1980s, Newby had moved to the suburban perimeters of New York City, where she continues to work.

Times Square

1981

LAWRENCE HEYMAN (b. 1932)
Oil on canvas, 30 × 50
Signed lower right: *L Heyman*
1981
Gift of D. Tania Heyman,
84.149

THE TKTS booth in Times Square has been a major attraction and amenity for both resident New Yorkers and out-of-towners since it opened in 1973. In a single year, more than 1.5 million people, undeterred by the worst of summer or winter weather, line up at the booth to buy half-price tickets for Broadway, Off-Broadway, and Off-Off-Broadway productions.[1] Its success led to the establishment of a branch for discounted entertainment tickets in the World Trade Center and another near Fulton Street in Brooklyn. After fifteen years of intensive use, the booth depicted here (actually a construction trailer) was replaced with one of newer design.[2]

In this view, a bright summer day has brought a cross section of people to one of the city's busiest spots—Duffy Square at the intersection of Broadway and 47th Street, in the heart of the Times Square theater district. The painting exemplifies Heyman's interest in the refractive and reflective effects of strong sunlight and shimmering rain. Here he uses a crisp realist style to capture not only the details of the neighborhood and its array of advertising material, but also the varying postures of the tourists and theatergoers lined up to purchase tickets and those sauntering past the line. In the throng is a figure garbed in something like a spacesuit, probably, the artist suggests, "just someone dressed up like that to attract attention to an advertisement."[3] In the thick of the crowd, no one seems to be giving it any notice.

Lawrence Murray Heyman, born in Washington, D.C., studied at the Tyler School of Fine Arts of Temple University, where he received a Bachelor of Fine Arts degree. In 1960 he enrolled at Atelier 17, a Paris printmaking workshop.[4] A printmaker as well as a painter, he frequently depicts modern midtown Manhattan, particularly the theater district, in bold, colorful scenes.

Red Wall II

1978

Philip Reisman (1904–1992)
Oil on canvas, 26 × 40
Signed lower left: *Philip Reisman
1978*
Gift of Mrs. Louise K. Reisman,
80.7
.

Philip Reisman, the Polish-born son of immigrants, discovered art in his early teens. His interest matured through etching and drawing courses he attended at the Art Students League while supporting himself as a soda fountain clerk and at other odd jobs.[1] Whereas he would eventually achieve wide recognition as a printmaker, book illustrator, and art instructor, by the 1920s Reisman was also immersed in painting New York City's teeming streets. Technically self-taught in that pursuit, he was guided by the Ash Can School's endorsement of modern urban truths as fit subjects for canvas and took inspiration from the city scenes of John Sloan and Reginald Marsh, both influential teachers at the league during Reisman's term of study there. In the 1930s his growing confidence as an artist, bolstered by a 1932 show at the Painters and Sculptors Gallery on East 11th Street and a fellowship at the Yaddo Foundation, Saratoga, New York, in 1933–1934, overlapped with the advent of Social Realism, which motivated Reisman's political awareness as a painter.[2] In the same period, the WPA's Federal Art Project presented opportunities for the artist to apply his skills to various easel and mural projects (including a now-destroyed mural for the Bellevue Psychiatric Hospital) and to travel through the American South while compiling a visual record of its indigenous architecture.

Reisman entered the 1940s with an enlarged social conscience and an empathy for the human condition. This Depression-bred sensibility informed the cityscapes he would paint for a half-century thereafter: scenes presented in an accessible style that privileged the "ordinary" in urban life, usually with a mixture of humor and compassion. He professed to eschew models or photographs, preferring to work like a draftsman "from observation and sketches, relying much on memory."[3]

Red Wall II, depicting the sidewalk activity along a stretch of Avenue B, is characteristic of Reisman's nimble brushwork and his probing but not pessimistic impressions of New York's grittier enclaves. The painting's title reflects his aesthetic concern with the urban landscape's structural components. Here, as in many of his paintings, Reisman sharply observes the timeworn facades of tenement dwellings, with their zigzagging fire escapes; a rooftop assemblage of utility shed, laundry lines, and television antenna; an expanse of blue-tinged pavement marred with cracks; the nondescript entrance to a corner convenience store. The horizontal wall, with ghost-like graffiti markings, injects a shock of color into the setting's otherwise drab palette, while functioning as a compositional device to interconnect the disparate foreground elements of the picture: a derelict automobile, an open hydrant, assorted vignettes of social exchange, and the layered rows of buildings in the receding visual planes.

For Reisman, however, the nuances of New York's built environment were less important than the parade of civilians native to it, with the casts of characters ranging from

pre–World War II Bowery bums to post-Vietnam punk rockers in the East Village.[4] Here, Reisman has mustered a collection of Lower East Side denizens from the late 1970s. At far right, a man in beret and bell bottoms drifts away from some cronies loitering outside the corner store. Moving left, an interracial threesome chats as a dog strains at its leash. Beyond, an addict sprawled on the sidewalk seems to panhandle a person confronting him. Several other pedestrians have proceeded past him, one carrying groceries, another, with a child, pushing what appears to be a stroller out of the picture's left edge. Two men continue their business with the car at curbside, although it is uncertain whether they are fixing it or looting it. All seem oblivious to the quotidian sights of a flowing hydrant and debris-strewn street just beyond.

From a studio just off Union Square and, subsequently, another one on the square, Reisman conducted a productive later career. He remained active as an art teacher at the Educational Alliance, served the governance of Artists' Equity Association in several different capacities, and introduced a younger generation of critics and museum goers to his urban-scene paintings of New York with *The Sixties and the Seventies,* a special exhibition mounted at the Museum of the City of New York in 1979. In honor of that show, Manhattan Borough President Andrew Stein proclaimed November 13, 1979, "Philip Reisman Day" to recognize the artist for his distinguished contributions to the city.[5]

Self-Portrait in Subway I

1982

Max Ferguson (b. 1959)
Oil on board, 22 × 17 ⅝
Signed on subway interior upper
right: *Max Ferguson 1982 New
York*
Gift of Mrs. Benjamin Joelson,
82.219

Max Ferguson's city scenes, rendered with extraordinary precision and attention to perspective, reflect the impression that seventeenth-century Dutch interior paintings made on him as an American student visiting Amsterdam's Rijksmuseum in 1979. Mesmerized by the pictorial realism and respect for detail exemplified in the works of Vermeer and other Dutch masters, Ferguson returned to New York intent on transferring their processes and standards of craftsmanship to current urban subjects.[1]

Self-Portrait in Subway I is part of a series of paintings devoted to New York's subterranean transit system dating from the early 1980s, shortly after Ferguson graduated from New York University. The subway, with its shadowy tunnels, sparse station architecture, and technological textures had fascinated him during years of ridership. Born in New York City, Ferguson was raised in Nassau County but often ventured into Manhattan and became adept at navigating this reasonably priced and speedy mode of inner-city transportation. He recalls being intrigued by the disorientation of moving through spaces divorced from natural light, whether during rush hours when anonymous commuters filled the trains or during off-peak hours when an ominous quiet settled underground.

Here, the parting doors of a graffiti-marked train yield a glimpse of a man sipping coffee on a bench at the waiting platform of the Seventh Avenue Local at 23rd Street (the exact setting is supplied in supplementary information the artist affixed to the reverse of his painting).[2] The viewer, who assumes the role of a passenger seated opposite the car's doors, inevitably locks gazes with the solitary stranger. The ambivalent interpretations prompted by this fleeting eye contact lend tension to the picture. Are we looking at an innocuous fellow passenger trying to revive himself with some caffeine while awaiting the next train? Or are we encountering a potential predator as he plots an assault? The joke, of course, is that the solitary urbanites portrayed in Ferguson's work are frequently self-portraits, with the artist inviting such disparate readings of his neutral persona. Ferguson's use of Triple Zero brushes, allowing for minute paint control, and masonite board as a receiving surface also combine to create an unnervingly tranquil image—one that belies the decaying reality of graffiti, crime, trash, and erratic service that beset New York's subway system in the early 1980s.

For the "Subterranean" series, Ferguson sketched and sometimes painted in the subways and also relied on photographs to guide his refinement of these studies in his studio. He dislikes having the label of Photorealism applied to his meticulous style, however, because he neither traces nor uses an airbrush. The timeless quality that distinguishes Ferguson's work stems as much from his subject choices as from his technique. Although his paintings are autobiographical in impulse, he

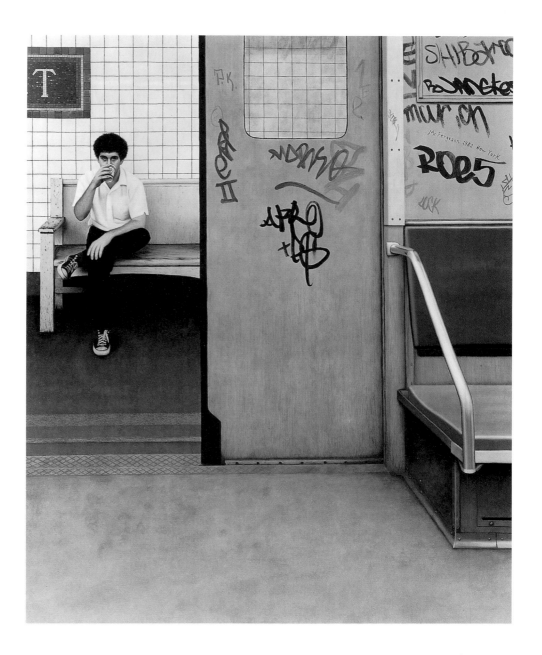

universalizes settings meaningful to him by depleting them of people and distilling their essential loneliness or marginality within the urban vortex. Renderings of nocturnal businesses and of a desolate, windblown Coney Island are also noted for their dark romanticism.[3] More recently, Ferguson has concentrated on what he categorizes as an "anterior" study of Jewish New York prompted in part by his late embrace of his own Ellis Island heritage and his concern over the disappearance of landmarks associated with traditional Jewish culture within the city.

Autumn

1980

CRAIG MCPHERSON (b. 1948)
Oil on canvas, 48 × 54
Signed lower right: *mcpherson*
1980
Gift of the American Academy
and Institute of Arts and Letters,
the Hassam and Speicher
Purchase Fund, 83.4

THE BUILDINGS in this painting, seen from a distance, typify many New York City views. Although part of Craig McPherson's interest appears to be the anonymous-looking buildings, he has described how they assume personalities that change with the time of day or the season. This is one of a series of paintings McPherson made that record the panorama from his first New York studio on West 168th Street.

Autumn, a view toward the south, captures the golden light of late afternoon as it raises the texture of the bricks and asphalt and makes the rooftops appear as a series of abstract constructivist structures, thus converting the ordinary into the aesthetic. The dominant sky and low horizon recall the countryside in McPherson's native Kansas.

McPherson holds a Bachelor of Fine Arts from the University of Kansas and currently lives and works in New York City. He has curated exhibitions in the Midwest and served as director of the Kansas Cultural Arts Commission Mobile Gallery, sponsored by the Wichita Art Museum, and as manager of the Michigan Artrain, a project of the Michigan Council of the Arts and the National Endowment for the Arts. After his arrival in New York City in 1971, McPherson was commissioned by the American Express Company to do two very large cycles—*Great Harbors of the World,* ten paintings depicting six of the world's major harbor cities, and *Twilight: The Waterways and Bridges of Manhattan,* four views of twilit Manhattan—for their corporate headquarters in the World Financial Center.

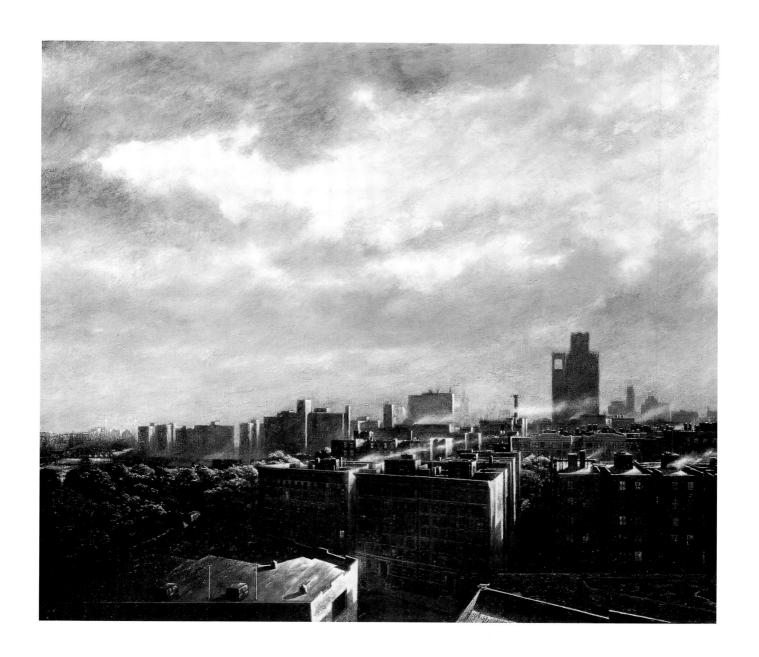

Howard the Duck

1989

LEE [Lee George Quiñones]
(b. 1960)
Acrylic on canvas, 57 × 90
Gift of Martin Wong, 94.114.1

THE PHENOMENON of graffiti, surfacing in the early 1970s on the walls of subway trains, playgrounds, and underpasses, spread quickly to other publicly accessible urban targets in New York's five boroughs. Rejecting the pejorative associations frequently attached to the word *graffiti,* its teenaged practitioners adopted the identification "writers" to emphasize their formal interest in letter shapes and interactions (personalized as "tags"). The term *writers* also reflected their belief in "getting up" (street argot for the skill of placing tags, or "hits") as a potent mode of inner-city communication unintelligible to mainstream observers. In the process of making its mark on the cityscape, the burgeoning subculture acquired codes of conduct, regional variations in style, and identifiable masters. It simultaneously earned the enmity of the Metropolitan Transportation Authority and of taxpayers unnerved by the mercurial appearance of graffiti on private and civic property.[1]

By the mid-1970s the controversies unleashed by graffiti's renegade tactics, and debates over whether graffiti should be considered decoration or defacement, stimulated art-world interest in the creators of these underground graphics. Some of the more adept and enterprising of these young writers were persuaded to transfer their energies from illegal to "legitimate" surfaces—in other words, to apply spray paint to canvas.[2] A select group, which included Lee Quiñones, soared into short-lived fame as inventors of the hybrid genre called aerosol art. Between 1978 and 1984 their work traveled internationally in a range of exhibitions, films, and alternative art showcases. Once stripped of the audacious circumstances of its street, or outlawed, production, however, graffiti's word-as-image aesthetic failed to sustain commercial momentum. To stay viable under these competitive circumstances, writers like LEE began to expand their repertoire pictorially, integrating cartoon, advertising, and other mass-media iconography into their compositions, along with occasional political commentary.

Born in Puerto Rico, LEE came to prominence as a graffiti writer in 1976 with a daring, decorative piece called *Doomsday* that covered two full cars parked in the Lexington Avenue Local train yards. Moving far beyond tag embroidery, this touchstone work incorporated images of tenements, flames, and a horned monster, establishing the maker's powerful intuitive design abilities. Two years later *Howard the Duck* appeared on the handball-court wall of Corlears Junior High School 56 on Henry Street on the Lower East Side. Proclaiming "Graffiti is a art [*sic*]," the duck figure, shown balanced on a trash can with lid held as a shield against a spray paint assault, was a mischievous character from D.C. Comics with whom LEE identified. Like a number of other site-specific murals he produced in the period, this was an invited commission arranged by the principal of the school.[3] The mural's impact was strong enough to earn him commissions from several nearby schools. A few years later an order followed for a smaller-scale partial replica of *Howard the Duck* on canvas, which revealed the influence of commercial art's illusionistic techniques.

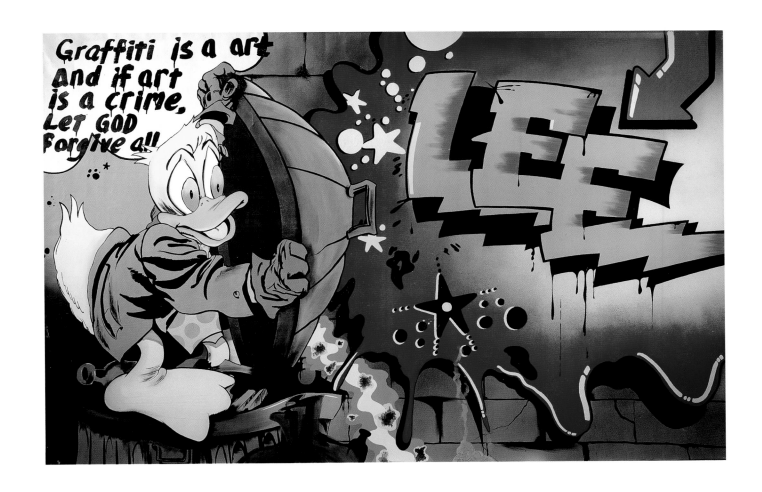

Katz's Deli

1991

Elinore Schnurr (b. 1932)
Oil on canvas, 36 × 50
Gift of the artist, 94.59

The interiors of public places in New York City, from intimate bars to cavernous hotel lobbies, have been the focus of a series of atmospheric paintings by Elinore Schnurr, who is intrigued by how such defined enclosures influence the interactions of their random occupants. Often posing as a patron of the setting she intends to paint, Schnurr records her initial impressions as small, on-the-spot watercolors that register structural environment, tonal relationships within the space, and the imprint of figures coming into and out of her visual field. She also makes careful color notes of the controlled lighting that heightens the drama of exchange between such spaces and people passing through them. These sketches inform compositions further developed on canvas in her Long Island City studio.

Katz's Deli is a moody evening portrait of the landmark eatery at 205 East Houston Street frequented by residents of the Lower East Side since 1888, when the Eisland brothers opened a delicatessen at the corner of Houston and Ludlow Streets.[1] After Willy and Benny Katz bought the store in partnership with Harry Tarowsky in 1920, the deli was renamed for the Katz brothers. Savory pastrami, pickled vegetables, and homemade knishes drew to Katz's a loyal neighborhood clientele as well as luminaries from New York's nearby Yiddish theaters. During World War II, the deli earned acclaim for its advertising slogan and sales campaign, "Send a Salami to Your Boy in the Army."

In this view, Schnurr depicts the thinning population of diners congregating at the deli after nightfall, evoked by the dark-blue-tinged light glimpsed through the window fronting Houston Street. Her principal interests, however, are the distinct effects of the overhead fluorescent rods running the length of Katz's vault-like interior, and of the inflooding neon light from the store's exterior street sign. By law, the fixtures illuminating the cooking area were sleeved in plastic, which grease eventually rendered "golden-crusted with age—tinting the already dead, flat fluorescent glow." Under this peculiar glare, patrons appeared to shrivel within the vast restaurant space, their individuality diminished by the sameness of "row upon row of Formica-topped tables replete with plastic ketchup bottles, napkin dispensers, and metal-topped sugar jars."[2]

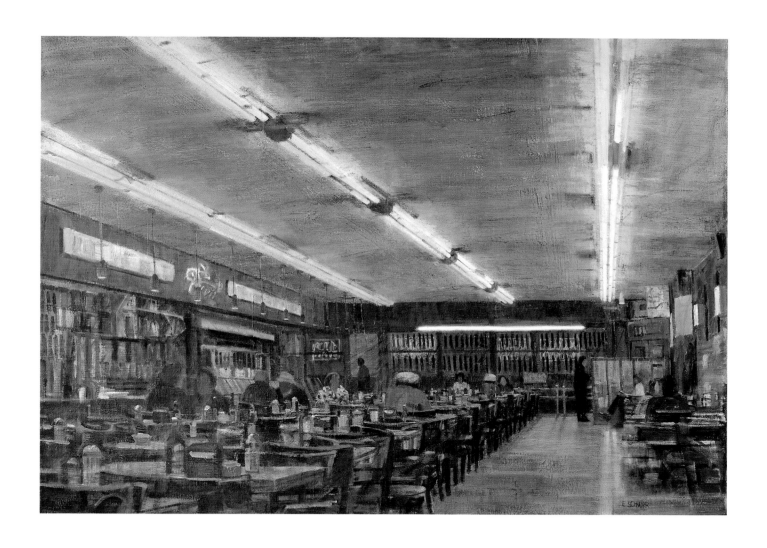

Gray Morning

1984

Marcia Clark

Oil on canvas, 42 × 30

Signed lower right: *M. Clark*

Gift of the American Academy

of Arts and Letters, New York;

Hassam, Speicher, Betts and

Symons Funds 1995, 95.4.1

THE CONSTRUCTION of the World Trade Center's twin towers in the 1970s provided artists with a new vantage point for observing the city. From this perspective, Marcia Clark created the dramatic vista of *Gray Morning*, which provides an unusual view of some of downtown New York's most familiar structures: The Brooklyn Bridge, the Municipal Building, the Woolworth Building, and St. Paul's Chapel.

As early as about 1835, an anonymous artist had used an upper story of St. Paul's Chapel to depict City Hall Park. In the late nineteenth century and the beginning of the twentieth, the proliferation of New York's bridges provided artists with the opportunity to produce panoramas, accommodating the post–Civil War interest in prints of city views from an imaginary elevated vantage point.[1] Whereas the prints strove to present factual representations of both the built environment and the open spaces of American cities, Clark employs an elevated perspective as a metaphor for vision in its larger sense: in her words, a "symbolic way of pushing beyond personal frontiers, embracing the totality … and reaching beyond it."[2] The muted light of the gray day underscores this idea by softening and blending the elements of her quintessential Manhattan view, which includes historic landmarks, new structures, traffic corridors, and the East River.

Clark studied at the Ecole des Beaux-Arts in Paris before receiving degrees in fine arts from both Yale University and the State University of New York at New Paltz. She has exhibited widely and taught at various institutions, including the Metropolitan Museum of Art. Currently she is an instructor of drawing at the Parsons School of Design.

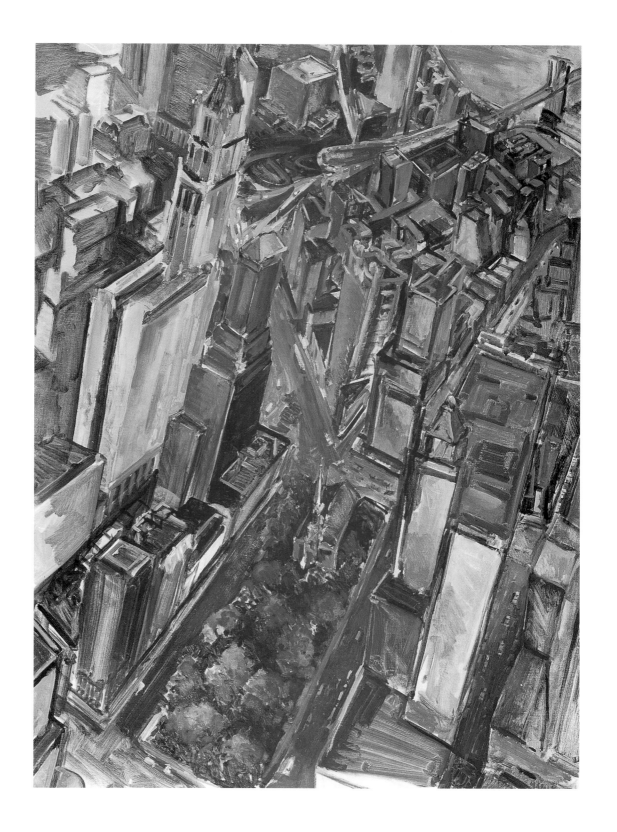

Tenth Avenue Luncheonette

1988

CHARLES FORD (b. 1941)
Acrylic on canvas, 28 ⅛ × 32 ⅛
Signed lower left: *C. Ford 88*
Gift of the artist, courtesy of
Michele Birnbaum Fine Arts,
93.56

THE MODEST eatery in this painting occupied a storefront on the east side of Tenth Avenue between 48th and 49th Streets, in the section of the city known today as Clinton, within walking distance of the artist's West 20th Street apartment. The denotation "Spanish-American" on the luncheonette's awning suggests Clinton's burgeoning Hispanic population during those years (representing 30 percent of local residents according to the 1980 census). More recently, real estate developers, the theater community, and restaurateurs have identified Clinton's Midtown location, adjacent to the Broadway theater district, as a neighborhood ripe for restoration and gentrification. Active block associations have taken this opportunity to clear their immediate streets of drugs and crime.

Tenth Avenue Luncheonette is typical of the architectural subjects that inspired Texas-born artist Charles Ford during his eight-year-long residency in Manhattan. "During my years in New York, I was drawn to these storefronts… as I found that the dilapidation and neglect somehow contributed to their character and made them storytellers of the past."[1] A self-taught artist trained as a mechanical engineer, Ford executed the painting almost entirely freehand, using the occasional aid of a ruler and a homemade perspective instrument. The artist usually first records his chosen subject on film, documenting the site from different angles and in varying light. These study photographs are propped next to his easel as guides; projection devices and grids are never used. Beginning with broad strokes of background color, the artist proceeds to refine the composition, building toward an image of fastidious detail.

313

Changing Shifts

1996

Roman Scott (b. 1965)
Acrylic on canvas, 60 × 72
Gift of the artist and Kim Foster
Gallery, 96.141

Against an evening sky still pale with summer light and streets slick with rain, the artist has documented the six o'clock change of shift at the Mystic Brokerage, at the corner of McGuinness Boulevard and Huron Street in the Greenpoint section of Brooklyn. This is the hour when cab drivers end their twelve-hour tour and surrender their vehicles to the next team of drivers to roam the city's streets. The mundane detail of laundry shown hanging out to dry on the garage roof evidences the gradual 1990s transformation of largely industrial Greenpoint into a residential neighborhood peppered with artist's studios and lofts.

New York City's automotive taxi industry was established in 1907 with the introduction of gas-powered vehicles equipped with taximeters. Two years later the city began officially monitoring cabs by establishing a fare schedule and appointing inspectors to apprehend any violators. The ensuing years saw competition between the owners and operators of the vehicles and the municipal administration, intent on controlling pricing, safety, and licensing. As a result, in 1925 licensing control was granted to the New York City police department and a newly formed Taxicab and Limousine Commission (TLC).

Until the 1970s, Jewish, Italian, and Irish immigrants, often joined by their sons, composed the majority of New York City taxi drivers. These opinionated "hacks" became part of New York City lore and were respected for their consummate knowledge of the city's geography. Today, drivers are often newly arrived from other countries and tend to know little about the city's layout or its driving regulations,[1] thereby providing more fuel for the ongoing controversy among the TLC, the cab owners and their force of drivers, the police, and paying passengers. The vehicles have also changed. The much-loved Checker cabs gradually disappeared from the city's streets after the assembly line that produced them in Kalamzaoo, Michigan, closed in 1982. By 1999, when the last of 12,053 Checkers retired, such models as the Chevrolet Caprice, Ford Crown Victoria, Honda Odyssey, and Isuzu Oasis had replaced them.

Roman Scott holds a Bachelor of Fine Arts Degree from the University of Denver and a Master of Fine Arts from Hunter College. Since moving from Colorado to New York in 1989, Scott has found himself drawn to the painterly possibilities of the city's prosaic activities—its streams of yellow cabs, humble street occupations, barrage of signage, and the distinctive reflections in wet streets of the urban scene, especially at night. Like other young city-scene painters, he finds his subjects in the city's marginal zones of residence, where he can afford to live and work.

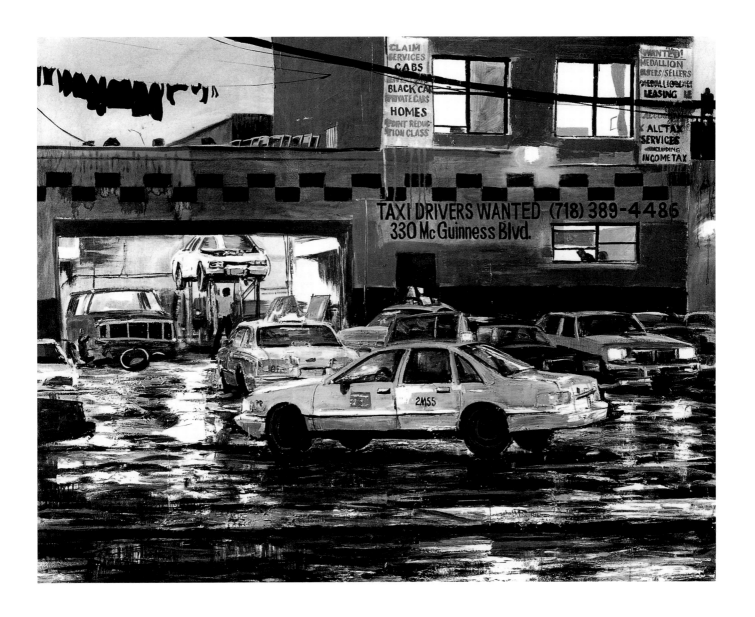

Pershing Square Bridge

1993

BASCOVE (b. 1946)

Oil on canvas, 26 × 42

Signed lower right: *B*

Museum purchase, 94.81

THE VIADUCT over Pershing Square carries Park Avenue from 40th Street to the 42nd Street facade of Grand Central Terminal. There, the north and south lanes separate, wrap around the terminal's girth, and reunite at 46th Street. The adjacent square was created a year after Grand Central opened in 1913. In 1920 the plot, named in honor of World War I General John Joseph Pershing, was sold to a developer who erected the Pershing Square Building at 100 East 42nd Street three years later.

Bascove uses a decorative, architectural style and bold, contrasting colors in her frequent depictions of bridges, which attract her "because they are about making connections."[1] The evening setting of this scene functions as a symbolic bridge between day and night—a transition from work to home, from public to private lives. Instead of the usual rushing traffic, the Grand Central area appears in hushed grandeur. The artificial glow of street lamps lends a mysterious quality to this stark tableau with its strong, shadowy forms.

For more than two decades, Bascove has specialized in book-cover designs for works of literary merit, such as the novels of Robertson Davies. Whereas her art borrows from the traditions of WPA muralists and French artists as diverse as Fernand Léger and Henri Rousseau, the result is a highly individualized and dramatically appealing style.

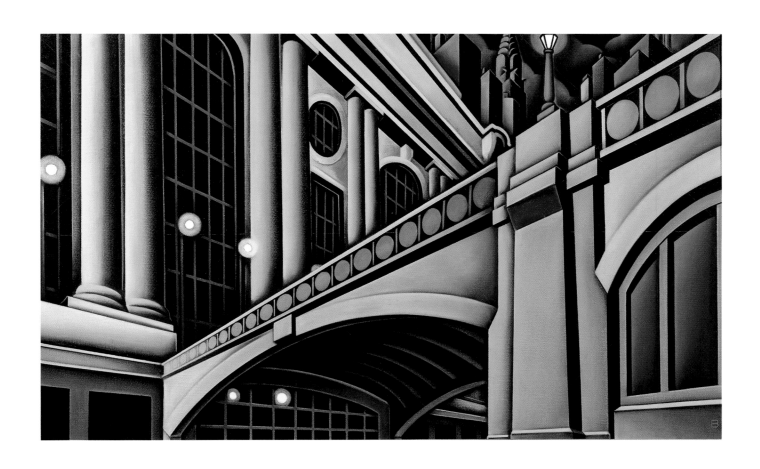

Coney Island Streetscape

1992

ROGER BULTOT (b. 1952)
Oil on linen, 18 × 24
Signed on verso, centered: *Roger Bultot "3/22/92 (Coney Island)" 1992 oil/linen* © 1992
Gift of Harvey Schulman, 94.100

AT THE TWENTIETH century's outset, the neighborhood surrounding Coney Island began its residential growth spurt. In the years before World War I, affluent New Yorkers built large mansions along Ocean Parkway, close to the still-unspoiled beachfront. After the completion of the Brooklyn-Manhattan Transit Company's extension to Coney Island, a surge of apartment-house construction attracted immigrants, particularly Italians and Jews, in search of low rents, job opportunities, and proximity to the fresh ocean air. In the 1920s and 1930s modest, low-cost, single-family summer bungalows proliferated. New York's housing shortage after World War II spurred the conversion of many such dwellings to year-round residences. Later, during the 1960s, some of the bungalows at the western end of Coney Island were demolished to make way for publicly financed high-rise housing projects.[1] This view of the corner of Brighton Street and Oceanview Avenue features some of the residences that survived the 1960s razing. Roger Bultot's observations, based on extensive location photography, note keeping, and frequent return trips to interesting sites, have been translated into a sharply delineated, Photorealist painting.

A native of Woonsocket, Rhode Island, Roger Bultot earned his undergraduate degree in art education from Rhode Island College and a Master of Arts in studio art from New York University. In the 1970s Bultot began to search out subject matter in the blue-collar residential neighborhoods peppered throughout Brooklyn, Queens, and the Bronx. Bultot has described his working method as a self-conscious attempt "to select buildings and places that are not immediately recognizable but are 'New York' in feeling and emotive of each unique area."[2] Like many other emerging urban-scene painters, he chooses to bypass the typical tourist-saturated Manhattan sites in favor of subjects drawn from the city's perimeters.

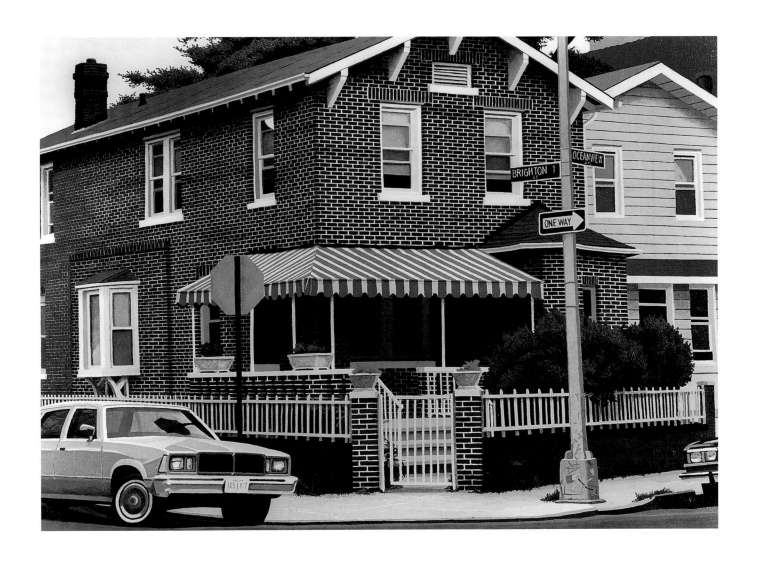

Three White Tanks

1993

STEPHEN J. DOLMATCH (b. 1956)
Gouache on paper, 14 ½ × 28
Signed lower right: *S. Dolmatch*
9/93
Gift of the artist, 95.142

THE PANORAMIC prospect of Brooklyn and Queens from the Kosciusko Bridge, which carries the Brooklyn-Queens Expressway across the Newtown Creek, encompasses factories, warehouses, and oil storage tanks. Until the mid-nineteenth century the area, known as Laurel Hill, was mostly farms, some of which had been established as early as the seventeenth century by Dutch settlers. The construction of the Laurel Hill Chemical Works in 1866 marked the beginning of alterations in the landscape from rural to industrialized. As business increased, the Chemical Works added one factory after another, until by 1882 it occupied an entire block and was the largest plant of its type in the country. In the ensuing years, other similar industries arrived in the neighborhood, until Laurel Hill entirely lost its bucolic aspect. In this view, some of the low buildings and the smokestacks visible at the left resemble a drawing of the Laurel Hill Chemical Works in *History of Queens*; they may well be the same buildings serving a different, modern function.[1]

Stephen Dolmatch has focused on the striking juxtaposition of tanks and layered rooftops in a dramatic off-center composition emphasized by the posts along the right edge, thus transforming an otherwise prosaic industrial vista into a complex study of color and shape. The scene's severe geometry of horizontal, vertical, and diagonal is relieved by a small patch of green trees and the soft depiction of distant buildings on the horizon.

Light—in this case the clear, saturating light of mid-afternoon—is a governing element in Dolmatch's work.

Although he earns his living as a lawyer, Dolmatch received a bachelor's degree in fine arts from Amherst College and has been an artist ever since. In addition to practicing law, he teaches painting at New York's Parsons School of Design.

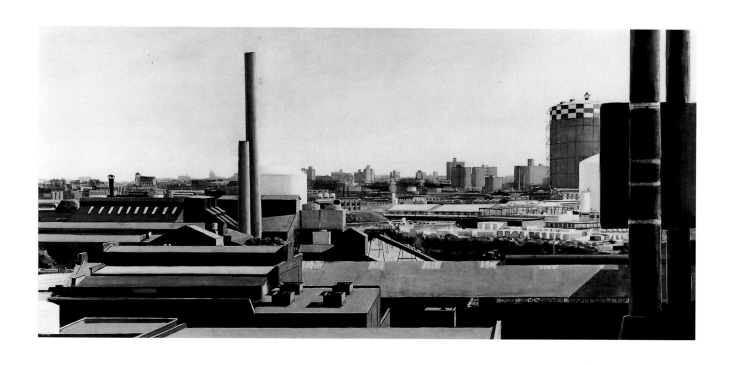

Still Open

1994

Douglas Safranek (b. 1956)
Egg tempera on panel, 4 ⅝ × 4
Museum purchase, 95.6

This evening view of Greenpoint, a work-ing-class neighborhood in Brooklyn, was re-corded from a high window in the building where the artist resides. Its focal point is the blazing facade of an all-night mini-market. The scene is further illuminated by a row of street lamps, random interior lights in otherwise darkened apartment houses, and the faraway massed skyscrapers of Manhattan, all rendered with delicate precision. This array of lights re-inforces the notion of a city that never sleeps.

Douglas Safranek, who found New York City's density and pervasive stimulation over-whelming when he arrived from the Midwest in 1984, turned to the meditative process of egg tempera, which allows him to achieve a deliberative stillness and quality of intimacy even in his most active compositions. For this carefully fabricated piece, he removed all of New York's frenetic and accidental elements. From the safe, elevated vantage point of a tall building, the viewer's gaze is focused on the cityscape of the streets. The quietude and timelessness of *Still Open* result in part from this imposition of controlled panoramic per-spective on the general disorder found in street scenes.

Safranek graduated from Boston College and in 1984 received a Master of Fine Arts from the University of Wisconsin, where he studied with James Wattras and John Wilde. Like many emerging urban-scene painters, he has been forced by the economics of New York's real estate market to locate in the city's

"borderline" areas. In these settings, Safranek's work proves, poetic subject matter can be found or made even from the seemingly mundane.[1] Typically, Safranek's titles, such as *Walking the Dog, Domino Sugar,* and *Over Brooklyn,* exemplify this lyrical quality. In ad-dition to the Museum of the City of New York, the Metropolitan Museum of Art and the New-York Historical Society also count his work among their collections.

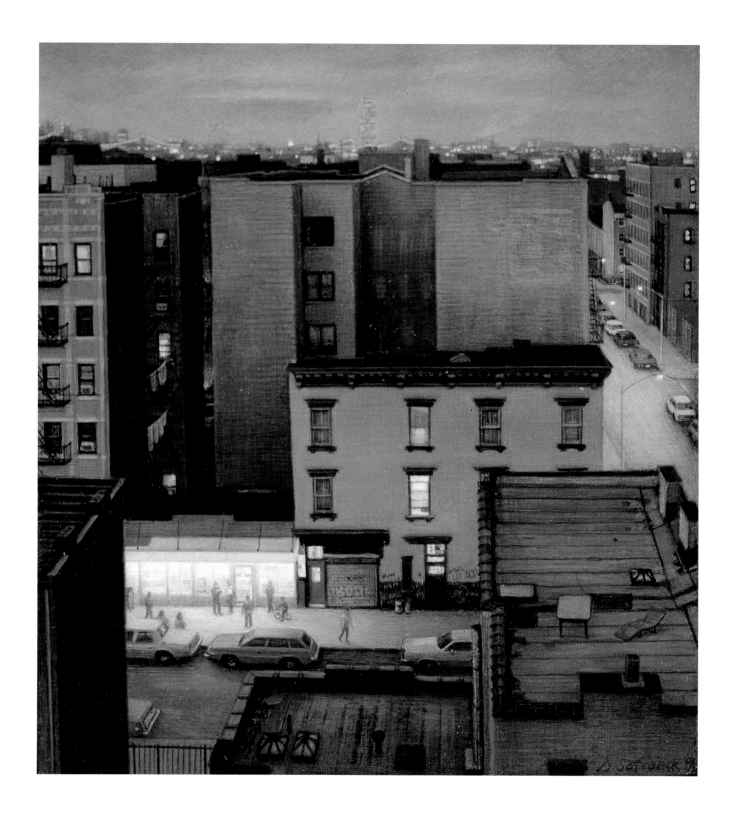

View from Fort Lee III

1994

Daniel Hauben (b. 1956)
Oil on paper mounted on paper,
21 ¼ × 29
Signed lower right: *Hauben 94*
Gift of the artist, 97.55.1

This striking vista of Manhattan's skyline and its vast western expanse along the Hudson River is visible from Fort Lee Historical Park, perched atop the Palisades near the New Jersey access to the George Washington Bridge. According to the artist, who frequently visits the park and has painted views from that point several times, the panorama alters over the course of a day, as sunlight shifts and atmosphere varies from lucid sunshine to hazy mist. In this version, executed in early spring before the trees foliated and obscured the view, Hauben worked to capture the salmon-tinged hue caused by intensifying moisture in the air.[1]

Although reminiscent of nineteenth-century prospects of lower Manhattan recorded from further south on the river's New Jersey shoreline, the elevated viewpoint from the highest point of the Palisades and the powerful geometry of the modern vertical city, contrasting with the horizontal piers and vessels edging the Jersey side, distinguish the scene from earlier painted landscapes. While Hauben carefully delineates certain landmark buildings, such as Grant's Tomb, the Empire State Building, and the twin towers of the World Trade Center, as well as New Jersey's newer shore-front buildings, his primary interest lies in documenting the fleeting, atmospheric melding of the urban vista.

After graduating from New York City's La Guardia High School of Music and Art, Daniel Hauben studied at the School of the Museum of Fine Arts in Boston and received his fine arts degree in 1983 from the School of Visual Arts in Manhattan. Like other emerging artists, he lives in an affordable, working-class neighborhood in the Bronx, which supplies him with endless subject matter that he depicts with a complex mixture of realism, elusive references, and moodiness, frequently established with his use of light and shadow. Hauben often paints on location, returning to his studio to rework the paintings and to add texture through the judicious manipulation of paint. Hauben has taught art at Bronx Regional High School and the Simon Senior Center at the Riverdale YM-YWHA. Although he frequently paints rooftop views of the city, he has shifted in recent years to more visceral scenes, closer to street level, and has inserted figures into his canvases.[2] Examples of Hauben's work have been acquired by Harvard University, by the New School for Social Research, and for several corporate collections.

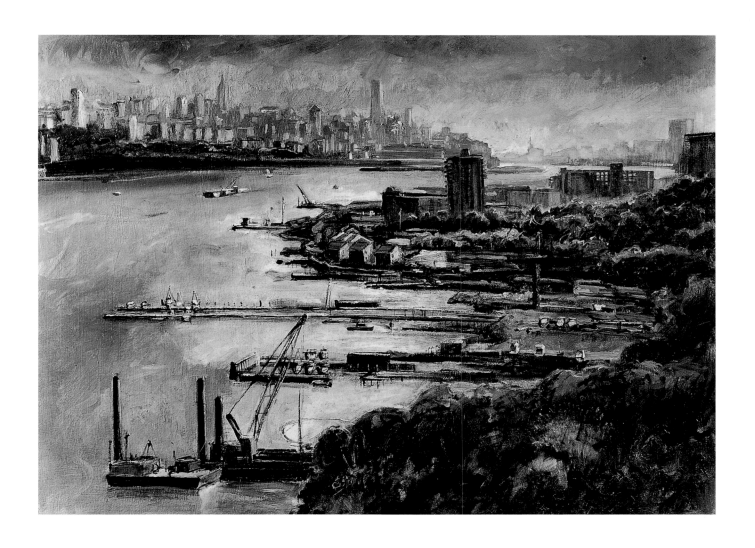

Undertow

1997

Marc Winnat (b. 1962)
Acrylic on canvas, 24 × 36
Signed lower right: *M. Winnat/*
© *1997*
Gift of the artist, 97.229.1

At the corner of Eldridge and Broome Streets, Estevez Grocery Store signifies the recent arrival of yet another wave of immigrants to the Lower East Side. Such small family-run bodegas serve the area's Latino community just as earlier populations of Irish, German, Italian, Russian, Romanian, Hungarian, Slovak, Greek, Polish, Turkish, and Jewish grocery-store owners provided their compatriots with both familiar products from their native countries and the newer items of their adopted homeland. Just beyond Estevez's store, signs in Chinese testify to the presence of another group of immigrant residents in the neighborhood.

The graffiti-covered van parked in front of the store may have belonged to the shop owner or an employee; as the artist has related, the vehicle seemed perpetually parked there, its presence having originally attracted him to study the scene.[1] In this painting, the graffiti embellishing the van appear to have spread to the adjacent building. As for the enigmatic title of the work, the artist chooses to leave it for the viewer to interpret.[2]

Like many cityscape artists, Marc Winnat supports himself with unrelated work. His job as a satellite technician has recently taken him to live in New Hampshire, but he frequently visits New York City. A self-taught artist, he became aware in the 1970s of the movie posters and fantasy scenes of illustrator Frank Frazetta, from which he learned that the subject matter of paintings could be something

more than flowers. Museum visits introduced him to Piet Mondrian's grids and boxes, which served as lessons in composition, and also to John Sloan, George Luks, and other artists of the Ash Can School, and to Winslow Homer.[3]

Winnat's forays into painting were initially inspired by his fascination with New York City's colorful history and its distinctive neighborhoods. He travels around the city with his camera, snapping shots of sites that appeal to his artistic sensibilities and his awareness of urban history. These records are then transformed into Photorealistic canvases. Since starting to paint in 1989, Marc Winnat has exhibited and won prizes at New York City's Salmagundi Club and the National Arts Club and is a member of the National Society of Painters in Casein and Acrylic. He is represented in the Museum's collection by two other paintings, *Fire on the Bowery,* 1995 (acc. no. 96.31), and *Under the Nets, Williamsburgh Bridge,* 1996 (acc. no. 96.77).

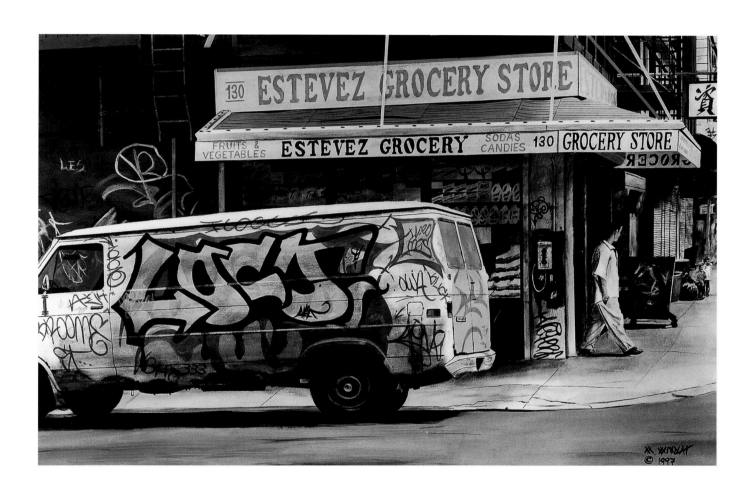

Two Ball Bank Shot

1997

ARTHUR ROBINS (b. 1953)
Oil on canvas, 30 × 40
Gift of Steven A. Soulios, 98.67

NOT ALL works catalogued in the Museum's collection of urban scene paintings feature the exterior cityscape. Some interior views convey typical components of New York City. Neo-Expressionist painter Arthur Robins has described *Two Ball Bank Shot* as an image of "distilled New York," representing a composite of various impressions of the city.[1] Robins has not depicted any particular pool parlor within the city, nor is the view glimpsed through the window a specific geographical setting. Instead, the picture is an atmospheric environment for the players, constructed from the artist's familiarity with local pool halls. Robins uses distorted viewpoints, which echo the angle of the player hunched over the near table; intense, saturated colors applied with vigorous, broken brushstrokes; and forms boldly outlined in black. Together, these elements create a mood both somber and active, with undercurrents of menace. The sharply angled floor, further wall, and nearer table surface form a background against which the details of doorway, window, figures, table edges, balls, and cues make a startling and compelling composition.

Arthur Robins, born in Brooklyn, received his art education at Syracuse University's summer program for high school students and, later, at Pratt Institute. Since 1971 he has lived in Manhattan and supported himself until the late 1980s with cabinetry and furniture making. Robins draws inspiration from the city's parks, subways, streets, and amusement areas, such as Coney Island. His work reflects a long-time interest in the work of Vincent Van Gogh, George Rouault, Chaim Soutine, and Edvard Munch. Like other emerging New York City artists drawn to the expressive use of paint to render social realities, he conveys in his paintings a passion for life as he observes it in the urban setting. He has said of his own painting that it is "simultaneously personal, political, art historical, universal and religious."[2]

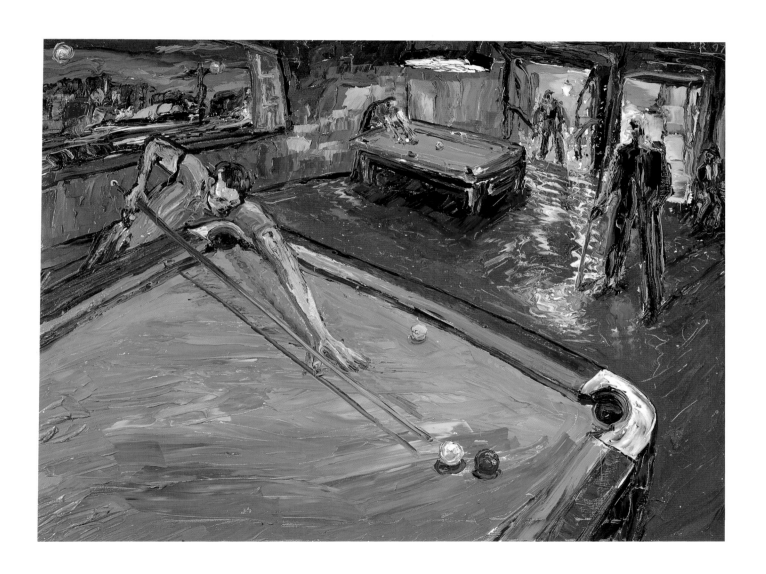

Last Clock on Fifth Avenue

1996

TOM CHRISTOPHER (b. 1952)
Acrylic, with pencil, on canvas,
30 × 40
Signed and dated on verso: *T.*
Christopher, '96
Gift of the artist, 98.81.1

TOM CHRISTOPHER'S five-year stint as a courtroom artist under pressure to depict the drama of criminal trials ably prepared him for his next sustained enterprise: capturing "snatches" of New York City's kinetic street-scapes on canvas. "I try to take it all in quickly—the seamless movement of cabs, buses, bike messengers," noted Christopher, a transplanted Californian, in a 1998 interview.[1]

It was New York's brash compound of speed, tension, and technicolor flux, so force-fully felt in the high-traffic neighborhoods of midtown and lower Manhattan, that ulti-mately persuaded Christopher to desert the West Coast, where he had been juggling sev-eral art-related jobs, and pursue New York as a central subject in the 1980s. Equipped with a camera for gathering on-location impressions, and ensconced in a leased studio in industrial Long Island City, he began to incubate ideas for his vivid, relentlessly energetic urban paint-ings. After a brief return to San Jose, Califor-nia, in the early 1990s, Christopher returned to settle in New York a few years later. With an outsider's attentiveness to qualities that distin-guish Manhattan's "aesthetics" from those of other metropolises, he broadened his com-positional interests to include light as a vital force in his painted cityscapes. Admitting to having originally found New York "awful, gray and sullen," Christopher was now intrigued by its crisp glare of northern light, especially in the spring and autumn, and by the power of that radiance to glue together disparate ele-ments in the street; that is, to sculpt form while disguising detail.

Last Clock on Fifth Avenue compresses all of Christopher's painterly concerns with the contemporary cityscape into a single tableau, its title paying tribute to a holdover from New York's timekeeping past. The featured clock—actually one of three remaining on the avenue from the turn of the century, when businesses and hotels installed such freestanding fixtures as a public service as well as to advertise their locations—stands on the west side of Fifth Avenue between 44th and 45th Streets. Neces-sities in an era that predated the universally available "dollar watch," most of these time-management totems fell victim to lapsed main-tenance when their parent properties changed hands and to worries about safety as vehicular collisions with them grew more frequent.[2]

Tilted in a perspective that has been term-ed hallucinogenic, the clock cues viewers to the playful qualities, ranging from subtle to exultant, that are a hallmark of Christopher's street scenes. Buildings bend inward or jut out from New York's methodical grid in slightly odd angles. Generic pedestrians bob along brightly lit sidewalks and weave past disem-bodied shadows, never quite certain about risks ahead in the oncoming crowds or in the city's volatile asphalt zones, where stoplights are cautionary at best. The blinding flood-light of a fall mid-afternoon seems palpable,

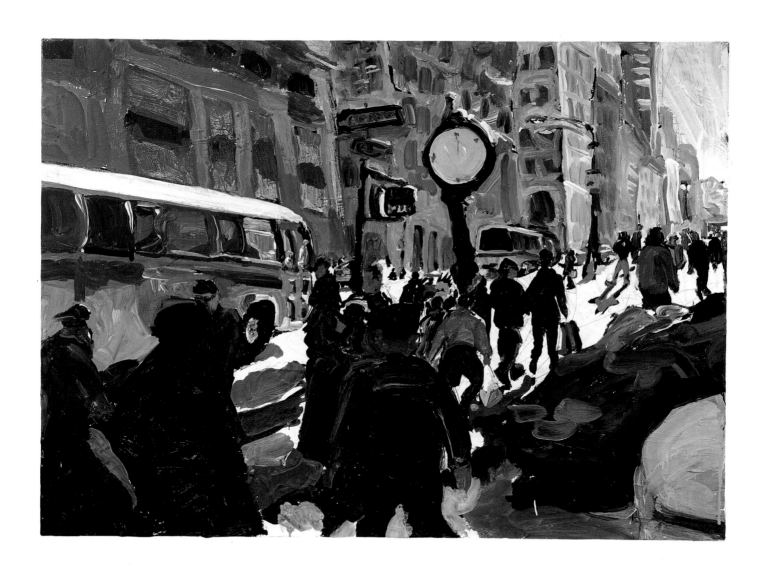

heightened by Christopher's intentional use of his white primed canvas, intensifying the sensation of brightness while creating a shifting dialogue between positive and negative shapes along Fifth Avenue's diagonal swath.[3] His palette is also deceptive. Favoring bold, saturated Day-Glo pigments that on first impression seem natural to the late twentieth-century city, the composition, when dissected, reveals its underlying patchwork of lavenders, burnt oranges, teals, and other unexpected hues. (The artist credits his inventive colorism to the influences of German Expressionists Emil Nolde, Ernst Ludwig Kirchner, and Karl Schmidtt-Rottluff and to the Bay Area figure painters he studied closely in California.) The end effect is of a city never fixed, containing a stunning visuality and dissonance that often compromise the act of reading its specific messages. Pencil lines, appearing as frenetic scribbles on the canvas surface between and underneath Christopher's broad, active brushwork, indicate the narrative possibilities constantly developing, if never fully realized, on New York's streets.

Christopher's California art training (including studies at Sonoma State University and the Art Center College in Pasadena) and diverse employment experiences (his résumé notes graphic work for NBC Studios in Burbank, poster designs for the Los Angeles Olympics, and tourist portraits painted at Disneyland in Anaheim, among other pursuits)[4] have been put to good use in the car-nivalesque urban terrain that is presently his fertile creative ground. In the 1990s he has taught at the Parsons School of Design, exhibited his New York cityscapes in numerous gallery and museum venues both locally and abroad, and received important commissions from clients ranging from the *New York Times* to the Times Square Business Improvement District. For the latter, in 1997, he executed his largest New York streetscape to date: an exuberant and throbbing 30-by-230-foot mural of Times Square on the side of the renowned Roseland Ballroom at Broadway and 53rd Street.

Notes to Catalogue

PLATE I

1 Durand was a prolific artist whose sphere of influence was wide. His career has been well documented by, among others, his son, John Durand, in *The Life and Times of A. B. Durand* (New York: Scribner's, 1894), and David B. Lawall, in *A. B. Durand, 1796–1886* (Montclair, N.J.: Montclair Art Museum, 1971). For additional references, see Museum Archives.

2 Durand's *Dance on the Battery* is listed as no. 212 in the academy's exhibition records for 1838; his *Rip Van Winkle,* noted as "for sale," was no. 78. In the same index, another painting by Durand, *Shipwreck, Clearing up after a Storm,* exhibited in 1850, is credited as belonging to T. H. Faile, the owner of *Dance on the Battery.* See *National Academy of Design Exhibition Record* (New York: New-York Historical Society, 1943), vol. 1, pp. 136, 139. Faile was a partner in a family-owned mercantile firm on Front Street.

3 The phrases quoted in the following paragraphs are from the 1860 edition of Irving's text; see Diedrich Knickerbocker, *A History of New York from the Beginning of the World to the End of the Dutch Dynasty* (New York: George P. Putnam, 1860), pp. 405–406.

4 Several preliminary drawings for the painting survive in a sketchbook (collection of the New-York Historical Society) dating from 1835–1936. A larger body of related preparatory sketches, now scattered in various museum collections—including the New-York Historical Society, the Corcoran Gallery of Art, the Karolik Collection of the Museum of Fine Arts, Boston, and the Free Library of Philadelphia—were assembled for comparison with the Museum's oil painting in the Hudson River Museum's 1983 exhibition *Asher B. Durand: An Engraver's and a Farmer's Art;* see the exhibition catalogue with the same title (Yonkers, N.Y.: Hudson River Museum, 1983), pp. 54–61.

5 Painter Daniel Huntington apparently wrote that Stuyvesant's head was a spoof portrait of Durand's patron, Luman Reed, and that the figure of the frightened attendant was supposedly Durand himself. See Richard J. Koke, discussion in *American*

Landscape and Genre Paintings in the New-York Historical Society
(New York and Boston: New-York Historical Society in associa-
tion with G. K. Hall, 1982), vol. 1, pp. 300–303.

PLATE 2

1 Gloria Deak, in "Banished by Napoleon: The American Exile of
Baron and Baroness Hyde de Neuville," *Magazine Antiques* 136,
no. 5 (November 1988): 1148–1157, gives this birth date, but
Richard Koke, in *American Landscape and Genre Paintings in the
New-York Historical Society* (New York and Boston: New-York
Historical Society in Associate with G. K. Hall, 1982), vol. 2, p.
189, cites sources stating that the Baroness was one hundred years
old when she died.

2 Several of these works—including another view of the same cor-
ner, studies of Broadway opposite Chambers Street, and studies
of New York Harbor—are in the I. N. Phelps Stokes collection at
the New York Public Library. Another group of scenes recording
sites in other eastern states is in the collection of the New York
Historical Society.

3 Many late eighteenth- and early nineteenth-century painted
views of New York City were the work of competent upper-class
European amateurs like the Baroness, who were either visiting or
newly immigrated.

PLATE 3

1 I. N. Phelps Stokes, *The Iconography of Manhattan Island* (New
York: Robert H. Dodd, 1918), vol. 3, p. 564.

2 See ibid., p. 586. According to Margo Gayle and Michelle Cohen,
Guide to Manhattan's Outdoor Sculpture (Englewood Cliffs, N. J.:
Prentice Hall, 1988), pp. 43–44, this first figure burned in 1858
and was replaced by a second wooden figure in May 1860. That
one was removed in 1887, and a new one of bronze, designed by
an unknown sculptor and fabricated by William H. Mullins
Company, and which remains to this day, was installed on
November 3 of that year.

3 Franklin D. Scott, trans. and ed., *Baron Klinköwstrom's America,
1818–1820* (Evanston, Ill.: Northwestern University Press, 1952),
pp. 60–61.

4 Stokes, in *The Iconography of Manhattan Island* (New York:
Robert H. Dodd, 1922), vol. 4, p. 1280, quotes from an order of
the Common Council to property owners to pave unfinished
sidewalks with "Flatt Stones or Bricks."

PLATE 4

1 For nearly a half century the American Museum had a succession
of private owners, most notably P. T. Barnum, who purchased it
in 1842.

2 *Versailles* is now installed in a specially constructed room of the
American Wing at the Metropolitan Museum of Art. A discus-
sion of it and of the rotunda is in Kevin J. Avery and Peter L.
Fodera, *John Vanderlyn's Panoramic View of the Palace and Gar-
dens of Versailles* (New York: Metropolitan Museum of Art, 1988).

3 I.N. Phelps Stokes, *The Iconography of Manhattan Island* (New
York: Robert H. Dodd, 1928), vol. 6, pp. 534–535.

4 Quoted in a letter dated July 27, 1982, from Philip J. Weiner-
skirch, assistant director of the Burndy Library, Norwalk, Con-
necticut, to the National Portrait Gallery, from the files of the
National Portrait Gallery Library.

5 Katherine McClinton, "American Flower Lithographs," *Maga-
zine Antiques* 49, no. 6 (June 1946): 361.

PLATE 5

1 Henry R. Stiles, *A History of the City of Brooklyn* (Brooklyn: pub-
lished by subscription, 1869), vol. 2, pp. 88–89.

2 Ibid., pp. 88–89.

3 Walt Whitman, "A Snow Scene in Brooklyn," in *Walt Whitman's
New York*, ed. Henry M. Christman (New York: Macmillan,
1963), pp. 19–20.

4 The painting at the Brooklyn Museum, at one time owned by
Augustus Graham, was damaged in a fire and is missing several

inches along its left side. Otherwise, Coleman's copy is almost identical.

5 Professor Alfred Kohler searched through genealogical records and city directories for two years, finally locating descendants of Coleman. They were able to provide documentation of her artistic activity and of family ownership of the painting prior to its entering the collection of the Museum of the City of New York.

PLATE 6

1 The formidable task of digging the canal had deterred several generations of earlier planners. Clinton, however, had staked his political future on the possibility of realizing this massive project, and won election to the state governorship in 1816 based on his pro-canal platform. See Brooks McNamara's chapter "Openings and Dedications, 1825–1864," in *Day of Jubilee: The Great Age of Public Celebrations in New York, 1788–1909* (New Brunswick, N.J.: Rutgers University Press, 1997), pp. 84–88.

2 The prominence of the British war vessels featured in Imbert's painting may explain its provenance. Before its purchase from a New York gallery and its subsequent donation to the Museum of the City of New York in 1949, the work had been owned by Colonel P. J. Bellamy, an English lieutenant whose family had long displayed the painting at their ancestral residence in Exmouth, Devonshire. The piece had passed to Bellamy in a direct line of descent from its original owner, Captain Thomas Baldcock, who had served as naval commander of the British ship of war *Swallow*, which occupies a prominent position in the composition. See Charles Allen Smart, "A Rare Historical Painting," *Magazine Antiques* (July 1931): 36–37.

3 The formal title of Cadwallader Colden's history is *Memoir Prepared at the Request of a Committee of the Common Council on New York and Presented to the Mayor of the City, at the Celebration of the Completion of the New York Canals* (New York: printed by order of the Corporation of New York, 1825).

4 The degree of Imbert's commercial success in the emerging graphic art field is questionable, however. Following his death, his widow, Mary, was obliged to earn her living as a purveyor of children's clothing and, later, of women's corsets, as indicated by her listing in New York City directories. See John Carbonell, "Anthony Imbert: New York's Pioneer Lithographer," in *Prints and Printmakers of New York State,* ed. David Tatham (Syracuse, N.Y.: Syracuse University Press, 1986), pp. 11–41; and Harry T. Peters, *America on Stone* (New York: Doubleday, Doran, 1931), pp. 228–229.

PLATE 7

1 "Union Square Turns the Century Mark," *Gas Logic* 2, no. 2 (May 1932). University Place, formerly part of Wooster Street, was renamed a year after New York University's first building went up on Washington Square in 1831. Jackson Avenue was another name briefly considered, and this appears on some maps.

2 Washington, Madison, and Bryant Squares were three other potter's fields that gave way to public park-like squares.

PLATE 8

1 A contemporary copy of this antebellum-era print, headed *American Theatre Bowery New York,* is in the collection of the New-York Historical Society. Its subtitle reads: *View of the Stage on the Fifty-seventh Night of Mr. T. D. Rice of Kentucky in His Original and Celebrated Extravaganza of JIM CROW on Which Occasion Every Department of the House Was Thronged to an Excess Unprecedented in the Records of Theatrical Attraction. New York 25th November 1833.* Contemporary research into the featured bills for the American Theatre in 1833, however, points to January 8, 1833, as the more probable date of the incident pictured. That evening represented the closing of Rice's initial run at the American Theatre, his debut having occurred fifty-seven nights earlier, on November 12, 1832. An announcement in the *New York Evening Post* for January 8, 1833, advertised the Ameri-

can Theatre bill as a special performance celebrating the Battle of New Orleans, followed by a series of scenes including the fourth act of *The Hunchback* and the fifth act of *Richard III.* Next, "Mr. Rice will appear and sing his celebrated Extravaganza of JIM CROW, being the last night of his engagement."

2　For a thorough discussion of the history of Rice's synthesis of the Jim Crow caricature and the meaning of the routine's unprecedented popularity among antebellum audiences in the urban American North, see Dale Cockrell, *"Jim Crow," Demons of Disorder: Early Blackface Minstrels and Their World* (Cambridge: Cambridge University Press, 1977), pp. 62–91; and for an alternate interpretation of "blacking up," see Eric Lott, *Love and Theft: Blackface Minstrelsy and the American Working Class* (New York: Oxford University Press, 1993).

3　In George C.D. Odell's *Annals of the New York Stage* (New York: Columbia University Press, 1928), vol. 3, p. 633, Rice's arrival at the American Theatre was said to take place on November 12, 1832, with his first benefit performance, "in which he personated the six characters in A Day after the Fair," recorded on November 17.

4　In later life, Rice suffered from a stroke, which for a time deprived him of speech and the use of his legs. By the early 1850s he had recovered sufficiently to be cast in a theatrical adaptation of Harriet Beecher Stowe's *Uncle Tom's Cabin* and to perform with Henry Wood's Minstrel Company. He died in New York in 1860.

5　William T. Porter, a critic of the period who covered entertainment news for the elite journal *Spirit of the Times,* occasionally "slummed" at shows presented at New York's working-class theaters. Dale Cockrell (*"Jim Crow,"* pp. 31–32) reproduces Porter's account of the spectators crowding on stage, commingling with the actors and props, during a performance of *Richard III* at the American Theatre in 1832.

PLATE 9

1　Quoted in Richard Koke, *American Landscape and Genre Paint-*

ings in the New-York Historical Society (New York: New-York Historical Society; Boston: G. K. Hall, 1982), p. 114.

2　The original watercolor is in the collection of the New-York Historical Society.

3　*New York Evening Post,* July 20, 1831; quoted in I. N. Phelps Stokes, *The Iconography of Manhattan Island* (New York: Robert H. Dodd, 1922), vol. 4, p. 1704.

4　Terry Miller, *Greenwich Village and How It Got That Way* (New York: Crown Publishers, 1990), pp. 95–96.

PLATE 10

1　Further biographical information about Calyo is in the entry for *Burning of the Merchants' Exchange, New York, December 16th & 17th, 1835* (plate 11).

PLATE 11

1　The sculptor Robert Ball Hughes (1806–1868) had executed a marble figure of Alexander Hamilton on commission from New York's merchants. A surviving plaster model is in the Museum's collection.

PLATE 12

1　C. Foster, *An Account of the Conflagration of the Principal Part of the First Ward of the City of New-York, Illustrated with Numerous Etchings, and a Plan Showing the State of Ruins . . .* (New York: C. Foster, 1836), pp. 26–27.

2　See listing for James Ackerman, and for Ackerman and Miller, in George C. Groce and David H. Wallace, *The New-York Historical Society's Dictionary of Artists in America* (New Haven: Yale University Press, 1957), p. 1. No other evidence has been found to substantiate the attribution to Ackerman or the circumstances under which this painting was produced.

PLATE 13

1　*New York Evening Post,* April 1, 1837. New York City acquired a

second major example of Egyptian or Coptic public architecture in 1842 with the construction of the Croton Distributing Reservoir at Fifth Avenue and 42nd Street, formerly known as Reservoir Square and the present-day site of the New York Public Library.

2 Colt's sensational trial received extensive press coverage because of the malice of the crime and the social prominence of the perpetrator. For a contemporary account, see C. F. Powell, *An Authentic Life of John C. Colt, Now Imprisoned for Killing Samuel Adams in New York, on the Seventeenth of September, 1841* (Boston: S. N. Dickinson, 1842).

3 For a contemporary description of the prison's decorative program, see *New-York as It Is: Containing a General Description of the City of New York: List of Officers, Pubic Institutions, and Other Useful Information . . .* (New York: Colton and Disturnell, 1839), pp. 24–25.

4 The large 9 ½-inch-cylinder Southwark Engine, built by John Agnew of Philadelphia, was the object of much envy by other volunteer companies in New York and received elaborate ornamentation, including painted panels and gleaming fittings made of "Prince's metal." For descriptions of its decorations and operations, see George W. Sheldon, *Story of the Volunteer Fire Departments of the City of New York* (New York, 1882), pp. 505, 530–531.

5 Steam engines were introduced into New York City's fire-fighting arsenal in 1855 over the resistance of many volunteers, who saw this innovation as jeopardizing their indispensability to the task of fire suppression. In 1865 the City of New York replaced volunteer brigades with a paid fire department.

6 The inscription discernible on the engine in the painting shown here reads: *Southwark / 38 / John Agnew / No. 402 / Philada.* Engine Company 38 acquired its "Southwark" engine around 1840, two years before the fire at the Tombs. This same volunteer company and engine reappear in Browere's painting *Fire at Broadway and Cedar Street* (1842), also in the Museum's collection (acc. no. 29.100.1310).

PLATE 14

1 Manual of the Common Council, quoted in I. N. Phelps Stokes, *The Iconography of Manhattan Island* (New York: Robert H. Dodd, 1926), vol. 5, p. 1436.

2 Ibid., p. 1433.

3 Ibid., pp. 1522, 1535.

4 Allan Nevins, ed., *The Diary of Philip Hone, 1828–1851* (New York: Dodd, Mead, 1927), pp. viii–ix.

5 The quotation is from a letter dated July 5, 1821, from George N. Gracie to his uncle, quoted in Stokes, *Iconography of Manhattan Island*, vol. 5, p. 1617. See p. 1608 for the revocation of auction permits.

6 Moses King, ed., *King's Handbook of New York* (Boston: Moses King, 1893), p. 158.

7 At this same period, a Mme Elizabeth Didier (1803–1877), a French porcelain painter, was also living in New York; "E. Didier" could also refer to her.

8 Stokes, in *Iconography of Manhattan Island*, vol. 5, p. 1602, quotes a visiting Englishman, Charles H. Wilson, who wrote about his observations in New York in 1819–1820: "In my perambulations I found a new object of attraction; red flags at several doors, and 'vendue' inscribed thereon—Dutch term for auction."

PLATE 15

1 McComb was also the architect for City Hall, Castle Garden, and two New York area lighthouses still in use at Eaton's Neck and Montauk.

2 Morgan Dix, *History of Trinity* (1898–1906), vol. 4, pp. 236–237, quoted in I. N. Phelps Stokes, *The Iconography of Manhattan Island* (New York: Robert H. Dodd, 1922), vol. 4, p. 235.

3 Unidentified news clipping, dated December 17, 1908, in the Museum Archives.

4 Elizabeth McCausland, *The Life and Work of Edward Lamson Henry N.A., 1841–1919* (Albany: University of the State of New York, 1945).

PLATE 16

1 Shot towers were used in manufacturing shot or bullets. Molten lead was poured through a sieve from the summit, hardening into balls as it descended into a reservoir of water.

2 A label on the back of the painting, now removed and in the Museum Archives, quotes McComb's account book of 1822: "For Plans and directions for building a shot tower."

3 A. Everett Peterson, in *Landmarks of New York* (New York: City History Club, 1923), p. 73, related: "So strongly was the tower built that when the present owner of the property contracted for its demolition a few years ago, the contractor gave up the job after removing the upper portion; so the base to a height of about ten feet still remains."

4 According to an unidentified, undated typescript in the Museum Archives.

5 One of the paintings is at the New-York Historical Society. The other belongs to the Newington-Cropsey Foundation, which owns and manages Cropsey's home and studio in Hastings, New York.

PLATE 17

1 Christopher Gray, "A Restored Memorial to Two Who Died on the Titanic," *New York Times,* real estate section, August 23, 1998.

2 Research information supplied from a conversation on August 19, 1993, with Christopher Letts of the Hudson River Foundation. The lush tree foliage and tufts of grass on the beach indicate summer.

PLATE 18

1 I. N. Phelps Stokes, *The Iconography of Manhattan Island* (New York: Robert H. Dodd, 1926), vol. 5, p. 1718.

2 Bartlett Cowdrey, *National Academy of Design Exhibition Record, 1826–1860* (New York: New-York Historical Society, 1943), pp. 159–162.

3 Nina Fletcher Little, "Thomas Thompson: Artist-Observer of the American Scene," *Magazine Antiques* 57, no. 2 (February 1949):

122. The print is plate 100 A in I. N. Phelps Stokes, *The Iconography of Manhattan Island* (New York: Robert H. Dodd, 1918), vol. 3.

PLATE 19

1 Harry Lines, "Niblo's Garden," unidentified article from the Museum Archives, n.d.

2 John Doggett, Jr., *Cries of New-York* (New York: John Doggett, Jr., 1846), p. 32.

3 *Journal of the American Institute* 1 (1836): 12.

4 "Fair of the American Institute," *Journal of the American Institute* 1, no. 9 (June 1836): 450.

5 Letter about Benjamin Johns Harrison's life from B. S. Harrison, the artist's son, to Miss Grace Mayer, n.d., Museum Archives.

PLATE 20

1 The reservoirs for Croton water were located at 42nd Street and Fifth Avenue, and between 79th and 86th Street and Fifth and Seventh Avenues. When Central Park was constructed, the latter reservoir was filled in, forming the Great Lawn. In 1857, a third reservoir was built while the park was under construction; it will cease to be used about the year 2000.

2 Allan Nevins and Milton Halsey Thomas, eds., *The Diary of George Templeton Strong: Young Man in New York, 1835–1849* (New York: Macmillan, 1952), p. 99.

3 *Miller's New York as It Is* (New York: James Miller, 1882), p. 99.

4 The Subject Index of the Inventory of American Paintings in the Smithsonian Institution lists High Bridge paintings by many artists.

5 The other painting appears in an advertisement, *Magazine Antiques* 3, no. 5 (May 1977): 842. Because there are at least two paintings very similar to the print, the likelihood is that the print was made first and widely distributed.

PLATE 21

1 Demand for passage was so great that New York's boatyards could not supply ships fast enough. The *Hartford* was built in Philadelphia in November 1848.

2 Laura Retting White, "New York's Part in the Gold Rush," *Bulletin of the Museum of the City of New York* 1, no. 5 (April 1938): 56.

3 Ibid., p. 58.

4 *Brooklyn Before the Bridge: American Paintings from the Long Island Historical Society* (New York: Brooklyn Museum, 1982) p. 134.

PLATE 22

1 Brower's initial twelve-seat coach, built by Wade and Leverich, was named the "Accommodation." It ran up and down Broadway as far north as Bleecker Street, charging a shilling's fare regardless of the distance traveled. By 1829 Brower had increased service with the addition of a second coach, the "Sociable," which featured trend-setting seats extending lengthwise and an entrance at the vehicle's rear. In 1831 a new coach financed by Brower appeared on Broadway bearing the name "Omnibus," borrowed from the mode of vehicular passenger service then popular in Paris. The new coach had been engineered by John Stephenson, owner of a recently established coach-making business in New York who quickly dominated all local competition in the design and manufacture of omnibuses.

2 The Knickerbocker Stage Company began operation around 1835 and enjoyed a brisk business through the Civil War, initially running omnibuses between the Merchant's Exchange on Wall Street and Eighth Avenue and 21st Street by way of Wall Street, Bleecker Street, and Eighth Avenue. The southern terminus was later extended to South Ferry. The company crossed the East River to Brooklyn, still a separately governed city, soon thereafter developing new passenger routes that eased commuting distances between Brooklyn and lower Manhattan. Stage companies like the Knickerbocker Line received serious competition after horse-drawn trolleys were introduced into service in 1854.

3 It seems reasonable to assume that the younger Johnson ordered this congratulatory painting from Boesé to commemorate both his fledgling business venture and his family residence. The provenance of the painting cannot be traced back beyond the donor, Herbert Platt, who gave it to the Museum in 1940. Edward Dechaux, whose preparator's stamp is visible on the reverse of the canvas, sometimes included Brooklyn, in addition to New York, as a service location for his nineteenth-century business.

4 Boesé's oeuvre includes conventional romantic landscapes, many depicting Hudson River Valley locales, and at least one detailed topographical view of New York City's Riverside Park, dated 1885. Additional information and citations pertinent to Boesé's painting career are found in his file in the Museum Archives.

5 See entry for Henry Boesé and his painting *The Stage Sewanhackey,* 1852, in the exhibition catalogue *Brooklyn Before the Bridge: American Paintings from the Long Island Historical Society* (Brooklyn: Brooklyn Museum, 1982), pp. 47–48, 127–128. Boesé's 1852 *The Stage Sewanhackey* (a corruption of the Native American name for Long Island, *Seawankacka*) records the procession of a new coach operated by the Fulton Avenue and Bedford Line approaching the new Brooklyn City Hall (now Borough Hall). An accompanying inscription along the canvas bottom further explains the scene: "The Members of the Common Council / Accepting an Invitation from the Proprietor / Montgomery Queen are About Enjoying an Excursion on the 23rd of June 1852. The Stage Commanded by William Canfield / H. Boesé, Art't."

PLATE 23

1 The *Herald's* account of the new Metropolitan Hotel was reproduced in "A Broadway Hotel," *Builder* 10, no. 504 (October 2, 1852): 630–631.

2 William Niblo's previous "pleasure gardens" had been destroyed by fire in 1846, prompting the wealthy proprietor to retire to the country. He was soon persuaded to return from retirement to again address the public's clamor for lively amusements of the variety his garden had offered. While the new Niblo's—on the northeast corner of Prince and Broadway, connecting to the Crosby Street block—was under construction in 1849, foundations were being dug for the Metropolitan Hotel. Niblo is cred-

ited as having suggested the idea of a hotel to Stephen Van Rennselaer, from whom he continued to lease his garden site.

3 See Mary Ann Smith, "The Metropolitan Hotel and Niblo's Garden: A Luxury Resort Complex in Mid-Nineteenth-Century Manhattan," *Nineteenth Century* 5, no. 4 (1979): 45–48. According to Smith, Trench and Stock had designed both the first stage of Stewart's store at 280 Broadway and the first of several additions to it. A pioneering retail store with an innovative marble facade, it was hailed as the "Marble Palace."

4 Mulner's name is associated with the painting as artist in the catalogue records prepared for the J. Clarence Davies Collection in 1929. No further evidence was supplied to explain the attribution, however, and research efforts to date have failed to locate any additional information about Mulner. A curator associated with the Davies Collection at the time of its receipt conjectured that the painting "is very presumably one of the views which form a part of the canopy for Porter Belden's 'Model of New York,' of which all trace has been lost." Belden's model, which featured on its canopy one hundred oil paintings representing leading New York City businesses and places of note, made its debut at the Minerva Rooms on Broadway in July 1846, well before planning for the Metropolitan Hotel was under way. It is thus unlikely that an image of the future hotel—whose foundations were not dug until three years later—could have found its way into the model's decorative program.

5 For an account of the hotel's later years and decline, see Frank W. Crane, "Realty Sale on Lower Broadway Revives Memories of Old Hotel," *New York Times*, February 23, 1941.

PLATE 24

1 There is no known record of the Old Empire Building's designer or builder. It has little stylistic distinction, being typical of massive commercial buildings of the period.

2 Among the office tenants in the Empire Building was financier Russell Sage (1816–1906), who was elected to Congress in 1852 and who, with Jay Gould, later made a fortune amounting to $70 million in railroads and on Wall Street. When he died, his wife, Olivia Sage, proceeded to give most of it to various charities, including a foundation bearing his name.

3 Following the 1830 ordinance prohibiting burials below Canal Street, Trinity Church opened a new cemetery at 155th Street and Riverside Drive. Among the wealthy and socially prominent church members interred there are John Jacob Astor, Clement Clark Moore, and Alfred Tennyson Dickens, son of Charles Dickens.

4 Richard J. Koke, *American Landscape and Genre Paintings in the New-York Historical Society* (New York: New-York Historical Society, 1982), vol. 2, pp. 134–135.

PLATE 25

1 See Brooks McNamara, *Day of Jubilee* (Rutgers: Rutgers University Press, 1997), for a full discussion of how theatrical traditions were adapted for these street events, which used the city as both stage and auditorium.

2 Kenneth T. Jackson, ed., *The Encyclopedia of New York City* (New Haven: Yale University Press, 1995), p. 643.

3 There are Kossuths in Indiana, Iowa, Mississippi, New York, Ohio, Pennsylvania, and Texas.

PLATE 26

1 Robert Underhill's journal is in the Manuscript Department, New-York Historical Society.

2 A family tree, developed by former Paintings Department intern Angela Blake from her extensive research at the New York Genealogical and Biographical Society, shows the family connection between artist and seaman and suggests that Theodore E. Blake, who donated the painting to the Museum, was a collateral descendant of the captain's. George Lane may have commis-

sioned the painting, as such commissions were common among sea captains at that period.

3 *Harper's New Monthly Magazine,* quoted in Helen La Grange, *Clipper Ships of America and Great Britain, 1833–1869* (New York: G. P. Putnam's Sons, 1936), p. 201.

4 See "Fitz Hugh Lane, 1804–1865," in John Caldwell and Oswaldo Rodriguez Roque, *American Paintings in the Metropolitan Museum of Art* (New York: Metropolitan Museum of Art, 1994), vol. 1, p. 492, describing Lane's "refined colorism, subtle composition, and beautifully painted surface."

5 The Metropolitan Museum of Art owns *The Golden State Entering New York Harbor,* which bears the signature "Fitz Henry Lane" on the reverse of the canvas.

6 John Wilmerding, Sarofim Professor of American Art at Princeton University and author of *American Marine Painting* (New York: Abrams, 1987), examined the painting in June 1993 and believes that it is by Fitz Hugh Lane with "no additional hands at work." He felt that Stevens or someone else might have been involved in the signature "Fitz Henry Lane."

PLATE 27

1 In 1823 Castle Clinton was given to the city and was converted into an entertainment center, known as Castle Garden, until the city reclaimed it to serve as an immigration center from 1855 to 1890. The original Castle Clinton was probably designed by John McComb, Jr., the architect of City Hall and several elegant private homes, and Lieutenant Colonel Jonathan Williams, who proposed the ring of forts that protected the harbor and for whom the fort on Governors Island is named.

PLATE 28

1 Barnett Shepherd and Charles Sachs, both formerly associated with the Staten Island Historical Society, were unable to determine a print source for the painting. Examination of various compendiums of American prints yielded no results.

2 Henry G. Steinmeyer, *Staten Island, 1524–1898* (Staten Island: Staten Island Historical Society, 1950).

PLATE 29

1 The Costume Department of the Museum has assigned an 1850s date to the clothes of the figure at the right.

2 Kenneth Jackson, ed., *The Encyclopedia of New York City* (New Haven: Yale University Press, 1995), pp. 610–611. Clay Lancaster, in *New York's First Suburb: Old Brooklyn Heights* (Rutland, Vt.: Charles E. Tuttle, 1961), p. 135, writes that Lafever built the arch during the mid-1850s, but Lafever's death in 1854 mandates an earlier date.

3 Lancaster, *New York's First Suburb,* p. 135.

PLATE 30

1 Maxine Friedman, *Wall Street: Changing Fortune* (New York: Fraunces Tavern Museum, 1990), p. 39.

2 Quoted in Grace M. Mayer, "A Painting of the 'Revulsion' of 1857," *Bulletin of the Museum of the City of New York,* no. 3 (May 1940): 71.

3 Stephen Wheeler, archivist of the New York Stock Exchange, has estimated this figure based on the figure of 112 members in 1848 published in William Armstrong, *Stock and Stock-Jobbing in Wall Street* (New York: New-York Publishing Company, 1848).

4 Grace M. Mayer, in "A Painting of the 'Revulsion' of 1857," referred to "a once existent key" but wrote that the catalogue of the auction (presumably the auction at which Judge Irwin Untermyer bought this painting) listed the "safely identifiable characters shown in the painting."

5 David Stewart Hull, *James Henry Cafferty, N. A. (1819–1869)* (New York: New-York Historical Society, 1986), p. 33.

6 Ibid., p. 17.

7 Natalie Spassky, *American Paintings in the Metropolitan Museum of Art* (New York: Metropolitan Museum of Art, 1985), vol. 2, p. 96.

PLATE 31

1 See E. Bénézit, *Dictionnaire . . . des peintres, sculpteurs, dessina-teurs et graveurs, etc.* (Paris: Librairie Grund, 1976), vol. 9, p. 492, and Museum Archives. Sebron was also noted for his detailed topographical paintings of European church interiors and festive pageants mounted in mid-nineteenth-century Paris.

2 Barnum's American Museum, opened in 1841, was a brilliant makeover of a defunct enterprise known as Scudder's Museum. Under Barnum's astute promotion, the revived operation, with augmented collections, became one of the city's leading recreational destinations until fire destroyed the building in 1865. Barnum then opened another museum farther north on Broadway, which also burned, at which point he shifted his sights to the circus as a new channel for his ideas regarding popular entertainment.

3 The appearance of these public sleighs evidently gave rise to a popular, if harassing, form of winter sport for New Yorkers on the streets, who hurled snowballs at the helpless passengers. Some of the lore associated with New York's omnibus-sleighs is discussed in John Anderson Miller, *Fares, Please: From Horse-Cars to Streamliners* (New York: D. Appleton, 1941), pp. 7–8.

PLATE 32

1 *Waugh's Great Italia . . . [McDonnell's Voyage to Rome] . . . A Hand-Book Descriptive of the New Series of Italian Views. Painted by S. B. Waugh, Esq. in 1853, '54, and '55. From Sketches Taken by the Artist During a Residence of Several Years in Italy* (Philadelphia, 1867), booklet in Museum Archives (acc. no. 33.169.3). Handbills explaining Waugh's earlier panorama are in the Harvard Theater Collection, Pusey Library, Harvard University. The Museum's booklet, though published later than the handbills, documents the ongoing tour of Waugh's *Italia* through the third quarter of the nineteenth century. A list of primary sources to both of Waugh's nineteenth-century Italian panoramas was sup-plied by Kevin J. Avery, an authority on American panorama paintings and then a research associate in the American Paintings and Sculpture Department of the Metropolitan Museum of Art, in a letter of January 24, 1988, Museum Archives.

2 During its stay of several months in New York harbor, the *Keying* proved a popular tourist attraction, with as many as four thousand people a day paying twenty-five cents to board her, and many more flocking to the viewing deck of Castle Garden to study her strange design and crew. Waugh may have intended to indicate that phenomenon in the distant flow of figures from Castle Garden, which most historians now read as immigrants newly registered at Castle Garden. See Norman Brouwer, "New York's Unusual Chinese Visitor . . . the Junk Keying," *Seaport Magazine* 14, no. 2 (Summer 1980): 18–19.

3 By the late 1840s, Bedloe's Island, the traditional landing station for overseas arrivals, had become strained by the swelling numbers of incoming vessels to New York, prompting the need for the new immigration facility. Castle Garden was originally Castle Clinton, a fort built in 1811 on an artificial island off lower Manhattan. It was converted into a theater in 1833 and was later connected by landfill to the Battery. It served as an immigration center between 1855 and 1890, ceding that function to Ellis Island in the 1890s.

4 In 1952 a conservator treating the painting in preparation for its display in the Museum's exhibition *New York Street Scene, 1852* found its nativist humor objectionable and painted over a whiskey bottle that Waugh had inserted in the back pocket of the young Irishman carrying a knapsack.

5 This analogy was suggested by Allen Feldman in "Gaelic Gotham: An Ethnographic Evaluation," in *The Gaelic Gotham Report: Assessing a Controversial Exhibition at the Museum of the City of New York* (New York: New York Irish History Roundtable, 1997), pp. 26–27.

PLATE 33

1 By inscribing his address on this and many of his other paintings, Bard took advantage of the opportunity to make himself accessible to any in search of similar services.

2 Erik Heyl, *Early American Steamers,* vol. 4 (Buffalo: Erik Heyl, 1965), p. 185.

3 The Mary Powell Steamboat Company became a subsidiary of the Hudson River Day Line in 1903.

4 Quotation from Heyl, *Early American Steamers,* p. 184.

5 Ibid. Malcolm Daniel of the Metropolitan Museum Photography Department has suggested that these photographic portraits might have been made as positive contact prints on glass from glass plate negatives, in the same way that lantern slides were made, or they might have been albumen prints mounted between two sheets of glass.

6 *Guidebook* (New York: Mary Powell Steamboat Company, n.d.).

7 A. J. Peluso, Jr., *J. and J. Bard Picture Painters* (New York: Hudson River Press, 1977), p. 86.

PLATE 34

1 Richard B. Birrer, M.D., M.P.H., "Ship of Health: N.Y.'s Floating Hospital," *Medical Times* (May 1985): n.p.

2 Quoted in ibid.

3 Ibid.

4 According to "The Floating Hospital of St. John's Guild," *Harper's Weekly* (September 12, 1874), the summer work began that year. However, in *The Origin of the Floating Hospital of St. John's Guild: The Retelling of a Story in Historical, Medical Perspective,* Louis Joseph Tesoro gives 1873 as the date.

5 Lynn S. Beman, *Julian O. Davidson, 1853–1894: American Marine Artist* (New City, N.Y.: Historical Society of Rockland County, 1986), p. 23.

6 Research has failed to discover whether the commission to paint the *Emma Abbott* was given by the guild itself or privately by another interested party. The title of the painting was assigned by the Museum in the absence of any known title assigned by the artist.

PLATE 35

1 Westchester County borders the Bronx. When the Bronx became part of Greater New York in 1898, the southern portion of the region, including the Jerome Race Track area, was annexed to the Bronx.

2 The number of paintings in the collection that depict stables and horse driving reflects the popularity of the theme as a subject for artists during the second half of the nineteenth century. Examples include John McAuliffe's *Frank Work Driving a Fast Team of Trotters* (acc. no. 29.100.1312); Jay Hambridge's *Summer on the Speedway* (acc. no. 34.100.33); and Louis Maurer's *The New York Riding Club at Judge Smith's, Jerome Avenue and 167th Street, 1886* (acc. no. 58.146.1).

3 *M. and M. Karolik Collection of American Water Colors and Drawings, 1800–1875* (Boston: Museum of Fine Arts, 1962), vol. 2, p. 79. Richard Koke, in *A Catalog of the Collection, Including Historical, Narrative, and Marine Art* (Boston: G. K. Hall, 1982), relates that in 1881 Oertel taught Christian art at the University of the South and that during 1889–1891 he was on the art faculty at Washington University, St. Louis.

PLATE 36

1 Alan Feldman, "Ruralization of the City-Scape," in *The Gaelic Gotham Report: Assessing a Controversial Exhibition at the Museum of the City of New York* (New York: New York Irish History Roundtable, 1997), p. 28.

2 The change in the connotation of *shanty* may stem from the political desire to imply that the dwellers were indigent and that being removed from the land (which was needed for private and civil projects) was in their best interest as well as in the interest of the developers.

3 Norman A. Geske, *Ralph Albert Blakelock, 1847–1919* (Omaha: Nebraska Art Association, 1974), p. 18. This catalogue presents an excellent overview of Blakelock's life and career.

PLATE 37

1 The painting's previously assigned date of c. 1870 has been, through identification of the clothing on the women walking the beach, shifted more accurately to 1862–65.

2 Edo McCullough, *Good Old Coney Island: A Sentimental Journey into the Past* (New York: Charles Scribner's Sons, 1957), pp. 18–20.

PLATE 38

1 *One Hundred Years of Brewing* (New York: H. S. Rich, 1903), p. 246.

2 Stanley Baron, *Brewed in America* (Boston: Little, Brown, 1962), p. 213.

PLATE 39

1 Ian R. Stewart, "Politics and the Park: The Fight for Central Park," *New-York Historical Society Quarterly* 61, nos. 3–4 (July–August 1977): 126.

2 For an in-depth discussion of the various camps arguing for and against a park, see Roy Rosenzweig and Elizabeth Blackmar, *The Park and the People: A History of Central Park* (Ithaca: Cornell University Press, 1992).

3 One hundred and forty-three of the acres, for which there was no charge, were two city reservoirs for Croton water. One of these has since been filled in and is now known as the Great Lawn.

4 The New-York Historical Society exhibition *Before Central Park: The Life and Death of Seneca Village* (January 29 to August 10, 1997) presented much of this little-known information, most of which was uncovered by Rosenzweig and Blackmar's research published in *The Park and the People.*

5 Henry Hope Reed and Sophia K. Duckworth, *Central Park: A History and a Guide* (New York: Clarkson N. Potter, 1967), p. 2.

PLATE 40

1 Document quoted in Frederick Law Olmsted, Jr., and Theodora Kimball, eds., *Frederick Law Olmsted, Landscape Architect: Central Park as a Work of Art and as a Great Municipal Enterprise* (New York: G. P. Putnam and Sons, 1928), p. 66. In 1866, one year after Culverhouse painted this scene, an official guidebook to the park calculated that 555,668 people had skated on the Lake in the month of January alone. See T. Addison Richards, *Guide to Central Park* (New York: James Miller, 1866), p. 57.

2 Culverhouse exhibited a work of the same subject titled *Moonlight in Central Park* at the National Academy of Design in 1865. Other dated ice-skating scenes of the park by Culverhouse are known, including an 1869 moonlit view of the Lake looking toward the Ramble from the south side of Bow Bridge (collection of Beacon Hill Fine Arts, New York, as of 1996). These represent some of the earliest painted views of Central Park; on this point, see William H. Gerdts, *Impressionist New York* (New York: Abbeville Press, 1994), pp. 126–127.

3 Culverhouse painted landscapes in Syracuse, Riverhead, Utica, and Trenton Falls, New York, in the Wissahickon Creek area of Philadelphia, and in other locations in the eastern United States; he also depicted scenes in his native Holland and in Paris. For a biographical summary of his career, see the entry for Culverhouse's *Skating on the Wissahickon* (1875) in Natalie Spassky, *American Painting in the Metropolitan Museum of Art,* vol. 2 (1816–1845) (New York: Metropolitan Museum of Art, 1985), pp. 131–134; and Museum Archives.

PLATE 41

1 M. M. Graff, *Central Park—Prospect Park: A New Perspective* (New York: Greensward Foundation, 1985), p. 79.

2 Quotation from *Tenth Annual Report of the Board of Commissioners of the Central Park, for the Year Ending December 31, 1866* (New York: Wm. C. Bryant, 1867), p. 32.

3 Roy Rosenzweig and Elizabeth Blackmar, *The Park and the Peo-*

ple: A History of Central Park (Ithaca: Cornell University Press, 1992), p. 230.

4 Henry Hope Reed, *Central Park: A History and a Guide* (New York: Clarkson N. Potter, 1972), p. 74.

5 Inman's exhibition record also includes floral pieces and other still lifes, landscapes inspired by trips to the Adirondacks, and various works based on twelve years spent in Europe. For additional information see Carolyn B. Wilkinson, "John O'Brien Inman," *Magazine Antiques* (November 1998): 722–727.

PLATE 42

1 "Frank Work Dead of Pneumonia at 92," *New York Times*, March 17, 1911.

2 Lady Colin Campbell, *Diana in Private: The Princess Nobody Knows* (New York: St. Martin's Press, 1992), p. 9.

3 Photographs in the Prints and Photographs Department of the Museum of the City of New York were used to make these identifications.

4 Landmarks Preservation Commission, *St. Nicholas Historic District, Borough of Manhattan*, no. 2 (March 16, 1967): 2.

5 Bruce Weber of Berry-Hill Galleries generously shared his finding of McAuliffe's obituaries in the *New York Herald Tribune* and the *New York Times* of December 10, 1900.

PLATE 43

1 Correspondence dated May 28, 1953, from the Queens Historical Society, in Museum Archives.

2 Rockaway encompasses the communities of Far Rockaway, Edgemere, Arverne, Hammels, Hollands, Seaside, Rockaway Park, Belle Harbor, and Neponsit.

3 *The WPA Guide to New York City* (1939; reprint, New York: Pantheon, 1982), p. 591.

4 Letter from Mrs. Bertha Schildt Hornbostel to Grace Mayer, Curator of Prints and Photographs at the Museum of the City of New York, November 20, 1952, in Museum Archives.

PLATE 44

1 Mantle Fielding, *Dictionary of American Painters, Sculptors and Engravers* (Philadelphia: privately printed, 1926), gives Sheppard's birth date as 1859. *Who Was Who in American Art*, ed. Peter Hastings Falk, gives the date as 1858. According to his obituary in the *New York Times* of Tuesday, February 28, 1937, Sheppard was eighty-one at his death.

2 Judith St. George, *The Brooklyn Bridge: They Said It Couldn't Be Built* (New York: G. P. Putnam's Sons, 1982), p. 104.

3 C. C. Martin, "Report of the Chief Engineer and Superintendent," in *Acts of the State of New York, and of the United States, in Relation to the New York and Brooklyn Bridge* (n.p., 1868–1884), p. 5.

4 "Two Great Cities United," *New York Times*, Friday, May 25, 1883.

5 David McCullough, *The Great Bridge* (New York: Simon and Schuster, 1972), p. 540.

PLATE 45

1 "The Cover," *Journal of the American Medical Association* 256, no. 1 (July 4, 1986): 7.

2 Ibid.

3 The pedestal was designed by architect Richard Morris Hunt (1827–1895).

4 Quoted in Brooks McNamara, *Day of Jubilee: The Great Age of Public Celebrations in New York, 1788–1909* (New Brunswick, N.J.: Rutgers University Press, 1997), p. 146.

5 According to the account of Anson Phelps Stokes, "the applause [for one of the speeches] was mistaken . . . as the signal . . . to pull the rope which unveiled the statue, upon which all the steamers and steam-tugs which were in attendance upon the island started their steam-whistles." Quoted in Ann Bernhard, "Trip to the Statue of Liberty," *Museum of the City of New York Junior Bulletin* 2, no. 1 (October 1941): 7.

PLATE 46

1 Hawley's crew appears to be a mixed force of Irish and Italian

track layers, the latter suggested by the prominence of the thick black mustaches sported by several figures who face forward, as if peering out of the picture at the viewer.

2 The Crimmins Construction Company recruited a predomi-nantly Irish workforce to expedite such major publicly financed construction contracts as the High Bridge and Croton Aqueduct, and the building of countless New York City streets, sewers, gas mains, and street railway lines. Affluent businessmen of Irish heritage like John D. Crimmins were alternately praised for employing so many Irish workers and criticized for paying many of them poorly. For more on the Irish presence in nineteenth-century New York City, see *Gaelic Gotham: A History of the Irish in New York* (curatorial script for the 1996 exhibition of the same title at the Museum of the City of New York) and Ronald H. Bay-lor and Timothy J. Meagher, eds., *The New York Irish* (Baltimore: Johns Hopkins University Press, 1996), sections titled "The Great Migration: 1844–1877" and "The Turn of the Century: 1877–1914."

3 Hawley's influential career as a renderer, little documented in the standard literature on American architecture, has been researched and summarized by Janet Parks in "Hughson Hawley," in *New York on the Rise: Architectural Renderings by Hughson Hawley, 1880–1912,* exhibition catalogue (New York: Museum of the City of New York, 1998).

PLATE 47

1 Conversation with an archivist at YIVO Institute for Jewish Re-search, May 31, 1994, garnered this information about Orthodox Jewish practice.

2 Roy Rosenzweig and Elizabeth Blackmar, in *The Park and the Peo-ple: A History of Central Park* (Ithaca: Cornell University Press, 1992), discuss the rules governing visitors to the park on pp. 238–240, 244–246, 254–256, 455, and 517–518. Debates about who could use the park, and how and when it could be used, began while construction was under way, continued during the first decades after it opened, and have occasionally recurred ever since.

3 Henry Hope Reed, Robert J. McGee, and Esther Mipaas, *Bridges of Central Park* (New York: Greensward Foundation, 1990), p. 46.

4 The Museum of the City of New York owns eleven of Slaney's watercolors, including *Old Mill, Bronx River, N.Y.* (acc. no. 34.100. 797), *Steps in Cave and Pool* (acc. no. 89.4.5), and *Stone Arch Near North Entrance to Cave* (acc. no. 89.4.2).

PLATE 48

1 Smith exhibited landscapes at the National Academy of Design almost continuously between 1877 and 1899, with various ad-dresses listed on West 11th Street, Union Square, and Broadway. Other connections to the local art community included mem-berships in the Salmagundi Club and the Artists' Fund Society. For clippings and dictionary entries related to Smith, see Museum Archives.

2 When this painting first entered the Museum as a long-term loan in 1942, it was identified as the 1892 Columbian Military Parade. However, the downtown direction of the parade recorded by Smith, confirmed by the position of the marchers approaching Washington Square Park, supports a correction to the School and College Parade of October 10, 1892. That parade went south down Fifth Avenue, disbanding in Greenwich Village. See "Young America Leads Off, First of the Great Parades of Columbus Week," *New York Times,* October 11, 1892. The more lavish Mili-tary Procession on October 12 flowed north on a route starting at the Battery, moving up Broadway, across 4th Street, and around Washington Square, passing north up Fifth Avenue, then filing through another temporary arch at 57th Street and moving north again to the newly dedicated Columbus Monument at what is now Columbus Circle. For a discussion of the complex events that were packaged as the Columbian Celebration, see Brooks McNamara, *Day of Jubilee: The Great Age of Public Celebrations in New York, 1788–1909* (New Brunswick, N.J.: Rutgers University Press, 1997), pp. 156–157.

3 The *New York Times* of October 11, 1892, noted the irony of the procession's inclusion of "Indian boys and girls from the Government school at Carlisle, Pennsylvania …. Why the North American Indian should make merry over the anniversary of the landing of Columbus in America was hard to tell."

4 Scion of two of New York's oldest and most prominent families (the Rhinelanders and the Lispenard-Stewarts), William Rhinelander Stewart (b. 1852) was a lawyer who spent most of his professional time advising on the management of his family's inherited estate holdings, including the powerful Rhinelander Real Estate Company, whence the Museum acquired Smith's painting in a loan that was subsequently converted into a gift. A trustee of Greenwich Savings Bank, a vestryman of Grace Church, and treasurer of the Washington Square Arch Committee, Stewart also served as a committee chairman of New York State's Committee on Reformatories and on Schools for the Deaf. His interest in such schools may explain a connection between the Columbian School and College Parade, represented in this painting, and Stewart as benefactor of some of the organizations that participated in the procession.

5 "Columbian Parade—Conceded to Be the Grandest in the History of the Metropolis," *New-York Daily Tribune*, October 13, 1892.

6 Henry Noble MacCracken, *The Family on Gramercy Park,* quoted in *New York Chronicle* (Fall 1989): 22–23. MacCracken's parents probably witnessed their son's parade from Stewart's grandstand or another stand assembled by New York University in Washington Square. The young MacCracken went on to become president of Vassar College.

PLATE 49

1 *The WPA Guide to New York City* (1939; reprint, New York: Pantheon, 1982), p. 119.

2 Ibid., p. 120.

3 Letter dated August 26, 1948, from the artist's widow, Mrs. Frederick A. Moore, Museum Archives.

PLATE 50

1 *The Citizens and Strangers' Pictorial and Business Directory for the City of New-York, and Its Vicinity* (New York: Chas. Spalding, 1853); quoted in I. N. Phelps Stokes, *The Iconography of Manhattan Island* (New York: Robert H. Dodd, 1926), vol. 5, p. 1851.

2 I. N. Phelps Stokes, *The Iconography of Manhattan Island* (New York: Robert H. Dodd, 1918), vol. 3, p. 104.

3 Moses King, ed., *King's Handbook of New York City* (Boston: Moses King, 1893), p. 166.

4 *Minutes and Documents of the Board of Commissioners of the Department of Public Parks For the Year Ending April 30, 1891* (New York: Martin B. Brown, 1891), p. 393.

5 Richard H. Love, "Childe Hassam's 'September Sunlight': The Grand Prix Connection," *Magazine Antiques* 131, no. 4 (April 1987): 726.

6 A. F. Ives, "Talks with Artists: Mr. Childe Hassam on Painting Street Scenes," *Art Amateur* (October 27, 1892): 116–117.

7 Ibid., pp. 116–117.

PLATE 51

1 Ferry service from Hunter's Point to Manhattan was restored in 1994, when New York Waterways opened a new terminal.

2 Extract of a letter in the possession of the donor, who supplied a facsimile on April 26, 1954, for the Museum Archives.

3 *World's Columbian Exposition, Revised Catalogue, Department of Fine Arts* (Chicago: W. H. Conkey, 1893), p. 73. Miller exhibited the painting at the National Academy of Design. Maria Naylor, ed., *The National Academy of Design Exhibition Record, 1861–1900* (New York: Kennedy Galleries, 1973), vol. 2, p. 630.

4 Although Munich later played host to many young American artists desiring formal academic training, Miller was described by Eliot Clark as one of the first to be schooled in this Bavarian city. Eliot Clark, *History of the National Academy of Design, 1825–1953* (New York: Columbia University Press, 1954), p. 172.

5 S. G. W. Benjamin, "An American Landscape-Painter," *Magazine of Art* 7 (1884): 95–96.

PLATE 52

1 Sampson and Schley were, in fact, at odds over credit for the victory at Santiago. Sampson had planned the attack but was not present for the battle, which was therefore directed by Schley, next in command, who then claimed the victory. See "Sampson, William Thomas" and "Schley, Winfield Scott," in *The New Columbia Encyclopedia*, ed. William H. Harris and Judith S. Levey (New York: Columbia University Press, 1975), pp. 2411, 2444.

2 The Museum Archives contain a letter dated June 10, 1991, from Edward M. Furgol, curator of the Navy Museum in Washington, D. C., in which he identifies the ships and presents the idea that Schley's vessel would not have flown his flag in the presence of Sampson because of the difference in their ranks. Mr. Furgol, however, feels certain that Schley was present and aboard the *Brooklyn* at this event.

3 "New York Greets Victorious Navy," *New York Times*, August 21, 1898.

4 See A. J. Peluso, Jr., "Fred Who? Fred Pansing, That's Who!" *Maine Antique Digest* (April 1985): 24–26. Pansing used the same technique in his portraits of individual vessels, as exemplified by *The Plymouth* (acc. no. 75.182.23).

PLATE 53

1 In 1814, an area of 240 acres, which had served as an arsenal, barracks, and potter's field, was pared down to 6.8 acres and named for President James Madison.

2 William Henry Seward (1801–1872) served as governor of New York State from 1839 to 1843 and was secretary of state under Presidents Lincoln and Johnson during the Civil War and for some years after.

3 Ms. Helaine Sicotte, curator for the family archives and their extensive holdings of Oppenheimer paintings, generously supplied a copy of the undated photograph, quite probably by Oppenheimer himself, now in the Museum Archives.

PLATE 54

1 Stephen Burgee Johnson, *The Roof Gardens of Broadway Theatres, 1883–1942* (Ann Arbor: UMI Research Press, 1985), p. 5.

2 Robert A. M. Stern, Gregory Gilmartin, and John Massengale, *New York, 1900* (New York: Rizzoli, 1983), pp. 220–221.

3 James T. Steen, "The Story of a Painting," *Carnegie Magazine* 31, no. 2 (February 1957): 58.

PLATE 55

1 Simpson, Jeffrey, "Coney Island: Ballyhoo and Innocence," *GEO* (September 1983): 86.

2 Harlan C. Pearson, *Tilyou's Gravity Steeplechase and Amusement Exposition, Surf Avenue, Coney Island, New York* (Concord, N.H.: Rumford Printing, 1900), p. 8.

3 John F. Kasson, *Amusing the Million: Coney Island at the Turn of the Century* (New York: Hill and Wang, 1978), p. 59.

4 This information was provided by the donor for the Museum Archives. Although the donor is unsure of the artist's dates of employment and first name, she believes that the time period is correct and that the artist's given name was Leo.

PLATE 56

1 Henry James, *Washington Square* (New York: Random House, Modern Library, 1950), p. 22.

2 Thomas A. Janvier, *In Old New York* (New York: Harper and Brothers, 1888), p. 148. Janvier's comments were subsequently published in *Harper's Magazine*.

PLATE 57

1 Peter Sluszka, senior vice president of the consulting engineering firm Steinman, helped to determine the location of the studio and also provided the information that the "balconies" are accessible by a series of platforms and ladders not open to the public.

2 Bernard Rabin, "Queensboro Bridge Is 75; A Birthday Party Will Be Held Tomorrow," *Daily News,* Sunday, March 25, 1984.

3 Department of Bridges, City of New York, *Annual Report* (New York: M. B. Brown Printing and Binding, 1913), p. 256.

4 Ibid., p. 301.

5 George R. Collins, "The Transfer of Thin Masonry Vaulting from Spain to America," *Journal of the Society of Architectural Historians* 27, no. 3 (October 1968). This article gives a full account of the European history of Guastavino tiles and their later use in the United States.

6 David Findlay, Jr., Fine Arts, "Sebastian Cruset (1859–1943)," flyer accompanying exhibition.

7 These paintings are *View of New York (Looking South),* 1940 (acc. no. 46.230.1), and *View of New York (Looking North),* 1941 (acc. no. 46.230.2).

PLATE 58

1 The standard text on the Triangle factory fire is Leon Stein, *The Triangle Fire* (New York: J. B. Lippincott, 1962). The analysis of this plate is also indebted to the discussion of Gatto's painting supplied by Ellen Wiley Todd in her insightful essay "New York Stories: Narratives of Gender and Urban Space, City Women/City Life," manuscript deposited in the Museum Archives, 1996.

2 The former Asch Building, which still stands at 29 Washington Place, is known today as the Brown Building of New York University. The victims of the Triangle factory fire are memorialized in a small tablet mounted on the building's corner.

3 Here, Gatto has taken liberties with the actual flow of events. During the fire, bodies fell to the sidewalks on both the Washington Place and Greene Street sides of the Asch building. They were not tagged and moved across the street from the factory site until the fire was extinguished.

4 Gatto's childhood and evolving art career are traced by Harry Salpeter in "Gatto, Little Primitive," *Esquire* (May 1946): 98, 207; by Bess Barzansky in *Victor Joseph Gatto: Retrospective,* exhibition catalogue (New York: ACA Galleries, 1977); and in the obituary "Victor Joseph Gatto Dies at 71; Plumber-Boxer Became Artist," *New York Times,* May 27, 1965. See, too, the information on Gatto provided in the catalogue notes for the Staten Island [Art] Museum's exhibition *The Island and Bay* (Staten Island, N.Y., 1957), entry no. 43, p. 20; and Museum Archives.

5 Gatto's painting merits comparison with Ernest Fiene's dramatic depiction of the Triangle Shirtwaist Fire, still visible as part of his 1941 W.P.A.-supported fresco on the history of the needlecraft industry for the auditorium walls of New York's High School of Fashion Industries on West 24th Street.

PLATE 59

1 W. H. de B. Nelson, "Theresa F. Bernstein," *International Studio* (February 1919): xcviii. That same year, Bernstein held her first solo exhibition at the Milch Galleries in New York, causing another critic to remark on her masculine sensibility as a painter: "It is with a man's vision that this artist looks at her subjects. . . . Then having found what she wants, it is with a man's vigor that she gets it down to stay." See Frederick James Gregg, "Theresa Bernstein: A Realist in the Old Sense of the Word," *New York Herald,* November 2, 1919.

2 "American Art Notes," *Gallery* (Spring 1985): 2; and Charles Movalli, "A Conversation with William Meyerowitz and Theresa Bernstein," *American Artist* (January 1980): 4.

3 The influences that converged to shape Bernstein's approach to painting, and the maturation of her style in her later career, are discussed in catalogue essays by Michele Cohen in *Echoes of New*

York: The Paintings of Theresa Bernstein (New York: Museum of the City of New York, 1990); Cynthia H. Sanford in *Theresa Bernstein; A Seventy-Year Retrospective* (New York: Joan Whalen Fine Art, 1998), and Cassandra Langer in *The Robert R. Preato Collection of New York City Paintings and Drawings* (New York: Museum of the City of New York, 1994).

4 In 1914 Bernstein's *Open Air Show*—inspired by the novel experience of attending a moving picture presented out of doors—was selected for exhibition at the prestigious Chicago Art Institute and purchased by the British art collector John Lane, publisher of *International Studio*. In 1919 it was this influential journal that ran a feature article commending Bernstein's "assurance and virility" as a painter, terming her a "true product of American precepts and ideals" (Nelson, "Theresa F. Bernstein").

PLATE 60

1 Quoted in John Tauranac, *Elegant New York: The Builders and the Buildings, 1885–1915* (New York: Abbeville Press, 1985), p. 37.

2 William R. Taylor, *In Pursuit of Gotham: Culture and Commerce in New York* (New York: Oxford University Press, 1992), p. 39.

3 *The WPA Guide to New York City* (1939; reprint, New York: Pantheon, 1982), p. 101.

4 Reynolds, Donald Martin, *Monuments and Masterpieces: Histories and Views of Public Sculpture in New York City* (New York: Macmillan, 1988), pp. 294, 295.

5 Margot Gayle and Michele Cohen, *Guide to Manhattan's Outdoor Sculpture* (Englewood Cliffs, N.J.: Prentice-Hall, 1988), p. 58.

6 Helen K. Fusscas, *A World Observed: The Art of Everett Longley Warner, 1877–1963* (Old Lyme, Conn.: Lyme Historical Society, 1992), p. 24. The older buildings were from the nineteenth century, not the eighteenth.

PLATE 61

1 Period newspapers sometimes identified landlady Katherine or Marie Branchard as a native of Switzerland who had run a boardinghouse in Syracuse, New York, before coming to Greenwich Village. Stephen Crane, Frank Norris, and the writer O'Henry were among her better-known literary boarders. The house was razed in 1948; the Loeb Student Center of New York University now occupies the site.

2 Some of these newer accommodations pitched at artists had been purpose built: in 1879, for example, the thirty-three-unit Tuckerman (dubbed the Benedick) apartment house, featuring four studio suites on its top floor, opened at 80 Washington Square East to cater to bachelors of independent means. Transients of creative bent could also settle into the hotel tower incorporated into the recently built Judson Memorial Church on Washington Square South at Thompson Street. Cheaper communal lodgings beckoned, however, in some of the earlier nineteenth-century townhouses edging the square's southern border that had been vacated by owners unnerved by the neighborhood's radical drift and claimed by enterprising landladies like Branchard, eager to reconfigure them as de facto arts colonies operated for a colorful but nonetheless paying clientele.

3 This pattern was observed as early as 1891 by the commentator C. M. Fairbanks: "The artist colony here [in Greenwich Village] has flourished for a few years, but already there is apparent an uptown tendency into what the men of the Latin Quarter have with some jealousy dubbed the 'Clique Quarter,' a region up about the southern boundaries of Central Park." Taking heed of the modern studio buildings newly erected in that vicinity, he noted by comparison that Washington Square South "has hardly been redeemed from the slums." C. M. Fairbanks, "The Social Side of Artist Life," *Chautauquan* 13 (September 1891): 748–749.

4 See Museum Archives for abbreviated biographical listings of Moore-Park, including book titles featuring his signature book

illustrations, culled from the standard dictionaries of artists. A useful summary of his career before his arrival in New York is found in Charles Hiatt, "The Work of Carton Moore Park," *International Studio* 12 (1900–1901): 171–179. Some references suggest that Moore-Park studied briefly with Edgar Degas.

PLATE 62

1 The politics that embroiled the Madison Square Victory Arch project, and New York City's subsequent efforts to commemorate World War I through a permanent monument, are analyzed by Michele H. Bogart in "A Loss of Memory: The New York City World War I Memorial," in her excellent book *Public Sculpture and the Civic Ideal in New York City, 1890–1930* (Chicago: University of Chicago Press, 1989), pp. 271–292. It is usually written that the arch was conceived by Mayor John F. Hylan and, in spite of the impermanent materials employed in its fabrication, cost eighty thousand dollars to build. Because Hylan believed that monuments should be financed by public contributions, he dispatched twenty thousand members of the city politic and police reserves to facilitate the collection of funds for the Victory Arch.

2 Peterson's World War I–related scenes of New York City ranged from depictions of its gala Flag Day processionals to scenes of the somber work of rolling bandages at the Red Cross Center on Fifth Avenue. She also produced a series of portraits of prominent actresses who were participating in the "Stage Women's War Relief."

3 Peterson's connections with New York City, and with its World War I preparedness and victory efforts, are noted in *An Itinerant Spirit: The Early Works of Jane Peterson*, exhibition catalogue (New York: Hirschl and Adler Galleries, 1995). The standing monograph on the artist is J. Jonathan Joseph's *Jane Peterson: An American Abroad*, intro. Patricia Jobe Pierce (Boston: privately printed, 1981).

PLATE 63

1 A summary of the involvement of artists in New York City's World War I parades, as members of special decorating committees and as visual recorders of these events, is offered by Ilene Susan Fort in "The Flag Paintings of Childe Hassam," *Magazine Antiques* 133, no. 4 (April 1988): 876–887.

2 Henry P. Davison, a leading officer in New York's Red Cross organization, whetted interest in the parade and fund drive by reminding the public, "Contributors to the Red Cross War Fund cannot give too much consideration to the fact that the Red Cross at the front is … holding the second line of defense by keeping up the morale and hopes of the people of France and Italy…. As an emergency force the Red Cross is resolutely holding the second line, and will continue to stand fast until the war is over." As quoted in "The Red Cross, the Second Line of Defense," *New York Times*, May 20, 1918.

3 "A human red cross, composed of 150 women, dressed in white and wearing red scarves over their heads, struck the keynote of the demonstration and evoked uniform cheers all the way down the line." As reported in "President Leads Red Cross Parade," *New York Times*, May 19, 1918.

4 The nurses' drive mobilized by the New York chapter of the Red Cross was especially effective, with a measurable increase in volunteer enrollments beginning in June 1918. Materials related to Ravlin's tour of service in the Red Cross reserve—including dated family correspondence, a copy of her "ordre de mission" from American Expeditionary Forces Headquarters dated December 28, 1918, and a photograph of Ravlin dressed in her nurse's-aide uniform—are owned by Ravlin's grand-niece Alta Ann Morris, who has done extensive research on Grace Ravlin's career (copies in Museum Archives are courtesy of Ms. Morris). In a letter to her sister Alta written from her apartment at 31 West 47th Street and dated October 26, 1918, Ravlin describes the routine and rigors of her training in a local children's hospital and

mentions her expectation of shipping out to the European front.

5 *Brooklyn Daily Eagle,* January 13, 1924.

6 Excerpts of six locally published reviews of Ravlin's exhibit with Robert Henri at the Macbeth Galleries in January, 1924, are contained in the Museum Archives. About her pairing with Henri, a critic for the *New York World* wrote on January 6, 1924: "They are so incongruous that the combination is disconcerting. They have nothing in common in aims and they are violently antagonistic in color."

PLATE 64

1 Allan Nevins, ed., *The Diary of Philip Hone: 1828–1851* (New York: Dodd, Mead, 1927), vol. 2, p. 716.

2 Tom Buckley, "Reporter at Large: The Eighth Bridge," *New Yorker* 88, no. 48 (January 11, 1991): 56. Buckly described Lindenthal as an "emblematic figure of the period: the intelligent and energetic young man who leaves Europe in search of opportunity in the United States, finds it, gains professional renown and financial success, enjoys the enduring love of a wife and daughter, lives in good health to a great age, and dies a profoundly disappointed man" (p. 40).

3 Peter Sluszka, senior vice president of Steinman, the engineering group founded by David B. Steinman, points out this similarity in his letter dated July 28, 1994, accompanied by a photocopy of the photograph (in the Museum Archives). Steinman worked on the Hell Gate project under Lindenthal; both men are in the group arrayed in the foreground of the photo.

PLATE 65

1 Sharon Reier, *The Bridges of New York* (New York: Quadrant Press, 1977), p. 73.

2 In *Samuel Halpert: A Conservative Modernist* (Washington, D.C.: Board of Governors of the Federal Reserve System, 1991), Diane Tepfer writes that Halpert, during his student years in Paris in the first decade of the twentieth century, fraternized with artists of both his own generation and the previous one. According to Tepfer, these included Patrick Henry, Robert and Sonia Delaunay, Man Ray, Max Weber, Albert Marquet, Henri Matisse, and Henri Rousseau, as well as Léger and Metzinger.

3 Mary Anne Coley, "Introduction," in ibid., p. 2.

4 Diane Tepfer, in ibid., pp. 5–16.

PLATE 66

1 Childe Hassam, "New York the Beauty City," *New York Sun,* February 26, 1913.

2 The Woolworth Building was described in a positive context as a "cathedral of commerce" at its 1913 dedication, and the term quickly became popular.

PLATE 67

1 Cropsey had been apprenticed to the New York City architectural firm of Joseph Trench from 1837 to 1842. Although better known as a painter, he had opted to work on selective residential and church commissions throughout his career. Nevertheless, his selection for the El station assignment was considered something of a curiosity, given that he was neither a civil engineer nor experienced in the new technology of elevated railroads. Scholars now surmise that his connection to the Metropolitan Railway executives may have been through George Pullman, a backer of the system and contractor for many of its cars. Cropsey had supervised the construction of two houses for Pullman in Chicago and Long Branch, New Jersey.

2 Passenger volume on the Sixth Avenue Elevated rose measurably in the early decades of the twentieth century, after the line was electrified. Its greatest level of usage was registered in 1921, when the line carried riders in the millions.

3 Carroll's career as a painter and graphic artist is summarized in *Who Was Who in American Art* (Madison, Conn.: Soundview

Press, 1985), p. 103. She married Latrobe Carroll of New York, residing on lower Fifth Avenue near Washington Square through the early 1980s.

PLATE 68

1 The name "Independent" signified that the line had no connections with the existing subway lines, the IRT (Interborough Rapid Transit) and the BMT (Brooklyn Manhattan Transit).

2 According to Clifton Hood, *722 Miles: The Building of the Subways and How They Transformed New York* (New York: Simon and Schuster, 1992), p. 212, the IND was intended to be the "people's subway." To emphasize this point, the line's inauguration was held in the open at John Hancock Park, with the proceedings broadcast over WNYC, the New York City radio station.

PLATE 69

1 Reginald Marsh, Isabel Bishop, Raphael Soyer, and Georges Shreiber were among the artists attracted to the area during the 1920s and 1930s, where the top floors of Union Square's older housing stock and commercial buildings offered ideal studio light. The relationship between New York artists and Union Square during its heyday as a center of American labor unrest is explored by Stanley I. Grant, James M. Dennis, and Kathleen M. Daniels in essays accompanying the exhibition catalogue *Between Heaven and Hell: Union Square in the 1930s* (Wilkes-Barre, Penn: Sordoni Art Gallery, 1996), pp. 5–40.

2 The March 6 demonstration coincided with announcements of the highest level of unemployment ever charted by New York State's Industrial Commission since statistics began to be collected in 1914. The Third International had called the rally to draw public attention to what was termed International Unemployment Day. When the gathering failed to end by one in the afternoon, the deadline given to the organizers by Police Commissioner Grover Whalen, police were ordered to exercise force to break up the protest as the participants prepared to move to City Hall.

3 Newspaper accounts of the preventive measures on call for the March 6 rally vary according to political persuasion. The *New York Times* reported the "readiness" of the fire department to assist police in maintaining "peaceful speechmaking" at the event. The following day, it noted that once fighting between police and protesters had extended into the center of Union Square, "firemen turned on hoses to clear the mass of paper and banners that littered the street." The *Daily News* of March 7, 1930, offered a more explosive article, reporting, "A hydrant was opened and firemen and street cleaners aided in turning streams of water toward the remaining thousands, many of whom were stymied and unable to progress in either direction, while motorcycle police, armed with unused machine guns and tear bombs, flanked the Square on all sides."

4 A graphic record of the riot's violent termination was made by a commercial cameraman on the scene. His footage was censored by the New York City Police Department, but segments of it resurfaced in a contemporary film produced by the Film and Photo League, reporting on the country's unemployment crisis. The league, whose coverage of the Depression's upheavals provided an alternative to the edited newsreels of the film industry, showed their "unemployment special" in union halls, churches, and other places where the jobless gathered.

5 The painting was exhibited originally under the title *May Day, 1928*, but Hopkins later retracted this title, citing the riot of March 6, 1930, as its more probable source of inspiration. The composition conflates details from several Union Square demonstrations, however, and since 1989 the artist has requested that the painting be known as *Riot at Union Square*, with no specific date attached to the title. His correspondence on this matter, which includes autobiographical notes, is housed in the Museum Archives.

PLATE 70

1 *The WPA Guide to New York City* (1939; reprint, New York: Pantheon, 1982), p. 423.

PLATE 71

1 *The Robert R. Preato Collection of New York City Paintings and Drawings* (New York: Museum of the City of New York, 1994), p. 46.

2 Quoted in Gerald Bordman, *The Oxford Companion to American Theatre* (New York: Oxford University Press, 1984), p. 732.

3 Ibid.

PLATE 72

1 Quoted in Grant Holcomb, "The Forgotten Legacy of Jerome Myers (1867–1940): Painter of New York's Lower East Side," *American Art Journal* (May 1977): 90.

2 Ibid., p. 80.

3 Sandra L. Langer, "Jerome Myers," in *New York: Empire City in the Age of Urbanism (1875–1945)*, ed. Robert R. Preato (New York: Grand Central Art Galleries, Art Education Association, 1989), p. 159.

PLATE 73

1 *The WPA Guide to New York City* (1939; reprint, New York: Pantheon, 1982), pp. 401–402.

PLATE 74

1 Palmer's career as an arts administrator, teacher, and practicing artist is summarized in Howard D. Spencer, *William Palmer: A Retrospective,* exhibition catalogue (Wichita, Kans.: Wichita Art Museum, 1982.) Palmer's archives, deposited at the Munson-Williams-Proctor Institute in Utica, are a rich source of biographical material. Other references for the artist are compiled in the Museum Archives. The painter also enjoyed a fifty-five-year association with the former Midtown Galleries on East 57th Street, which featured Palmer's work in numerous solo and group exhibitions from its inception in 1932 until his death.

2 The painting and its mate came to the Museum in June 1934 through a deposit initiated by the PWAP, administered through the Whitney Museum of American Art. Palmer's involvement in the various incarnations of WPA's art program can be tracked in Patricia E. Harris and Gladys Pena, *For a Permanent Public Art: WPA Murals in the Health and Hospitals Corporation's Collection,* exhibition catalogue (New York City: Tweed Gallery, 1988–1989). See, too, commentary on Palmer in the exhibition catalogue *A New Deal for Public Art: Murals from Federal Work Programs* (Bronx: Bronx Museum of the Arts, 1993–1994).

3 Palmer's companion painting *New York Transportation* (acc. no. L1226.1), using the same three-layered compositional conceit, depicts the vivid hubbub of Times Square at its busiest. The multiple levels of transit shown include the square's underground subway station, the roads above clogged with walkers, cars, trucks, and double-decker buses, and the El running above this midtown congestion. Outcroppings of skyscrapers, water towers, buildings under construction, and other roof lines occupy the picture's upper section.

4 The *Washington Square* screen, rendered in a brighter springtime palette and cited as being in the collection of Mrs. William C. Palmer, has been exhibited periodically. It was featured in the Nassau County Museum of Art's *American Realism Between the Wars: 1919–1942* (1994), plate 7, p. 55.

PLATE 75

1 For a brief history of the Barbizon-Plaza Hotel, designed by Murgatroyd and Ogden, see Carter B. Horsley, "Upgrading Under Way in Central Park South Hotels," *New York Times,* February 25, 1973; and W. Parker Chase, *New York, The Wonder City, 1932* (New York: Wonder City Publishing, 1932), p. 139. Although the hotel had street-front footage on stylish Central Park South,

where the building's entrance was located, the majority of the building fronted on West 58th Street.

2 The six pioneering members of An American Group were Shulkin, Jacob Getlar Smith, Chuzo Tamotzu, Stuart Edie, Robert Phillip, and Frederic Knight. By the decade's end, membership had expanded and the group's annual exhibitions had been committed to the Seligmann Gallery in New York. See Ernest Brace, "An American Group," *Magazine of Art* 31 (May 1938): 271–275.

3 At least one critic of the period singled out the hotel management for its progressivism in facilitating the installation of Shulkin's mural: "The management of the Barbizon-Plaza should be congratulated on its discrimination in approving a modern, creative, plastic artist as against a naturalistic recorder of actualities as the logical decorator of walls and for its broad-mindedness in avoiding censorship." Ralph M. Pearson, "Mural by Anatol Shulkin, in the Dining Room of the Barbizon-Plaza/Central Park South at Sixth Avenue," 1934, original pamphlet in the Shulkin files of the Archives of American Art, Smithsonian Institution, microfilm roll N/AG8.

4 For a sample of critical commentary about Shulkin's mural at the time of its installation, see Carlyle Burrows, *New York Herald-Tribune,* April 24, 1934, and May 13, 1934; Henry McBride, *New York Sun,* May 17, 1934; Melville Upton, *New York Sun,* May 17, 1934; and Margaret Breuning, *New York Evening Post,* April 16, 1932. These and other contemporaneous clippings appear in Shulkin's files at the Archives of American Art, Smithsonian Institution, roll N/AG8, frames 765–771.

5 Without the precedent of the Mexican mural movement, scholar Greta Berman has observed, "mural painting in the United States might easily have taken an entirely different direction, if it was to develop at all." For an analysis of the Mexican influence on American muralists of Shulkin's generation, see Greta Berman, *The Lost Years: Mural Painting in New York City under the WPA Federal Art Project, 1935–1943* (New York: Garland Publishing, 1978), p. 77.

6 For numerous clippings and biographical entries on the artist, see the Museum Archives.

7 Shulkin's obituary ("Anatol Shulkin, Painter, Was 60," *New York Times,* Nov. 22, 1961) noted that his first exhibition at the Art Center Gallery, in 1927, had included a rush-hour scene titled *Half Past Five,* reportedly the first of a series of paintings Shulkin planned on New York.

PLATES 76–81

1 Charles Hagen, "The Shahn Who Could Break Free of Politics," *New York Times,* February 17, 1995.

2 When Rivera refused to remove Lenin's portrait from his mural, he was banned from further work on the project. The building's management, contending that the artist had strayed from his approved sketches, destroyed the mural, causing an international controversy.

3 Notes from a conversation on November 18, 1992, with Jonathan Kuhn, curator of monuments, New York City Parks Commission, in the Museum Archives.

4 Shahn's later murals included one in 1937–1938 for the community center of a federal housing development for garment workers in Roosevelt (formerly Jersey Homesteads), New Jersey; one in 1938–1939 in the Bronx Central Annex post office; and one in 1940–1942 in the Federal Security Building in Washington, D.C.

PLATE 82

1 In the 1850s, Fourth Avenue north of 14th Street was renamed Park when the rails were sunk out of sight beneath a grate- and grass-roofed tunnel. Below 14th Street to 8th Street it remains Fourth Avenue, and below 8th Street it is called Lafayette Street.

2 Congdon, who worked primarily as an ecclesiastical architect, was educated at Columbia College and apprenticed to John

Priest, a church architect from Newburg, New York. Other churches by Congdon were built in various cities in the eastern United States. See Henry F. Withey and Elsie Rathburn Withey, *Biographical Dictionary of American Architects (Deceased)* (Los Angeles: New Age Publishing, 1956), p. 134.

3 The western half of Harlem was occupied by large estates; the eastern part had been owned by James Roosevelt, great-grandfather of President Franklin D. Roosevelt, who sold it in 1825.

4 "*Saint Andrew's Protestant Episcopal Church: Designated Landmark Site in the Village of Harlem*, A.D. *1829–1989 ... ,*" single-page history prepared and published by the church, 1989.

5 The quotation is from *The WPA Guide to New York City* (1939; reprint, New York: Pantheon, 1982), p. 256.

PLATE 83

1 Letter from the artist to curator Jan Ramirez, January 28, 1988, Museum Archives.

2 See "The New Heart of Bohemia—Sheridan Square," *Vanity Fair* (January 1918); Martha Grossman, "America's Bohemia," *McCall's* (July 1917); Corinne Low, "The Village in a City," *Ladies Home Journal* (March 1920).

3 For a general history of the advent of cafeterias in New York City, see Jan and Michael Stem, "Cafeteria," *New Yorker* (August 1, 1988): 37–54. In addition to the Life Cafeteria, Hubert's and Stewart's were popular Village self-service restaurants of that period.

4 "Sheridan Square," in *The WPA Guide to New York City* (1939; reprint, New York: Pantheon, 1982), p. 141.

5 Maxwell Bodenheim, *My Life and Loves in Greenwich Village* (New York: Bridgehead Books, 1954), p. 231. Commenting on the conflict between owners and eaters that led to the cafeteria's demise, Bodenheim wrote: "According to the proprietors of 'Life,' the cafeteria was a business venture and not a philanthropic experiment. They had established a restaurant, not a public meeting place for true Villagers to weave endless carpets of

conversation, embroidered with strange designs from Sappho, Buddha, Oscar Wilde, Tolstoy, and the Marquis de Sade" (p. 231).

PLATE 84

1 Herbert Asbury, "Exotic Chinatown," in *The Empire City: A Treasury of New York*, ed. Alexander Klein (New York: Rinehart and Company, 1955), p. 61.

2 Although the tongs were originally benevolent societies, in the early twentieth century they degenerated into American-style gangs struggling for control of Chinese gambling and opium trades. See Margarette De Andrade, *Water under the Bridge* (Rutland, Vt: Charles E. Tuttle, 1988), p. 43. In *How the Other Half Lives* (New York: Dover Publications, 1971), Jacob Riis describes the horrors associated with Chinatown—the white slave trade, the corrupt gambling, and the opium trade.

3 At the end of the twentieth century, Chinatown remains both a bulwark of Chinese life in New York City and a place to which the younger generations of Chinese who have migrated to the suburbs return regularly, either to visit those who remain or to shop for goods less available to them out of town.

PLATE 85

1 F. Scott Fitzgerald, *The Great Gatsby* (1925; reprint, New York: Collier, 1992), p. 73.

2 Alice C. Flenner (daughter of the artist), letter dated July 14, 1971, to Mr. Joseph Noble, Museum Archives.

PLATE 86

1 Harry Salpeter, "About Cecil Bell," *Coronet Magazine* (August 1939): 10–14.

2 Bell's wife, when interviewed by a *New Yorker* writer three years after his death, spoke of his devotion to drawing and painting the city—art he considered altogether separate from his paying work. "Cecil made his living doing cartoons to be used by the

salesmen of the Doughnut Corporation of America," she said; "he kept this completely separate." The interview's occasion was the opening of *The Vanished City: Paintings of New York—1930–1970,* a posthumous survey of Bell's city scenes at the Museum of the City of New York presented in 1973. See "Vanish," Talk of the Town section, *New Yorker* (November 26, 1973): 37.

3 *New York Times Index, Year 1938,* pp. 2222–2223, cites multiple articles reporting on the excessive heat, humidity, and storms besetting New York City over the summer months.

4 See *The Robert R. Preato Collection of New York City Paintings and Drawings,* exhibition catalogue (New York : Museum of the City of New York, 1994), p. 36. The catalogue was published two years after the newly acquired bequest was exhibited at the Museum of the City of New York.

PLATE 87

1 Peter Hastings Falk, ed., *Who Was Who in American Art* (Madison, Conn.: Sound View Press, 1985), p. 6. Afroyim lost his citizenship when he was believed to have voted in Israeli elections while living there during the 1950s, a violation of the Immigration and Naturalization Act. In 1967 he won a landmark Supreme Court case, which hinged on his ability to convince the Court that he had never voted in Israel, and regained his U.S. citizenship.

2 Michael E. Quint, in "Artist Paints Symphonies," *Staten Island Sunday Advance,* April 4, 1971, writes that Arnold Schoenberg was so taken with Afroyim's "visual music" paintings that he asked to have two of them hung in his music studio as a source for discussion with his students.

PLATE 88

1 *Manhattan Skyline* is very close in style to these works, which are confirmed as Chiu's; however, the signature on this piece is not completely legible. It appears to be Chiu's, but without a complete provenance of the canvas the work can only be attributed to Chiu.

PLATE 89

1 Hylan (1869–1936) had formerly worked as a motorman on one of the El line's steam locomotives.

2 The history and symbolism of the Sixth Avenue El's long-threatened demolition are summarized well in a period account by Ernest La France, "Rebirth of an Avenue: As the 'L' Comes Down, Gotham's Cinderella, Long Stifled, Begins to Breathe Freely Again," *New York Times Magazine,* March 19, 1939.

3 The chronology of Kish's career is incomplete, but capsule biographies can be consulted in *Who's Who in American Art* (New York: R.R. Bowker, 1978); Patricia Hills, *Social Concern and Urban Realism: American Paintings of the 1930s* (Boston: Boston University Art Gallery, 1983), p. 62, and *American Paintings: A Complete Illustrated Listing of Works in the Museum's Collection* (Brooklyn: Brooklyn Museum, 1979), p. 75. In 1976 Kish donated five hundred items of correspondence, sketchbooks, and catalogues to the Archives of American Art, Smithsonian Institution; see microfilm roll 66. In the 1970s the artist also began to distribute his paintings widely to museum repositories; in 1971 the Museum of the City of New York acquired the first of two canvases by Kish, the other being *East River Waterfront,* 1932 (plate 70).

PLATE 90

1 *New York: A Guide to the Empire State* (New York: Oxford University Press, 1940), pp. 260–261.

2 Longacre Square was a local designation owing its origin to the cluster of carriage and harness shops that once predominated in the area. Its name derived from a district in London where carriage factories had been concentrated. Following the laying of the cornerstone for the new Times building in January 1904, the city

renamed the intersection Times Square, which today defines a much larger section of midtown Manhattan anchored by the original triangular site of the newspaper's early twentieth-century headquarters.

3 For more extensive commentary about Webster's artistic abilities in relation to the work shown in this solo exhibit, see Henry McBride, *New York Sun,* February 10, 1940, and Carlyle Burrows, "Two American Realists," *New York Herald Tribune,* January 2, 1940; the other American realist evaluated in this essay was Ernest Fiene (see plate 100).

4 A fine summary of Webster's career and the influences that shaped it is supplied by Harry Rand in the exhibition catalogue *Stokely Webster: Paintings, 1923–1984* (Daytona Beach, Fla.: Museum of Arts and Sciences, 1985), pp. 5–22.

5 For example, Webster's paintings were the subject of a monographic exhibition presented at the Hammond Museum in North Salem, New York, May 8–June 20, 1993.

PLATE 91

1 In addition to using a camera and countless on-the-spot sketches as compositional aids, Marsh equipped his ninth-floor studio on Union Square with binoculars and a telescope, enabling him to focus closely on unsuspecting people spotted on nearby rooftops and the streets below.

2 The Harris Theater, designed by renowned theater architect Thomas W. Lamb, was built by the Candler family from a fortune made on Coca-Cola. The facility debuted with motion pictures in May 1914 but quickly turned to live musicals, at which point it acquired the name "Cohan and Harris." Sam Harris assumed exclusive control of the operation in 1921, when the house was renamed after him alone. The Shubert theatrical empire assumed control of the Harris in the mid-1920s but relinquished the house to movie operations in the 1930s.

3 For an in-depth analysis of Marsh's attitude toward contemporary urban women, see Ellen Wiley Todd, *The "New Woman"*

Revised: Painting and Gender Politics on Fourteenth Street (Berkeley, Calif.: Univ. of California Press, 1993). Marsh's career has been well documented by modern scholars, and numerous sources citing Marsh's activities as chronicler of New York during the Depression and World War II can be found in the Museum Archives.

4 *Harris Theater* was the third in this trio of New York City scenes that Marsh donated to the Museum following an enthusiastic solicitation by Grace Mayer, the Museum's founding curator of prints and photographs, who remained on staff until 1958.

PLATE 92

1 Quoted in Elliot Rosenberg, "Fiorello's Army," *Seaport Magazine* (Summer 1995): 14–19. La Guardia was appointed to head the national Office of Civilian Defense in May 1941. In June the federal government wrote to all local defense councils urging them to organize air-observation posts. Although denied usage of any title implying federal military authority, La Guardia established the city Patrol Corps in early 1942, offering its recruits khaki-colored uniforms, training in infantry drills, marksmanship, and first aid, and a published manual that outlined its discipline regulations.

2 History confirms the use of this same site as a tent ground and drilling common for Union soldiers during the Civil War. Throughout World War I, Bryant Park served as a book-drive center for American troops overseas, a role it repeated during World War II.

3 It is hard to determine whether Rohowsky intended the uniformed figures to represent official military presence or civilian corpsmen newly enlisted into the city Patrol Corps. The Patrol Corps was not functioning until 1942, however, and khaki uniforms on loan from the U.S. Army Quartermaster were not widely available to these recruits until that summer. Civilian corpsmen also were initially refused the right to carry weaponry. La Guardia succeeded in altering state law pertaining to gun issue during wartime, recognizing the boost to morale and authority

that would be achieved by equipping his civilian defense recruits with smart attire, guns, and clubs.

PLATE 93

1 The history of Times Square's signage, so iconic of New York City night life, was the subject of a special exhibition, *Signs and Wonders: The Spectacular Lights of Times Square*, at the New-York Historical Society, November 12, 1997–March 8, 1998. For the impact of war-era dim-out regulations on the square's illuminated outdoor signs, see Tama Starr and Edward Hayman, "War and Peace," in *Signs and Wonders: The Spectacular Marketing of America* (New York: Doubleday Dell, Currency Books, 1998), pp. 132–151.

2 The Broadway Association, a vocal advocate for Times Square's businesses, argued for increased street lighting to counteract the negative economic impact of the larger blackout rules, pointing to newsreel evidence of London shops and theaters lit up except during air-raid warnings. The city, however, countered by asking for even more stringent electrical conservation, including the closing of all stores at eight in the evening. A prolonged debate followed, resolved only by the ending of the war. See Starr and Hayman, "War and Peace," pp. 134–137.

3 An excellent overview of the forces behind the area's distinctive nightlife and commercial character is provided in William R. Taylor, ed., *Inventing Times Square: Commerce and Culture at the Crossroads of the World* (New York: Russell Sage Foundation, 1992). The area's evolution as expressed through the lens of the *New York Times,* and its wartime aspect, are discussed in Meyer Berger, *The Story of the New York Times, 1851–1951* (New York: Simon and Schuster, 1951).

PLATE 94

1 See Emily Genauer, "This Week in Art: Sievan Exhibit," *New York World Telegram,* March 17, 1945.

2 Ibid. For a fuller treatment of Sievan's artistic development and exhibition history, see Francis V. O'Connor, "Maurice Sievan (1898–1981), an Artist of the New York School," in *Creative Lives: New York Paintings and Photographs by Maurice and Lee Sievan* (New York: Museum of the City of New York, distributed by the University Press of New England, 1997), pp. 33–81

PLATE 95

1 For a comprehensive description of the background and construction of Rockefeller Center, and later alterations to it, see Carol Herselle Krinsky, *Rockefeller Center* (New York: Oxford University Press, 1978).

2 Various press clippings describing the artist and the exhibition are in the Israel Litwak scrapbook in the Art Reference Library of the Brooklyn Museum. The museum also owns examples of Litwak's work.

PLATE 96

1 *The WPA Guide to New York City* (1939; reprint, New York: Pantheon, 1982), p. 264.

2 Notes from a conversation with Major David Dulgose of the Salvation Army, May 24, 1994, Museum Archives.

3 Suba's snapshots related to this work are in the Museum Archives.

4 Robert Rosenbloom, in "Art: Precisionist Painting," *Architectural Details* 50, no. 3 (March 1993): 140–143, describes the Precisionists' "vision of static, limpid perfection" as their response to the twentieth century's "law, order and newly discovered beauty of cubic utilitarian buildings, cylindrical oil tanks and circular wheels within wheels." The spirit of most of Suba's carefully detailed works seems generally more humanistic.

PLATE 97

1 Biographical information from *Hugh Miller's New York,* brochure for exhibition of the same name, January 5–February 5, 1994, Kraushaar Galleries, New York City.

PLATE 98

1 Van Esselstyn has modestly attributed her acceptance into Yale to the wartime scarcity of men to fill class places.

2 Artist's notes, Museum Archives.

PLATE 99

1 When former congressman and millionaire brewery owner Jacob Rupert, who bought the team in 1915, decided to build in the Bronx, skeptics dubbed the plan "Rupert's Folly," believing that fans would never venture to a Bronx-based ballpark. The new stadium, which cost $2.5 million, was tagged "the house that Ruth Built" because of the turnaround Ruth had effected in the Yankees when he joined the team in 1920, during its final years at the Polo Grounds. The site of Yankee Stadium, formerly an undeveloped 11.6-acre plot, boasted convenient access to the subway and elevated trains.

2 Corvino's impulse to memorialize this moment in the Yankees' history may have been prompted by the team's altogether disappointing performance in the late 1960s. Beginning in 1965 the Yankees, who had been enjoying consecutive winning seasons for years, dropped to sixth place and stayed out of pennant contention through the remainder of the decade. By 1969 the team, to their ignominy, watched the New York Mets win both the National League Pennant and the World Series. See Miro Weinberger and Dan Riley, eds., *The Yankee Reader* (New York: Houghton Mifflin, 1991).

PLATE 100

1 Ernest Fiene, quoted in "A Painter Questions Emphasis on Novelty in Modern Art," *Kansas City (Mo.) Star,* May 18, 1956.

2 This painting was one of nineteen works by Fiene, most representing recent Manhattan night scenes, that were featured in a one-man exhibition at Midtown Galleries on East 57th Street, January 27–February 21, 1959.

3 The term *Midmanhattan* enjoyed a passing vogue in the 1950s.

For a survey of the construction centered in the area during the building-boom years concurrent with Fiene's painting, see *Midmanhattan, Portrait 1957* (New York: Bank of New York, 1957).

4 Quoted in "Ernest Fiene, 70, Realist Painter," *New York Times,* August 11, 1965. For an overview of Fiene's career before his production of this painting, see Lynda Hyman, *Ernest Fiene, Art of the City, 1925–1955,* exhibition catalogue (New York: ACA Galleries, 1981). The Museum Archives contain extensive clippings of press notices, short biographies prepared for *Who's Who in American Art* and for various gallery shows, obituary notices, and information about Fiene's larger New York City oeuvre.

PLATE 101

1 In the introduction to her book, when making the point that the older housing might have been badly deteriorated but at least was more humanistic in its size and setting, Jacobs quoted a tenant of one of the East Harlem housing projects, who said: "Nobody cared what we wanted when they built this place. They . . . pushed us here and pushed our friends somewhere else. We don't have a place around here to get a cup of coffee or newspaper even." Jane Jacobs, *The Death and Life of Great American Cities* (New York: Random House, 1961), p. 15.

PLATE 102

1 Kenneth T. Jackson, ed., *The Encyclopedia of New York City* (New Haven: Yale University Press, 1995), p. 696.

2 Donald Tricarico, *The Italians of Greenwich Village: The Social Structure and Transformation of an Ethnic Community* (Staten Island: Staten Island Center for Migration Studies, 1984), pp. 1–3, 51, 54.

3 Celebrations such as the Santa Lucia festival have been described as "vibrant expressions of New York's communities . . . [which display] . . . ethnicity, faith, artistry, humor and fun . . . [and reaffirm] ties to the past," in the pamphlet *Celebration City!: A Sampling of New York City's Cultural Festivals and Parades* (New York: City Lore, 1997).

PLATE 104

1 Wil Haygood, *King of the Cats: The Life and Times of Adam Clayton Powell, Jr.* (Boston: Houghton Mifflin, 1993), p. 307.

PLATE 105

1 Donald Stewart's sixty-three-page monograph *A Short History of East Harlem* (New York: Museum of the City of New York, 1973) remains the only work in print dedicated to surveying the long settled history of this culturally diverse neighborhood. A full list of East Harlem painters and sculptors who displayed work as part of the 1973 project is in the Museum Archives. It is worth noting that efforts to establish an institutionalized venue for the presentation of artwork by local residents of Puerto Rican heritage predated the Museum's exhibition, with the 1969 founding of El Museo del Barrio. This museum, which led a peripatetic existence for the next seven years, moving from a public school classroom to a brownstone on East 116th Street to a series of storefront quarters, found a permanent home in the Heckscher Building at 1234 Fifth Avenue in 1977. Today, its mission has broadened to exhibit and promote the artistic heritage of Latin Americans, primarily in the United States.

2 For a contextual account of the East Harlem community's struggles with heroin's invasion in the years following World War II, see Jill Jonnes, *Hep-Cats, Narcs, and Pipe Dreams: A History of America's Romance with Illegal Drugs* (New York: Scribner, 1996), pp. 136–145. The painting is reproduced in her text. Since its 1973 acquisition by the Museum, Allende's canvas has been requested frequently as a loan to special exhibitions attempting to interpret aspects of America's twentieth-century drug wars, such as the Margaret Woodbury Strong Museum's *Altered States: Alcohol and Other Drugs in America,* 1992.

3 In an effort to augment the artist's biography, Museum curatorial staff wrote to a number of East Harlem artists and community activists who participated in the planning of the 1973 *East Harlem* exhibition, but few could supply more than incidental details about Allende. A former associate from Grupo des Artistas Latino Americano reported that Allende had died in 1997 and that his family remained in Puerto Rico. See correspondence in the Museum Archives.

PLATE 106

1 An unpretentious cremation facility was built at Fresh Pond in 1884 as one of the earliest projects of the United States Cremation Company. A newer, larger marble and brick crematory, officially known as the Fresh Pond Crematory, replaced it in 1893, with the transition marked by an elaborate dedication ceremony. See *A Brief Outline of the History of the United States Cremation Company* (Middle Village, Queens Borough, New York, 1936). Modern efforts to make the Fresh Pond Crematory an official New York City landmark were halted by its trustees, who wished to preserve their freedom to modify and enlarge the facility. It is, however, listed on the National Register of Historic Places.

2 Other subjects in the series include the interior of the Ridgewood Savings Bank, the Queen Ann Cottage Gate House at Mount Olivet Cemetery in Maspeth, a parsonage in Maspeth, the Cox House in Maspeth, the George Schwartz House in Glendale, and several street scenes in Ridgewood and Middle Village, Queens (acc. nos. 84.66.1–.8), all donated to the Museum of the City of New York by the artist in 1984.

3 Werner articulated her recollections of painting these sites in a series of letters dating from May and June 1995. That summer, the Museum included her Ridgewood Savings Bank and Fresh Pond Crematory interiors in its special exhibition *New York Now: Contemporary Cityscape Painting.* Soon after the exhibition opened, a visitor informed the Museum of Werner's suicide that same July. By this date, the artist had been living in northern Manhattan but had shifted to health care as her primary field. The Museum Archives contain clippings, exhibition notices, and other biographical materials that suggest Werner's promise as a New York cityscape painter during the 1970s and 1980s.

4　"The technique I used for all my works is classic egg oil emulsion under painting with full oil over glaze similar to Canaletto and Vermeer and some of Vuillard's work," Werner noted (letter in Museum Archives, June 6, 1995). In 1983 her painting *Showroom by Michael Graves* was borrowed for the Museum's special exhibition *Painting New York* (October 4, 1993–April 1, 1984).

PLATE 107

1　Pinto, in a letter dated November 23, 1994, in the Museum Archives, summarized the events and ideas that led to the painting of the mural, which she characterized as "a documentary of Soho's creation." The mural was eventually removed from its original setting and reinstalled at the New Ballroom restaurant club in Chelsea. The New Ballroom's announced closing in 1994 spurred the trio of owners who had opened the first Ballroom on West Broadway to donate the painting to the Museum of the City of New York.

2　See Gerrit Henry, "Overnight Celebrities," *Spectator,* April 24, 1976. The mural's unveiling was covered widely by the contemporary art press in publications ranging from the *Village Voice* and the *Soho Weekly News* to the *New York Times* and the *New York Post.* Clippings, and a key to the sitters depicted in the mural, are in the Museum Archives.

PLATE 108

1　In a letter dated July 1995, in the Museum Archives, Cohn remarked that he was continuing the series.

2　McGraw-Hill Publishing Company sold the building to Group Health in 1974, the year the publishers moved to Rockefeller Center. In 1980 the medical insurance organization in turn sold the building to a joint venture of Aaron Gural and George S. Kaufman, representing their real estate concerns, Newmark and Company Real Estate and Kaufman Management Company, respectively.

3　Paul Goldberger, "Critic's Notebook: Raymond Hood and His Visions of Skyscrapers," *New York Times,* January 3, 1984.

4　Letter of July 1995 in the Museum Archives.

PLATE 109

1　Traditional knishes consist of boiled buckwheat groats or mashed potatoes wrapped with dough, then baked and served hot. Today knishes have an amazing variety of fillings, such as broccoli, spinach, and cheese.

2　Information about the founding of the business and the family's continued role in it come from a letter from the artist to the curator, Museum Archives, and from a telephone conversation in December 1994 with Mrs. Lillian Berger (now retired), Yonah's granddaughter and the third generation of the family to run the business.

PLATE 110

1　Philip Sherrod, artist's statement dated July 5, 1983, submitted to the Museum of the City of New York when this painting was exhibited in the special exhibition *Painting New York, 1984–94.* The statement concluded, "My form and color are derivative of the city as are my rhythms and images! (It's like—OUT WHERE IT'S AT, MAN !!)."

2　The Museum Archives contain press notices, biographical information, and other correspondence illuminating the breadth of Sherrod's career as a street painter, portraitist, and poet-philosopher.

PLATE 111

1　Quoted from artist's statement, July 15, 1983, one of two essays submitted by Nedra Newby to the Museum of the City of New York when *Murder on Clinton Street* was initially lent to the Museum's special exhibition *Painting New York* (1983–1984).

PLATE 112

1 Tom Rubin, "TDF... Theatre's Good Friend," *Playbill* 88, no. 6 (June, 1983).

2 "New Booth at TKTS Site," *New York Times,* May 19, 1988.

3 Letter from Lawrence Heyman, dated November 27, 1995, Museum Archives.

4 Donald Fitzhugh, "D.C. to Parks and Back: Star Calendar Sparked Art Career," *Sunday Star,* May 1, 1966.

PLATE 113

1 In a 1982 interview Reisman recalled that his early fascination was kindled by an art correspondence course that his eldest brother took in 1914. A constant "doodler," Reisman dropped out of high school for a job in an art service that promised to teach him illustration but in fact taught him "how to run errands and wrap packages." His career as an illustrator advanced quickly, however. By the late 1920s he had sold etchings to the Metropolitan Museum of Art, completed an assignment for *Collier's* magazine, and had exhibited his drawings and prints in a number of gallery and museum venues. The artist's reminiscences are quoted in Sandra Durell, "The Artist in Society: An Interview with Philip Reisman, N.A." (December 1982), in *Philip Reisman: A Life Remembered, 1904–1992* (New York: privately printed by Louise K. Reisman, 1993), pp. 29–34.

2 During the early 1930s Reisman was also active in the John Reed Club, and, later, in the Artists' Union and the American Artists' Congress. See Patricia Hills, *Social Concern and Urban Realism: American Paintings of the 1930s* (Boston: Boston University Art Gallery, 1983), pp. 76–77.

3 Philip Reisman, quoted in the exhibition catalogue *The Sixties and the Seventies: Paintings of New York City by Philip Reisman* (New York: Museum of the City of New York, 1980), p. 2.

4 The Museum owns two other oil paintings by Reisman that evoke "types" seen around the city in particular eras: *The Sleeper,* 1966

(acc. no. 92.71), depicting a street bum dozing on a bench, is a reminder of New York's tenacious homeless population, and *Games,* 1985 (see fig. 9), records some exuberant sidewalk "break dancers" and a gaming arcade employee wearing an "I Love New York" T-shirt.

5 Reisman's career is extensively documented in articles, entries in artist dictionaries, and obituary notices in the Museum Archives. For many years, he exhibited at the ACA Gallery in Manhattan with other artists who made use of social commentary, and copies of these associated catalogues contain useful information. For selective summaries of his later career, see, for example, Raymond J. Steiner, "Profile on: Philip Resiman," *Art Times* (April 1985): 8–9; and Patricia Van Gelder, "Philip Reisman: Manhattan Chronicles," *American Artist* 43 (October 1979): 68–73, 114–115.

PLATE 114

1 Ferguson became interested in painting and drawing during a year spent at the Gerrit Rietveld Academie in Amsterdam. The influence of the Dutch masters on his painted New York cityscapes was noted by several critics who tracked his rising career in the early 1980s. See, for example, John Loughery, "Max Ferguson," *Arts Magazine* 61 (November 1986): 124.

2 The backs of Ferguson's paintings typically include detailed technical information to aid in their future conservation, and they have been likened to open scrapbooks because of his tendency to include quotes, comments, and relevant souvenirs taped to the surface.

3 The haunting qualities conveyed in many of Ferguson's cityscapes caught the attention of TDI (Transit Display, Inc.), which in 1998 used one of his paintings—showing a lone figure looking out at the Central Park Reservoir, dwarfed by the beauty of an unfolding spring—as a background for a city bus campaign with the superimposed public service message "Mental illness should not be faced alone."

PLATE 116

1 The literature on the history of New York City's graffiti movement in the 1970s is vast and often contradictory. A balanced overview is offered by Jack Stewart in his doctoral dissertation "M.T.A.—Mass Transit Art," New York University, 1989; excerpts were published as an article accompanying the 1997 Groniger Museum exhibition catalogue *Graffiti: Coming from the Subway.*

2 Many of the dealers and art-world figures involved in courting these young graffiti artists, who came predominantly from New York's poorer ethnic neighborhoods, faced accusations of having exploited them for gain and then withdrawing support when the art market for aerosol paintings grew cold in the 1980s. A few other notable efforts to rechannel "writing" off the tracks and into studios had preceded this period, however. For example, the 1972 organization of United Graffiti Artists (UGA) at City College, spearheaded by a streetwise sociology major named Hugo Martinez, gave graffiti writers an early forum for discussing craft aesthetics and for exhibiting their spray work on "legitimate" surfaces like background paper. By 1973 paintings by UGA members had broken into the Soho art world with a show at the Razor Gallery, which also toured elsewhere. The initial group disbanded in 1974, although Martinez remained active in promoting the movement's legitimizing ambitions.

3 In a telephone interview on October 14, 1998, LEE recalled that Corlears' art teachers were "upset" when he did the handball-court mural because "all the kids wanted to do was watch me paint, rather than pay attention to their school work." In 1979 he produced murals for other school playgrounds in the vicinity, the piece for P.S. 137 being titled *Hell Never Dies.*

PLATE 117

1 From *A Short History of Katz's Delicatessen* (New York: Katz's Delicatessen, 1994). By the early twentieth century, the Lower East Side was home to sixty delicatessens, most featuring Eastern European Jewish cuisine. See Kenneth T. Jackson, ed., *The Encyclopedia of New York City* (New Haven: Yale University Press, 1995), p. 324.

2 Quotations are from Schnurr's artist's statement, dated July 22, 1995, Museum Archives.

PLATE 118

1 Sebastian Cruset's *View from Queensboro Bridge after St. Patrick's Day Storm* (plate 57), painted shortly after the bridge opened in 1910, is an example of such panoramas. For more on these "bird's-eye" prints, see John W. Reps, *Views and Viewmakers of Urban America* (Columbia, Mo.: University of Missouri Press, 1984), p. 3.

2 Ibid.

PLATE 119

1 Artist's statement, Museum Archives.

PLATE 120

1 *The Encyclopedia of New York City* cites the Middle East, Latin America, Russia, the Caribbean, South Asia, and Africa as the areas of origin for more than 75 percent of New York's licensed cab drivers in the late twentieth century. Kenneth T. Jackson, ed., *The Encyclopedia of New York City* (New Haven: Yale University Press, 1995), p. 1155.

PLATE 121

1 John A. Parks, "Creating a Sense of Order," *American Artist* (May 1996): 33.

PLATE 122

1 Ellen M. Snyder-Grenier, *Brooklyn! An Illustrated History* (Philadelphia: Temple University Press, 1996), p. 197.

2 Artist's letter, dated May 6, 1995, Museum Archives.

PLATE 123

1 *History of Queens County* (New York: W. W. Munsell, 1882), p. 276.

PLATE 124

1 The 1990s boom market of Manhattan real estate has produced several Brooklyn art colonies, including Greenpoint (where Safranek lives), DUMBO (District Under Manhattan Bridge Overpass), and Williamsburg.

PLATE 125

1 Artist's statement, Museum Archives.
2 Pam Frederick, "Daniel Hauben Captures the Bronx on Canvas," *Riverdale Press,* September 26, 1996.

PLATE 126

1 Letter from the artist, July 1998, Museum Archives.
2 Notes from a telephone conversation with the artist, August 18, 1998, Museum Archives.
3 Ibid.

PLATE 127

1 Notes from a telephone conversation with the artist, March 11, 1998, Museum Archives.
2 Arthur Robins, *Discovering the Nature of Existence Through Art* (New York: Revelation Fine Art, 1997).

PLATE 128

1 Tom Christopher, quoted on the back-cover profile in *Reader's Digest* (April 1998). The artist has been the subject of numerous articles, several prompted by openings of solo exhibitions of his New York cityscapes at the David Findlay Galleries in New York and the Galerie Tamenaga of Paris, Tokyo, and Osaka. See, in particular, David Owen, "The Creative Life: Monet Had His Water Lilies, and Tom Christopher has Times Square," Talk of The Town section, *New Yorker* (October 19, 1998).

2 According to Marvin Schneider, clockmaster of the City of New York, these formerly common street fixtures were installed on prominent thoroughfares from the post–Civil War period through 1915, paid for by individual businesses that were expected to maintain them. Many of the clocks were weight driven and were manufactured by Seth Thomas and E. Howard. When city traffic was still powered principally by horses or streetcars, accidents causing impact with the clocks were generally not fatal to the traveler—or the timepiece. As automobile and bus traffic increased in volume and speed, collisions became more catastrophic, and construction operations were also inconvenienced by the presence of the clocks. Today, few remain, but the existing street clocks have acquired great sentimental value for the public. Three such clocks still stand at 205, 522, and 738 Fifth Avenue, respectively.

3 The artist has written of this particular painting, "There is a time in Manhattan, mid to late day, and usually in autumn, when the shadows grow to sixty feet long and everyone is scrambling to get somewhere. It's not that early morning bustle when everything is torqueing forward, but at this time of the day, it's a little more contemplative. And if you are lucky you catch it just right, the city is at it's truest and best and reminds you of why you live here." Letter from the artist, May 28, 1998, Museum Archives.

4 Christopher has enjoyed a versatile career, with many far-flung assignments. As of 1998, New York City paintings were his principal occupation, although the artist had at this point left his Long Island City studio to paint his frenetic streetscapes from a more serene barn in South Salem, New York. For the growing critical literature inspired by Christopher's expanding reputation as a leading cityscape painter, see the Museum Archives.

Acknowledgments

DOCUMENTATION of the extensive collection of urban-scene paintings at the Museum of the City of New York commenced with a generous initial grant from the National Endowment for the Arts (NEA) in 1989–1992, which enabled the Museum to concentrate on the creation of systematic object files and artist files for the collection, while benefiting from the advice of consulting art historian Dr. William H. Gerdts. The NEA also supported the subsequent conservation of many individual paintings. Consecutive grant awards from the Bay Foundation paid for additional conservation of key canvases and panel paintings. The National Endowment for the Humanities advanced the documentation of the collections by providing for the invaluable expertise, during the period from 1992 to 1995, of consulting scholars Elizabeth Blackmar, Daniel Bluestone, Cristine Boyer, Kevin Starr, Ellen Todd, and the late Milton Brown. The grant included partial funding for the preparation of the catalogue manuscript, the content of which was enlivened and focused by contributions of consulting historians Michele H. Bogart and William R. Taylor. *Furthermore,* the publication program of The J. M. Kaplan Fund and the Moore Charitable Foundation also awarded funds that made possible the final organization and printing of this book. W. Cody Wilson generously made possible the special fold-out page showing the Anatol Shulkin mural (plate 75) and the Ben Shahn series (plates 76–81).

The creation of *Painting the Town* has drawn heavily on the expertise and assistance of many scholars and researchers, as well as on staff members of numerous galleries, auction houses, archives, historical organizations, and libraries. Sources of information are generally cited in the endnotes accompanying each essay and catalogue entry. Certain individuals and institutions, however, deserve special acknowledgment for their contributions: Archives of American Art, the Art Students League, Joe Austin, Kevin Avery (Department of American Paintings and Sculpture, Metropolitan Museum of Art), the Bauta family, Rick Beard, Raymond Beecher (Greene County Historical Society), Lynn S. Beman, Deborah Bershad (New York City Art Commission), Mary Brendle, Lillian Brenwasser, Kennedy Galleries, Brooklyn Museum Library and the American Paintings Department, Norman Brouwer (South Street Seaport Museum Library), the late Milton Brown, Katherine Burnside (Hirschl and Adler Galleries), Marietta Bushnell (Pennsylvania Academy of the Fine Arts Library), Kathleen Collins (New York City Transit Authority Archives), Irene Cramer (Woodstock Art Association), Gloria Deak, Joseph DePlasco (New York City Department of Transportation), David Dearinger (National Academy of Design), Joseph di Troia, Jameson W. Doig (Princeton University), Douglas Dreishpoon, the Floating Hospital, Frick Art Reference Library, Maxine Friedman (Staten Island Historical Society), Abigail Gerdts (National Academy of Design), Holly Haswell (Columbiana Library, Columbia University), Catherine Hayes (Hirschl and Adler Galleries), Richard Hollinger (Transit Authority Museum Archive), Pamela Hubbard (Department of American Paintings and Sculpture, Metropolitan Museum), Joseph Jackson (New York Yacht Club Library), Steven Jaffee (Con Edison Library), Kennedy Galleries, Norman Kleeblatt (Jewish Museum), Marianne Kramer (Central Park Conservancy), Jeffrey Kroessler, Jonathan Kuhn (New York City curator of monuments), Grace La Gambina, Cassandra Langer, Sarah Landau, Claire Laurens (Brooklyn Historical Society), Christopher Letts (Hudson River Foundation), Kathleen Luhrs, Kenneth Maddox (Newington-Cropsey Foundation), John Manbeck (Brooklyn Borough Historian), the National Academy of Design, Janet Marcuse, Kathleen McCauley

(Bronx County Historical Society), Brooks McNamara, the Metropolitan Museum (Thomas J. Watson Library and the Department of American Paintings and Sculpture), Elsa Meyers (New Jersey Historical Society), National Museum of American Art, Kenneth Moser, Kenneth Myers, Ellen Nelson (Cape Ann Historical Society), New York Public Library, Miriam and Ira D. Wallach Division of Arts, Prints, and Photographs, Kenneth Newman (Old Print Shop), Anthony J. Peluso, Nina Root (American Museum of Natural History), Laura Rosen (Triborough Bridge Authority Archives), Michael Rosenfeld (Michael Rosenfeld Gallery), Charles Sachs (New York City Transit Museum), Marvin Schneider, Vincent Seyfried (Queens Historical Society), Paul Schweitzer (Munson-Williams-Proctor Institute), Wendy Shadwell (New-York Historical Society), Howard and Carolyn Sievan, Peter Sluszka (Steinman, Boynton, Gronquist and Birdsall), the Society of Illustrators, Joel Swimler (American Museum of Natural History), Barbara Sykes-Austen (Avery Library, Columbia University), Irene Tichener (Brooklyn Historical Society), Leonard Louis Tucker (Massachusetts Historical Society), Laura L. Vookles (Hudson River Museum), Robert C. Vose, Jr., Cristina Wasserman (National Museum of Women in the Arts), Bruce Weber (Berry-Hill Galleries), Nancy Weinstock (*New York Times* Picture Archives), Steve Wheeler (New York Stock Exchange Archives), Margo Williams (Brooklyn Historical Society), John Wilmerding (Princeton University), Mina Weiner, Sharon Worley (Cape Ann Historical Society), Devra Zetlan (Municipal Reference Library), and Richard Zigun (Coney Island U.S.A.)

Patient, loyal volunteers and student interns in the Museum's Department of Paintings and Sculpture contributed countless hours to organize material and follow up research leads. Their detective work and enthusiasm kept the project moving forward. Volunteers included Ann Blatt, Nancy Cochran, Florence Daniels, Fritz Gold, the late Barbara Halpern, Margo Hensler, Andrea Lakian, Ellen Schreiber, the late Herbert Schwartz, Nanette Scofield, Hilda Spitz, the late Ruth Stone, Edith Umansky, Rein Virkma, Helga Windhager, and Carole Zicklin. Interns were Shelley H. Butler, Mora Beauchamp Byrd, Jennifer Hochhauser, Katherine Kuo, Katherine McCusker, Hong Mei, Eileen Kennedy Morales, Nicholas Popper, Miriam Shuman, Jonathan Solomon, and Sally Weiner.

Present and former colleagues at the Museum of the City of New York provided vital support and good humor, making themselves available to guide research and assist with the technical production of this publication. Special thanks to Terry Ariano, Kathleen Benson, Darnelle Bernier, Sheila Clark, Mary Cope, Andrew Davis, Rob Del Bagno, M. Alison Eisendrath, Edward P. Henry, Marty Jacobs, Edya Kalev, Lisa Kim, Lisa Koenigsberg, Marguerite Lavin, Barbara Lund-Jones, Phyllis Magidson, Carol McGrath, Jane McNamara, Josephine Nelson, Leslie Nolan, the late Mark Ouderkirk, Australia Ramos, Wendy Rogers, Peter Simmons, Deborah Dependahl Waters, Amy Weinstein, Steven West, Kassy Wilson, Jennifer Wolf, and Bonnie Yochelson.

This publication is limited in scope. A list of the entire collection, with additional catalogue entries, images, and an interpretive essay, will be available on the Museum's website (www.mcny.org) in the year 2000.

Index